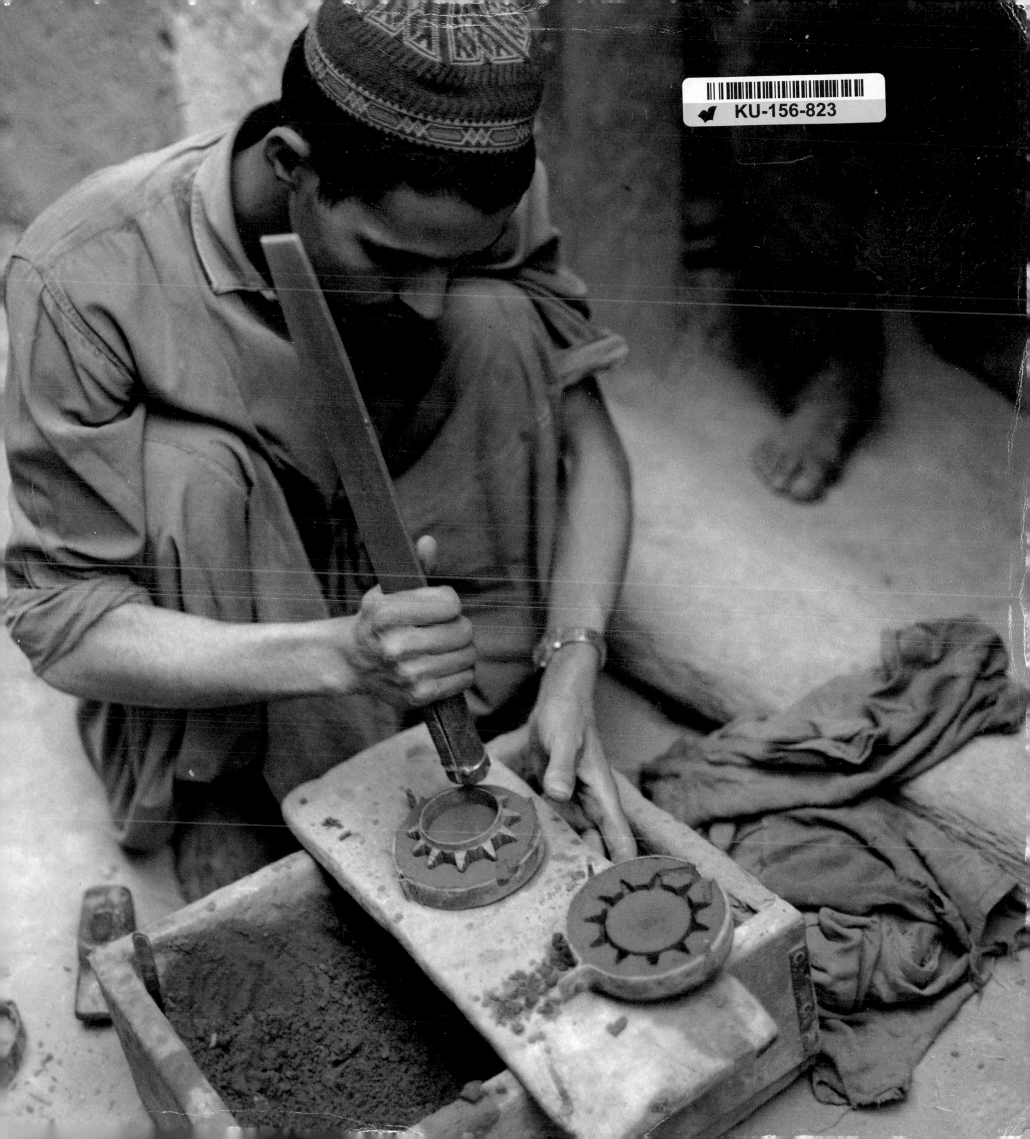

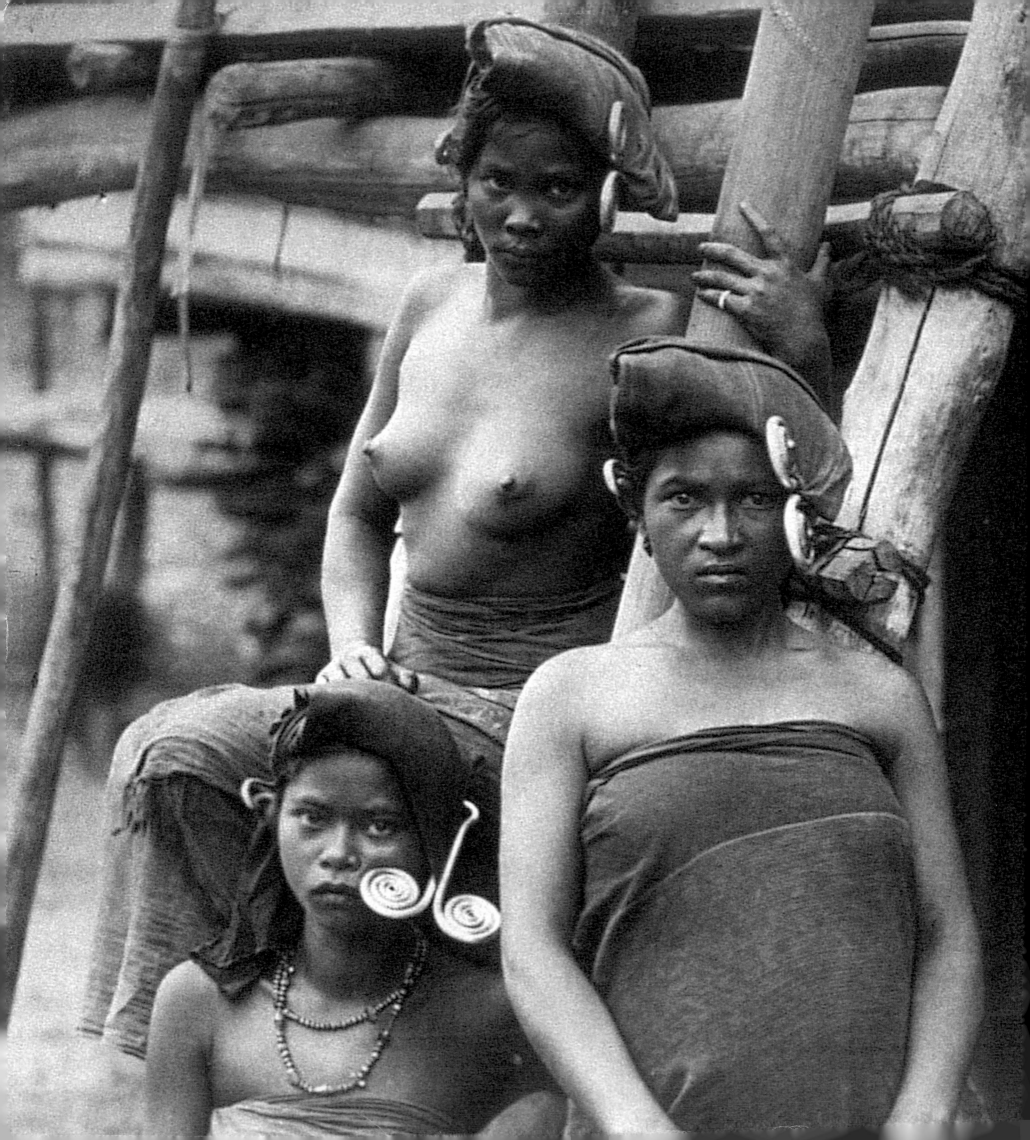

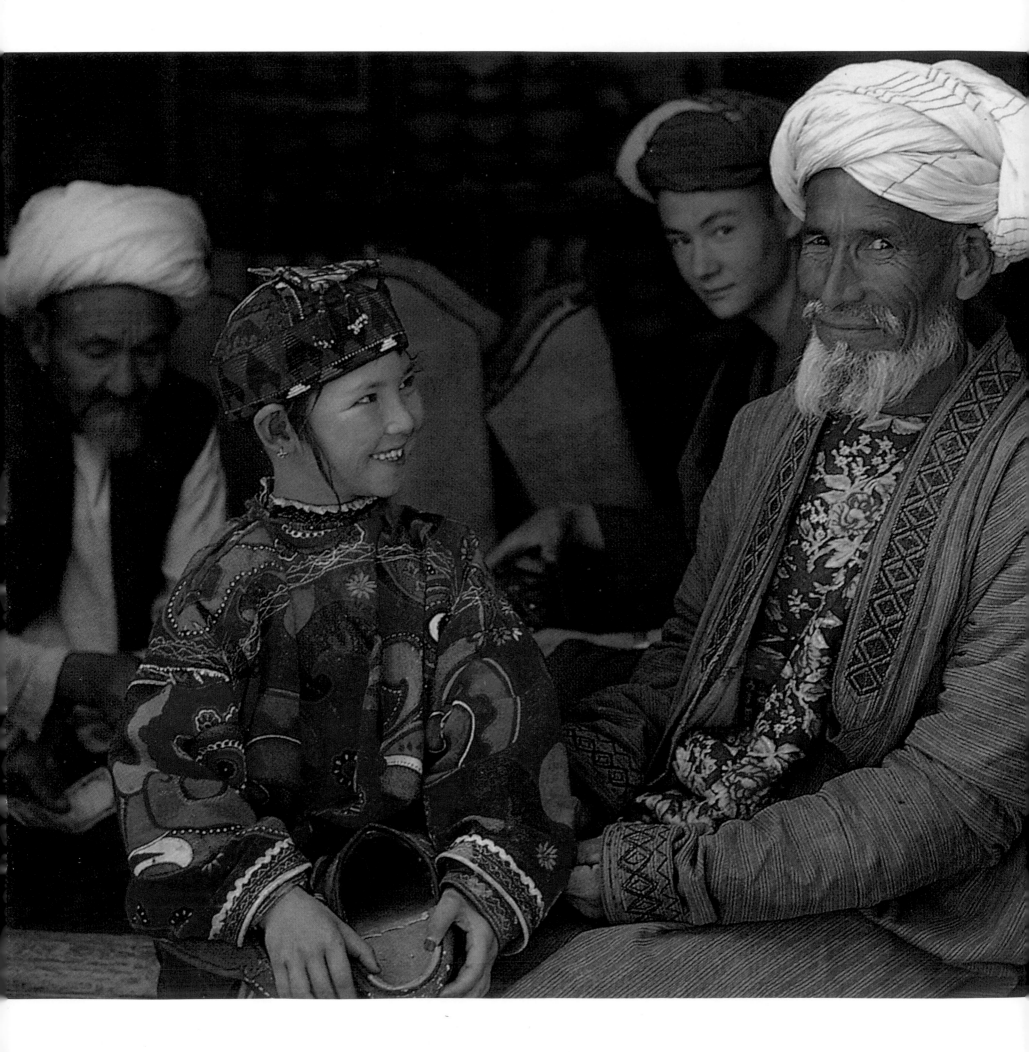

ETHNIC JEWELLERY

FROM AFRICA, ASIA AND PACIFIC ISLANDS

The René van der Star Collection

Photographed by

Michiel Elsevier Stokmans

THE PEPIN PRESS

AMSTERDAM AND SINGAPORE

On the Jacket:

Silver ankle and toe ornaments worn by a Lambadi woman, Andhra Pradesh.

Page 1:

Moroccan Silversmith. Two metal containers with a small opening in the rim were filled with a mixture of sand and sugar . The piece to be copied was pressed halfway into one of the containers, then the other half was pushed into the other container. The containers were put together and liquid silver was poured through the small opening. After the silver was cooled off the containers were pulled apart. Morocco, 1969. (see page 32)

Page 2:

Karo-batak women with big earrings (*padung–padung*) made of a silver alloy, Sumatra, Indonesia, c.1880. (see page 230)

Page 3:

Gold hoop earrings (*kunuk*) worn at the top of the ear by Indian-Syrian Christian woman. (see page 149)

Page 4:

Turkmenian man with daughter, Agcha, Northern Afghanistan, 1960s.

Page 8:

'Mohammed Silver', weighing silver jewellery with a pair of hand scales, Egypt, 1992.

With contributions by:
Dr. Corien W. Hoek, Centre of Islamic Culture, Rotterdam
Dr. Annelies Moors, anthropologist with the University of Amsterdam
Roelof J. Munneke, curator of the Department of Southwest & Central Asia of the Museum of Ethnology, Leyden
René van der Star, expert in ethnic jewellery, The Netherlands
Dr. Oppi Untracht, expert in traditional Indian jewellery and jewellery-making techniques, Finland
Pim Westerkamp, curator of the Indonesia Department, Nusantara Museum, Delft

This book is published on the occassion of the exhibition of the ethnic jewellery collection of René van der Star in The Rotterdam Kunsthal, The Netherlands. The collector would like to dedicate it to all the peoples whose work is featuted in it, with the hope that they will be able to maintain their own identity and culture. He once read that 'keeping a balance between culture and progress is the art of the future'. A world with a wide variety of cultures is a much more fascinating world than one of relative uniformity.

ISBN 978 90 5496 141 3
Copyright © 2002, 2008 The Pepin Press BV

This book is edited, designed and produced by The Pepin Press in Amsterdam and Singapore
Design: Pepin van Roojen
Translations: UvA Translators and Eric van den Ing (captions)
Copy-editing: Rosalind Horton
Editorial assistant: Eveline Korving

The Pepin Press BV
P.O. Box 10349
1001 EH Amsterdam, The Netherlands
Tel +31 20 4202021
Fax +31 20 4201152
mail@pepinpress.com
www.pepinpress.com

10 9 8 7 6 5
2012 11 10 09 08

Printed and bound in Singapore

Contents

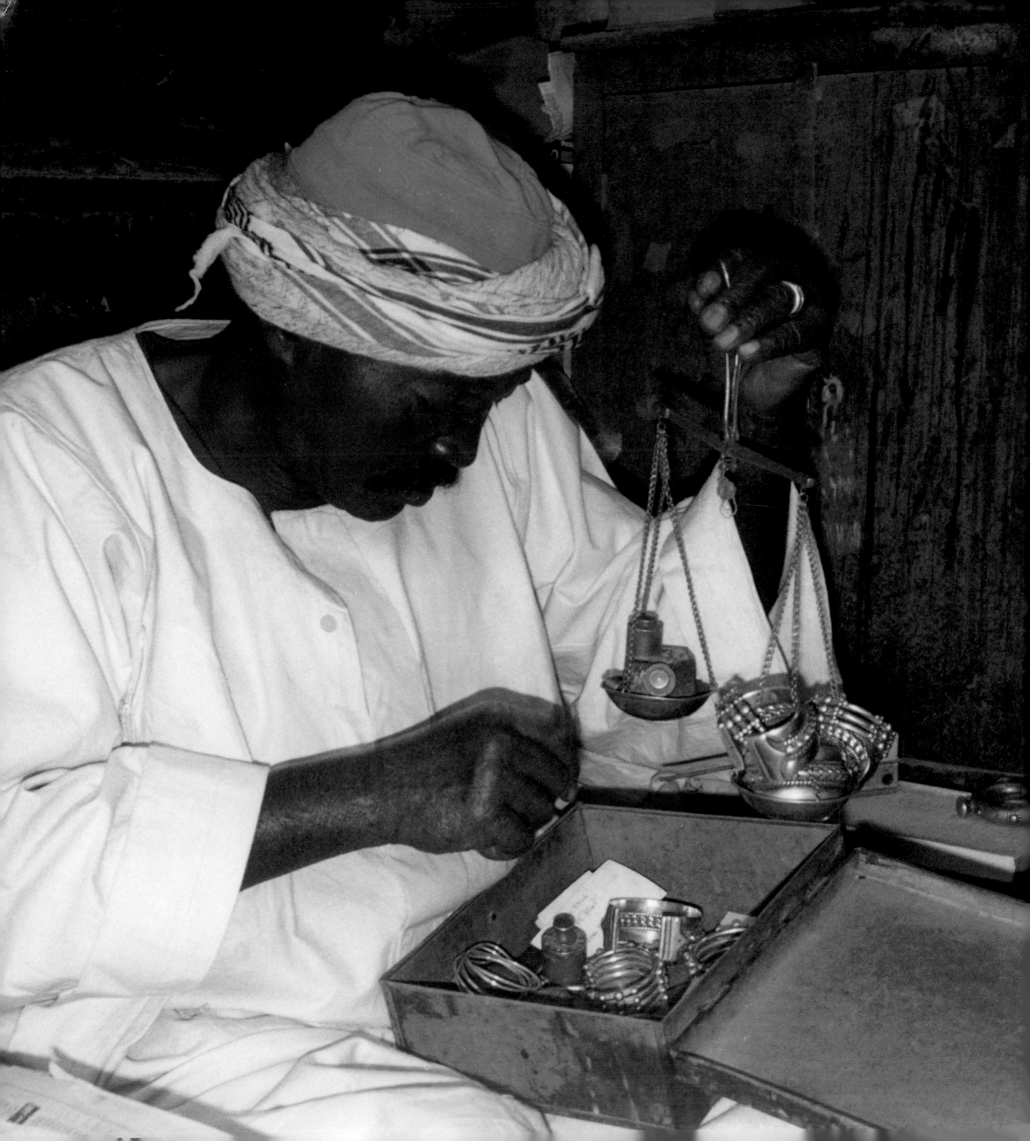

Preface

René van der Star

My serious collecting activities started some 25 years ago. With my partner I mainly collected Japanese lacquer work. We were looking for beauty, craftsmanship and perfection. Our interest in ethnology and jewellery was already present in those early days.

Making trips to distant countries dates back to this period too. We would usually travel to Asia or North Africa once or twice a year. About 18 years ago I was introduced to Indonesian beadwork. I consider the beadwork made by the Dayak of Sarawak and Kalimantan, to be amongst the most beautiful in the world. The step from beadwork to jewellery is just a small one, as I found out during a holiday in North Thailand, where we came across the jewellery of the hill tribes in the Golden Triangle. This beautifully designed jewellery was widely available at the time. In the beginning I felt very unsure about what made good jewellery. My purchases were based purely on intuition, on the same criteria of beauty, perfection and craftsmanship, that we had used when buying Japanese lacquer work. In my view this is still the best approach, although I am better educated and more experienced now. The combination of collecting and travelling is an ideal one. Collecting while travelling is not an aim in itself, but gives an added value to the travelling. Travelling and being introduced to other cultures is an enriching experience, for there are lessons to be learned from all cultures. Three countries have a special place in my heart. The first is Sarawak, because of the genuine friendliness and warmth of the people. When we were travelling in Sarawak, in small boats on the rivers, we were regularly invited to come and stay in a longhouse. I have a vivid recollection of one particular experience. At the time I wore contact lenses and one evening I asked for some boiled water to help me put in my lenses. A dozen people drew around, and just stood there, not saying a thing, but very much interested in what I was doing. The following morning I had to go through the same procedure again. When I started the ritual, some 50 people gathered around to watch what was going to happen. To my question, 'Don't you have any lenses?' one of the bystanders answered, 'No, because we don't have a blind association.'

The second country for which I have feelings of great warmth is Oman. In the Netherlands I came across some jewellery with a very strong design that was completely different from the jewellery made in other regions of the world. This Omani jewellery triggered my interest in the country and after some time I went there on a visit. I can still hear the people around me saying, 'What on earth are you going to do there? It is just one large sandpit.' This was far from the case. In winter the desert is in full flower and green. The wadis are full of water, and alive with fish and frogs. The beautiful scenery and the kindness of the people make Oman a wonderful country. The third country of which I have very special memories is Egypt. There we met a Nubian silversmith, Mohammed Silver, a pitch-black man with a long, white robe and a bright orange hat. We spent a few afternoons with him. He owned a small shop, about 2.5 metres wide and three metres deep, in which there was an enormous safe. We bought some pieces of jewellery from him, which he weighed on a pair of hand scales suspended from his fingers, adding some extra grams with his little finger every now and again. Whenever he showed us a piece of jewellery that we decided not to buy, he looked at it again with extra love in his eyes and then said in a loud, clear voice, 'Beautiful, beautiful.' Then he took another very penetrating look at us and if this did not work and we still were not persuaded, cast another glance at the piece of jewellery, carefully put his treasure back in its box and said 'Sleep, sleep!'.

I gather a lot of impressions during my travels. It is good to be able to see with your own eyes how jewellery and beadwork evolve or, sadly, disappear. Authenticity is very important to me, even more important than the age of the jewellery. Jewellery that is worn tends to show minor signs of wear, but this makes silver jewellery in particular more beautiful. I am convinced that the age of much jewellery is overestimated in many publications. There is usually no heritage culture associated with rural and tribal jewellery. Second-hand jewellery was not worn. Parts of it were re-used or it was melted down and turned into new jewellery. Of course the date can never be more than an educated guess, because of the absence of gold or silver marks. This is what I have tried to indicate in this catalogue, to the best of my knowledge.

This book, and the exhibition with which it is published, crown my collecting work. I would like to take the opportunity to thank a number of people. Wim Pijbes, director of Kunsthal Rotterdam, who allowed me to curate the exhibition with him in an atmosphere of perfect understanding; Michiel Elsevier Stokmans, the photographer, to whom I am very grateful for his commitment and the beautiful results of his pictures. Without his help this book would never have been what it is now. I have really enjoyed working with him. For me he is one of Holland's top photographers and a real master of his art.

I would also like to thank the experts who have written their individual chapters with so much enthusiasm, and added a unique value to this catalogue.

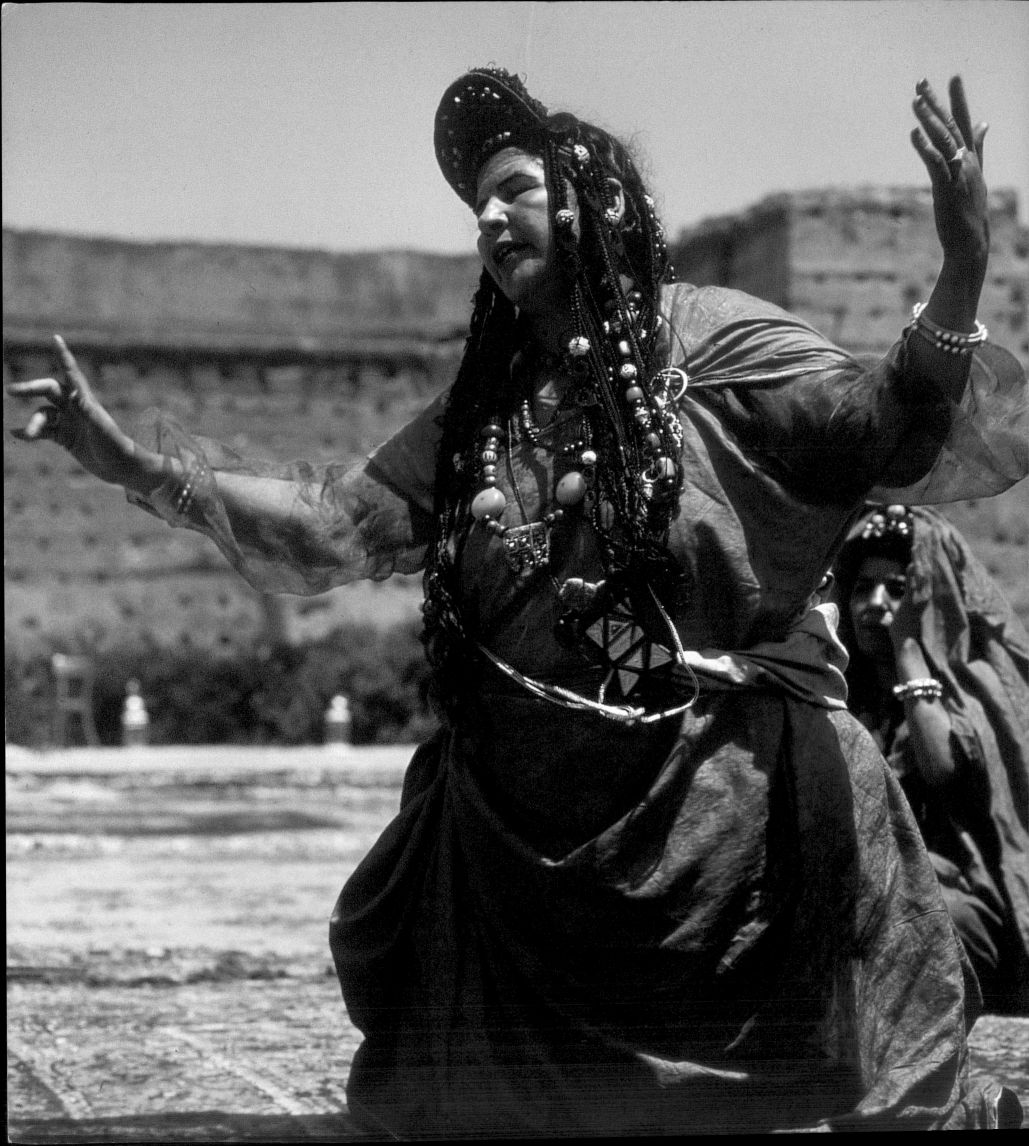

Africa

Algeria
Morocco
Mauritania
Tunisia
Egypt
Sudan
Palestine
Ethiopia
Burkina Faso
Ghana
Nigeria
Cameroon
Congo
Kenia
Namibia
Angola

Left:

Dancing Berber woman,
Marrakesh, Morocco, c. 1990

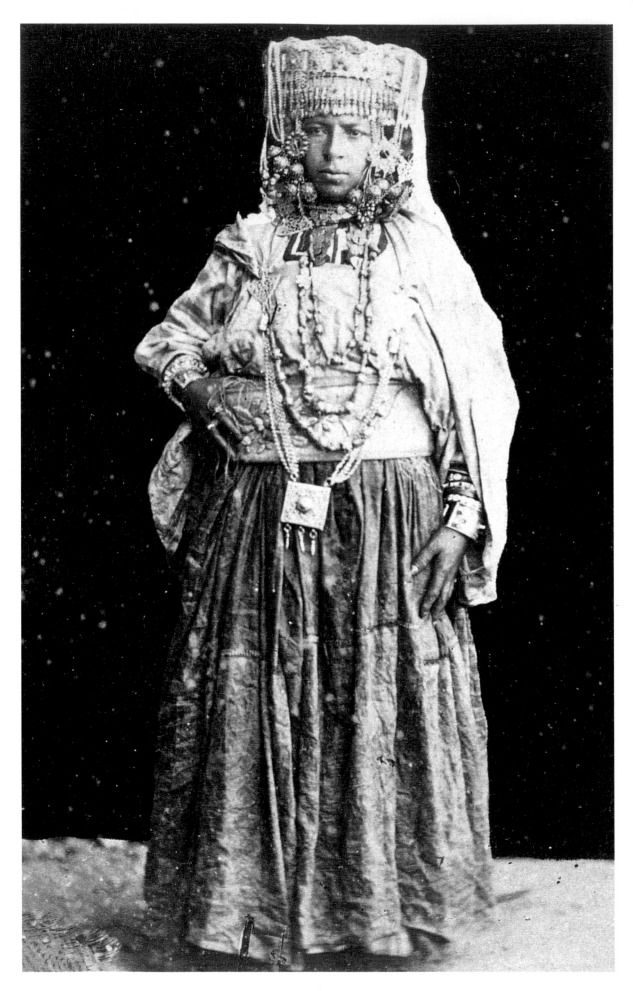

Algerian woman wearing
traditional jewellery, c. 1880

Jewellery from the Maghreb

Corien W. Hoek

The Maghreb[1] has a very interesting tradition of jewellery making that is characterised by a variety of techniques, materials and designs. Notwithstanding the differences, the jewellery from this region has a unity of style. This applies particularly to the jewellery of the Berbers discussed in this chapter. The range, form and function of jewellery indicate similarities throughout the region, even though details of design and decoration can be attributed to particular local tribal families or family units. A relative homogeneity throughout the area is due also to the fact that at various times in the past powerful civilisations such as the Greco-Roman, Byzantine and Arab empires dominated the whole, or large parts of, the region, leaving their imprint on local culture. Islamisation and Arabisation of the Maghreb in particular created homogeneity in the regional cultures. Moreover, mobility of the silversmiths and of the local Bedouins contributed to a uniformity of style in jewellery.

The Maghreb covers an area of more than 2000 km[2]. On the eastern and northern sides the area borders the Mediterranean Sea, on the west the Atlantic Ocean and to the south the Sahara (see map on page 15). The area is a zone of transition where people and cultures from all points of the compass meet. The Maghreb, where Berbers are considered indigenous people, has been dominated by foreign empires throughout history. In the ninth century BC, the Phoenicians founded the city-state of Carthage. Steadily the number of Carthaginian settlements increased, spreading over a wide area. In the second century BC, the Punic Wars brought an end to this expansion and the demolition of Carthage. The Romans had usurped the area by 40 AD. The fifth century AD saw the Vandals arriving from the north and in the sixth century the Byzantine Empire reconquered part of the region. Then in the seventh century, the Arabs came to spread Islam. The majority of the Berber population soon converted to the new religion. Arabisation, the adaptation to the Arab language and culture, took at least another century. In 1061, the Almoravids dynasty, who were of Berber origin, united Morocco and Andalusia into one empire. In the twelfth and thirteenth centuries another Berber dynasty, the Almohads, ruled the empire. International trade brought wealth and prosperity and the arts flourished. From the mid-sixteenth century the Ottomans ruled the Maghreb in relative stability. The Ottoman provinces corresponded to the present day states of Libya, Tunisia and Algeria, which at that time included a large part of modern Morocco. A century later the Alawids came to power, conquering Fez and Marrakech in Morocco. The present King of Morocco, Mohammed VI, is the eighteenth king of the Alawids dynasty. Finally, French colonial rule lasted from the end of the nineteenth century until the mid-twentieth century. In the course of time, domination by foreign cultures influenced, changed and renewed the societies of the Maghreb.

The Berbers

The Berbers are a non-Arabic people who were already living in the region in 3000 BC. They speak their own language, Berber, of which some 300 dialects are known. Berber-speaking people inhabit areas dispersed over a large part of North Africa. They live in Egypt, for example in the oasis of Siwa, in the Fezzan in south Libya, in a more or less continuous area from the northern part of Libya and the south-eastern part of Tunisia to the island of Djerba, in the mountainous littoral between north Tunisia and Morocco, in particular in Kabylia and the Aures in Algeria, the Rif mountains of northern Morocco, the High Atlas, the Sous valley and the Anti-Atlas. The Berbers living in rural areas are involved in agriculture and herding. In the cities and small towns they occupy in a variety of professions, just like other groups of the population.

Production of jewellery

Berber jewellery has its own style, in which silver is dominant. The presence of silver mines, for example in Taza and the Atlas, has contributed to the dominance of silver as a precious metal. Islam may have strengthened this tendency. Islamic cultures traditionally tend to prefer silver to gold, although the increase in wealth in some parts of the Islamic world has seen a growing preference for gold. Berber jewellery is worn particularly in the rural areas outside the cities.

In the Maghreb two different basic metalworking techniques are practised. The first is hot-casting, the other is cold-forging. The casting technique uses two horseshoe-shaped casting moulds filled with fine, wet clay in which an existing jewellery model is pressed. The object is taken out of the mould and the clay model carefully touched up. When the mould is dry, molten silver is poured through a small drain into the mould filling the cavity. The solidified casting is taken out and further refined and polished. With the forging method, the metal, which usually comes in the form of a rod or wire, is hammered on an anvil. The silver is bent, slit or cut with hammers or chisels. Parts may be soldered, nailed or joined together with hinges. A particular decoration technique used in southern Morocco consists of soldering rows of minuscule rings in a particular design. The technique was used for constructing a fibula, known as the 'worms' fibula (tizerzai n tawaka), because of its special effect.

Silversmiths practise a large variety of embellishing techniques, which are often specific to a particular locality. They use for example doming, piercing, repoussé work and chasing, stamping or engraving. Doming is the process of forming a hollow hemisphere. Piercing is done from the front using sharp chisels. The cut edges turn inwards. This technique was already in use in the ancient Roman pierced-work jewellery, known as opus interrasile (opening work). Comparable techniques were used even earlier than this. Geometric, floral or animal motives were created through piercing. In Tunisia in particular, one can find beautiful representations of flowers, birds and fishes, which seem to be copied from jewellery from the ancient Greeks and Romans. With repoussé the metal is being worked with punches from the back, while chasing creates a design indented in the surface, and is generally finer. The two techniques are often combined. The stamping method involves both embossing, whereby the sheet is hammered over an open stamping die which contains an intaglio pattern, or impressing with a punch bearing a design in relief. These are also techniques that were practised by the ancient Greeks and Romans. Highly skilled engraving is applied to many types of jewellery. The incisions are made with sharp-pointed engravers or burins. Jewellery is also gilded, mostly through the application of gold leaf.

The technique of filigree, long used in the Middle East and Europe, is well developed in the Maghreb. Unlike these techniques, filigree requires heat in its

execution. Wires drawn in various thicknesses are formed into hooks, eyes, petals or intricate patterns. The wires may be given a self-twist, be double-strand twisted or braided. The piece of jewellery may be constructed in openwork, or joined to a sheet metal backing. Filigree is combined with granulation. The granules (shot or small, solid balls) are made by heating small snippets of the metal, which then naturally form into balls, because of the force of surface tension.

In particular areas such as Kabylia in Algeria and in several parts of Morocco and Tunisia, filigree is combined with enamelling. The enamel, which is a glass-like substance, is used to fill the patterns created by the filigree work joined to the sheet-metal backing. This is known as cloisonné enamelling, the wire creating miniature walls (cloisons). In the enamelled jewellery of the Kabyle the enamel is left at a different height from the cloison. This may be compared with champlevé enamelling, where grooves, excavated in the base metal with chisels, are filled with enamel. Enamel powder is a mixture of sand, aluminium, potash and sodium. To this mixture pulverised cobalt is added to obtain a blue colour, chromeoxide for green and lead for yellow. The cobalt comes from Algeria and Tunisia. For the green and yellow colours, glass beads imported from Bohemia were pulverised and used. The technique of niello, applied in a similar manner to champlevé, is known throughout the Maghreb. Niello is a tri-metal alloy of silver, copper and lead. These are fused together by heat. The addition of sulphur causes the result to become black, and forming the metallic sulphide compound which is pulverised for further application.

The use of enamel to ornament jewellery probably goes back to ancient Persia. The technique practised in the Byzantine Empire in the sixth century, flourished in Spain in the twelfth and thirteenth centuries. It has been suggested that Jewish artisans who left Spain to settle in the Maghreb during the fourteenth and fifteenth centuries have brought the enamel technique to this region (Camps-Fabrer, 1990). Niello, already used in Mycene culture, was also popular in the Byzantine era and later spread throughout the entire Islamic world. Instead of niello, the resin of the juniper was often used (taqa). Wax or paint also substituted for coloured enamel.

Natural materials other than metal

Natural materials other than silver also play a dominant role in Berber jewellery. Amber, blood coral, shells, glass beads, cloves and leather are mostly favoured. The use of yellow and brown coloured amber (lluban) in particular is widespread. In Roman times, this fossilised resin was imported to North Africa from the Baltic Sea through the amber routes crossing Europe. The amber beads can be extremely large, over 5 cm in diameter. Substitutes made of bakelite are also incorporated in the jewellery. Blood coral, which was fished in the coastal waters of Algeria, is used throughout the Maghreb. It gives the jewellery pieces their warm colour. Red glass or celluloid may substitute for coral. Cowry shells are another favourite material from the sea. Furthermore, coins, such as the Spanish douro, French napoleons and douro Hassani, minted in France, are commonly used as well as imported beads and semiprecious stones. The use of cloves, whole or ground and worked into a paste with other fragrances, provides odoriferous jewellery. Wood and bone are ornamented with silver wire.

The use of jewellery

Jewellery in North Africa and the entire Islamic world has a very prominent role. A young woman receives a substantial part of her jewellery when she marries, as part of the bride price (mahr). The pieces are bought partly by her parents, with money received from the groom, partly by the groom himself. After her marriage, the woman will continue to buy and collect pieces. These are her own property with which she can do whatever she wants. She will wear all her jewellery at important occasions and feasts such as moessems. As a young girl and after her marriage she keeps a small number of pieces for everyday wear. Jewellery is worn as adornment, to enhance the beauty of the wearer, and also as accessories to clothing. Closely associated is the use of jewellery as dress accessory. However, buying and collecting jewellery is also a way of saving. The prolific use of coins in jewellery demonstrates this. At times when money is needed or in case of a divorce or widowhood, parts of a piece (such as the coins) or the whole piece may be cashed. A well-known proverb relates this meaning: bracelets are made for difficult times (al hadayed li-waqt al shadayed) (Musée des Arts d'Afrique et d'Océanie, 1995).

Wearing jewellery also has a protective function because of the magic power ascribed to it (also a form of saving). Material, colour, form and type of decoration relate the kind of power the jewellery evokes. All natural materials used in jewellery have a specific preventive or curative effect. Colours determine this effect too. To each shape, form and pattern of decoration a symbolic function is ascribed. One discerns particular floral, animal, stylistic and geometric motifs that can conjure specific powers. A similar meaning is attributed to numbers applied in decorations. Amulets (lherz) are typical of this function of jewellery, and are used throughout the Islamic world. They are mostly cylindrical, square or triangle-shaped boxes that contain writings. The writings may be excerpts from the Koran, magic matrices or benedictions. They offer protection against the evil eye, which stands for envy, or they bring blessing (baraka). The hand (khamsa, or hand of Fatima) is another significant ornament in the Islamic world. It decorates textiles, pottery, tapestry, architecture, and jewellery. This motif was already being applied in the Maghreb at the time of the Phoenicians and Romans. It meant baraka. The khamsa (Arabic for five) refers to the five pillars of Islam: the profession of faith, the five daily prayers, fasting during the month of Ramadan, the giving of alms (zakat), and the pilgrimage to Mecca (Hajj). The representation of the hand signifies human surrender to God's will and protection. The hand averts evil and protects the wearer from disaster.

Finally, there is a ritual function of jewellery, closely connected with its protective force. A husband gives his wife a beautifully decorated cloak pin (fibula or tabzimt), when their first son is born. Rings, bracelets and anklets are often given and received with the symbolic meaning of alliance and eternity. The anklet a boy receives on the occasion of his circumcision is placed at the foot of his bride at her henna party (the party to celebrate her farewell to her girl's life and preparation for her married life).

In the Maghreb men wear little jewellery because this is condemned in Islamic culture. However, swords and daggers, now worn solely with a symbolic meaning, are often beautifully decorated. This is also the case for everyday utensils such as containers for kohl (black paste used as eyeliner), pinches and, in earlier times, powder horns. These objects are not regarded as jewellery.

Silversmiths

In North Africa silversmiths still occupy a small workshop and work with very simple basic instruments. In the small room, which is also a shop, pieces of jewellery are everywhere, attached to strings or hanging on the wall. The silversmith sits on a cushion and has his fire close by in a hole in the ground. Here he can melt and solder the silver and heat the enamel. A burner is also used. The little fire is blown with a hand bellows. Other instruments the silversmith uses are an anvil, a diversity of tongs, pliers, hammers, chisels, burins and matrices for finer working on the jewellery. A compass is used for the construction of geometric forms. For the filigree work the silversmith draws the silver wire with tongs through a draw board. There may be some clay moulds for casting work drying near the fire. Since silversmiths usually visited the nomadic people or even travelled with them, their modest instrumentation was an efficient device. Artisans are often located in rural areas and are thus able to preserve the old techniques and decorative arts. In the larger cities, crafts are easily influenced by new

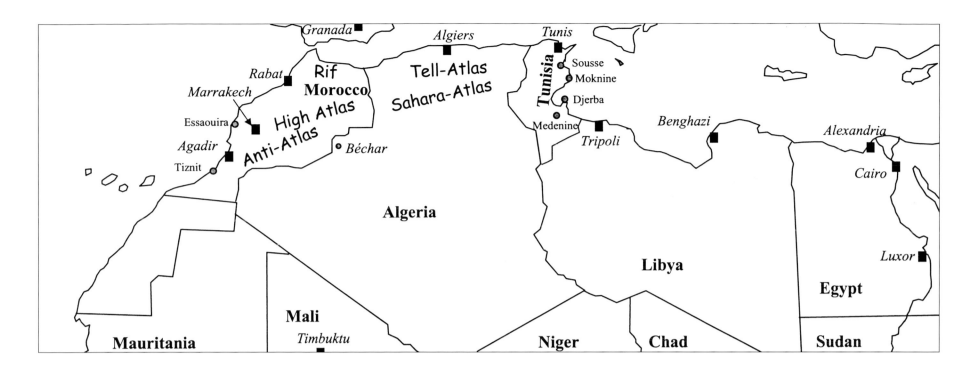

fashions and changing tastes.

Jewish silversmiths have played a dominant role in the art of jewellery making in the Maghreb. They came to the region at various times in history. At the time of King Solomon, Jews arrived on board Phoenician ships. They were sent by the King to buy gold near Salé. In the fourteenth and fifteenth centuries Jews came from Spain to live in North Africa. They settled in northern Morocco, along the main trade routes and in the High Atlas, Algeria and Tunisia. Many of them were craftsmen, in particular silversmiths. Since Jews often lived together in special protected quarters of the towns (mellahs), these areas became jewellery centres. Their women wore almost the same ornaments as Muslim women. In the course of history, Jews were assimilated into local communities, where their ancestors had already lived. They often continued to refer to their origin preserving customs related to their culture such as maintaining a holiday on Saturday. In the 1960s a large number of Jewish people left the region, with serious consequences for the art of jewellery making. Muslim silversmiths have only partly continued the work.

The jewellery

Jewellery in North Africa includes fibulae, headdresses, anklets, necklaces and breast-ornaments. The most significant and characteristic ornament in the whole area is the fibula (Latin: figere which means to pin). This cloak pin is closed by blocking the needle, pinned in the textile, through turning an omega-shaped semi-ring attached to the base of the needle. Fibulae were already known in Roman times, but archaeological evidence dates their use even earlier. The omega-shaped ring of the fibula used in the region, points to a link with Spain, where this technique was used between 200 and 700 AD. In that case these particular fibulae may have come to North Africa in the lootings of General Tariq (after whom Jebl al-Tariq or Gibraltar was named). Coming from Africa, he defeated the Visigoths in Spain around 700 BC. Fibulae may also have come to the region with Jewish immigrants from Spain in the fourteenth and fifteenth centuries. Fibulae are worn singly or in pairs. If the latter, they attach a shoulder-scarf to a dress on the breast, left and right below the shoulders. Large chains link the two fibulae with each other. The detailed design, decoration and size of these interesting ornaments differ according to different localities and the craftsmanship of the silversmiths.

Enamelled ornaments are characteristic of certain areas in the Maghreb. In the eighteenth and nineteenth centuries enamelled work was done by the Kabyle of northern Algeria, in particular the Beni Yenni families, in Moknine and Djerba in Tunisia, and in Morocco, especially in Tiznit and in the High Atlas. The art of filigree precedes enamel work. The arabesque and geometrical patterns constructed with the silver wires create the spaces for the enamel to fill. While the Kabyle use yellow, blue and green, in Morocco yellow and green are predominantly used. In Moknine and Djerba gilded silver and red enamel are used more often. Red enamel is not found in Kabylia where they probably used the blood coral for that purpose. In Morocco and Moknine semiprecious stones or glass beads replace the coral. Each centre has its own characteristic detail, but the general technique, form and range of jewellery are very similar. The striking colours of the enamel, and massive and weighty pieces characterise Berber enamel jewellery. Berber jewellery decorated with moulding and piercing techniques represents a much lighter variety.

After the Jewish silversmiths left, production almost disappeared from Djerba. In Tiznit, Morocco, the craft has been continued by Muslim artisans and seems to be surviving. The Kabyle silversmiths, who are at present all Muslim, follow traditional methods. It has been suggested that they are Islamised Jews (Camps-Fabrer, 1990).

Algeria

Two regions in Algeria are relevant to Berber jewellery: Great Kabylia and Aures. Both are mountainous regions located on the High Plateau. The first is part of the Tell Atlas in the north, the second of the Sahara Atlas in the south. The settlements in Kabylia are situated in the foothills of the mighty Djurdjura Mountains. In the western part, olive and fig trees grow. The eastern part is more rugged with extensive woodland alternating with dry savannah. The inhabitants are the Kabyle (from the Arabic word qabila which means tribe or family) who make a living from pressing olives for oil and drying figs. Pottery and jewellery making are other important sources of income. The villages in the Aures are located on top of the hills or higher up in the mountains. Cedars, fig trees and even date trees grow in the valleys. The inhabitants are Shawawi (pastoralists), who are also involved in agriculture. The women of the Kabyle and the shawawi carry out a

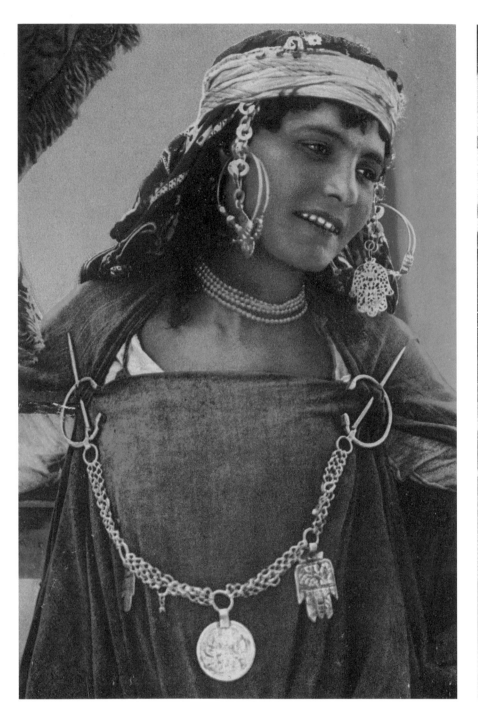

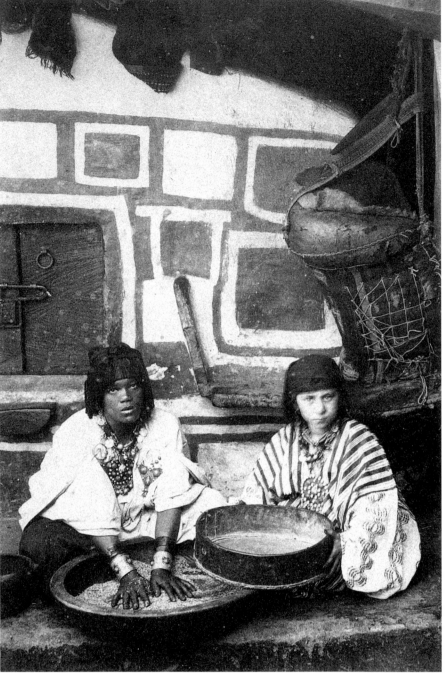

Bedouin woman with traditional jewellery, like the set of fibulae (cloth clasps) connected by a chain with a.o. two hands of Fatima. Tunis, Mabrouka (postcard), c. 1910.

Women of the Beni Yenni, Berber people from Great Kabylia preparing dinner. Both women wear several pieces of enamelled jewellery. Algeria, 1880–1909.

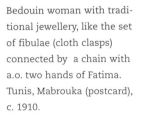

large part of the work. The people in both regions speak Berber.

The number of silversmiths who make Berber ornaments has greatly decreased since the early twentieth century. Nevertheless, their art and craftsmanship are still renowned in the Maghreb. The jewellery of the Beni Yenni is well known, but the Beni Rbah and the Beni Ouacif also produce skilled work. The jewellery in the Aures has special characteristics. The silversmiths in Great Kabylia are Muslim, but have probably been exercising their profession for not more than 200 years. It is likely to have begun with silversmiths who passed through Small Kabylia from the coast. These were predominantly Jews (Camps-Fabrer, 1990). In Great Kabylia the work is still handed down from father to son. When a silversmith does not have a son, he will call on his wife or daughters. Thus the secret knowledge remains within the family.

Algerian jewellery

The fibulae are the most remarkable ornaments in Kabylia, as they are throughout the Maghreb. The beautiful enamelled fibulae are typical of this area. The small fibula (ibzimen or adwiren) is worn by a woman on the front or on the side of her headscarf. This piece has often a coin as its basis. The star or flower pattern created with the silver wire is filled in with different coloured enamel. The central cabochon with coral and sometimes the smaller corals, mounted in silver, draw attention to the overall pattern. Small silver granules follow the symmetry of the decoration. Sometimes the coral is replaced by celluloid. Pendants are attached to the adwiren, each having a particular shape and name. There are eight different kinds. They are also combined with other types of jewellery such as necklaces and earrings.

The tabzimt is a round fibula attached to the dress on the breast. This impressive piece consists of a silver piece with a hole of 1 or 2 cm in the middle. The pin is attached to a piece of silver with the same diameter. This construction is linked to the plaque in an eye close to the edge of the hole. Twisted or braided wires divide the circle into eight segments. Five corals in a silver fitting are placed in the segments. One is soldered onto the loose piece in the middle. The enamel follows the geometric pattern of the filigree. The decoration refers to the place where the tabzimt is made. The tabzimt of the Beni Yenni for example has four hemispheres in the middle of the enamelled segments. These are also decorated with filigree and yellow and blue enamel. On top is a small coral. Attached to a tabzimt is a row of between seven and 11 of the usual pendants. It is typical that the back of the enamelled jewellery is also enamelled with great dexterity. There is a tech-

nical reason for this. It gives a counterweight to the heavily decorated front and thus prevents the jewellery from deformation. The ornamentation on both sides is evidence of great craftsmanship and enhances the splendour of the jewellery.

The necklaces made by the Kabyle come with or without pendants, corals or cloves. Modern varieties are lighter, for example with a central coral decoration and with refined pendants.

Jewellery pieces in the Aures are mainly cast. However, the technique of hammering and applying filigree and corals is also known. Enamel is never applied. Typical of the region is the chin ornament that is attached on either side of the head in the hair, just above the ears. Necklaces may consist of a network of small chains. The junctions are decorated with filigree medallions.

Morocco

Morocco can be divided into a number of regions relevant to the art of jewellery. In each region the pieces have a resemblance of material, form, technique and decoration, even though differences can also be noted. The borders of the regions are not fixed. Rabaté (1996) distinguished the following regions: the Sous region or the western part of the Anti-Atlas; the Central Anti-Atlas; the Central High-Atlas; the eastern part of the High-Atlas; the western part of the High-Atlas and the oases of Jbel Bani and Guelmim.

In the western part of the Anti-Atlas, Tiznit is the main centre of Berber jewellery. Many silversmiths live and work in the old and new markets (souq) of this town. They have succeeded the Jewish artisans who left in the 1960s. The investments of emigrants who have earned money in Europe give a tremendous boost to the craft. In the workshops, one can find old jewellery next to new pieces which follow old techniques and designs. Adaptations and new techniques or designs taken from elsewhere have been introduced. For example, the silver inlay in wood and bone is a relatively new technique for this area. Filigree work with green and yellow enamel has become characteristic for this region, whereas engraving and the niello technique, which used to be typical of the Anti-Atlas, is disappearing.

Moroccan jewellery

The use of enamelled, triangular fibulae is widespread. The sides of these cloak pins, which are called in Berber tizerzai, are milled. The triangle itself is decorated with chiselled geometric and floral motifs and hemispheres with yellow and green enamel. Some fibulae measure over 30 cm. The typical 'worms' fibula can be found here. The technique seems to be lost. The chains that link the fibulae

have attached a number of small enamelled plates, amulet boxes (lherz), and more recently khamsa. A large filigree and enamelled ball (taguemmut) may be the centrepiece of the chain. These balls can be so heavy that they have to be attached to the clothes with a pin. The headdresses also consist of enamelled plates joined together with a complex system of small chains. Typical of this area are necklaces made of a range of large amber beads, coral beads, silver pendants, coins and other beads imported from Europe. Necklaces in the southern part of this region have remarkable round pendants with a spiral engraving and niello finish. These are called tazelagt in Berber.

The central part of the Anti-Atlas is a dry area, difficult to access and thinly populated. The niello technique has reached its height here. Filigree with enamel can also be found. Even so few Jewish settlements were located in this area. At present no traditional jewellery is made. Among the old jewellery, the headdresses of the Ida ou Nadif families are outstanding. They consist of a number of silver plates of differing sizes and shapes decorated with niello. The plates are connected to one another through rings. The larger plates have two rows of pendants in niello or enamel. Large amber beads, alternating with a myriad of thin, cylindrical coral beads and amber droplets form the impressive necklaces in this area. The silver and enamel pendants have an interesting human shape.

In the central High-Atlas region, the most significant technique used to be filigree work in combination with enamel. This used to be the speciality of the Jewish silversmiths living in the mellahs of the valleys of the Dadès and Draa and the Siroua Mountains, east of Ourzazate. The immigrants brought the technique from Spain and it spread through the southern part of the Atlas. The frequent use of Spanish douros also point in this direction. After the Jewish artisans left, Muslim craftsmen continued the work. However, the quality is inferior, for example paint or coloured wax replaces the enamel powder. The traditional headdresses in filigree and enamel work show a wide variety. Coins hang from frontal plates that are linked to a network of small chains covering the head. Filigree rosettes decorate the junctions of these chains. Large open earrings with a filigree-enamel decorated crescent, pendants and a red glass cabuchon are often attached to the sides of such remarkable headdresses. The typical 'worms' fibulae occur in this region too, characterised by very refined decorations on their sides. Large amber beads some 6 cm in diameter adorn the necklaces and an interesting type of filigree, lherz, is used with a finely engraved decoration on the back.

In the eastern part of the High Atlas, at the foot of the Sarhro mountains, another Berber dialect is

Berber woman with white cloths and kerchief and traditional jewellery: earrings and a few fibula's (cloth clasps), and several necklaces. Morocco, 1991

spoken, the *tamazight*. The population in this region consists of Berber, Arabs and Haratin. The latter originally inhabited the pre-Sahara. The jewellery is typical Berber, however, with characteristic new features. For example, the technique of casting in combination with very fine engravings predominates. In the fifteenth century, one of the most significant centres of jewellery had already been founded in the Dadès valley, upstream from El Kelaa des Mgouna. In the twentieth century this centre moved to the Draa valley, which did not have a tradition of local jewellery making. Jewish silversmiths used to dominate the art of jewellery in the Dadès region. After they left in the 1960s, Muslim artisans took over the casting technique.

The fibulae (*tiserhnas*) here are remarkable pieces. They consist of an upper part that is hammered in a trapezium form and a lower part that is cast. Small decorations jut out from the sides of the lower part. The cast relief may be decorated with symmetrical motifs around an almond-shaped and smoothly polished centre. The joints between the needle and the upper part are floral shaped. The trapezium part as well as the joint for the chains is often enhanced with engravings. Other fibulae have pierced decorations. Arab women in the easternmost part of the region sometimes wear smaller trapezium-shaped fibulae. The chains joining the fibulae have remarkable pendants. These are round silver boxes with a convex lid decorated with chiselled work, which contain the fragrant paste of cloves. Occasionally a cast bird or dove is used as decoration, for example in the headdress. These used to be more widespread and have their origin with Jewish craftsmen in the region around the Draa, the Dades and Jbel Bani. The women of the Haratin, often intermediary jewellery traders, prefer coral. Cylindrical coral beads are lavishly used in the necklaces, together with amber and other imported beads. Headdresses are embellished with chains, conical pendants, chiselled work, hooks and coins. Ornaments for hair plaits are favoured too. The women of the Ait Atta families living as nomadic pastoralists in the region, prefer necklaces with amber, or imitations of amber. They also wear the heavy bracelets with protruding pins, during their daily work of herding goats and sheep, cooking and spinning of wool.

The jewellery of the western part of the High-Atlas, around Agadir and south of Marrakech, is characterised by an obvious heterogeneity because of the influence that radiates from urban centres such as Essaouira. This town was founded in the seventeenth century. Its dominant Jewish population maintained trade links all over the Atlas region. Camel caravans left from here heading for Timbuktu. The workshops were located in the Jewish quarters of the city and the villages along the main trading routes. The common denominator in this region is the technique of casting combined with engraving work. It is applied to objects that are not otherwise related.

Members of the Berber Ihahen families wear striking fibulae. These triangle-shaped pins also have a hammered upper part, decorated with engraved floral or geometric motifs and a cast lower part. In this design, however, the upper part with rounded corners is bent around one third of the lower part. The design is reminiscent of a ram's head. Another cast type originates from Agadir's hinterland. Its relief is delicately engraved in symmetric patterns. Typical urban influences are to be recognised in smaller examples and the use of *khamsa* (hands) as a decorative motif.

The region around the oases of Jbel Bani and Guelmim is interesting from the point of view of jewellery because it is a zone of transition. Ornaments show influences from many areas. The Haratin brought strong southern influences such as the use of multicoloured beads, coral beads, shells and plait ornaments of large beads or rings. From the west and the north came filigree. The dove or bird motif derives from the Draa valley in the east and the coins on the headdress indicate a link with the Dadès region. Amber necklaces have attractive cross-shaped pendants in the middle, which are known as the Southern Cross (Rabaté, 1996). They abound in Mauritania under the name of *agades*[2]. The anklets found in this region are beautifully chased with engraved details, while the ends are formed into silver balls. Today, these anklets, some of which weigh at least 500 grams, are seldom worn.

Tunisia

There are a number of jewellery centres in Tunisia of which the most important are located in the capital, Tunis. From these centres traders disperse the jewellery over the rest of the country. Two prominent centres were located in the Sousse region: Djerba and Moknine. These no longer exist. They distinguished themselves as centres of filigree and enamel work. Silversmiths in Tunisia apply the familiar techniques such as casting, chasing, chisel- and engraving work, pierced work, filigree and only rarely enamelling. A unique way of constructing chains is the technique of soldering flat rings whereby the patches are virtually invisible. This technique suggests the method of welding coats of mail.

Tunisian jewellery

The ornaments can be divided into two types. The first includes earrings, bracelets, anklets and fibulae, all ring-shaped. The other type concerns complex necklaces, headdresses and brooches. These latter ornaments are made by women. They buy the

ready-made parts from the craftsmen, who also make the 'ring' type jewellery. With needle and thread, just as they embroider cloth, the women compose authentic new jewellery adding glass beads, coral, rosettes, khamsa and imitation coins. Local custom and their own personal taste lead to outstanding creations.

Earrings are prevalent among the first type of ornaments. They vary from simple silver or golden wire bent into a circle, to a dazzling creation with mounted precious stones. The ring is usually worked with a chisel and can have at its end a cast snake form or other motif. The fibulae are mostly open rings, with the needle attached at one end. The traditional type is a silver crescent, more than 10 cm long, and round balls at the ends. They are enhanced with a variety of engraved motifs, such as crescents, stars, birds and arabesques. This type of decoration is typical of the Medinine region.

The women wear their home-made headdresses at their wedding and on many later occasions. They begin with a piece of cloth, silk, velvet or wool, which they decorate with silver and golden pieces, coins, coral and glass beads. The fragrant paste (skhab), made of cloves, ambergris and other odoriferous substances is integrated in the self-made ornaments. Necklaces and breast decorations are among to the most creative objects. The different parts are often fastened parallel or vertical around a central motif (qotba, wasta). Box-shaped amulets (lherz) which contain writings from the Qoran are added. Khamsa are also favoured.

The Tunisia fish are a very significant motif used for decorative purposes. Images of a fish are embroidered on cloth, painted on pottery, calligraphed on golden paper and engraved or modelled in jewellery. It is a very old motif. The three-tailed fish with a triangle above his head in which an eye is visible is a returning motif on the manduz (marriage trunk). The same image appears on an Egyptian vase from the eighteenth dynasty (1450 BC). The fish was used in Phoenician times as a symbol for fertility. In Christian culture it is used as a symbol for the Biblical story of the miraculous feeding of the five thousand and it was used in this way during the Byzantine Empire. The fish in Islamic culture is seen in relation to the waters of paradise and fertility. The hand and the fish come from a distant past and are still potent images of power and fertility. Fish decorations, as well as parts of fish such as the vertebrae, teeth or tail, often decorated, serve the same purpose. Cowry shells and decorated pieces of gazelle antler come from the south. These are all symbols of good fortune, blessing, fertility and vitality and a protection against the evil eye.

Berber Jewellery in present time

In recent times Berber jewellery has experienced dramatic changes. Traditional models have been replaced by lighter versions, other material is used and new decorations are being introduced. Furthermore jewellery nowadays is often worn in a completely different context. Only at marriage ceremonies and during other traditional festivities may a glimpse be seen of the culture for which the jewellery was originally made and worn. However the art of jewellery in the Maghreb is still of great importance. Although the form, structure and meaning of the ornaments change over the years, jewellery pieces maintain their specific attractiveness. Women continue to buy, receive and wear jewellery because of its aesthetic and economic value. Moreover, the symbolical meaning of the jewellery remains valid just as it was for preceding generations of women. Traditional Berber jewellery is also still attractive because of the specific form, the distinguished design, the variety of materials used and the techniques of decoration applied. It has an aesthetic value. Since it is not produced any more, it has become an expensive object of art. Moreover, the pieces offer a wealth of information about the way different cultures have interacted in the Maghreb in the course of time. They give evidence of the care and craftsmanship of the silversmiths and more importantly, of the norms and values of the people who wore and still wear the jewellery. The traditional jewellery and new adaptations and developments inspire and enrich art and culture in the present time.

Notes

[1] The Maghreb (Arab. Maghrebi, literally 'place of setting [of the sun]', indicates a region in North Africa that includes Morocco (Arab. Maghreb), Algeria and Tunisia. Some definitions include part of Libya.
[2] At present the agades are made in Germany for the tourist market in Mauritania.

References

Brent, M., and Fentress, E., *The Berbers*, Oxford, Blackwell, 1996.

Camps-Farbrer, H., *Bijoux berbères d'Algerie*, Aix-en-Provence, Edisud, 1990.

Galerie Exler & Co, *Die Hand: Schutz und Schmuck in Nordafrika: Katalog zur Aufstellung*, Frankfurt, 1981.

Gargouri-Sethom, S., 'Les Bijoux de Jerba', in *Cahiers des Arts et Traditions Populaires*, Institut National d'Archéologie et d'Art, 195-202, 1990.

Grammet, I., De Meerman, M. eds., *Magisch Marokko*, Paris, Editions Plume, 1988.

Mack, J., *Ethnic Jewellery*, London, British Museum Publications, 1998.

Musée des Arts d'Afrique et d'Océanie, *Noces tissées. Noces brodées*, Paris, Editions Joël Cuénot, 1995.

Rabaté, J. et M-R.,. *Bijoux du Maroc*, Aix-en-Provence, Edisud/Le Fennec, 1996.

Rouach, D., *Bijoux Berbères au Maroc*, Paris, ACR Edition, 1989.

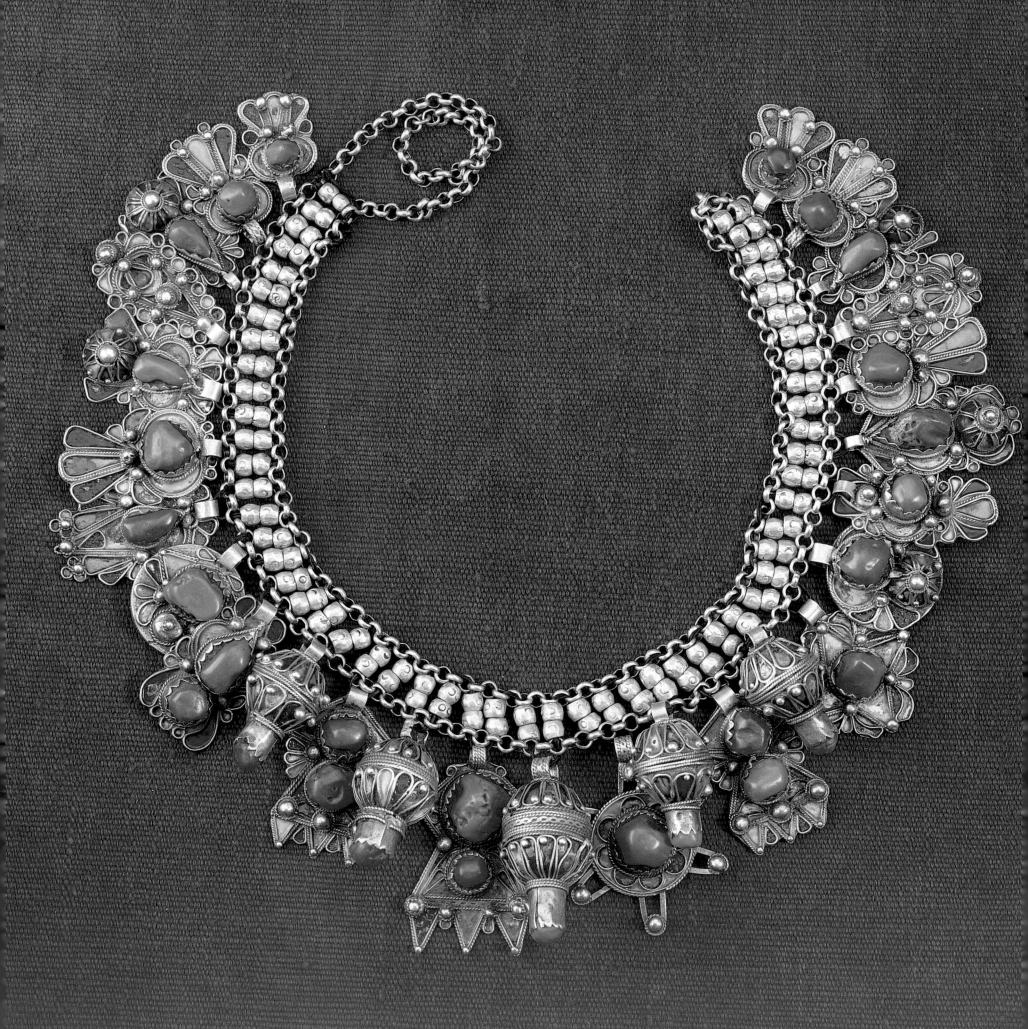

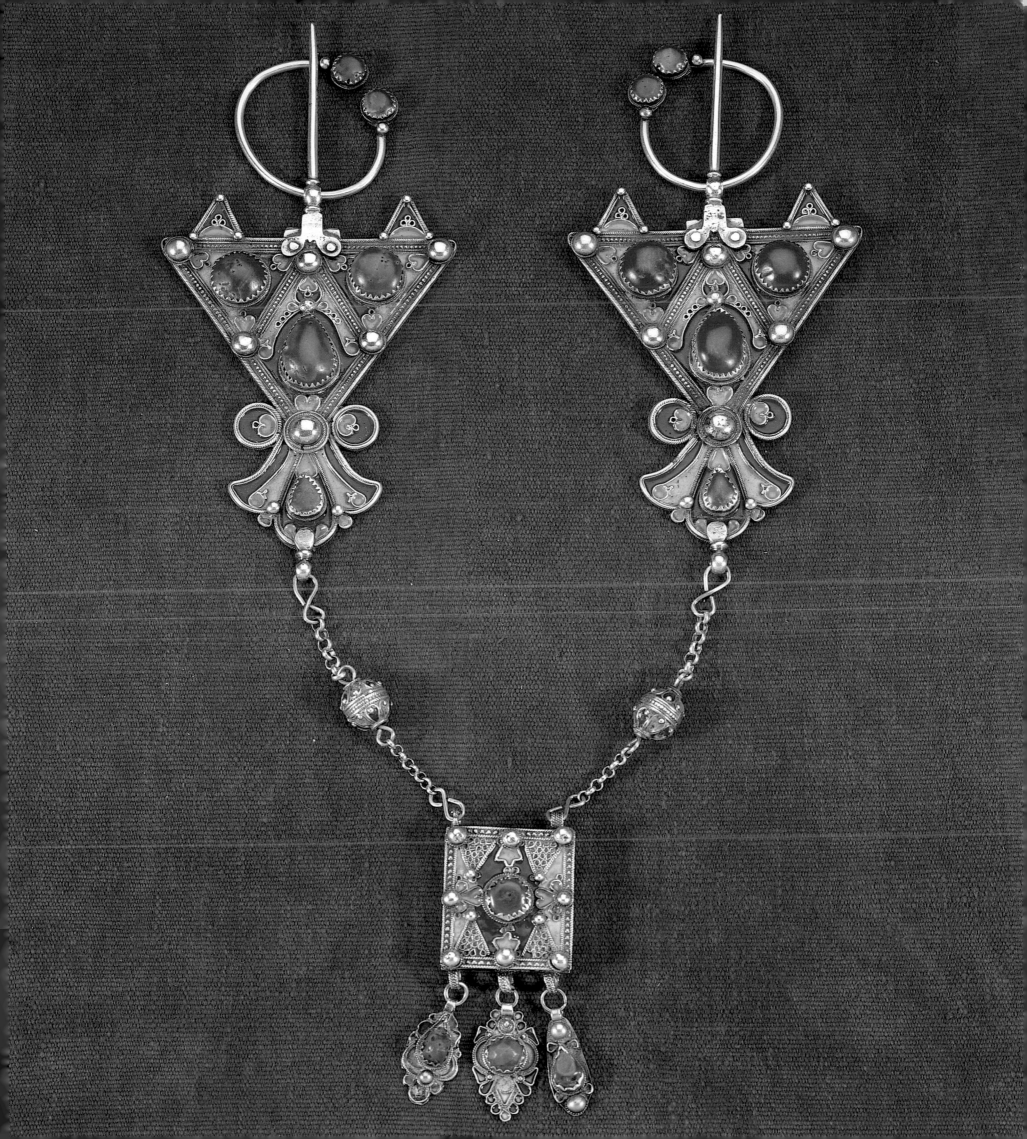

Page 20:

Algeria
Great Kabylia
(Berber tribe: Beni Yenni)
D 22 cm, 315 grammes
silver, enamel, red coral
name: *azrar*
necklace
middle 20th century
27 pendants, a.o. hands of
Fatima and 5 balls

Page 21:

Algeria
Great Kabylia
(Berber tribe: Beni Yenni)
total length 37.5 cm,
336 grammes
silver, enamel, red coral
name fibula: *ibzimen*
name box: *lherz*
fibula (clothing fastener,
worn on the breast)
early 20th century
fibula and box enamelled
on both sides; length of
fibula 19.2 cm, width 9.2 cm
(see page 16, right)

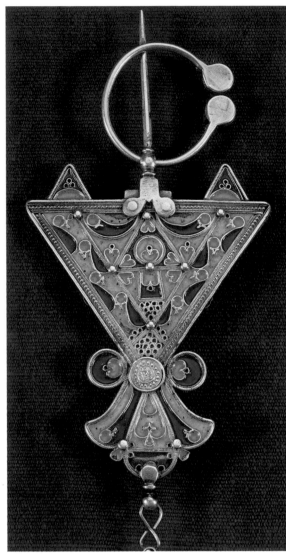

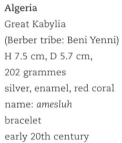

Algeria
L 19.2 cm, W 9.2 cm,
fibula
(see reverse of fibula on
page 21)

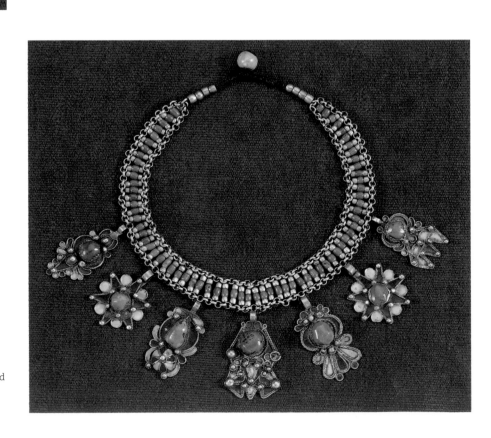

Algeria
Great Kabylia
(Berber tribe: Beni Yenni)
H 7.5 cm, D 5.7 cm,
202 grammes
silver, enamel, red coral
name: *amesluh*
bracelet
early 20th century

Algeria
Great Kabylia
(Berber tribe: Beni Yenni)
D 18 cm, 109 grammes
silver, enamel, red coral
name: *azrar*
necklace
1st half 20th century
7 pendants; inner string red
coral beads and fastener

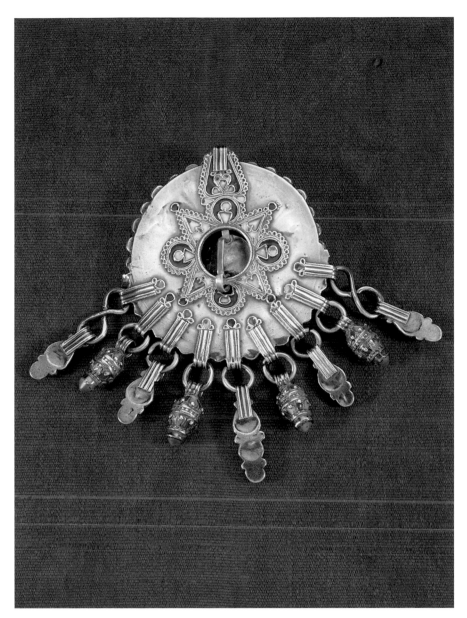

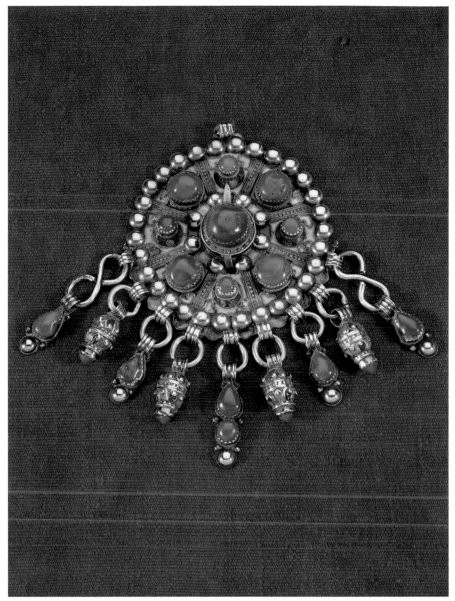

Algeria
Great Kabylia
(Berber tribe: Beni Yenni)
H 17 cm, W 12 cm,
271 grammes
silver, enamel, red coral
name: *tabzimt*
breast jewel, fibula
(clothing fastener)
early 20th century
enamelled on both sides
(The photo on the left
shows the back view of the
tabzimt.)
(see page 16, right)

Morocco
Western Anti-Atlas
H (without chain) 14 cm,
D 10 cm,
235 grammes (total weight)
silver, enamel
earrings
1st half 20th century
sometimes fastened
through the ear, sometimes
next to the ear; the hook on
top to be fastened to head-
cloth

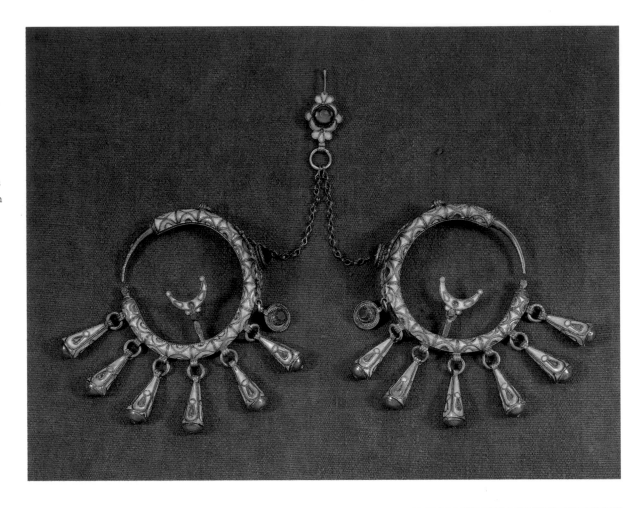

Morocco
(see page 18)
Left top:
Ait Hadiddou, Haut Atlas
H 17 cm, W 8.5 cm, 256
grammes (total weight)
silver
name: *tiserhnas*
fibula
1st half 20th century
image: turtle (symbolising
protection), hallmarks on
reverse

Left bottom:
Ait Atta, Drâa Valley
H 14 cm, W 6.8 cm, 205
grammes (total weight)
silver
name: *tiserhnas*
fibula
1st half 20th century
six-pointed protrusions bot-
tom/side

Right:
Sous Valley, Western Anti-
Atlas
L (chain) 30 cm, H (fibula)
18.5 cm, W 8.5 cm, 322
grammes together
silver
name: *tizerzai*
pair of fibulas
first half 20th century
decorations: partly floral,
partly geometrical motifs,
engravings on reverse

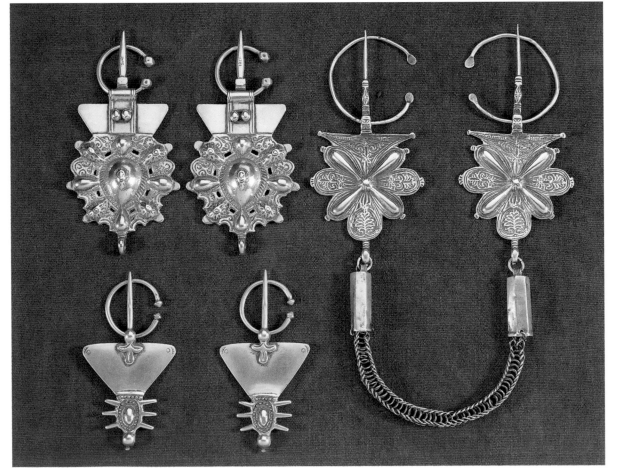

Right:

Algeria
Great Kabylia
(Berber tribe : Beni Yenni)
H 13 cm, D 8 cm,
960 grammes together
silver, enamel, red coral
name : *ahelhal* , pl. *ihelhalen*
pair of anklets
late 19th century

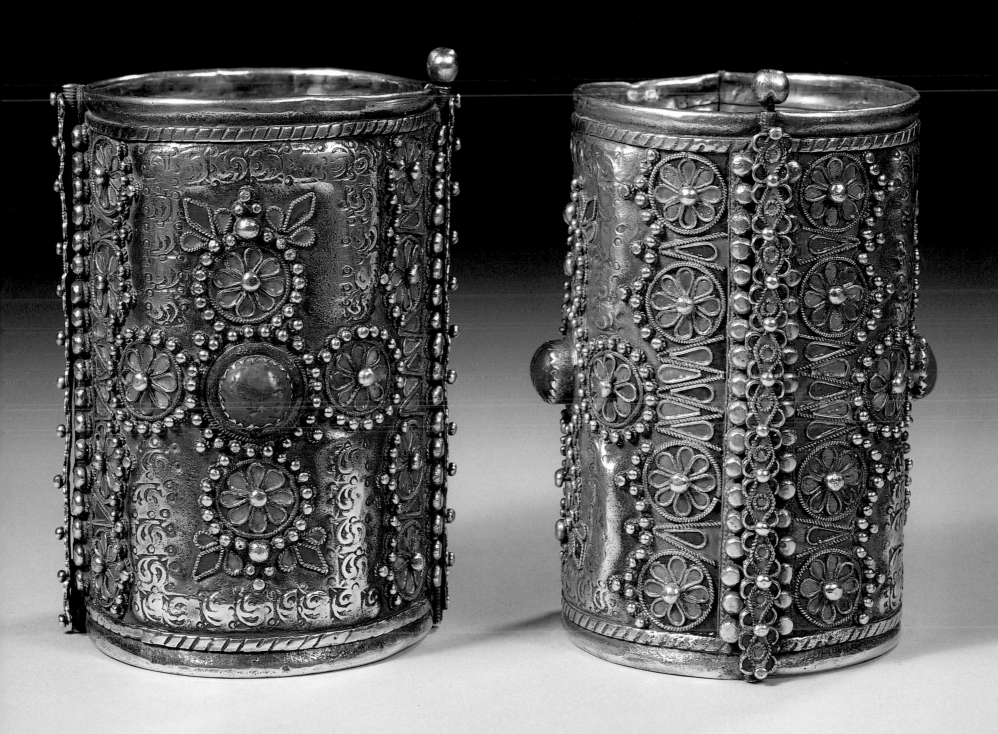

Tunisia
H ±49 cm, W 31 cm,
341 grammes
silver
fibula (clothing fastener)
plus chain
early 20th century
the two hands of Fatima
protect the wearer against
the Evil Eye; a hand also
represents the five funda-
mental principles of Islam
(see page 14); in the bottom
pendant a star can be seen
(see page 16)

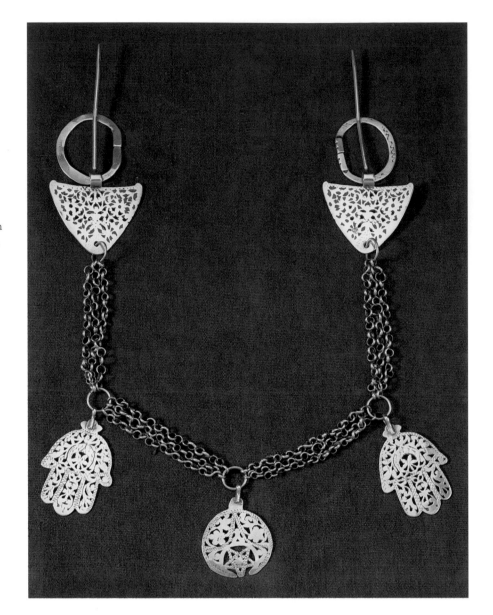

Tunisia
D 15 cm, 138 grammes
silver
name: *hillal*
fibula
1st half 20th century
engraved on both sides
(front also engraved Star of
David);
reverse with stamps: doves
symbolising love, fish sym-
bolising prosperity

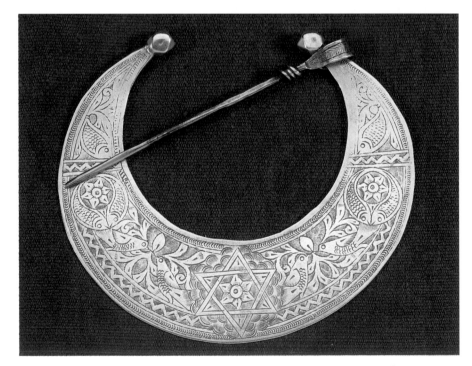

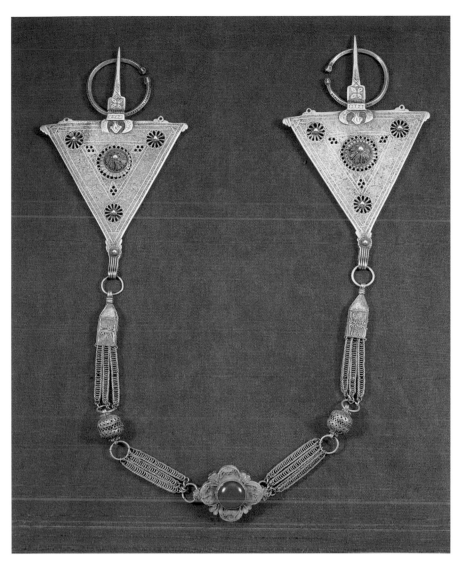

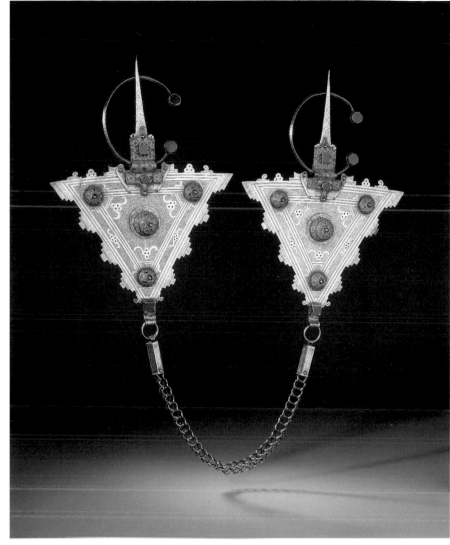

Morocco
Western Anti-Atlas
H 24 cm, W 14.5 cm,
693 grammes (total weight)
silver plus enamel, glass
name: *tizerzai n'tawaka*
fibula
late 19th century
length of connecting chain
60 cm; the inside of the
fibulas built up from worm-
shaped tubes that are sol-
dered together
(see page 18)

Morocco
South Morocco, Western
Anti-Atlas
H 40.5 cm, W 26.5 cm,
length of chain 49 cm,
1210 grammes (together)
silver, enamel, glass beads
name: *tizerzai*
fibulas (clothing fasteners)
early 20th century
worn by dancing girls in the
Tiznit region
(see page 18)

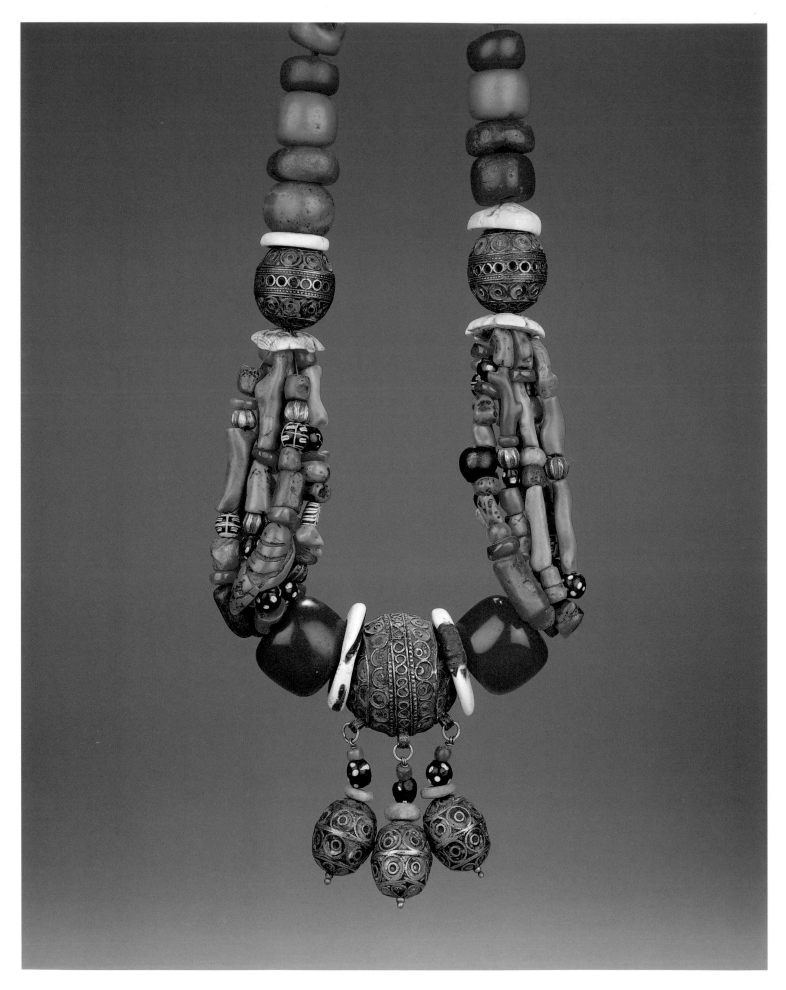

Morocco
Anti-Atlas , Drâa Valley
H ±35 cm, W 21 cm,
728 grammes
coral, amber, glass, shell,
amazonite, silver
necklace
1st half 20th century
bottom centre enamelled
ball with three balls
attached

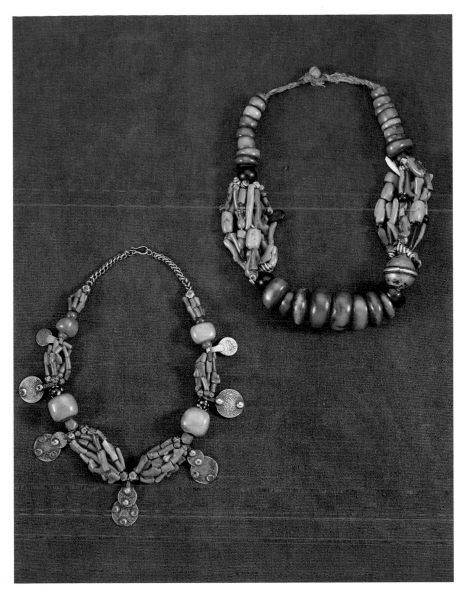

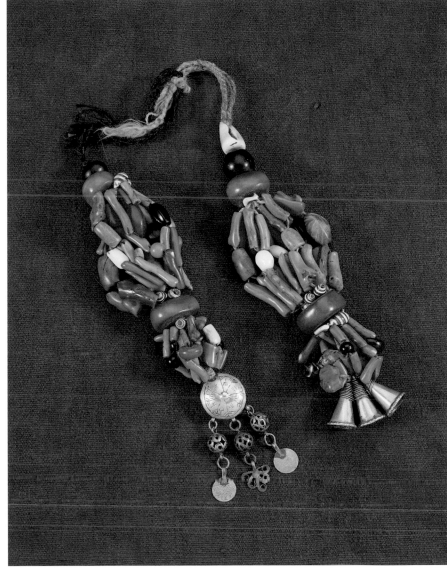

Morocco

Left:
Western Anti-Atlas
D 22cm, 207 grammes
coral, amber, silver,
glass beads
necklace
1st half 20th century
seven coins have been
turned into beads

Right:
South Morocco, Drâa Valley
D 23 cm, 306 grammes
coral, amazonite, glass
beads, amber, silver, shell
necklace
1st half 20th century
asymmetric chain, one
silver ball

Morocco
South Morocco, Drâa Valley
L ±32 cm, W +5.5 cm,
405 grammes together
silver, red coral, amber,
amazonite, shell,
glass beads
name: *tidjgagalin*
braid ornaments/temple
pendants
1st half 20th century
pair of temple pendants
with different undersides

Page 30:

Morocco
South Morocco, Drâa Valley
L 32 cm, W 23 cm,
730 grammes
coral, amber, silver, shell,
glass beads, amazonite
necklace
early 20th century
detail: protective leather
spacers have been put
between the pieces of
amber

Page 31:

Morocco
South-west Morocco,
Goulimine region
L ±42 cm, W ±32 cm,
1105 grammes
amber, shell, silver coins,
silk
bridal necklace
early 20th century
three strings of amber
beads (117 beads)

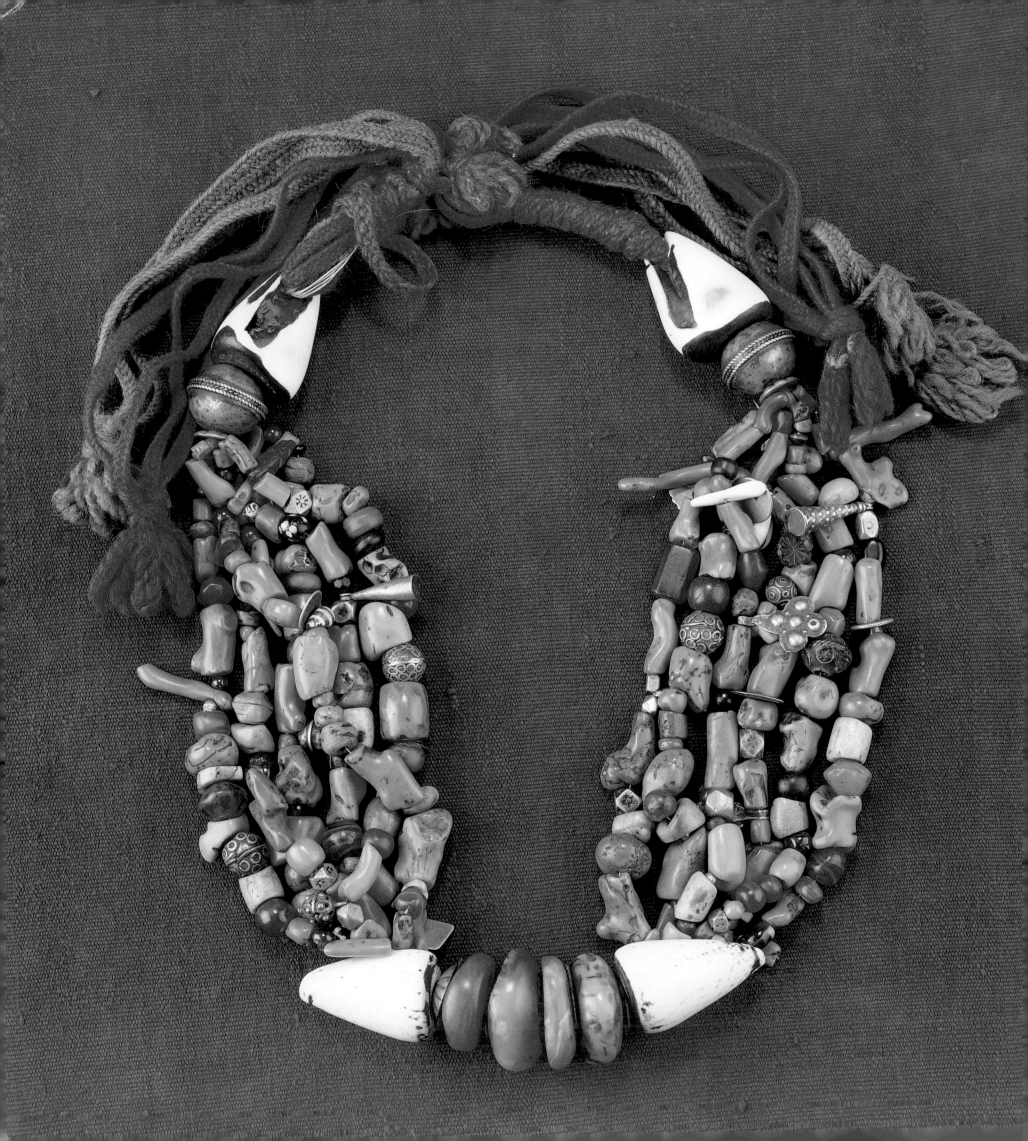

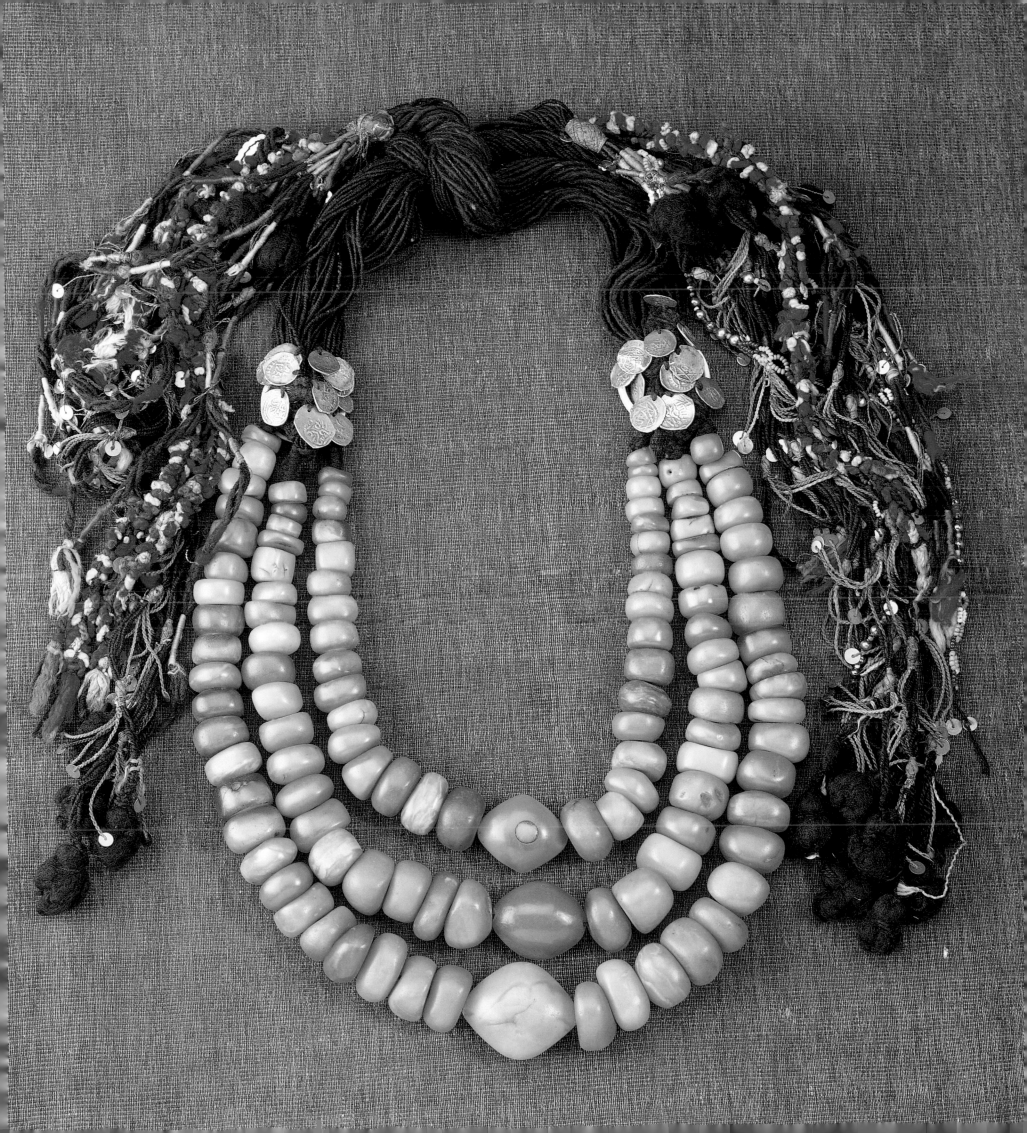

Morocco
Left:
Central Anti-Atlas
H 3.8 cm, W 6.2 cm,
L 6.7 cm,
264 grammes together
silver, niello, enamel
name: *tanbel* or *nbala*
bracelets
1st half 20th century
oval bracelets; niello is a
dark powder, obtained from
a metal/sulphuric acid
compound of lead, silver,
copper and borax.

Right:
Western Anti-Atlas
D 6.5 cm, 79 grammes
silver, enamel
name: *tanbel* or *nbala*
bracelet
1st half 20th century
enamelled bracelet with
two glass cabochons

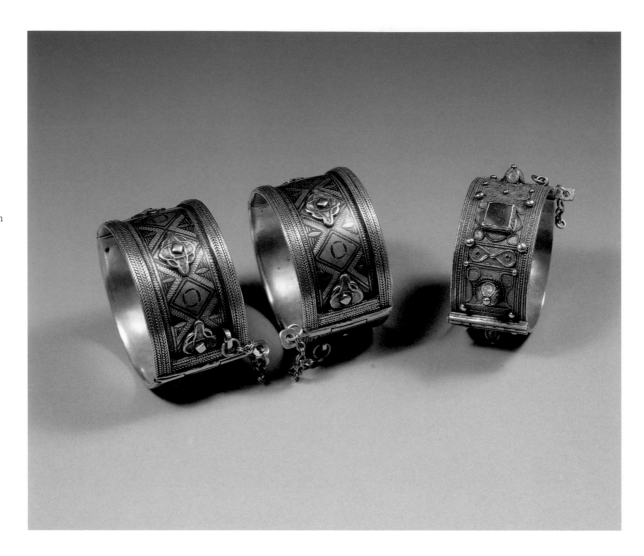

Morocco
South Morocco, Ait-Atta
H 5 cm, D 12 cm,
1185 grammes together
silver alloy
name: *azbi n'iqoerrain*
bracelets
middle 20th century
bracelets with 12 points,
also defensive weapons
(see page 1)

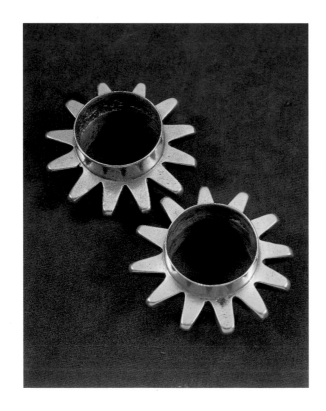

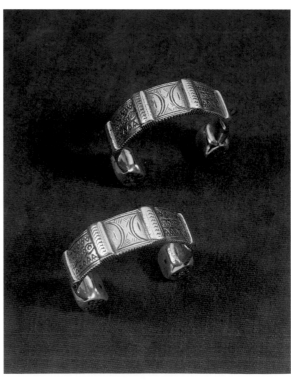

Morocco
Middle Atlas
H 6.5 cm, W 8 cm,
Thickness 2.5 cm,
492 grammes together
silver
name: *khelkhal*,
pl. *ikkelhalen*
anklets
1st half 20th century
engravings

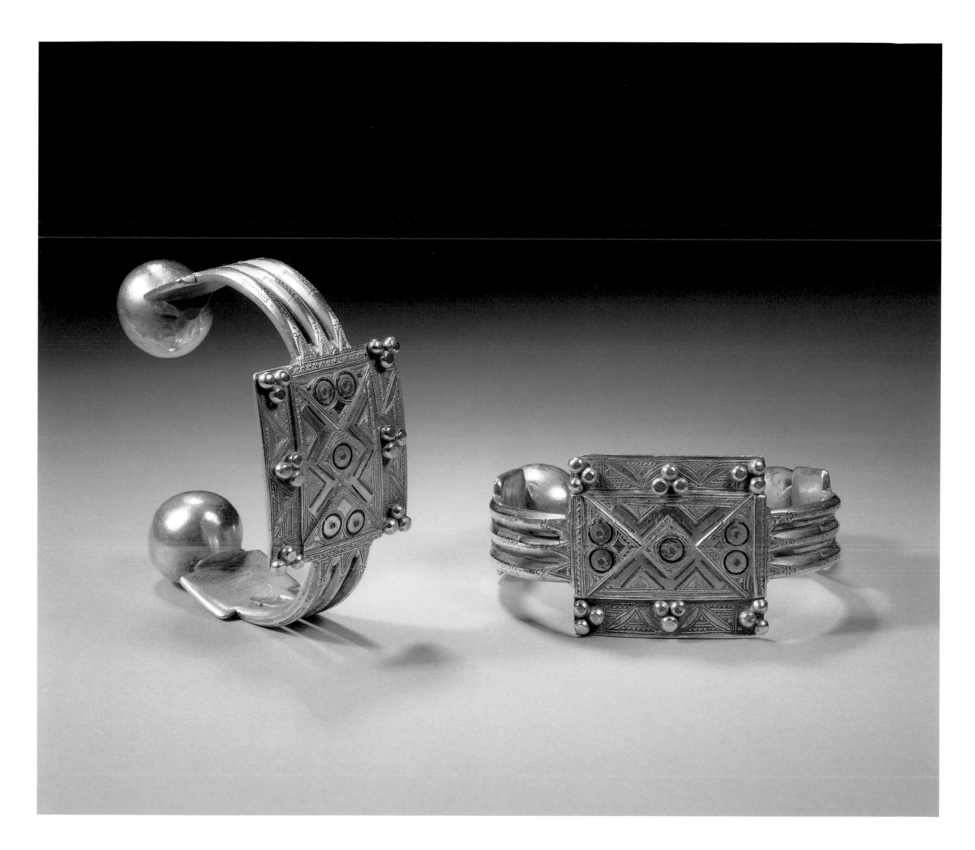

Mauritania
H 5.3 cm, W 10.4 cm,
D 9 cm,
834 grammes together
silver
name: *khelkhal*
pair of anklets
middle 20th century

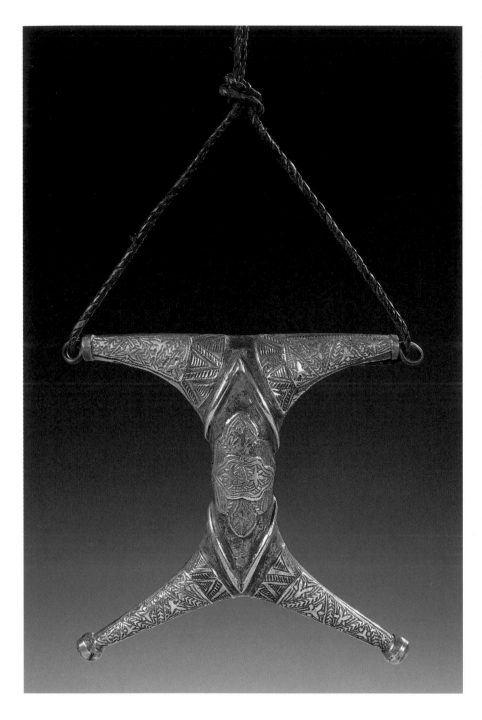

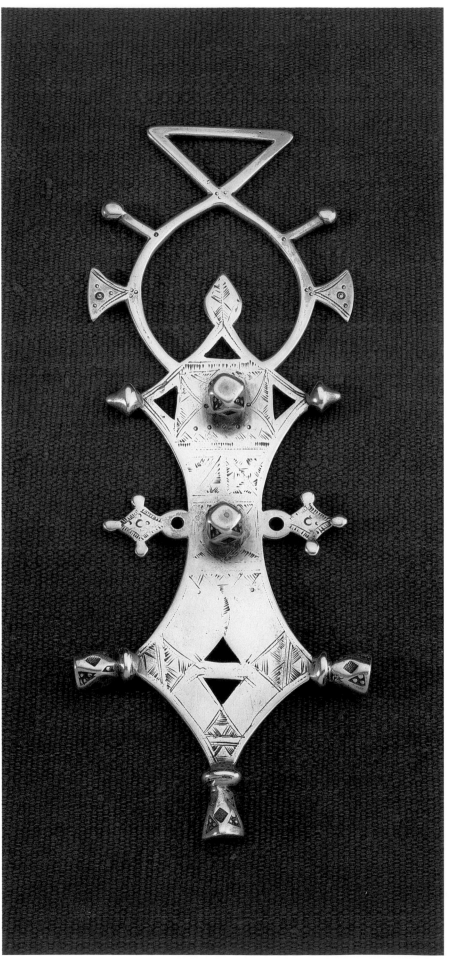

Mauritania
Tuareg people
H 11 cm, W 11 cm,
87 grammes
iron, copper, brass and
silver
name: *kitab*
amulet
worn as an amulet by men;
containing verses from the
Koran
1st half 20th century

Niger, Mali, Algeria
Tuareg people
H 17.5 cm, W 6.5 cm,
89 grammes
silver
name: *assrou n'swoul*
counterweight for scarf/veil
1st half 20th century

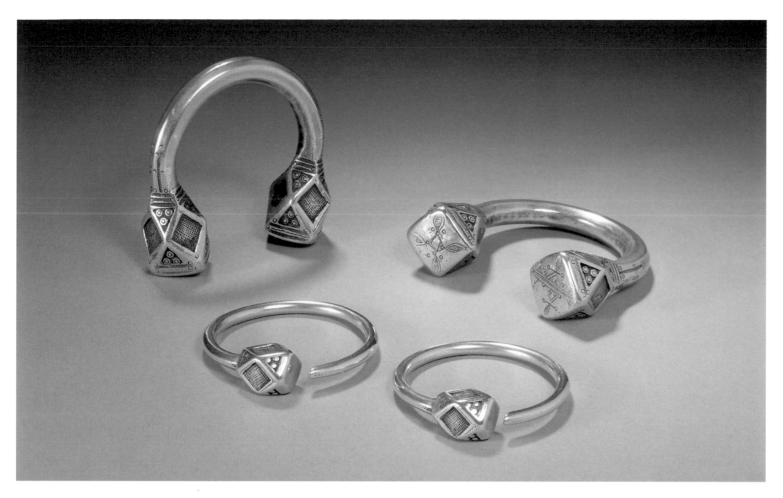

Niger, Mali, Algeria
Tuareg people
Top:
H 7 cm, W 7.5 cm,
493 grammes together
silver
name: *elkiss*
bracelets
1st half 20th century

Bottom:
D 6 cm,
96 grammes together
silver
name: *tsabit*
earrings
1st half 20th century

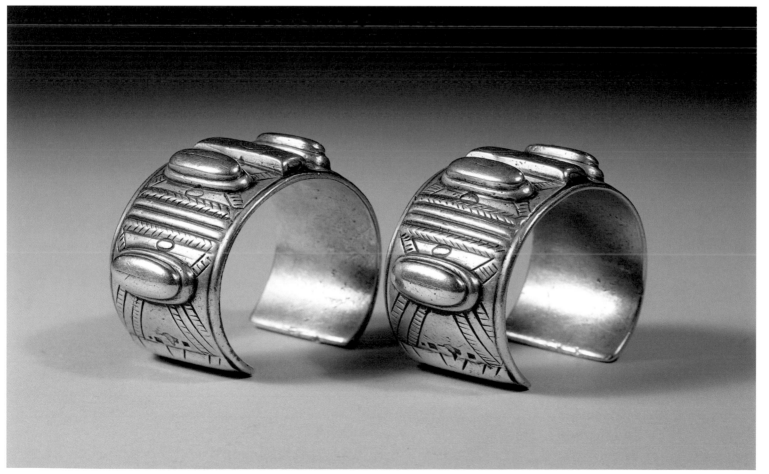

Egypt
Oasis of El Fayyoum,
west of Cairo
H 5.5 cm, W 8 cm,
485 grammes together
massive cast silver
bracelets
early 20th century
4 hallmarks (a.o. a cat) in
each bracelet; the cat hall-
mark was used in Egypt
between 1915 and 1945

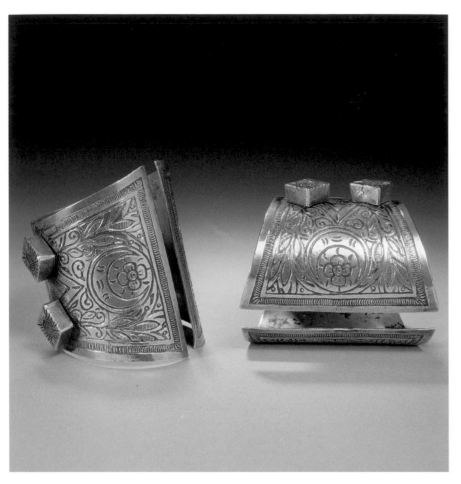

Egypt
Siwa oasis as far as coastal
area of Marsa-Matruh
H 7.5 cm, D 6.5 cm,
441 grammes together
silver
name: *suarr nguren*
pair of bracelets
middle 20th century
pair of cylinder-shaped
bracelets with 9 knobs;
Egyptian hallmark (a.o. lily,
after 1945); engraved and
embossed work

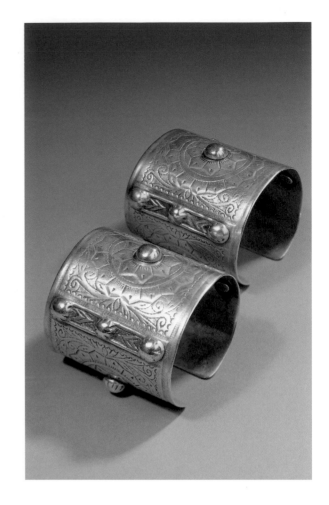

Egypt
Siwa oasis
H 9.5 cm, D 7 cm,
535 grammes together
silver
pair of bracelets
middle 20th century
various hallmarks, a.o. lily,
the hallmark of Egypt after
1945

Egypt, Sudan
(see page 8)
Top left:
H 7.2 cm, W 8.8 cm,
238 grammes
silver
bracelet
1st half 20th century
massive silver bracelet with
engravings

Top right:
H 5.5 cm, W 8 cm,
310 grammes
silver
name: *iswara*, pl. *asawir*
bracelet
1st half 20th century
Egyptian hallmark (a.o. cat),
hallmark between 1915-45

Bottom:
H 5 cm, W 6.5.,
410 grammes together
silver
name: *iswara*, pl. *asawir*
pair of bracelets
middle 20th century
Egyptian hallmark (a.o. lily,
the hallmark of Egypt after
1945), also 2 stamps of the
maker; nomadic bracelets,
worn in a wide area.

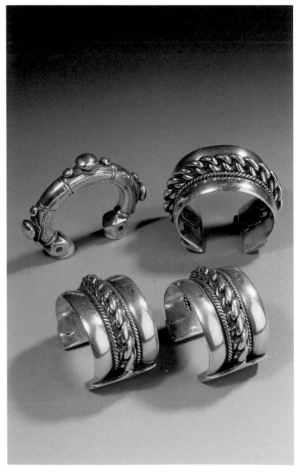

Egypt, Sudan

Top:
Sudan
H 5 cm, W 6.5 cm,
229 grammes together
silver
bracelets
middle 20th century
cast bracelets, consisting of
2 sets of 4

Bottom:
H 6 cm, W 7 cm,
246 grammes together
name: *asawir melvi*
bracelets
middle 20th century
with Egyptian hallmarks
(a.o. lily, after 1945); *melvi*
means plaited, but these
bracelets have been cast)

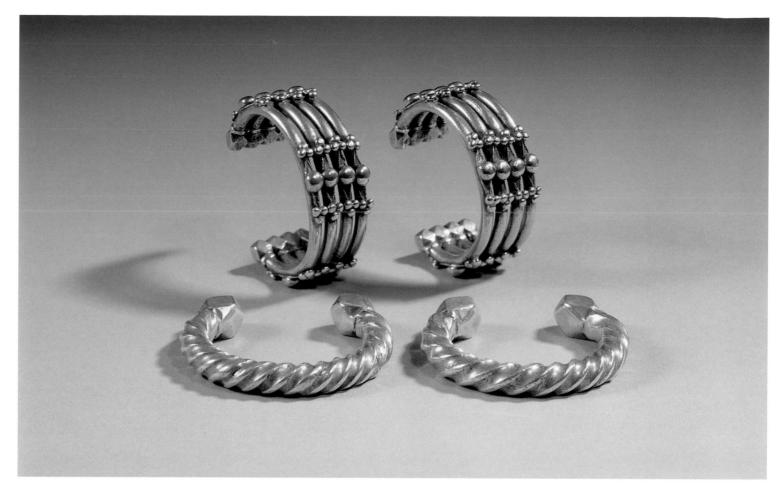

Egypt, Sudan
Halâ'ib, Egyptian-Sudanese
border
H 11.5 cm, W 13 cm,
635 grammes together
silver
hollow anklets
middle 20th century

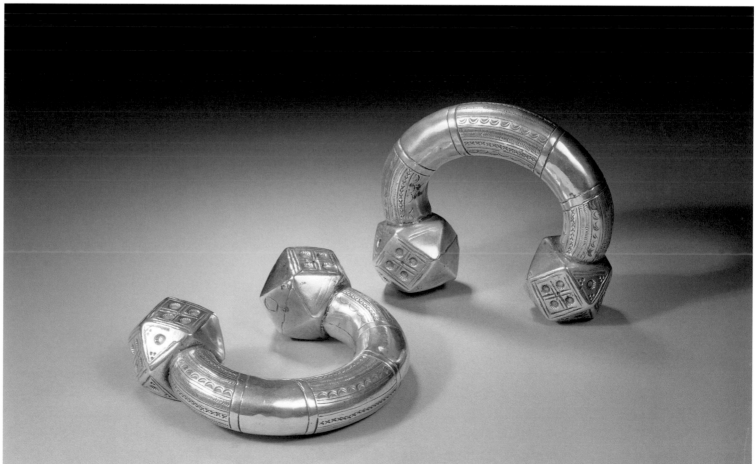

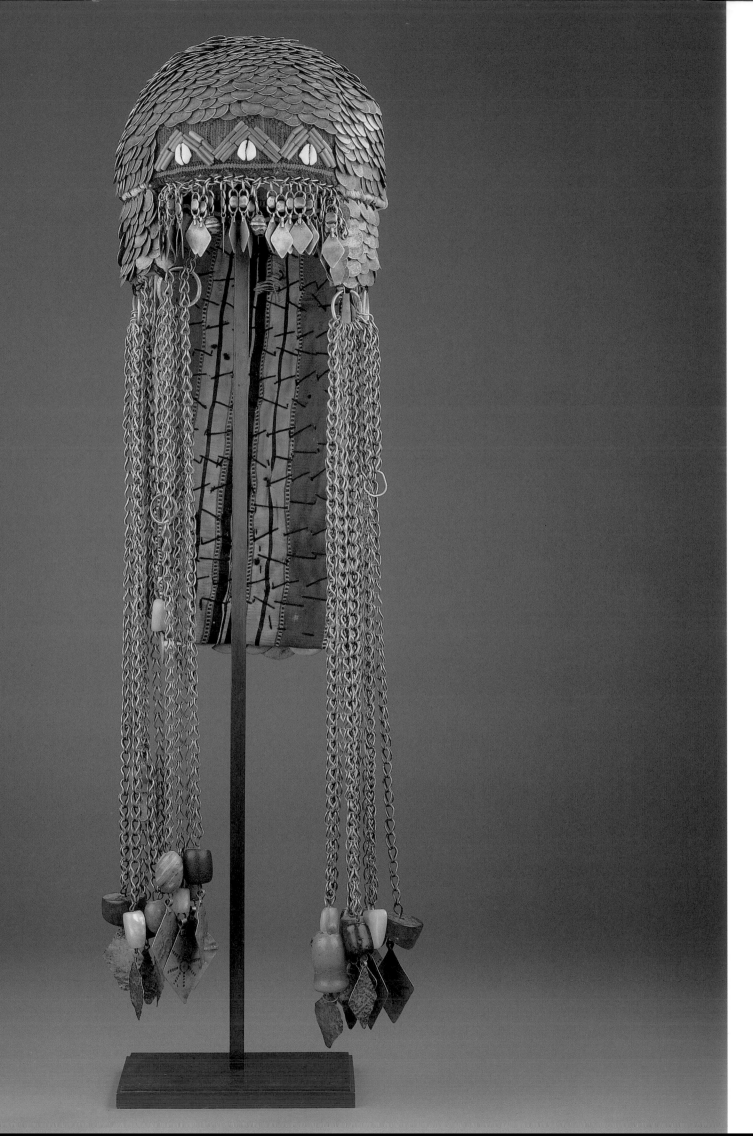

Palestine
Hebron
H (bridal cap) 43 cm,
(cap with chains) 66 cm,
D 18 cm, 2635 grammes
silk, silver, silver alloy,
coral, shell, amber
name: *wuqayet darahim*
bridal cap, worn within the
same family for several
generations
late 19th century
silk bridal cap covered with
Ottoman coins (all ca. 1874);
the top of the cap is
embroidered and adorned
with coral and cowrie
shells; chains in front with
a.o. amber.

Right:

Ethiopia
(most probably) Arsi tribe
H 12 cm, W 2.5 cm
bone
early 20th century
herdsmen's amulet, worn
from a string of glass beads

Sudan

Top:
Dinka tribe
H 13.8 cm, W 12.5 cm, 118
grammes
ivory (elephant)
bracelet
early 20th century
old repair (three pegs); the
bracelet consists of two
parts, joined by means of a
piece of cord

Bottom left:
Dinka tribe
D 10.8 cm, 96 grammes
ivory (hippopotamus),
buffalo horn
bracelet
19th century
wonderful patina, the three
parts of the bracelet firmly
linked by means of buffalo
horn

Bottom right:
Nuer (or Shilluk) tribe
L 14 cm, W 9.8 cm,
160 grammes
ivory (elephant)
bracelet
early 20th century
bracelet cut lengthwise
from the ivory

Below:

Cameroon

Top:
Fon and Bamileke tribe
L 25 cm, W. 10.5 cm,
833 grammes
ceremonial bracelet
early 20th century
all rings, made of a single
elephant's tusk, are kept on
palm fibres; they are worn
by the chieftain of a tribe
on special occasions

Bottom:
Bamun tribe
H 8.4 cm, W 7.8 cm,
166 grammes
ivory
bracelet for high-ranking
woman
early 20th century
magnificent cream-
coloured ivory; old crackle
surface

Right:

Kenya
Samburu tribe (comparable
necklaces are also found
among the Rendille tribe)
H 30 cm, W 20 cm,
685 grammes
leather, glass beads, hair
from an elephant's tail
name: *mpooro engorio*
necklace (indicative of sta-
tus)
1st half 20th century
glass beads and red 19th
century Venetian beads
with a yellow core (*cornaline
d'aleppo*)
woman's collar given at the
wedding; nowadays palm
fibres (cheaper and more
easily available) are used
instead of elephant's hair

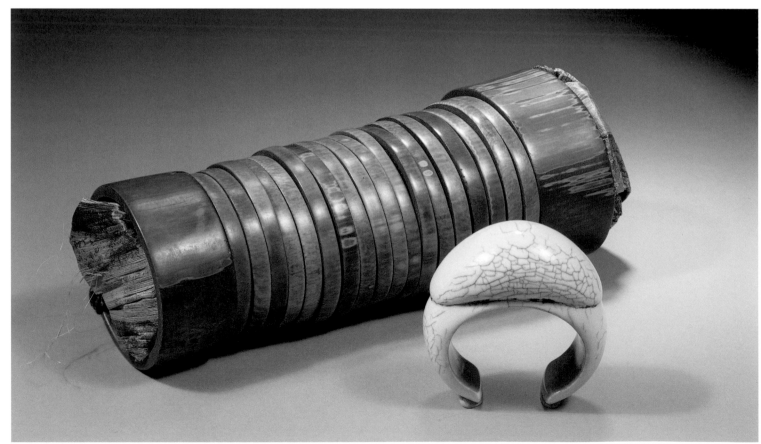

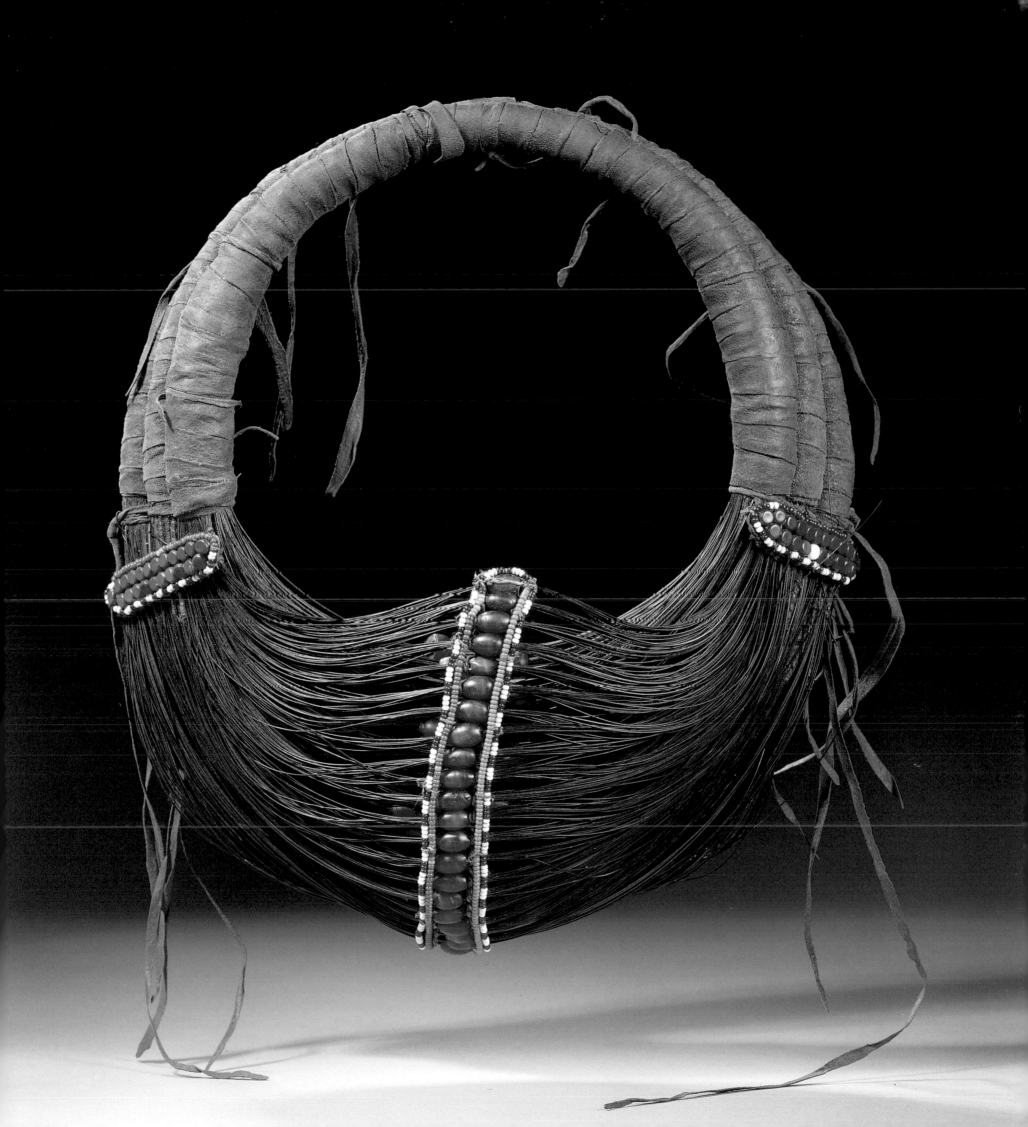

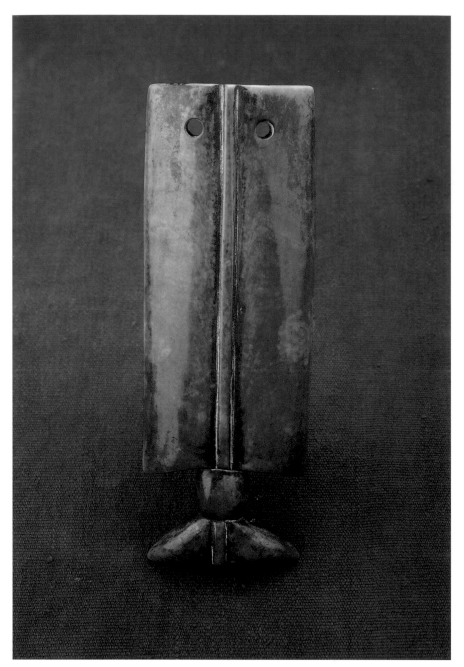

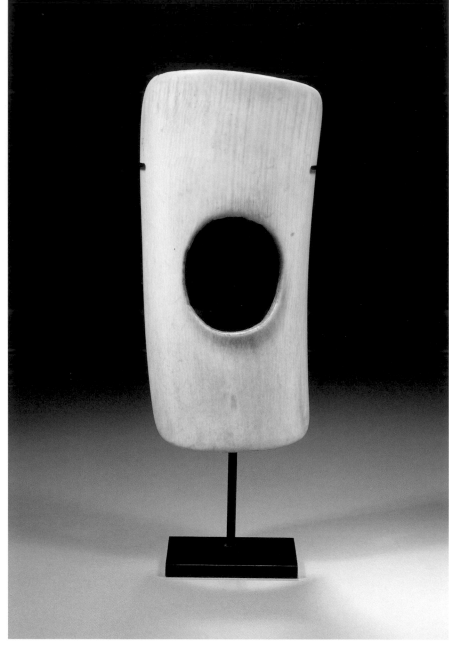

Burkina Faso
Lobi tribe
H 19.5 cm, W 7 cm,
231 grammes
ivory
name: *thungbubie* ('elephant
flute')
pendant worn on the chest
early 20th century
worn by high-ranking men
at funerals and festivals

Burkina Faso, Ghana
Gurunsi (Burkina Faso) and
Kasena (Ghana)
H 24.5 cm, W 12 cm,
408 grammes
ivory
name: *gungulu*
woman's bracelet
early 20th century
made from the length of a
tusk

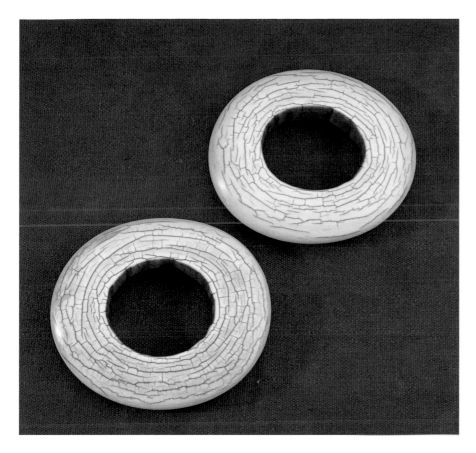

Nigeria
Ibo tribe
L 13 cm, W 11 cm, 583
grammes together
ivory
pair of bracelets
early 20th century
fine crackle surface

Nigeria, Western Africa
Left:
H 10.5 cm, W 9 cm,
H 7.5 cm, 608 grammes
ivory
bracelet
late 19th, early 20th century
old repair; ivory being a
valuable, highly appreciated
material, the breach has
been carefully repaired

Right:
Western Africa
L 9.7 cm, W 9 cm,
171 grammes
ivory
bracelet
early 20th century
fine old repair

Angola, north Namibia
Seven tribes: Kwanyama,
Ngandjera, Kwalundhi,
Ndonga, Kwambi,
Kolonkadhi and Mbalantu
H 6 - 8 cm, W 5.5 - 6.5 cm
ivory
name: *ekipa londjoba* ('ele-
phant button'), pl. *omakipa*
sign of affluence, worn on a
leather band
early 20th century
elephant buttons are given
to the bride by the bride-
groom; the greater the
number of buttons, the
more respect the wearer
enjoys

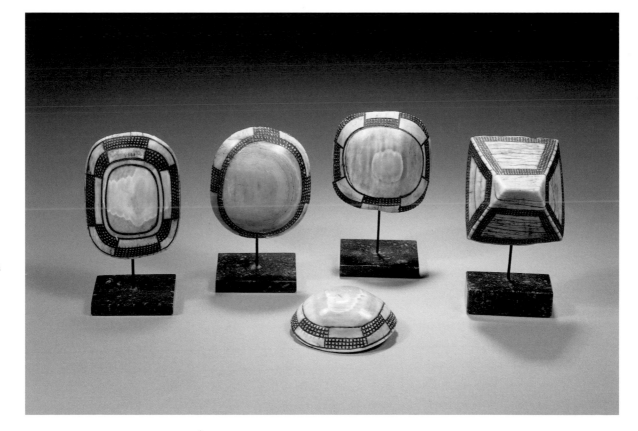

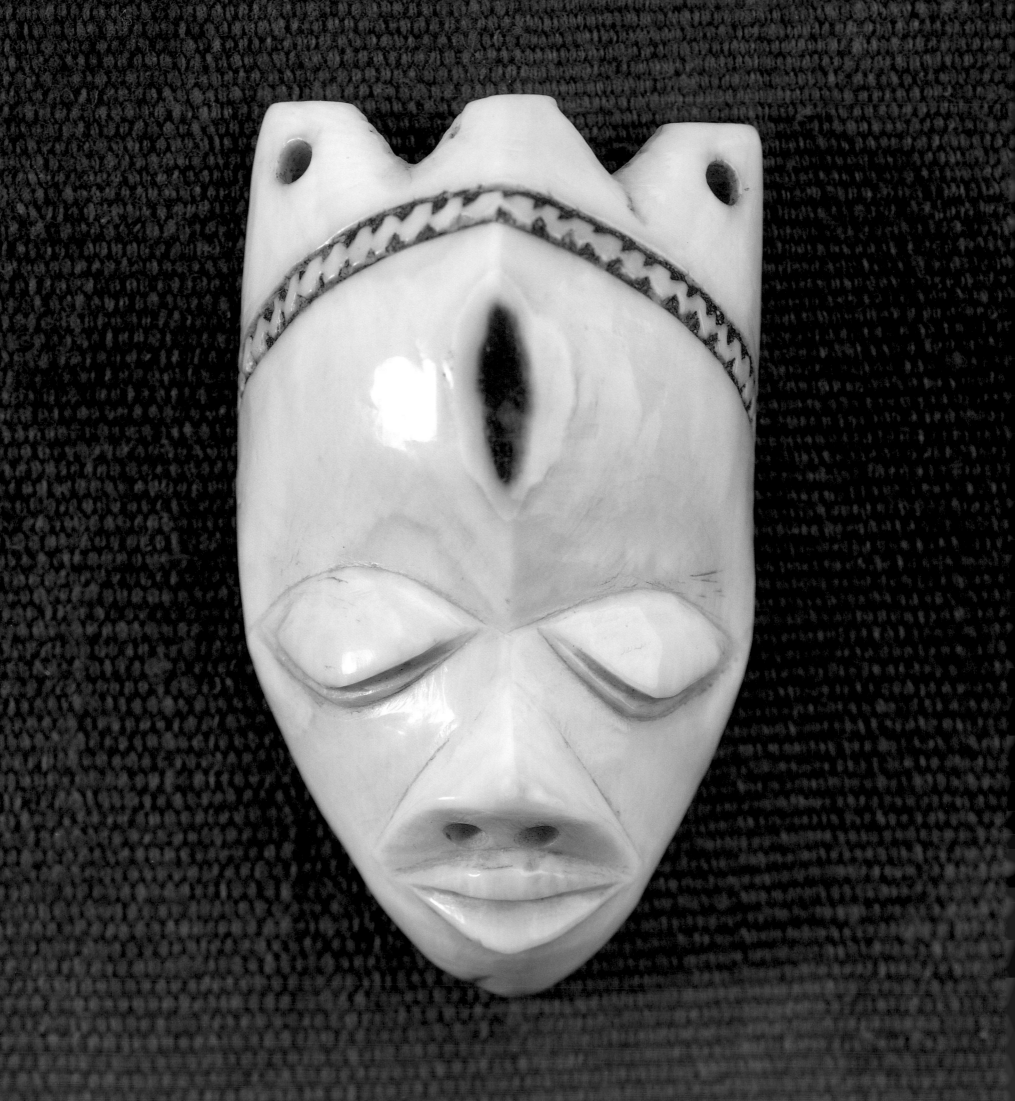

Oman and Yemen

Congo
Bapende tribe
H 6.5 cm, W 3.8 cm,
50 grammes
ivory
name: *minyaki*
amulet
early 20th century
ivory mask, human face,
worn by men to show they
have experienced the
kumpasi ritual, and have
been proved worthy of
being included into the
brotherhood of adult men;
the mask is worn around
the neck or on the arm; it
has the power to protect
and even to heal diseases;
ivory masks can only be
worn by the initiated

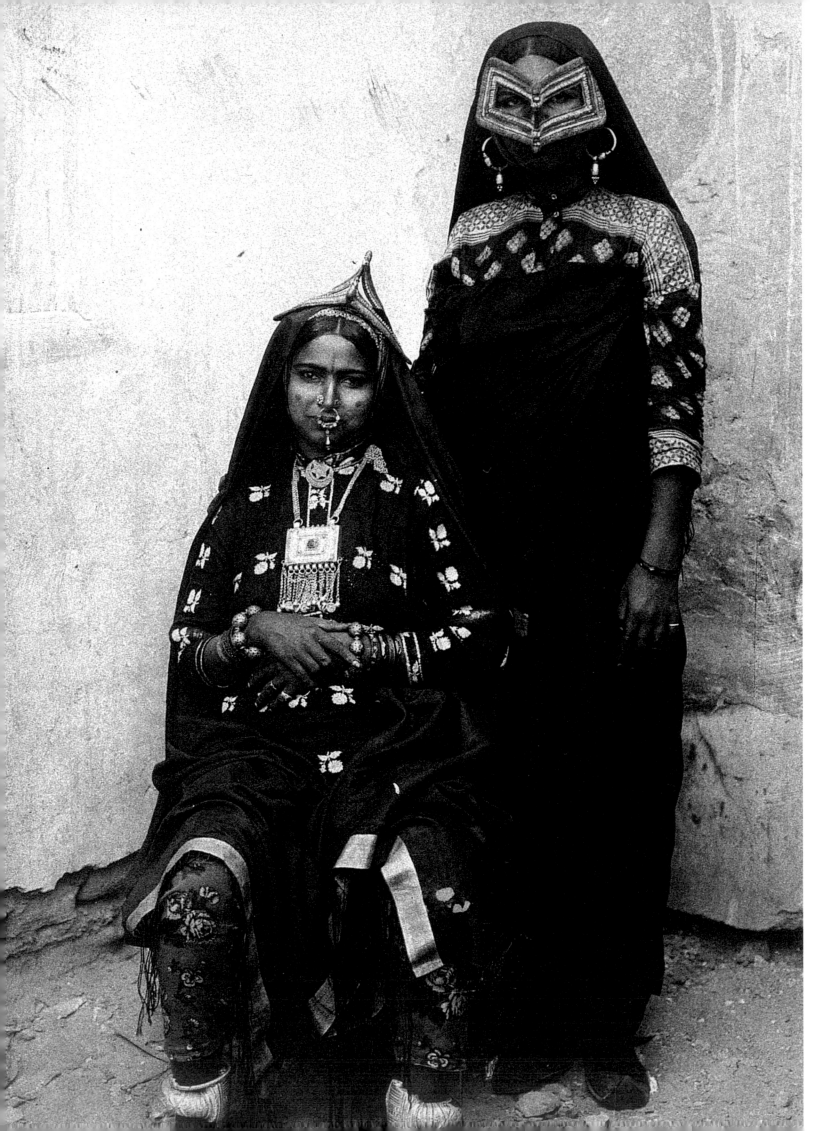

Native women of Oman. The heavy silver anklets, earrings, bracelets and necklace with amulet box are typical, as is the face mask (*burka*), 1911.

Silver jewellery from Oman and Yemen

Annelies Moors

Little concrete information is available about the history of silver jewellery production on the Arabian Peninsular. As silver jewellery tarnishes easily and wears rapidly, it was often melted down to be reworked into new pieces. Hence, older pieces of jewellery are few and far between. One exception is the jewellery collection of Princess Salme (born in about 1844)[1] that is at present in the National Museum of Oman. Whereas her jewellery is obviously that of a person of high status and great wealth, there are many stylistic similarities with the silver jewellery made and worn in more recent times.

Many similar styles and motifs in silver jewellery are found all over the Middle East, North Africa, Central Asia and India. These often resemble those of the silver jewellery of the ancient civilisations and empires, such as those of Sumer, Egypt, Western Asia and the Horn of Africa. The remarkable similarities between Omani jewellery and that from Zanzibar, Iran, India and South China (Hainan) may be the effect of Omani colonisation or of long-standing trade links. Such similarities may also be due to the technological possibilities of working a metal such as silver.

Still, Omani jewellery has its distinctive features.[2] The silver used is of a high level of purity (over 80%) and semiprecious stones are rarely used. Amber, that was highly popular in Yemen, and turquoise, widely applied in Saudi-Arabian jewellery, are uncommon in Oman. When such forms of decoration are used, red coral is employed or, because of its high price, red glass and red ceramic beads may be applied instead.

Within Oman there are considerable regional and local differences, although the latter have diminished with the increased ease of transport. North-Omani jewellery differs from that of Dhofar in the South, and jewellery worn in the coastal towns is different from that worn in the interior. Jewellery in the North tends to be larger and heavier, amulet boxes are very popular and anklets are also more common than is the case in the South. In Dhofar, pieces are generally smaller and more delicately worked than in the North. They are also more often decorated with coloured beads and, as such, are more similar to Yemeni jewellery.

Producing silver jewellery

Silver jewellery was produced and sold by craftsmen. Clients came to the workshop of the silversmith to order particular items or, in the larger coastal cities of Oman, such as Muscat and Mutrah, to buy the popular items that were widely in demand and hence available ready-made. Elsewhere, silversmiths only had small stocks and most items were made to order. There were also some itinerant silversmiths who travelled around to the remote areas in the interior with a small stock of jewellery.

Working silver was a craft handed down from father to son. Although much jewellery seems to be very similar to that from earlier periods, silversmiths incorporated some changes in their designs. In the case of one particular style of Dhofari bracelets, for instance, the shape of the silver beads changed from barrel- to squared and angular-shaped, and the series of loose rosette-shaped spacer-discs were soldered together. It was only in Dhofar that there were also a few women involved in producing silver jewellery, while in the interior area village women were engaged in the work of stringing beads on twisted cotton threads. In some places, like Muscat and Mutrah, the men went to the market to buy ready-made silver items for women. Elsewhere, such as in Rustaq, townswomen went themselves to the silversmiths and often commissioned specially made items.

Whereas Oman has a more or less continuous tradition of producing silver jewellery as a craft, in Yemen this was different. In the caste-like system of professions in Yemen, crafts, such as working silver, were the province of Yemeni Jews. Historical sources indicate that the large majority of silversmiths in eighteenth-century Yemen were Jewish. Pieces stamped with the names of Jewish silversmiths such as Bausânî or Badîhî were acknowledged to be of the highest quality. This tradition was strongly affected when in the late 1940s the Israeli government transferred the majority of the Yemeni Jews to Israel. This did not only affect Yemeni silver jewellery production, but also meant the demise of a highly skilled craft, as the large majority of these Yemeni silversmiths had to turn to other work in Israel.

The Maria Theresia thaler

While nowadays silver to be worked is imported from China in the form of bars, for centuries the chief sources of silver for jewellery making were old silver items that were melted down and the Maria Theresa thaler. This coin is named after the Austrian Empress Maria Theresia, and was first minted in 1751 when increased trade led to a growing demand for silver coins with a high and constant silver content (at least 84%). On the face of this large and heavy coin – with a diameter of almost 4 centimetres and weighing a little over 28 grams – Maria Theresia was depicted, on the reverse the Austrian coat of arms, a double eagle with the imperial crown (in Arabic the coin was also called abu rîshe, the father of feathers). This new coin rapidly became popular both in large parts of Europe, and also in the Ottoman Empire. From 1783 onwards the Maria Theresia thalers were only produced for the export market and for the next two centuries this coin was to remain popular especially amongst traders in the Middle East and the Horn of Africa. In 1935 Austria was forced to grant the monopoly to strike Maria Theresia thalers for the period of 25 years to Italy. Italy needed these for establishing and extending its control over Libya and the Horn of Africa, where the Maria Theresia thaler was common currency. In response to this, London, Paris and Belgium also started to mint large amounts of Maria Theresia thalers for use in their colonies. They did so until 1960 when Austria regained its monopoly over the production of the coin. In the 1970s the value of the coin increased enormously because of the rapid rise of the price of silver on the world market. In 1977 more than ten million Maria Theresia thalers were produced; thereafter production went down to less than 200,000 coins a year. Invariably, the date of 1780, the year Maria Theresia died, was stamped on these coins. Until recently the Maria Theresia thaler was common currency both in Oman and in Yemen, where people still hold Maria Theresia thalers as a source of economic security. The Maria Theresia thaler was not only melted down to provide silversmiths with the silver to work with, but it was also often incorporated as part of a necklace. Smaller coins, such as the silver rupee, were also used as decorative parts of jewellery.

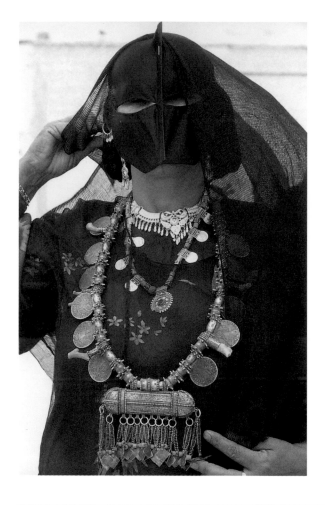

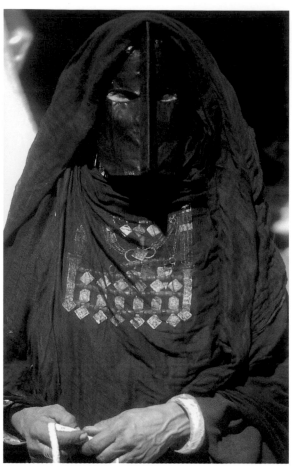

Far left:

Woman with necklace (*hirz*), and face mask (*burka*), Oman.

Left:

Bedu woman wearing a necklace (*shibgat*) and *burka*, Oman.

Below:

Woman with a *shabka* (a head cover of goat leather adorned with pieces of silver), Oman, 1990.

Page 49 left:

Girl wearing plait clip (*halka ar ras*), Oman.

Page 49 right:

Woman from Yemen with bridal jewellery. The necklace is called *labba*.

Page 49 below:

Three girls with yellow faces. The girl in the middle is wearing a *samt mukahhal* necklace, Oman.

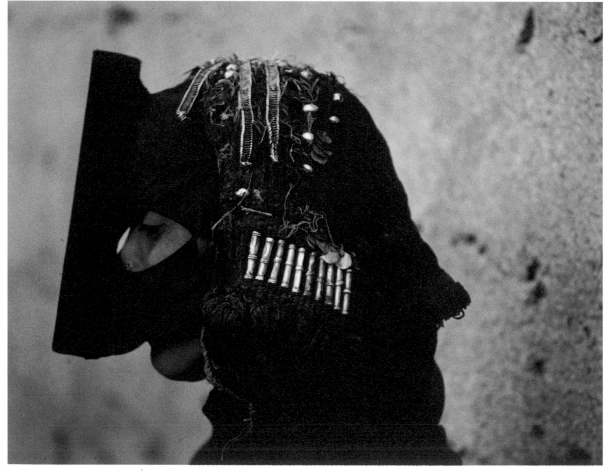

Techniques for working silver

Silversmiths used a number of different techniques. Silver was prepared either by hammering or casting. After heating and annealing the silver, it was hammered flat (or more recently put through a rolling mill) to make sheet silver. Strips of silver were cut and pulled through progressively smaller holes of a draw-bench to produce silver wire. Most silverwork was made of sheet silver that was then beaten into dies, shaped to form the halves of the intended piece and then soldered together.

For making more complex pieces, such as amulets, the most popular method was sand casting. Two metal containers with a small opening in the rim were filled with a cooked sand-sugar mixture. The piece to be copied was pressed halfway into one of the containers until it had left a good impression; then the remaining half was pushed into the other container. The containers were put together, and liquid silver was poured through the small opening. After it had cooled off the containers were pulled apart.

Both embossing (raising relief from the back) and chasing (indenting patterns from the front) were employed to decorate various pieces of jewellery. Hollow pieces, such as elbow-rings and anklets were worked by forming silver sheet into the shape of a

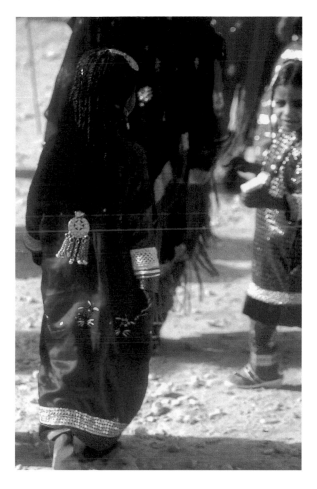

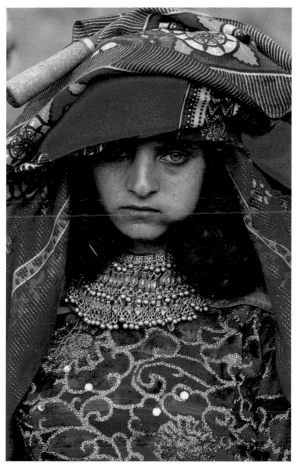

tube. Sealed at one end, this was filled with molten lead that made it possible to work the silver sheet. The lead was later removed by means of heating. Another technique for decorating was engraving; that is chipping away patterns with a sharp tool, sometimes piercing the object. In this way flat amulets were decorated with Quranic verses.

Filigree and granulation are long-standing and highly popular ways to embellish jewellery. Filigree is a means of decorating silver either in an open style by producing a lace of twisted wire or by fusing twisted wire flat to a silver base. Granulation is also used in various pieces of jewellery. Charcoal with minute holes was used as a mould to produce very small silver balls. These small balls were then placed in rows or put into the shape of a pyramid that then produced a mulberry-like appearance.

Another technique, niello, produces a black design on silver. This technique was mainly used to decorate a large round piece of silver worn as part of a necklace. In order to produce niello decoration, the desired pattern was first engraved in the silver, then it was filled with a molten black alloy, the surplus was removed, and the black pattern was clearly visible.

Meanings of silver jewellery

Silver jewellery was bought and sold according to the weight of the silver. This jewellery was not simply worn as a form of adornment, but was first and foremost a source of economic security in hard times and a means of storing wealth. It was seen as having a more stable value than bank notes, while at the same time possessing a high liquidity; it was easy to transport and to sell it. At the same time, this silver was also worn as jewellery. Whereas boys may wear some small protective items (such as a silver amulet or earring) and men perhaps a ring with a stone on the little finger or a silver elbow-ring, in addition to a silver-decorated dagger, most silver jewellery was worn by women. As such, it was seen as an expression of the status and wealth of a woman's kin and/or her husband and as an indication of their affection and respect.

Silver jewellery was not only worn by women; it was also considered their property. When they had received it from their own kin, as gifts or as part of an inheritance, it was their own unalienable property. Wealthy women, for instance, often gave some of their items of jewellery to their daughters but for the most part women obtained the majority of their silver when marrying. Virtually everywhere in the Middle East the dower (to be paid by the groom to the bride) was used to buy her jewellery. Although this bridal jewellery was also considered as her own property, in Oman she was not always quite as free to deal with it as was the case with the gifts received

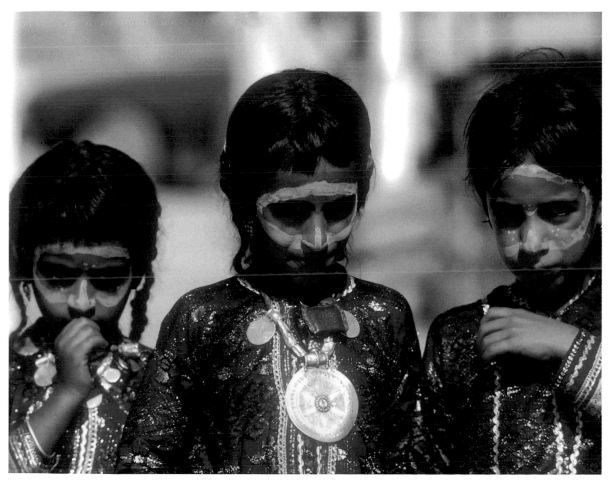

from her own kin. If the marriage did not work out and the woman was the one initiating separation, she may have been obliged to return the silver to her husband.

What sort of jewellery did women receive at marriage? In the coastal cities in the North this could have included bracelets, a long necklace with dangles and possibly an amulet-box, earrings, brooches, toe-rings, a set of five pairs of finger rings (or at least a pair for the fourth finger), and chains with forehead pieces. In the interior, anklets and elbow-rings were also important, and amulet boxes attached to a headdress were often included. Amongst the Bedouin the marriage silver usually consisted of a nosering, different types of earrings, spiked bracelets, and perhaps one of the expensive Bedouin necklaces. In parts of Dhofar's rural interior, on the other hand, brides did not even take part in the celebrations of the wedding; they would only receive a little jewellery to wear on the hands and feet, and sometimes earrings would have been given. Dhofari town weddings, on the other hand, were more public and festive events. Brides would at least be given necklaces and earrings and, in the case of wealthier fathers, wedding silver would include finger rings, a number of different bracelets and the more expensive earrings and necklaces.

Some items of jewellery were also considered to have protective properties. Amulet objects, such as a small silver box or cylinder into which paper could be put, or silver sheets with Quranic verses written on them were to deter evil spirits. In the case of an illness which was difficult to cure, sometimes a zar ceremony was held to induce evil spirits to leave the person affected. These spirits often asked for silver jewellery, especially silver belts, to be worn underneath the clothing, or for intricately domed zar rings in order to leave their victim.

Silver jewellery and the life cycle

Few families were able to buy silver for their children. Those who could do so would buy a pair of simple hoop earrings for small girls who had their ear-lobes (and also their left nostril) pierced soon after birth; small boys may have worn earrings through a small hole in mid-ear. Some young children were also provided with small amulet boxes or other talismanic objects. A father may have given his child a piece of silver to wear on the forehead; for boys this had the shape of an inverted horse-shoe, for girls it was a circular disc. This was also meant to function as protection. Girls were also sometimes given silver plait ornaments. The Bedouin would wear simple loops on wrists and ankles, and in Dhofar girls may have worn D-shaped earrings and tiny necklaces with a small amulet box and a few coral beads.

Wealthier girls may also have been given silver bangles, earrings, necklaces with a gold forehead piece, and with puberty a few rings, silver plait ornaments, a gold nose-stud and a pair of slim anklets with little bells; other types of jewellery were only permitted to be worn after marriage. The simple plait decorations consisted of a ring to fasten the plaits, that is a round shape with circle cut out, sometimes leaving a star shape; at the base, chains and small bells may have been attached. At women's gatherings, girls from wealthy families wore a particularly impressive headdress. This consisted of bands of plaited leather covered with large silver domed beads, rows of silver discs, with at the centre point a forehead piece, finishing at the back with a single broad leather plait decorated with rows of discs and domes and an amulet box with chains with diamond-shaped dangles attached.

When girls in Northern Oman approached the age of marriage their ears were pierced in other places, but it was only after marriage that they would be allowed to wear earrings there. While the types of jewellery girls were allowed to wear was limited, for married women lack of finance was the only restriction. For everyday wear women had basic things, like a nosering, earrings, one pair of finger rings, a simple necklace and bracelets. At the weddings, feasts and festivals on the other hand, women would wear all the jewellery they could lay hands on including that borrowed from the better off.

Forms of adult women's silver jewellery

Necklaces

While the simplest necklaces worn in Oman consisted of one or two long strings of small plain silver beads, there was also a variety of choker necklaces that were quite commonly worn. In North- and Central-Oman this was first of all a choker necklace of hollow, rounded beads, separated by smaller red beads with a central ovoid bead with a raised pattern in the middle. The Dhofari version of this necklace was more elaborate. It had a black stone as its central bead and also included barrel-shaped, spherical and pyramidal silver beads, and rosette-shaped spacer discs. Another simple, very different style of choker necklace from the North consisted of a wide flat silver band ending in a hook or attached to a chain, sometimes with small bells or dangles attached to the bottom. More elaborate was another choker necklace (the *makhnaq*, also called 'pearl of the neck') with a large central silver or gold bead with a raised centre part, strung on a silver rod, with a red bead encased in silver on either side. This rod was attached to two elaborately worked chains with thick plaited work ending in triangular-shaped series of small balls and beads. A popular style of

necklace, for which Nizwa is particularly well known, has large Maria Theresia thalers, which incorporated barrel-shaped loops. Sometimes a large niello-decorated disc with large circles and a flower or star-shape in the middle, was the central piece, to which smaller and cheaper silver rupees may be attached. Dhofar was known for one particular style of jewellery, a heavy chain with intricate, differently patterned links, worn over one shoulder and under the other arm.

Necklaces also often incorporated amulets worn for protective powers. The highly decorated rectangular or cylindrical silver boxes sometimes contained Quranic verses. Flat amulets, some of them in triangular shape and covered with gold leaf, often had Quranic verses (especially the Throne Verse, Sura 2: 255, known for its protective functions) engraved onto the front and small figures on the back. These boxes or flat pieces were also worn attached to heavily plaited silver chains or as part of a head ornament, and often had chains and dangles hanging from their base.

Some expensive necklaces were only worn at special festive occasions. The most valuable necklace worn by women in the North was the *manthûra*, originating from Rustaq. It was strung on thick twisted cotton thread. At both sides was a long silver tube, with fine wire around it and decorated with granulation. From this extended three strands of cotton thread, on which rows of barrel-shaped silver beads were strung, that were vertically attached to each other, connecting the strings of cotton. At the bottom, large and heavy elaborately made dangles were attached, that ended in a large piece of mulberry granulation.

Two expensive necklaces were especially associated with the Bedouin of Central Oman. The digg necklace has a lower part that consists of a bar across the chest with a row of different beads on a rod. The central bead, a smooth ovoid bead with a decorated ridge down the middle is always gold or gold leaf, to its sides are reddish beads and rosette-shaped discs. The upper half of the necklace consists of strands of tiny silver beads strung on cotton. These are twisted together into heavy bunches and attached to each side of the rod with a silver loop. At the other end there are two large wide silver beads through which the cotton passes, with an amulet box set between them. The *shibgat* necklace is also a very elaborate but very light piece of jewellery worn suspended either from a leather loop around the ears or from a headdress. It consists of rows of silver thread-rods (usually three) on which there are red ceramic beads, flat diamond or oblong shapes of sheet silver, covered with a layer of gold, and small cylindrical silver beads with serrated edges. The diamond shapes were attached to the first and third row, the oblong shaped on the second row. At the side these

rows were held together by two broad strips of silver covered with gold leaf, and on top there was a length of broad chain from which it was suspended.

The most expensive Dhofari necklace was the *rehîneh*, even in the old days usually made of gold. It consisted of eight, ten or twelve small gold guineas with cylindrical thread rods decorated with granulation or small cones soldered on top. The centrepiece was a larger, elaborately worked gold disc, and in between cylindrical coral beads were placed.

Yemeni necklaces included those with large squared amber beads, those with large hollow open-worked beads, often with filigree work, some with amulets incorporated, and those with red coral. While a necklace with chains hung horizontally, sometimes with amulet boxes attached to the lower part, was widely popular, the labba, a piece mainly consisting of rows of hanging parts, was a central element in women's bridal jewellery.

Bracelets, elbow rings, and anklets

Bracelets, elbow rings and anklets were worn in pairs, and if hollow, often had pieces of gravel or small stones inside to make a tinkling sound. Elbow-rings were simple hollow silver rings without hinges, with engraved or chased designs that were worn underneath the clothing.

The simplest bracelets consisted of hoops patterned with dies. Bossed bracelets, sometimes hinged but often not, were also highly popular. They had either rounded or spiky, pointed bosses in one to three rows, with between each of the larger bosses a vertical row of four small dots. Wider bossed bracelets were worn in the interior; in the desert areas sometimes a number of such bracelets were joined together. In the central part a curved, often elaborately decorated, hollow tube style bracelet was worn, narrow at the back of the wrist and broader in the front. Dhofar has two distinctive types of bracelets. One type originally consisted of a series of cylindrical or barrel-shaped coral or red glass beads, heavy barrel-shaped silver beads and loose rosette-shaped spacer discs. The other type is D-shaped, with the curved part of heavy twisted silver, while the straight side has bosses and a decoration of silver thread.

Anklets were an essential part of women's outfits in North-Oman. In addition to round, light and narrow silver anklets, one characteristic style of anklets had a rounded inner surface and a more square-shaped outer surface, which was elaborately worked and fastened with a pin-join in the middle of the flat panel. Along the coast women also wore *Baluchi*-style anklets, that is a hollow silver ring with a gap at the back and sides engraved with floral and geometrical designs. In the coastal areas of Dhofar broad silver anklets were widely used that were

made of joined vertical sections with a long pin fastener and with large bells at the base.

Noserings and earrings

Noserings were essential for married women in Oman. In the North they were flat with the bottom third wrapped in silver wire. In the coastal areas, a *Baluchi*-style with a piece of sheet silver in the lower half and tiny beads was popular. Both in Dhofar and in Central-Oman noserings usually were D-shaped, with a small coral bead.

The simplest earrings consisted of hoops with twisted wire around the lower half. Heavier ones in the North would have an ovoid bead, sometimes with a ball or a mulberry-shaped design on the bottom, and a number of dangles attached. Whereas lighter earrings were worn in the ear, the heavier ones were suspended from leather hoops around the ear or from headbands. D-shaped earrings were worn both in Sur in the North, where there were three beads on the straight piece, a red one in the middle with a spiked silver bead at both sides, and in Dhofar, where they were a larger version of the D-shaped noserings.

A very expensive set of earrings in North-Oman was the *nis`a* earrings, owned by wealthy settled Bedouin. They may weigh 2 kg. and were worn attached to a band across the top of the head. Each 'earring' consists of five or six large cylinders more narrow at the top than at the bottom, with fine silver wire bound around and dots and spikes at the bottom. The top and bottom of the cylinders were joined by a loop of wire with two or three beads on it. Each cylinder had its own sets of dangles attached to the bottom. Amongst the Bedouin in Central-Oman *ghalâmîyât* earrings were popular. These consisted of two silver pyramids soldered together with a round bead and granulation. A smaller and simpler version, light enough to wear in the ear, was used by the less well off.

Earring decorations hung from earrings were popular everywhere, but perhaps most so in Dhofar. In simple versions this may have included silver hoops, short lengths of chains, and little bells. More expensive were those with solid elongated double cones of silver, with decorated embossed discs, or with pendants consisting of a solid rectangular piece of silver, with at the top a solid lozenge-shaped piece, and at the base again small dangles, and bells. These various parts could be decorated with a variety of incised and embossed patterns.

Headdresses and hair decorations

Women would wear a variety of headbands. A band of several chains with small loops at the end was worn over the top of the head and was used to

attach to heavy earrings. Some of these had small amulet boxes attached at the back, and a circular forehead piece in the front, sometimes also with chains and dangles attached. A chin strap with four to six rows of chain with two decorated triangles at the end was employed to hold women's headdress in place.

For special occasions, Bedouin women of the interior would wear a headdress, decorated with large silver domed beads and rows of silver discs, that completely covered the head. In Dhofar both girls and women would wear plait ornaments for special occasions, that is cones of silver (six for girls and eight for married women) would be attached to the end of their plaits with chains and bells at the base, at festive occasions sometimes in combination with an elaborate headdress with cylindrical amulet boxes. Some would wear a forehead band ornamented with silver chains, discs, rosettes, tiny pearls and a small gold forehead piece. Women also commonly used circular or diamond-shaped brooches to fasten head-cloth. In Dhofar an ornamented silver triangle with a silver ring at its apex and a dense fringe of chains and bells at the bottom was attached to the end of a headdress to keep it in place.

Finger rings and toe rings

Both finger and toe rings always came in pairs. Finger rings were different for each finger. On the thumb a broad silver band with raised horizontal lines was worn. For the index finger there were two shapes, one a 'teardrop', round at the bottom and tapered to a point, the other a circle surmounted by a lozenge. The middle finger had a diamond-shaped ring with rounded corners. The ring finger may have had a ring with a large square, or a hexagon with niello decoration or a dark red stone. For the little finger there was a ring with a pyramid of small, granulated silver balls. Zar rings that were meant to protect the wearer from evil spirits were square with a dome in the centre (either open filigree or solid) and a small mulberry in each corner. Toe rings were simple round rings with bosses. In rural areas many women wore no rings at all; wearing a finger or toe ring was much less important than wearing a nosering, earrings, bracelets and necklaces.

The move from silver to gold jewellery

Until the 1950s Omani jewellery was by and large made of silver; only a few pieces have been made of gold. Only amongst wealthy traders in the larger ports, such as Muscat, Sur and Mutrah, was some gold jewellery regularly worn. From the 1950s onwards the growing wealth of Oman gradually led to the replacement of silver jewellery with gold. The

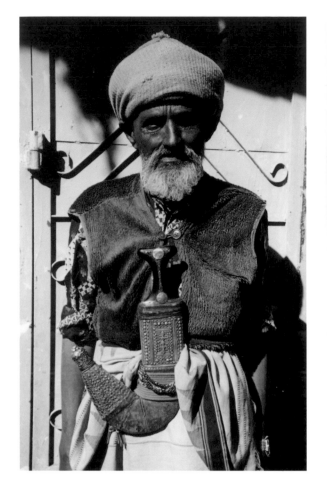

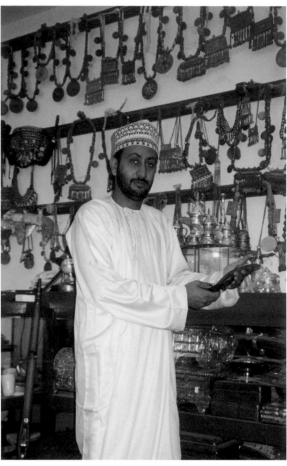

first step was the use of gold leaf to decorate specific parts of silver jewellery. In North Oman the technique of gilding silver items became popular. The next step was that silversmiths began to make smaller items of solid gold, such as noserings and earrings, to be followed by parts of necklaces, such as amulet boxes and diamond-shaped pieces. These pieces of gold jewellery were smaller than the silver items, but otherwise similar. By the late 1970s more and more Omani women were able to buy gold jewellery, and the market for silver became increasingly restricted to expatriates and tourists. With the very rapid increase of the price of silver on the world market, many women sold their silver jewellery to foreign traders who were eager to buy silver jewellery in bulk in order to melt it down. As a means of storing wealth, gold jewellery is more secure and its lighter weight is appreciated. By the late 1980s, silver jewellery had become increasingly seen as old-fashioned and gold jewellery was both more freely available and had become widely sought after. This gold jewellery is no longer produced by local artisan silversmiths, but has become the province of businessmen, often Indians, who deal in mass-produced Indian-style gold jewellery. Today, only a small number of silversmiths still produce jewellery.

Notes

[1] She was the daughter of Sultan Sayyid Said and wrote her memoirs under the title Memoirs of an Arabian Princess. In 1867 she married a German and took on the name Emily Ruete.

[2] The sources used are mentioned at the end of this contribution. For the description of various pieces of Omani jewellery Morris and Shelton (1997) has been especially helpful.

References

Klein-Franke, Aviva, 'The Jews of Yemen', in Werner Daum, ed., *Yemen: 3000 Years of Art and Civilisation in Arabia Felix*, Amsterdam, Royal Tropical Institute, 1988.

Bothmer, Hans-Caspar Graf von, 'Silberschmuck des 18. Jahrhunderts aus dem Jemen', *Jemen-Report*, 31, 2: 19-23, 2000.

Flandrin, Philippe, *Les thalers d'argent: histoire d'une monnaie commune*, Paris, Editions du Félin, 1997.

Gerritse, Jan, 'Een monetaire pin-up', *NRC Handelsblad*, 13/1/1998.

Hawley, Ruth, *Omani Silver*, London and New York, Longman Group, 1978.

Mundy, Martha, 'San'a Dress 1920-75', in Robert Serjeant and Ronald Lewcock, eds., *San'a: An Arabian Islamic City*, London, World of Islam Festival Trust, 1983.

Morris, Miranda and Pauline Shelton, *Oman Adorned: a Portrait in Silver*, Muscat and London, Apex Publishing, 1997.

Ross, Heather Colyer, *Bedouin Jewellery in Saudi Arabia*, Montreux, Arabesque Commerical SA, 1978.

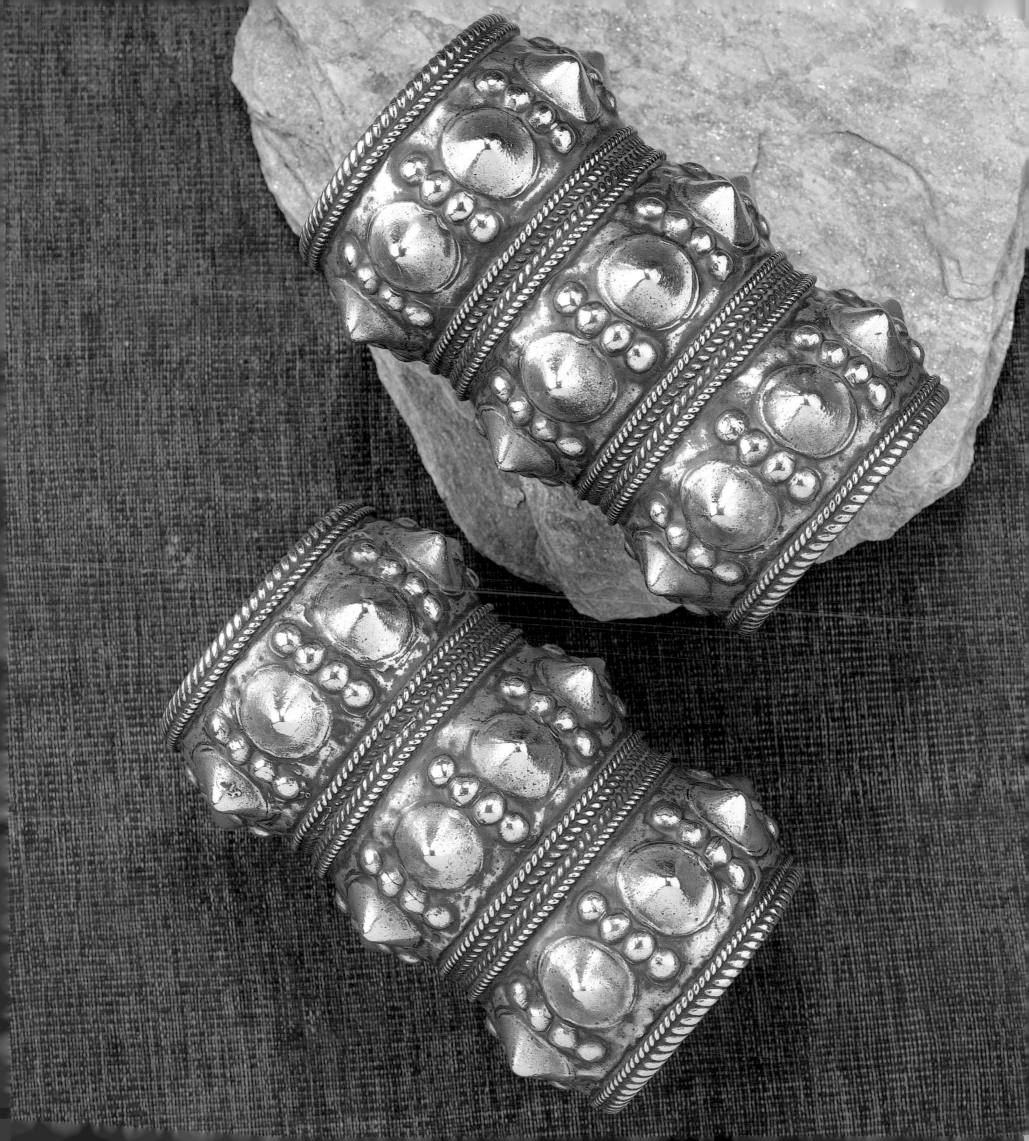

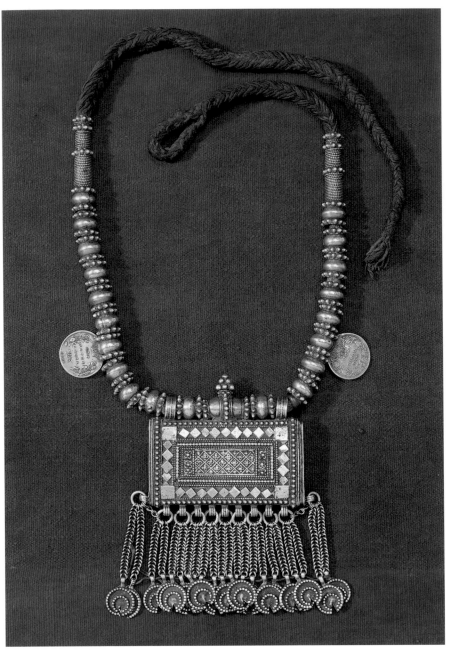

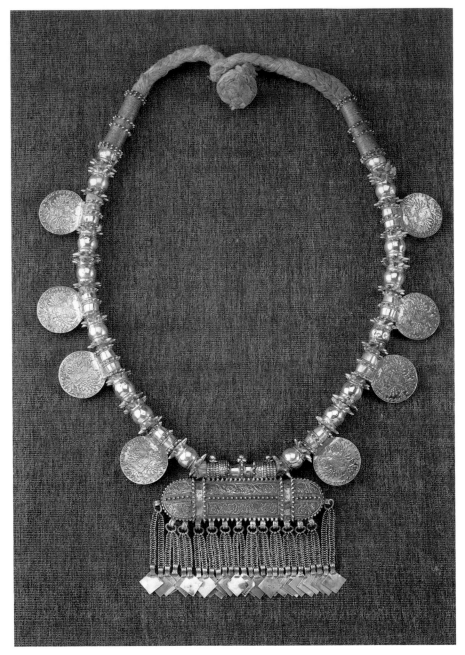

Oman
H ±34 cm, W ±23 cm,
543 grammes
leather, silver & silver gilt,
a glass bead
name: *hirz*
amulet box, necklace
1st half 20th century
box opens on the side; the
chain consists of silver
beads and thorny points;
two beads with Indian
rupees (1892 and 1906) on
leather strap; half moons at
the bottom
(see page 46)

Oman
H 50 cm, W 35 cm,
780 grammes
silver and gilding
name: *hirz*
necklace
1st half 20th century
silver pointed beads, 8
Maria Theresia thalers and
cylindrical amulet tube
wrought on either side.
(see page 48, top left)

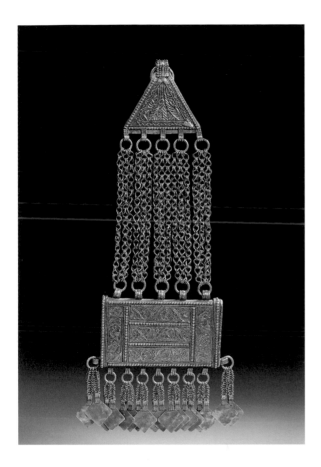

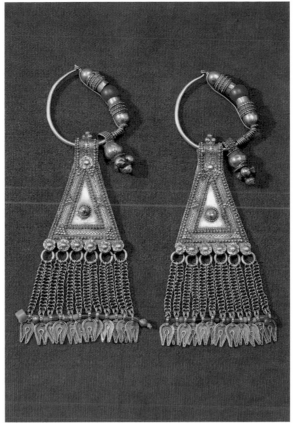

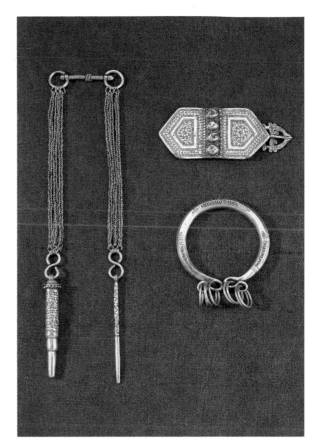

Oman
H 29.5 cm, W 12.5 cm,
210 grammes
silver and silver gilt
name: hamhoon
counterweight for head-
dress
middle 20th century
box does not open

Oman
H 23.5 cm, W 9 cm,
326 grammes (together)
silver and glass
name: dufur and kharam
earrings/temple pendants
middle 20th century
D-shaped earrings with red
glass beads; beneath them
temple pendants, chains
and hands of Fatima

Oman
Left:
L 28 cm, 104 grammes
silver
name: makhal
kohl pot for men with fit
ting chain
1st half 20th century
kohl is applied around the
eyes with a silver pen; it is
done for ornamental pur-
poses, but also in the belief
that it improves vision, kohl
reducing the sun's reflec-
tion; kohl is a black powder
consisting of sulphide, rose
water and incense

Top right:
L 12 cm, W 5 cm,
07 grammes
silver
name: ibzim
clasp for boys
middle 20th century
this clasp is worn by boys
until the age of 10; after
that age they are old
enough to wear a khanjar
(dagger)

Bottom right:
H 10 cm, D 8 cm,
160 grammes
silver
name: madada
man's bracelet
middle 20th century
this bracelet is always worn
close to the elbow; it always
has 8 rings at the bottom,
which make a tinkling
sound when walking

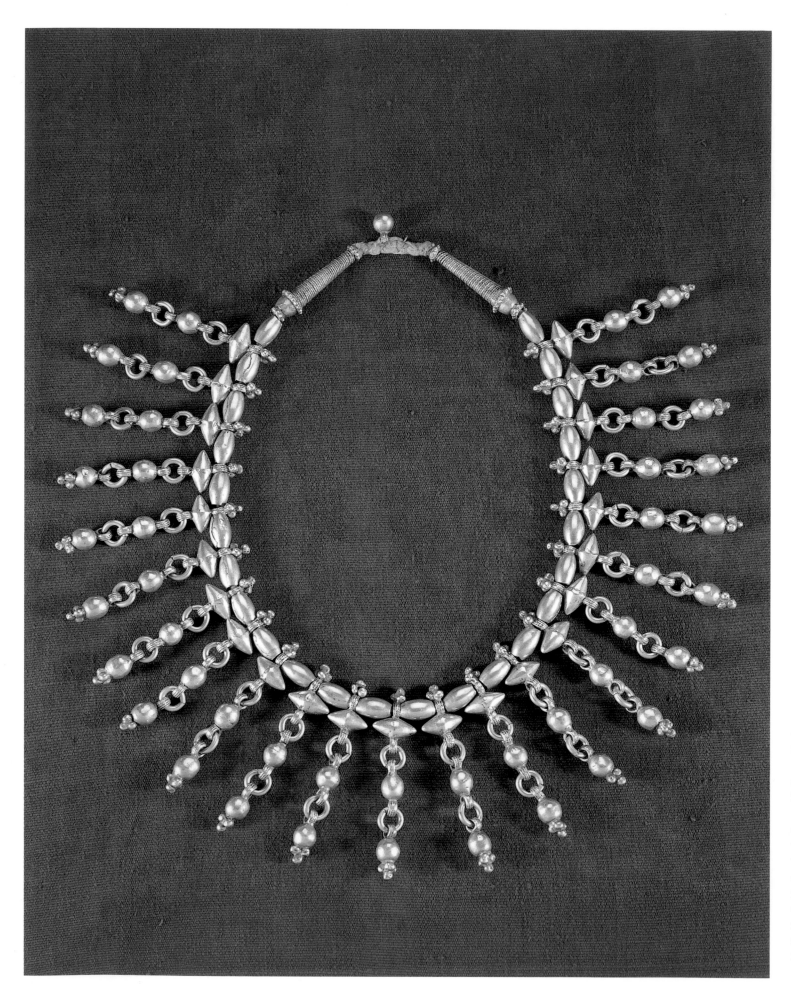

Oman
H 32 cm, W 38 cm, 665 grammes
silver
name: *malketeh*
necklace
middle 20th century

Oman
H 37 cm, W 53 cm, 1180 grammes
silver and gilding
headband with 12 earrings
1st half 20th century
chain with gilding; chains with the hands of Fatima; the name for this type of earrings is *halaq*; a complete set of earrings, hoops and chain is known as a *mishall* – this *mishall* is made up of a total of 12 *halaq*

56

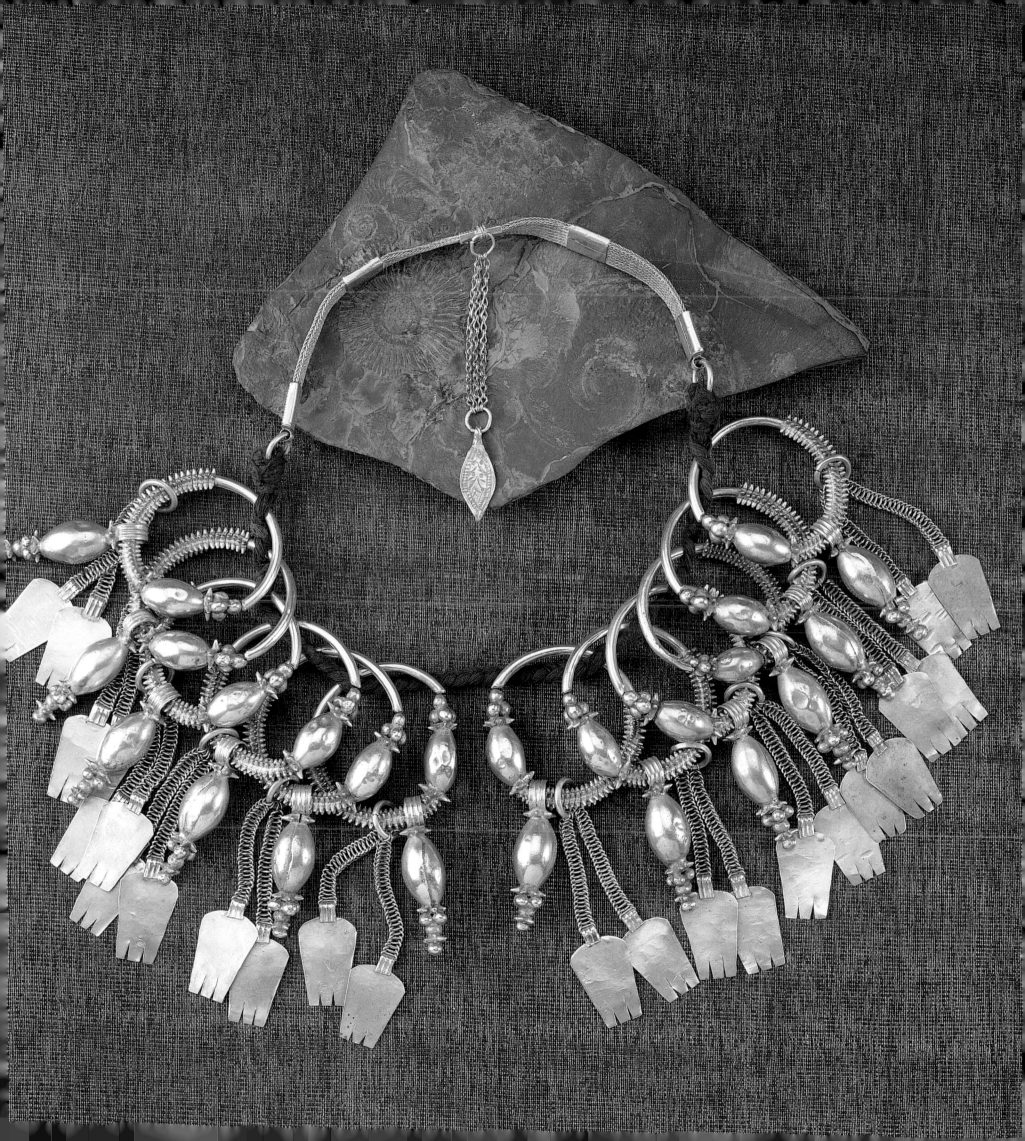

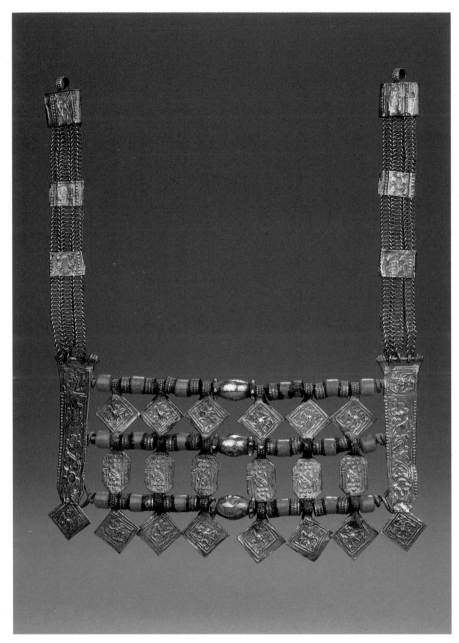

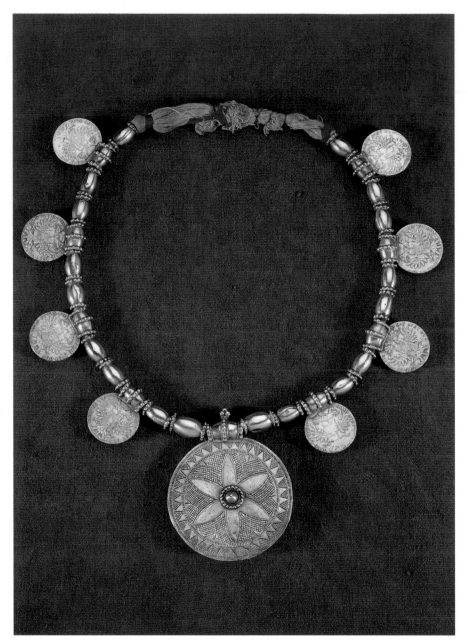

Oman
H 21 cm, W 17 cm,
150 grammes
goldfoil on silver and red
glass beads
name: *shibgat*
necklace
hanging from the hair, or
attached to the ears
middle 20th century
floral motifs and a depic-
tion of *Hanuman*, an Indian
god, here seen as a *djinn*
(ghost)
(ee page 48, top right)

Oman
H ±39 cm, W ±31 cm,
550 grammes
silver
name: *samt mukahhal*
necklace
middle 20th century
silver beads, of which 8
with Maria Theresia thalers;
in the middle engraved disc
with gilt point
(see page 49, below)

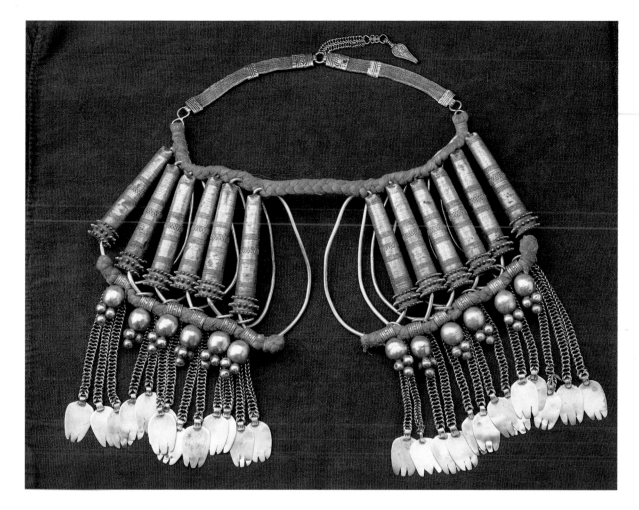

Oman, United Arab Emirates
H 49 cm, W 43 cm,
1395 grammes
silver
name: *nis'a*
headband with 12 elongated earrings
1st half 20th century
at the bottom cord granulated balls; chains with the hands of Fatima

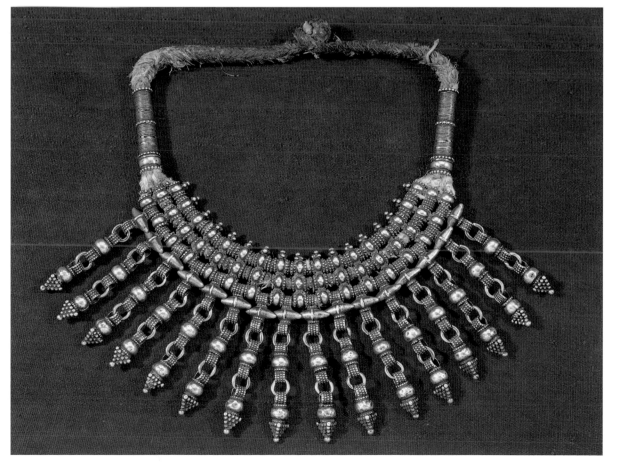

Oman
Rustaq area
H circa 32 cm, W circa 34 cm, 660 grammes
silver on cotton
name: *manthûra*
necklace
middle 20th century
thick twisted cotton thread; two fastening beads (twisted silver around hollow tube); three strings of beads (cotton threads), top and bottom mulberry granulation

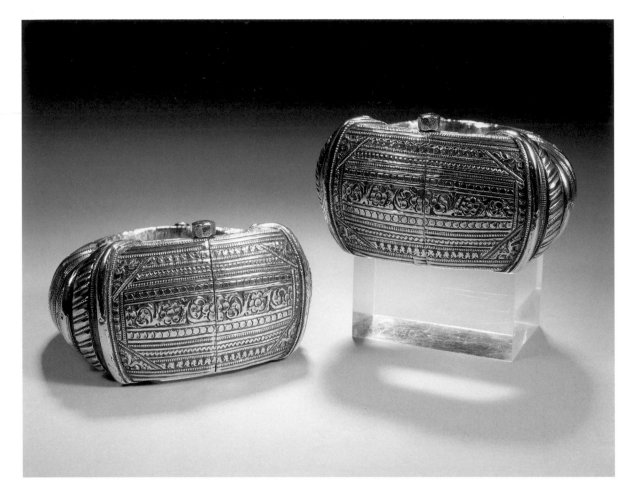

Oman
H 7 cm, W 11 cm, D 10 cm,
756 grammes together
silver
name: *natal*
anklets
middle 20th century
geometric and floral motifs;
opens by means of a peg
middle front; comparable
anklets are found in Gujarat
(India)
(see page 46)

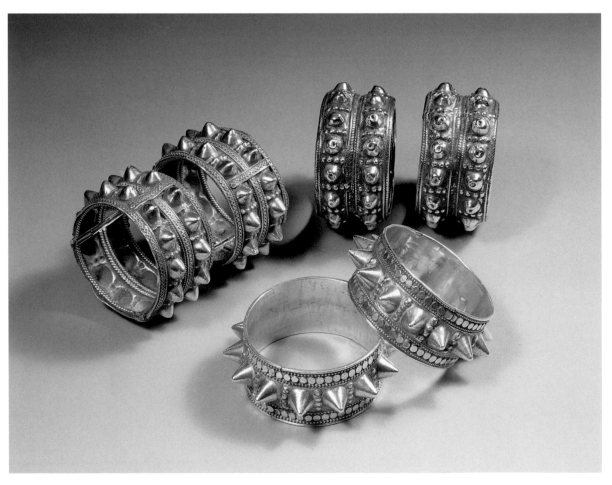

Oman

Left:
D 8.5 cm, 219 grammes
together
silver
name: *benagir bu shôkâ*
('thorny bracelet')
bracelets
the points resembling
thorns originate from the
shape of many desert
plants

Top right:
D 7.5 cm, 261 grammes
together
silver
name: *benagir bu shôkâ*
bracelets
1st half 20th century
closed bracelets

Bottom:
D 7.5 cm, 208 grammes
together
silver and silver gilt
name: *benagir bu shôkâ*
bracelets
middle 20th century

Oman
North Oman
D 15 cm,
704 grammes together
silver
name: *hajul* or *hagul*
anklets
middle 20th century
engraved
these anklets were original-
ly worn by women in
Baluchistan; now also worn
in Oman

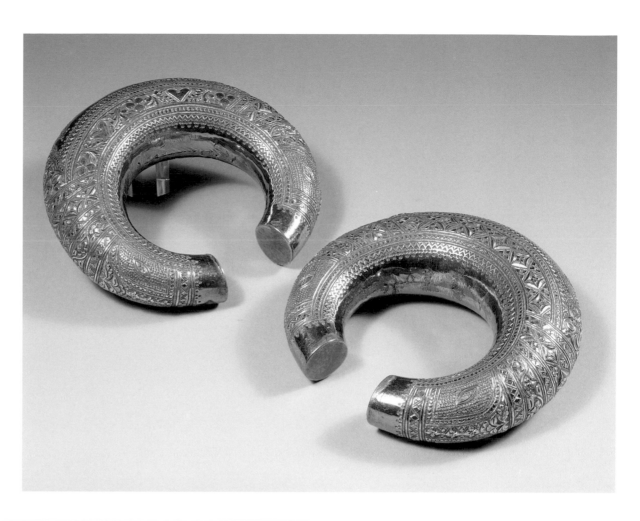

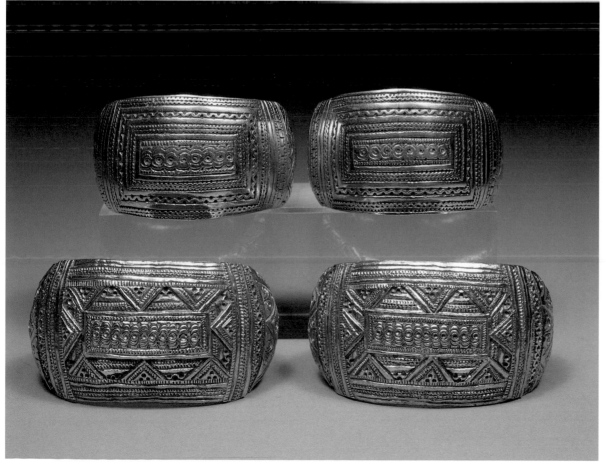

Oman
Top:
H 4.5 cm, D 7.5 cm, 254
grammes together
silver with engravings
name: *hagula*
bracelet
1st half 20th century
closed bracelets

Bottom:
H 5 cm, D 8 cm,
403 grammes together
silver and silver gilt
name: *hagula*
bracelets
middle 20th century
closed bracelets

Oman

H 32 cm, W 33 cm,
1180 grammes
silver, gilding, gold, red
coral, lacquer
name: *digg*
necklace
middle 20th century
two large pieces of red
coral, old beads

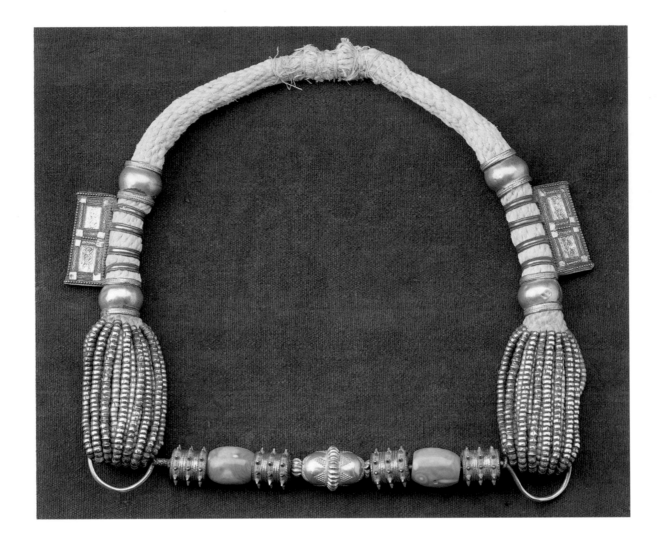

Oman

Top:
H 14 cm, D 6.7 cm,
93 grammes
silver
name: *halka ar ras*
plait clip worn at the back
middle 20th century
worn by unmarried girls;
engraved openwork star;
hands of Fatima on the
underside
(see page 49, top left)

Bottom:
L 35 cm, 194 grammes
silver, gold, lacquer, 2 red
glass beads
name: *makhnaq* ('pearl of
the neck')
necklace
middle 20th century
one gold bead flanked by
two red glass beads,
attached to a silver chain

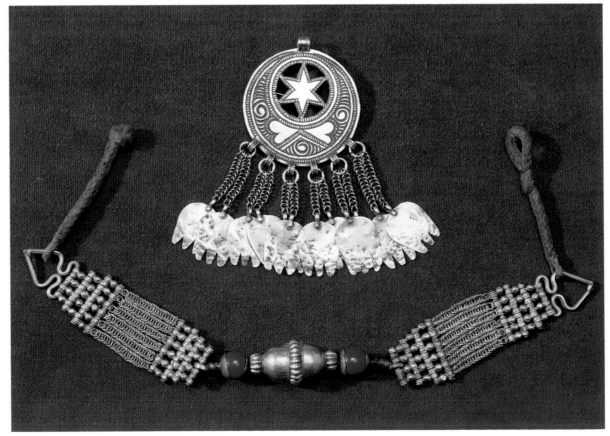

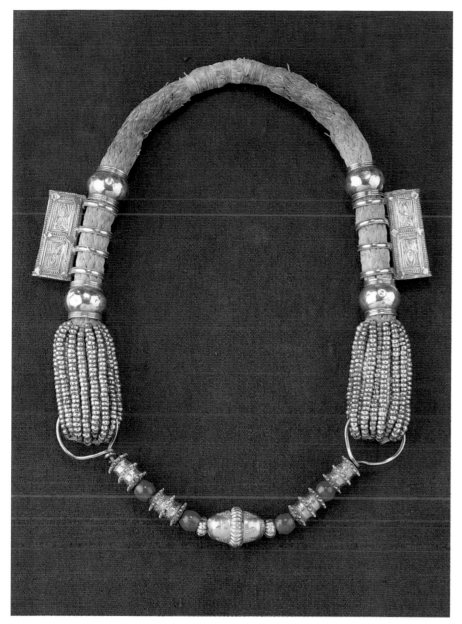

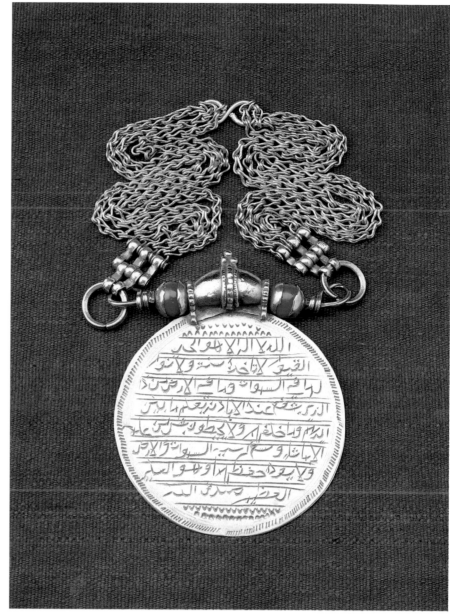

Oman
H ±40 cm, W ±26 cm,
787 grammes
gilding, silver, gold, lacquer,
glass beads
name: *digg*
necklace
middle 20th century
two amulet boxes on the
side are partly gilded; the
bead in the middle is gold
filled with lacquer; the
slightly curved bottom of
the chain is usually worn
straight

Oman
H (amulet) 12 cm, D 9.5 cm,
217 grammes
silver and 2 red glass beads
name: *kirsh kitab*
amulet pendant
middle 20th century
with engraved Koran text
(Sura 2:255): *Allah: there is
no God but Him, the living, the
eternal One. Neither slumber
nor sleep overtakes Him. His is
what the heavens and earth
contain. Who can intercede*
*with Him except by His per-
mission? He knows what is
beyond and behind men. They
can grasp only that part of His
knowledge which He wills. His
throne is as vast as the heav-
ens and the earth and the
preservation of both does not
weary Him. He is the exalted,
the immense One.*
This text was used to exor-
cise evil spirits; on the
reverse side an engraved
djinn ('protective spirit')

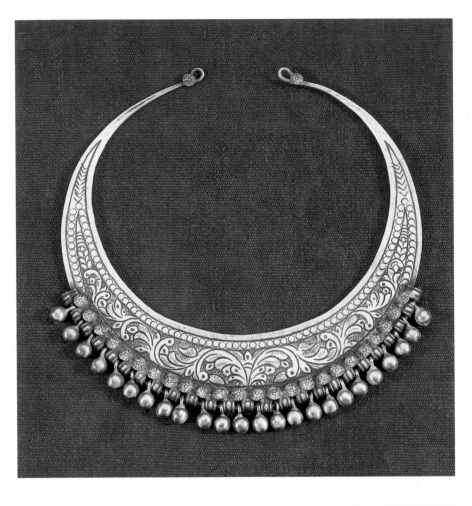

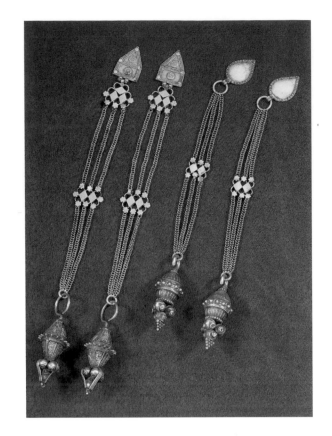

Left:

Oman
H 18 cm, W 17.5 cm,
135 grammes
engraved silver
necklace
middle 20th century
the decoration shows simi-
larities with designs of the
hill tribes in China and of
people from the Golden
Triangle; in the past there
used to be trade relations
between Oman and Hainan
(South China)

Above:

Oman
Left:
L (earrings) 12 cm, 104
grammes together
L (chains) 36 cm,
193 grammes together
silver and silver gilt
name: *ghalâmîyât*
earrings and headdress
chains
middle 20th century
pyramid-shaped, consisting
of 2 parts; bottom: mulberry
fruits and granulation

Right:
L (earrings) 10.5 cm, 111
grammes together
L (chains) 30.5 cm, 142
grammes together
silver
name: *ghalâmîyât*
earrings and headdress
chains
middle 20th century

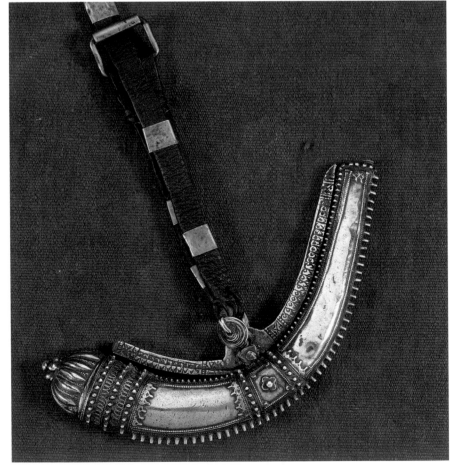

Left:

Oman
L 19 cm, weight with
leather belt: 307 grammes
silver and leather
name: *talahiq*
powder horn
19th century

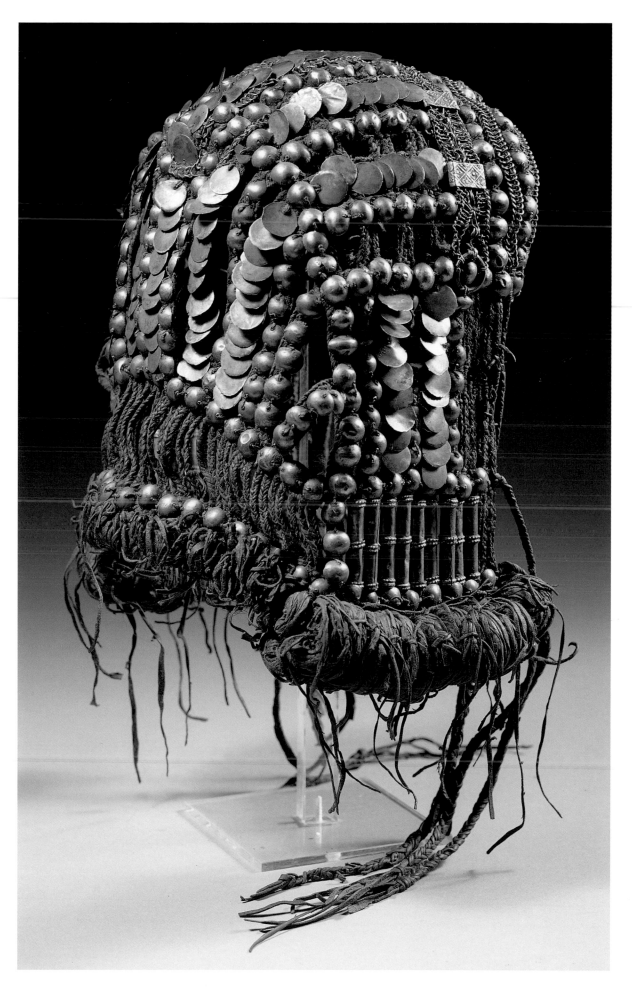

Oman
609 grammes
goatskin and silver
name: *shabka*
headdress
middle 20th century
this type of head covering
was made to measure for
every nomad woman; the
forehead piece is called
àlàka
(see page 48, below)

Page 66:

Yemen, South India
H 34 cm, W 19 cm, 926
grammes
silver, wood, iron
name : *djambia*
dagger for prestige and self-
defence
early 19th century
the level of craftsmanship
is very high; probably taken
from Yemen to South India
in the 19th century; the
dagger may also have been
made in South India itself
and there worn by Muslim
men; Indian owner's name
engraved on the back.
(see page 52, left)

Page 67:

Oman
H 30 cm, overall weight
with belt: 806 grammes
leather, silver, iron, horn
name: *khanjar*
dagger
19th century
silver stitched on leather;
grip of rhinoceros horn ;
this dagger is worn to pro-
tect its owner and to confer
status on him – every man
or boy older than 10 is sup-
posed to wear a dagger

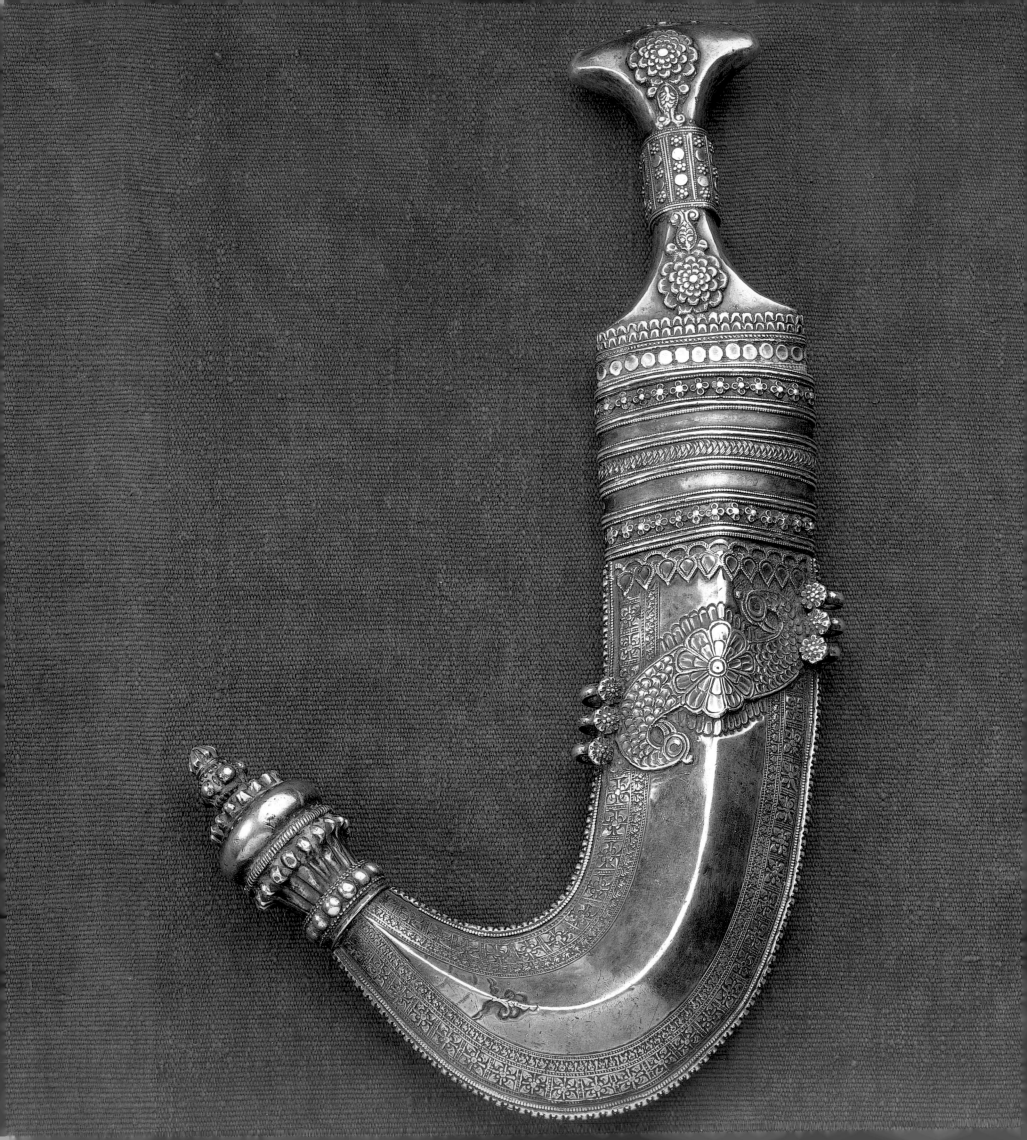

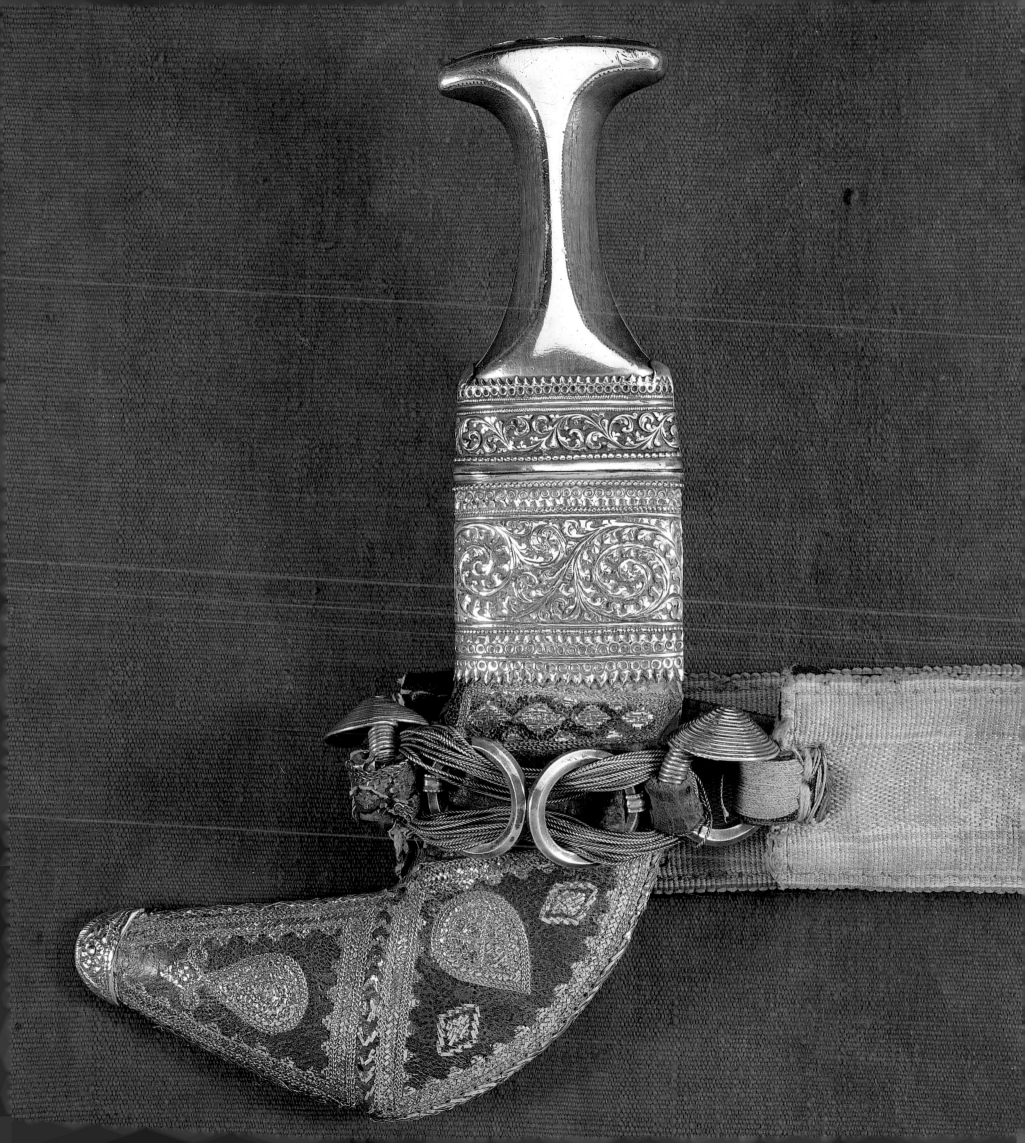

Oman
Dhofar (South Oman)
D 8 & 7 cm, 90 & 70
grammes
silver and red glass beads
name: *malnaut*
two bracelets
contemporary
barrel-shaped red glass
beads, and silver beads and
loose rosette-shaped spacer
discs

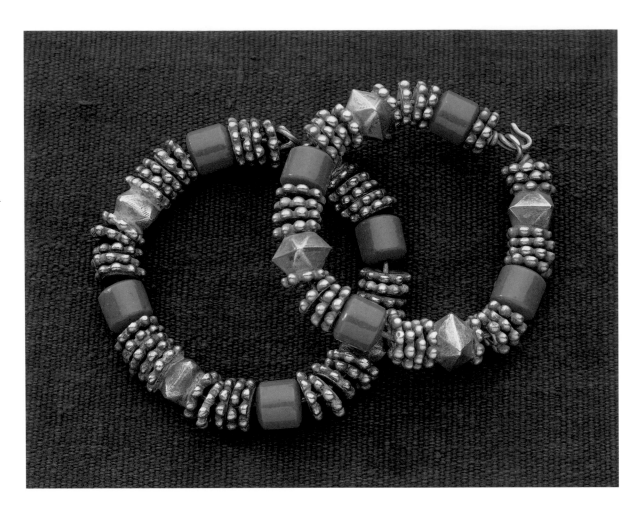

Oman
Sur area
H 6 cm, W 10,5 cm, D 9,5
cm, 725 grammes together
silver and gold foil
name: generally called
natal, specific name *heyul*
anklets
middle 20th century
opens by means of a peg
middle front

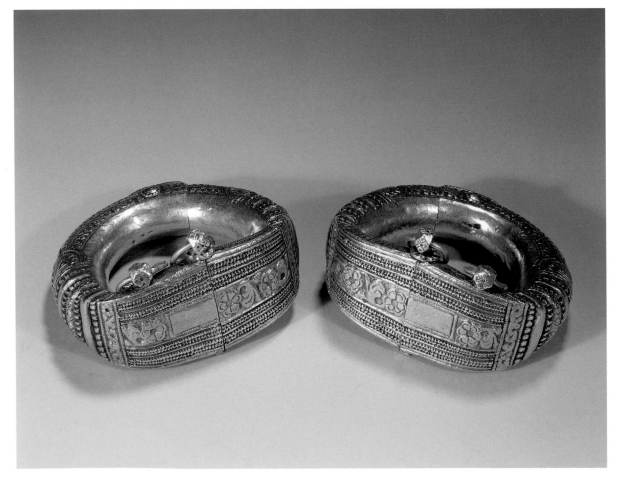

68

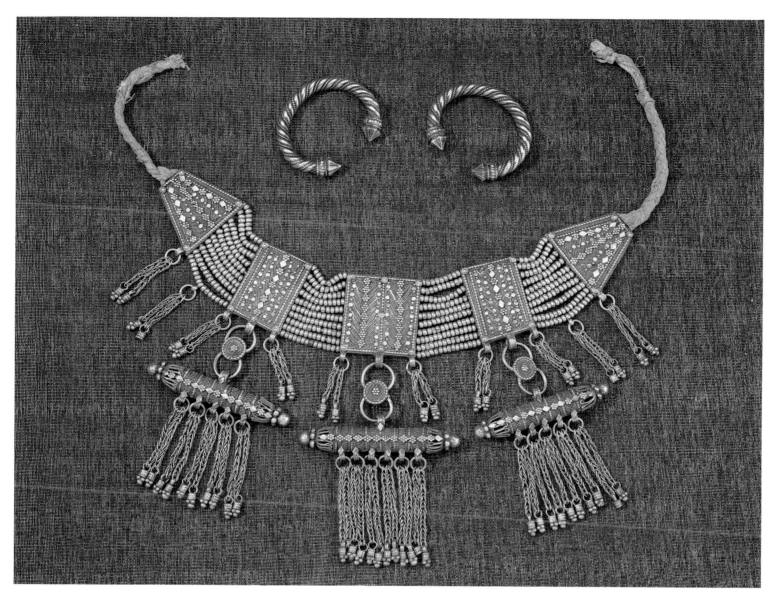

Yemen

Bottom:
H ±20 cm, W ±30 cm, 530
grammes
silver
name: *iqd*
necklace
1st half 20th century fili-
gree and granulation work;
3 pendants, called *hirz*

Top:
H 6 cm, W 7 cm,
167 grammes together
silver (thick and thin inter-
twining)
bracelets
1st half 20th century
bracelets in the Celtic style
of 200 BC; this style is
found throughout the Arab
countries; these bracelets
were bought in South
Yemen, just before being
melted down by a local sil-
versmith

Yemen

Left:
Yemen
H 7 cm, W 7.5 cm, D 1.5 cm,
146 grammes
silver
man's purse (suspended
from belt)
1st half 20th century
granulation; peg fastener
on top

Top right:
H 6 cm, W 7.5 cm, D 1.5 cm,
68 grammes
silver

man's purse (suspended
from belt)
1st half 20th century
filigree and granulation;
stamped on the back; peg
fastener on top

Bottom:
H 6.2 cm, W 8 cm, D. 2 cm,
103 grammes
silver
man's purse (suspended
from belt)
1st half 20th century
engraved, a.o. with inscrip-
tion; peg fastener on top

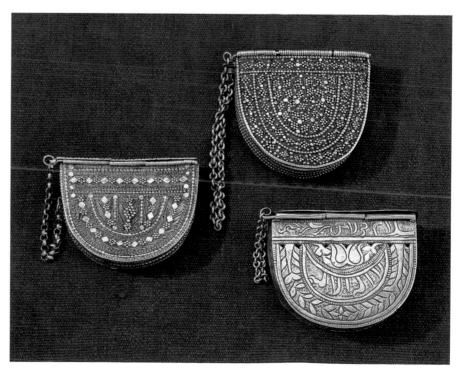

69

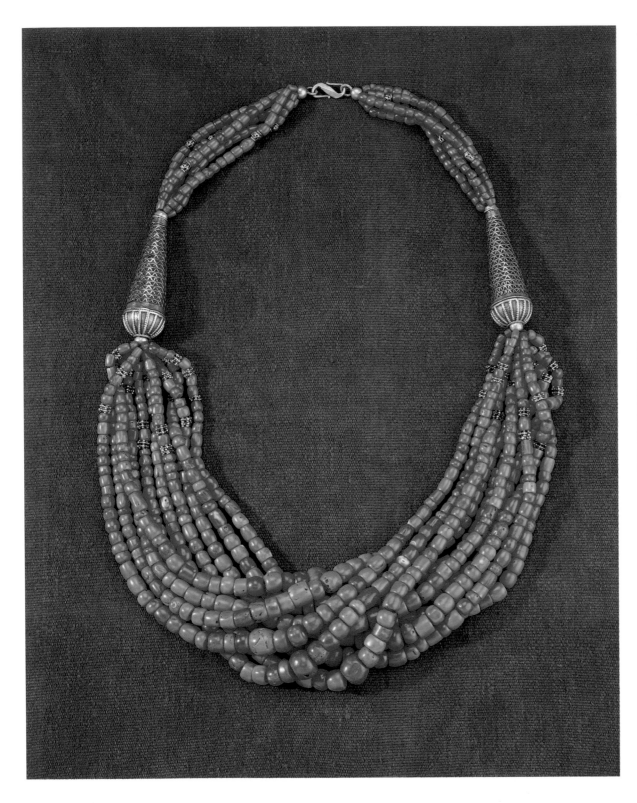

Yemen
H 31 cm, W 23 cm,
515 grammes
silver and red coral
necklace
bottom part consists of 10
strands; top part 2 x 5
strands

Yemen
H 43 cm, W (amulet box) 10
cm, 252 grammes
Silver and amber
necklace; amulet box open-
ing on the side
early 20th century
red amber beads
perfect craftsmanship by
Jewish silversmiths; filigree
and granulation work

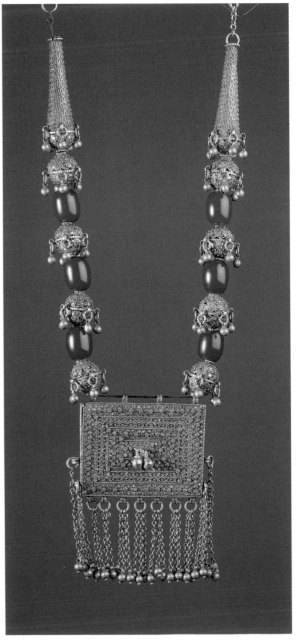

Yemen
Wadi Hadramauwt (South
Yemen)
H (hirz) 18 cm, W 16 cm,
898 grammes
silver
name: *hirz*
amulet jewel
1st half 20th century
total length 63 cm, chain
snake's vertebrae tech-
nique; *hirz*: engraved floral
motifs, showing
Muslim/Indian influences;
bottom: hands of Fatima
and bells

Yemen
H 19 cm, W 29 cm, 515
grammes
silver alloy
name: *labba*
necklace
middle 20th century
17 small boxes of filigree
work with granulation;
attached a small apron of
threaded silver balls and
rounds – all with filigree
and granulation
(see page 49, top right)

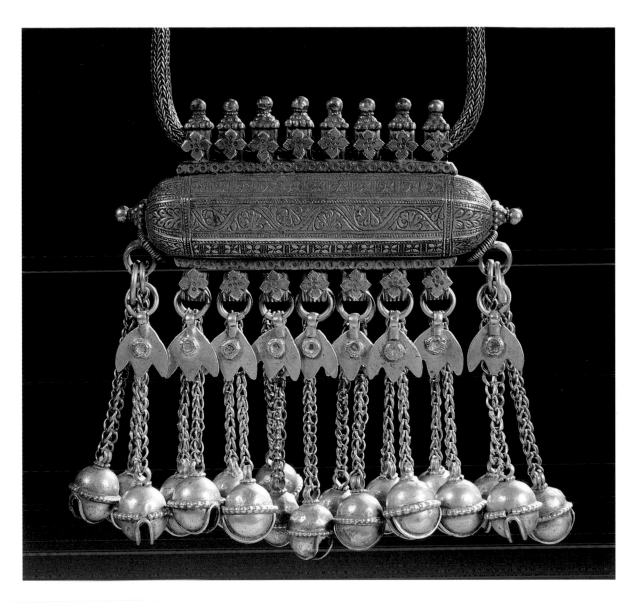

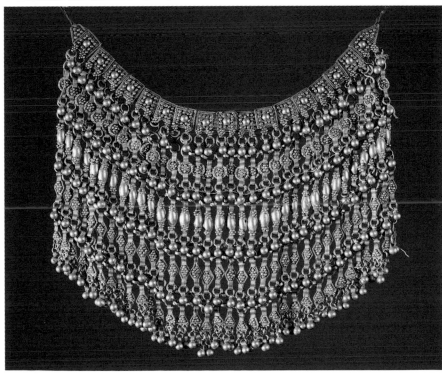

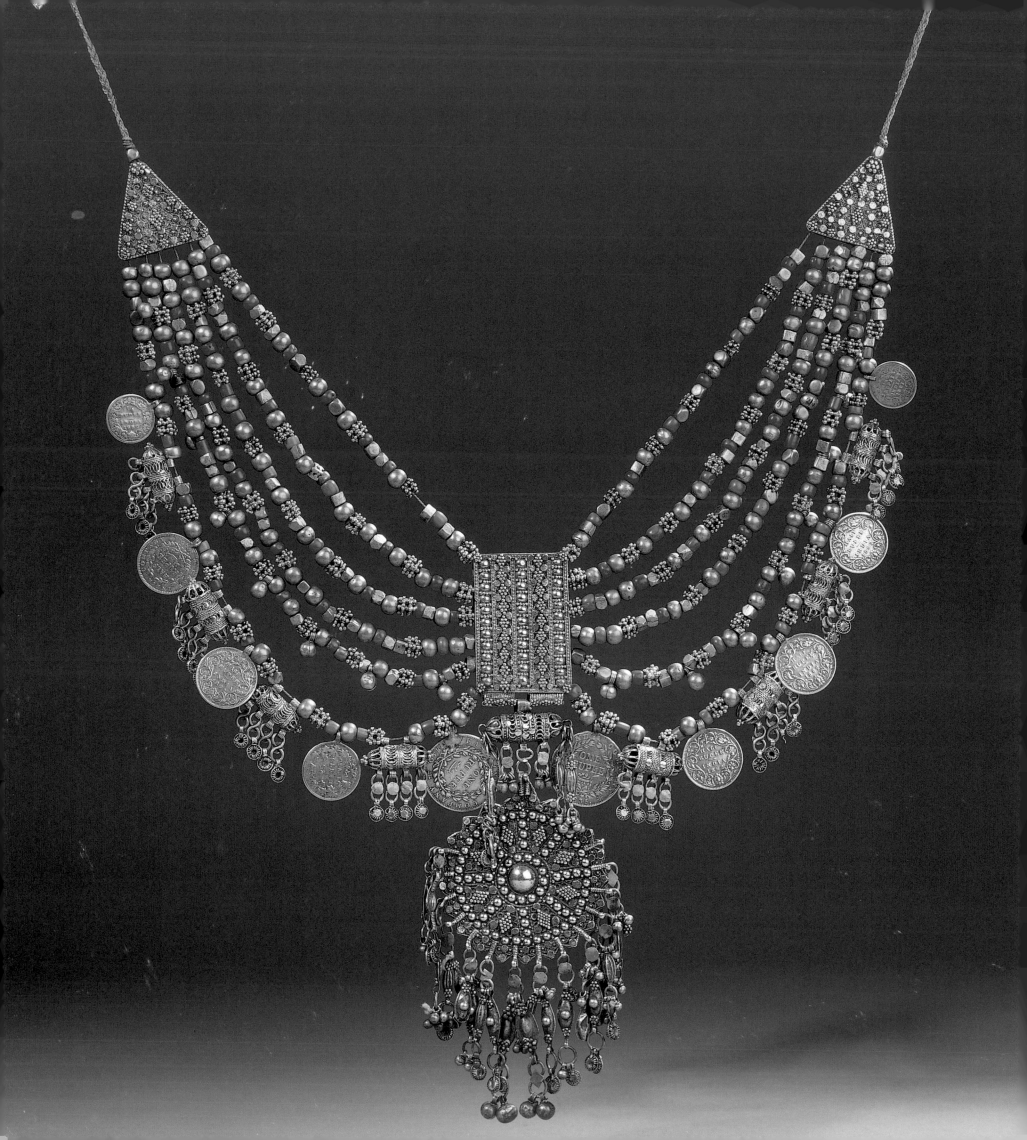

Central Asia

Turkmenistan
Uzbekistan
Tajikistan
Kazakhstan
Azerbaijan
Dagestan
Armenia
Iran

Yemen
H 40 cm, W 34 cm,
711 grammes
silver and red coral
necklace
early 20th century
filigree and granulation; at
the bottom of the chain
Indian rupees (dated
between 1835–1882) and 9
cylinder-shaped pendants
plus one large central piece

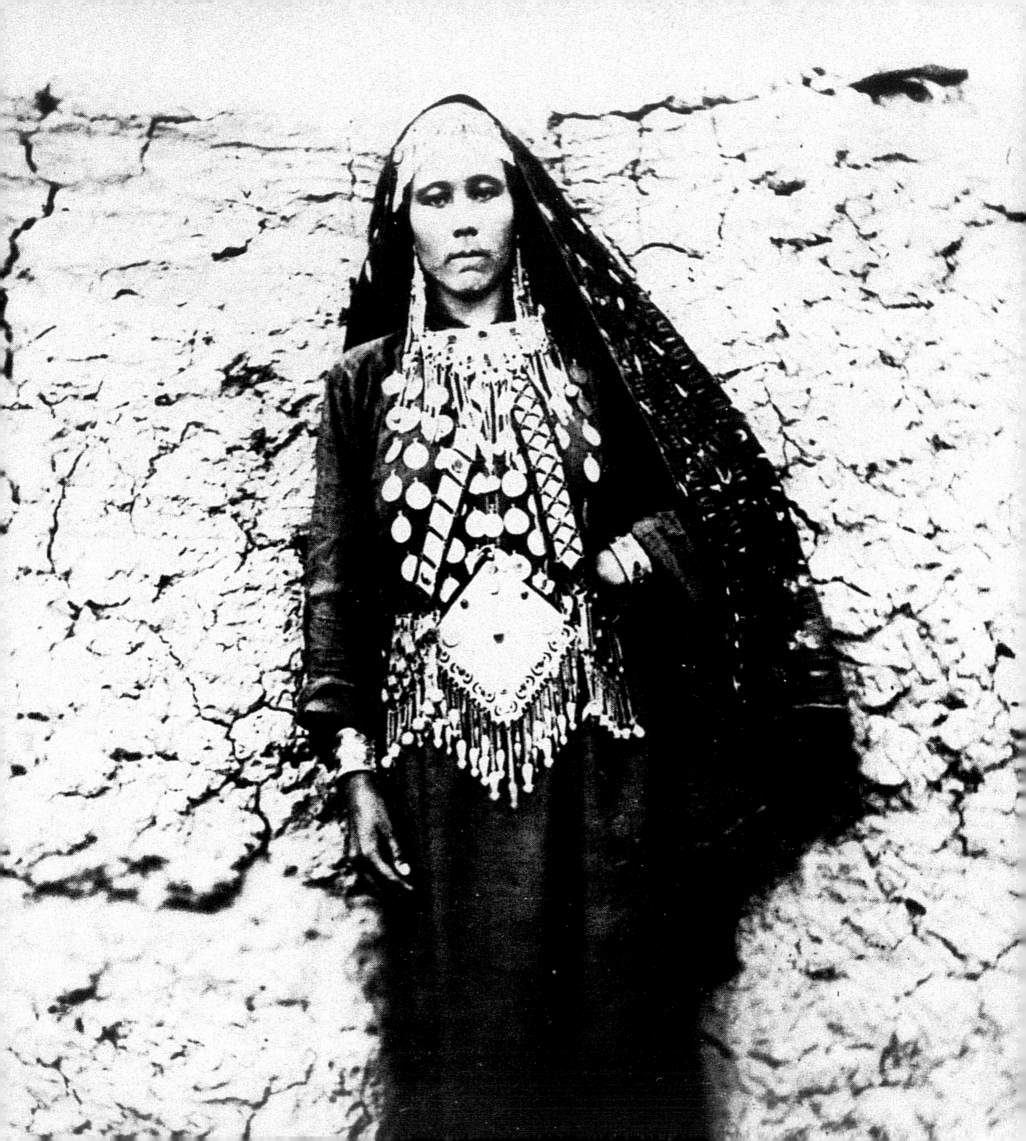

Turkmen jewellery from Central Asia

Roelof J. Munneke

In the past few decades Turkmen jewellery has become increasingly sought after. Both museums and private individuals want items to add to their collections. The quality, size and diversity of Turkmen jewellery have long stirred the imagination, so it is interesting to gather information about the nature of the Turkmen people, about past and present lifestyles and about the backgrounds of the many exceptional pieces of jewellery which they have added to their material culture. Some pieces of Turkmen jewellery have been called highlights of Turkmen decorative art.

Because of the absence of contemporary sources it is not always easy to answer questions about the function and the meaning of the jewellery. In this chapter I will attempt to lift the veil and give some answers to a number of questions.

Much of the Turkmen jewellery known today was made in the nineteenth and the first quarter of the twentieth centuries. A century ago the jewellery would have been shown to its best advantage at a wedding and it was mainly worn in the first years of marriage. On the day of her wedding a bride from a prominent family was literally weighed down by seven to eight kilograms of jewellery. This jewellery was the dowry, which also consisted of household goods, like carpets and clothes. The textile part of the dowry was usually made by the bride, with the other female members of her family. The quality of the hand-knotted and embroidered work determined the prestige of the female part of the bride's family.

In prestigious Turkmen society, which was politically and economically power-oriented, marriage was an extremely important event. It was the confirmation of a relationship between two families. The bride was handed over to the family of the groom covered with treasures from head to foot, to remind everyone of the wealth and the glorious past of the family that had raised her. For a year (and in earlier times even a full two years) the newly-wedded bride would walk about like this.

The Turkmen and their territory

The Turkmen are nomadic herdsmen by origin. They live in the area surrounding the Karakum desert, which with its 488,000 square kilometres covers nearly 80 per cent of the area of the present republic of Turkmenistan. The language spoken by the Turkmen is part of the southwestern or Oghuz group of Turkish languages and is closely related to modern Turkish. There are approximately three million Turkmen, of whom 1.9 million have settled down in the republic of Turkmenistan which carries their name. Some 390,000 Turkmen live in Afghanistan and another 313,000 in Iran. The most important Turkmen tribes in terms of jewellery are the Tekke, the Ersari, the Yomud and the Sarik.

In about 1830 the number of Turkmen yurts – the round, Central-Asian type of tents that the Turkmen used to live in – was estimated at 120,000. Assuming that there were five persons to a yurt, this means that there were about 600,000 Turkmen at the time, 200,000 Tekke, 200,000 Ersari, 100,000 Yomud and 100,000 Sarik. In 1926 over 50 per cent of the Turkmen population were Tekke and Yomud, while the Ersari accounted for 20 per cent.

Turkmen territory is bordered in the west by the Caspian Sea. In the south it runs all the way down to North Iran. In North Afghanistan it is bordered by the foothills of the Hindu Kush mountains. In the east the valley of the Amu Darya river is the natural borderline, while the circle is closed in the north by Lake Aral and the Ust Yurt plains.

From the sixteenth century onwards the Turkmen have spread from the shores to the east of the Caspian Sea across Turkmenistan and the bordering areas. The Tekke, the largest and most powerful Turkmen tribe, have taken possession of three large and important oasis areas in the south of Turkmenistan: Akhal, Tedzhen and Merv. The Yomud are mainly found in the border area with Iran, along the shores of the Caspian Sea and the lower reaches of the Amu Darya between Khiva and Kunja Urgenj. For quite some time now the Ersari have occupied the middle reaches of the Amu Darya in Turkmenistan and the area across the border in Uzbekistan and the north of Afghanistan. Turkmen territory is largely desert-steppe landscape, consisting of sandy plains, with the odd bush or shrub and sometimes some towering dunes of sand, showing hardly any life at all. The area has large differences in temperature between summer and winter and day and night. In summer, temperatures can easily reach 45° or 49° Celsius in the shade. In winter when polar air flows freely into Central Asia, due to the absence of natural barriers, temperatures in North

Turkmenian woman with a head jewel (*ildirgitch*) large breast jewel (*göndschük*), and on the right hip an amulet holder, called *tumar*, c. 1880.

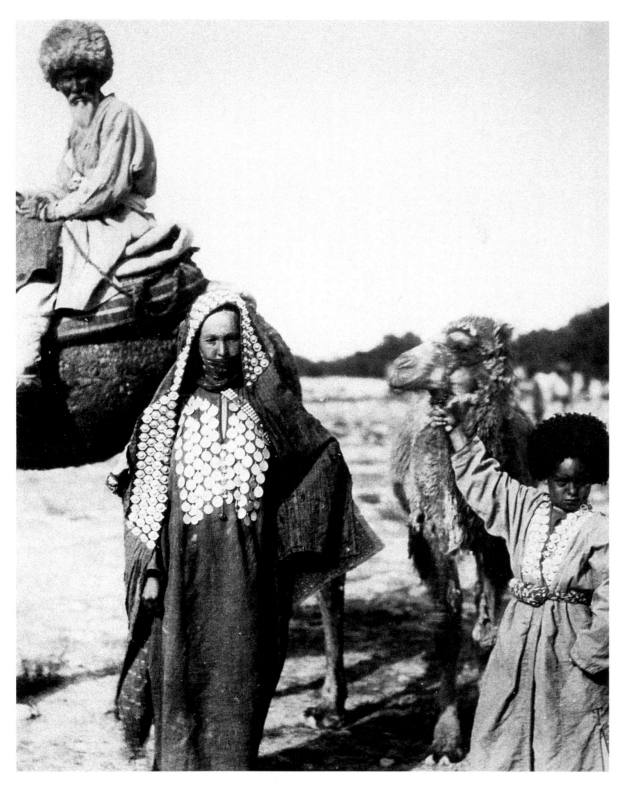

Turkmenian family, from the Tekke tribe. The father and the son wear caps made of sheep fleece, c. 1880.

Turkmenistan can drop to below -30° Celsius. Precipitation is irregular, but when there is rain, it usually falls in spring and autumn. After the spring rains the steppes and large parts of the desert are briefly covered with flowering plants. The normal desert and steppe vegetation in these areas consists of low shrubs and grasses, which serve as fodder for the sheep and the camels. For their agricultural activities the Turkmen mainly depend on irrigation. Most Turkmen settlements are in the basin of one of the rivers flowing in the south along the borders of Turkmenistan and the neighbouring states.

Resident farmers and nomadic herdsmen

The nineteenth-century division of the Turkmen people into nomadic herdsmen, *chorva*, and resident farmers, *chomur*, suggests an important division of tasks. The ideal combination was a division of tasks in which some members of the tribal group engaged in nomadic husbandry while others stayed behind in an oasis to till the land or keep an eye on the slaves working on the land.

The relationship of herdsmen and resident farmers was a symbiotic one. The nomads sold their animal products - wool, skins, leather and meat - and were given corn in return. This corn was used for baking bread, the most important element of the herdsmen's daily diet. There was also a continuous alternation between resident life and nomadism, partly because of internal conflicts, one group chasing another group from the oasis or stealing its traditional grasslands. Despite a development towards a resident life, the first signs of which were already clearly showing in the nineteenth century, the Turkmen held onto the yurt which so clearly represented their nomadic past. Husbandry was not the only source of Turkmen income. Even as long ago as the nineteenth century, money was made by selling hand-knotted carpets. These carpets were made by the women at home, from the wool of the sheep in the herds. In the carpet trade these carpets are usually called 'Bukhara carpets' because the first Turkmen carpets exported to Europe from Central Asia were bought in the markets of the city of Bukhara.

Political organisation

The political organisation of the Turkmen was based on the male line of descent. Each Turkmen was a member of a number of umbrella groups of relatives. One step up from the family was the umbrella group of the *bir-ata* – literally meaning 'one father' – holding ten to 15 families. They had one common ancestor, a grandparent or a great-grandparent, lived close together and helped each other as much as possible.

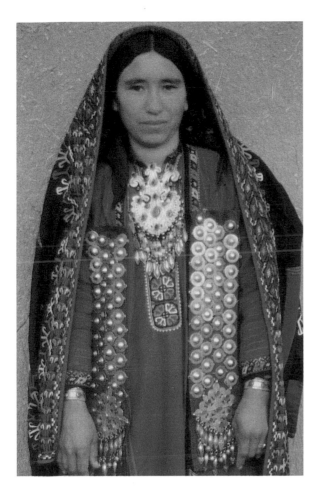

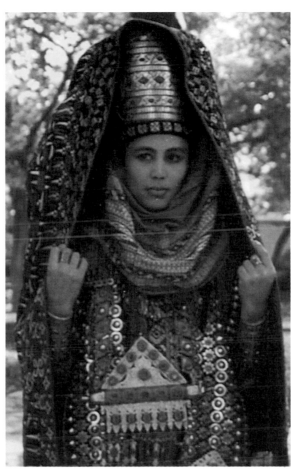

Another step up from the *bir-ata* were a number of other umbrella units, uniting a large number of bir-atas. They were mainly of political military importance and were meant to defend the territory and the interests of the larger group. After the Turkmen had been gradually subdued by the Tsarist armies in the nineteenth and twentieth centuries, they were no longer an independent military power. Even the umbrella organisations at the level of groups like the Tekke, the Yomud and the Ersari have lost much of their importance. Both in Turkmenistan and in other parts of Central Asia the Turkmen now rather see themselves collectively as Turkmen and less and less as Ersari, Yomud or Tekke. In the course of the twentieth century new administrative state-related units increasingly took over the functions of the old political structures, rendering the old political organisation virtually superfluous.

The financing and creation of Turkmen jewellery

The huge amount of jewellery created by the Turkmen in the nineteenth century cannot possibly have been paid for exclusively with the profits from the herds or the agricultural oasis activities. But how were they paid for? Perhaps they were bought with the Bukhara carpets knotted by Turkmen girls and women? This seems unlikely. There is a relationship, though, between the enormous increase in the amount of jewellery owned by the Turkmen in the nineteenth century and the so-called *alamans*, raids on villages in neighbouring areas to get slaves. The main target of this slave hunt, for which the Tekke were especially notorious, was the province of Khorasan in the northeast of Iran. From this region one million people are said to have been taken as slaves by the Turkmen in the nineteenth century. The principalities of Khiva and Bukhara were very much interested in these slaves. The money made this way was mainly invested in jewellery by the Turkmen. For nomadic herdsmen, jewellery represented one of the very few possibilities for safe investment In his article about Turkmen decorative art, Dupaigne gives a few examples, illustrating the enormous amount of jewellery the Turkmen had been able to gather in the nineteenth century. He notes that several times in the nineteenth and twentieth centuries enormous quantities of jewellery were collected to be melted down. In 1873, after the Russians had taken the city of Khiva, they imposed a huge war contribution on the local ruler, the khan, of which the enormous sum of £42,500 pounds sterling had to be paid by the Yomud Turkmen. According to Mac Gahan, the eyewitness quoted by Dupaigne, 'The largest part of the war contribution – however strange this may sound – came from the women. Every Turkmen woman has a large amount of solid silver jewellery, such as bracelets, necklaces, collar buttons and headdress decorations. The major form of wealth – not counting the horses – seems to be this silver jewellery. The Turkmen women contributed hundreds of silver jewellery items and they were counted on the basis of 25 roubles per pound of silver. The pieces of jewellery were all made of the purest silver, a set of bracelets often weighing more than a pound.'

There is not much information about how and by whom the jewellery was made. In a number of reports it is suggested that the jewellery was made by artisans, living in the countryside and moving from nomad camp to nomad camp, making jewellery (and other objects) to order. They are presented as jacks-of-all-trades, 'melting gold and silver into rings for the women, and were able to shoe a horse and repair rifles', according to the English journalist O'Donovan, who stayed in the area in about 1880 and paid a visit to the Merv oasis. And yet this explanation of how Turkmen jewellery was made can hardly be called conclusive. Kalter states that jewellery above a certain level of quality can only have been made in urban centres such as the

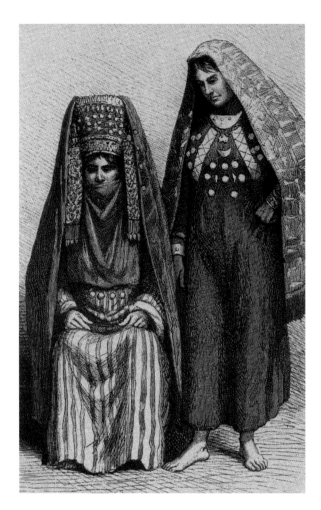

Two Turkmenian women probably from the Jomud tribe. The woman on the left wears two temple pendants, called *adamlik,* 1885.

city of Khiva. He also supports Janata's suggestion that there was a clear distribution of roles between sub-specialists in the production of Turkmen jewellery. These specialisms, like chasing, engraving and gilding, were practised by different artisans. These specialists need not have been the artisans who created the basic shape of the jewellery. In Kalter's view, the fact that much jewellery reveals the highest degree of artisan perfection is further proof of the existence of this distribution of roles. It also coincides with the way other metal workers, such as coppersmiths, operated in urban centres. In addition to the very skilful urban silversmiths, local artisans might have been active in the smaller towns, working for less wealthy sections of society. This, according to Kalter, might explain the large differences in quality between individual pieces of jewellery.

Function and forms of the jewellery

For us jewellery is generally meant to make the people wearing it look their best. But to the Turkmen showing off their wealth was just as important. For influential members of their society, who used their social position to win the loyalty of a maximum number of community members, showing off their riches was of crucial importance. This competition for prestige was even characterised by a certain degree of aggression, manifesting itself amongst other things in the production of larger and larger pieces of jewellery.

Jewellery was also an attractive means of investment, particularly for nomadic groups. Precious metals like silver and gold can be carried easily, even when your enemy is breathing down your neck. Their value remains stable and if necessary they can be exchanged for money or goods. Most Turkmen jewellery of an earlier date was also made of pure silver coins that had been melted down.

In addition, many pieces of jewellery had a protective function as an amulet or a talisman. By wearing objects known for their protective function on his garments, a man would try to protect the things he cherished most against danger. Colour and materials were important features. Blue beads were supposed to give protection against the effects of the evil eye. The orange-red semiprecious carnelian was associated with fertility, blood and hence with life.

Apart from the colour and the materials, shape was extremely important too. In the Middle East the triangle has been credited with a protective function since times immemorial. The Turkmen piece of chest jewellery called the tumar is a combination of a triangle and a cylinder-shaped amulet case, which usually contains a protective proverb in the form of a sacred text, often this is a fragment from the Koran, copied by a mullah and carefully folded and safely stored in the amulet case, while blessings are said.

The styles of the Tekke, Yomud, Ersari and Sarik

Of all Turkmen jewellery Tekke jewellery is best known. It is characterised by a high degree of symmetrical design and a harmonious style. The drawings on the jewellery are based on the contrast between gold and silver. The decorations generally consist of flower, leaf and tendril ornaments. A thin layer of gold is applied to the jewellery by heating a mixture of gold dust and quicksilver. The quicksilver evaporates and the gold adheres to the jewellery. In Tekke jewellery the semiprecious orange-red carnelian is used more frequently than in the jewellery of the other Turkmen tribes. Filigree is also an essential part of the decoration of much Tekke jewellery and it is this aspect in particular which makes it different from Yomud jewellery.

The most salient feature of much Yomud jewellery is the small gilded silver ornament – the lozenge, circle and square – which is made in moulds and welded to the jewellery. Some pieces of Yomud jewellery are gilded all over. Prior to 1925 carnelians were regularly used on Yomud jewellery. In jewellery of a later date the carnelian was replaced by pieces of glass of various colours.

Ersari jewellery is different from its Tekke counterpart in that the gilt is missing and silver is much more prominent. According to Janata, Ersari style is also characterised by the elegance and the lightness of its lines. Carnelian is used, but it is less dominant than in Tekke jewellery. Kalter states that the almost complete absence of filigree decorations gives the Ersari style a character of its own. A characteristic shared by both Ersari and Sarik jewellery is the absence of gilt but according to Janata, Sarik jewellery tends to have slightly flatter forms and lines, which may seem rather plump at times. For Janata the extensive use of filigree work is another essential characteristic of Sarik jewellery.

Jewellery for boys and girls

For a Turkmen woman, jewellery was important. For a young child its importance was limited. The jewellery worn by children mainly consisted of amulets attached to their clothes. There was also a difference between boys and girls. In Turkmen society boys had higher status than girls, a privilege recognised by evil spirits .This resulted in the assumption that one amulet would do for a girl (Stucki). It also explains why objects for warding off all kinds of evil, such as beads, bird's claws, triangles, rosettes, buttons and coins are found far more often on boys' clothes. Apart from cylinder-shaped cases with protective texts, round or rectangular metal amulet

cases, the *bent* or *bazbent*, are sewn on the clothes as well.

The most striking piece of amulet jewellery for the boys was the *ok-yay*, a stylised bow and arrow, worn on the back, probably to protect the child against evil forces which might attack from behind.

For slightly older girls aged seven or eight, the most striking decoration was the jewellery attached to their hats. This jewellery had a clear, symbolic function: in the middle was a sort of dome shape, the *gupba*, on top of which there was often a cylinder-shaped tube, holding a plume of feathers. A hat with *gupba* and feathers indicated that a girl had reached marriageable age (12 to 15) but was not yet engaged. Generally the hats with the *gupba* were worn until the wedding day, then replaced by a headdress symbolising the newly-acquired position of married woman.

In addition to the *gupba*, the older girls also wore bracelets (*bilezik*), amulet cases (*bazbent*) and temple decorations (*chekelik*). The list of girls' jewellery sometimes included the eye-and-hook fasteners (*chapraz*) used for keeping coats closed at the front.

Women's clothes

The daily Turkmen women's costume, a combination of clothes and jewellery, consisted of a long, often tunic-like ankle-length dress (*oinek*) and some loose-fitting trousers (*balak*). The dress and the trousers could be combined with a coat (*chabut*). When a woman went out of the house, a robe (*chyrpy*) was worn over this coat. This robe was worn over the head and could be drawn in front of the face as a veil. The headdress was often wrapped in a shawl, which covered the chest, back and shoulders and hid some of the jewellery. A further wrap, generally worn under the chin, could be raised to cover the face.

During and immediately after a wedding ceremony the bride would be very heavily veiled. But as the women grew older, especially when they reached middle age, the veil became less important. The Koran does not give any rules for wearing veils. The veil-wearing tradition is much older and in the Middle East it existed long before the start of the Christian era. The Koran only appeals to the women and daughters of the faithful 'to have an upper garment hang down and cover them, so that they will not be troubled' (Sura 33, verse 59).

Headdresses

When a girl married, she exchanged her embroidered gupba hat for a headdress clearly showing her status as a married woman to the world.

Headdresses could reach heights of 30 to 40 centimetres and had a tapering cylinder shape. The hard core of this headdress used to consist of felt, leather or a light wood. The Ersari of North Afghanistan use cardboard these days.

For the young wife the period following the wedding ceremony was a period of servitude to her in-laws. But after the birth of her first child, the woman passes from bride to wife. This transition was translated into a simpler headdress, with less exuberant decorations. When the woman gave birth to a son, her position in her husband's family was strengthened even further and after a while, at the time of her menopause, she reached a new stage in her life: that of the respected, older woman. Over the years the headdress grew smaller and gradually lost its jewellery.

Head ornaments

Until the final quarter of the nineteenth century the kinds of impressive jewellery that brides and newly-married women wore on their headdresses included the *ildirgitch*, a piece consisting of a large number of decorative elements. According to Dupaigne this head ornament used to be characteristic of the headdresses worn by the Tekke women of the Merv and Akhal oases. The type is supposed to have originated in the last quarter of the nineteenth century. According to the Russian researcher Vasileva (see Rudolph) the *ildirgitch* lost some of its popularity among young women at the beginning of the twentieth century and a slightly bent, rectangular plate, the *egme*, took its place

The height of these largely gilded silver, tiara-like plates ranges from ten to 20 centimetres. Some of them, the tall ones, have a pattern reminiscent of a carpet: they have a central area which is decorated with five carnelians, surrounded by a narrow, open-work inner edge. This is surrounded by a main edge also set with carnelians or red glass beads. The outer edge is another open-work structure. The *egme* tiara is worn on a textile background and is fastened to the headdress with ribbons. After it had developed into a piece of bridal jewellery for Tekke women from the Merv oasis in the late nineteenth to early twentieth century, it is supposed to have fallen into disuse in about 1920. The Russian researcher Morozova notes that the headdresses of Tekke women grew taller and taller in the first two decades of the twentieth century. In the Merv and Akhal oases they are supposed to have reached heights of 40 centimetres.

In addition to the *egme* and the *ildirgitch* tiara there were two other pieces of jewellery that Tekke women wore on their headdresses: the *manglaylik* and the *öwürme*. Some photographs showing this jewellery seem to suggest that the *manglaylik* and the *öwürme* were types worn by married women with children. The *manglaylik* consisted of five to seven rectangular gilded silver strips decorated with carnelians and pendants. This piece of jewellery is supposed to have originated in the Merv oasis. To this very day the *öwürme* is worn as a headdress decoration on festive occasions by older Tekke women in the Akhal oasis area. Both the manglaylik and the *öwürme* were fastened to the headdress with small hooks.

In the Turkmen Ersari tribe in North Afghanistan the tall head ornament, the *bogmaq*, is still worn today. The decoration, sewn on a red cotton background and consisting of beads and silver pendants, is an integral part of the headdress of both brides and married women with children. At the wedding ceremony another piece of jewellery, the *sandchalik*, is added to the tall headdress of the Ersari bride. It is fastened to the top of the headdress with long, needle-like pins, which are part of the jewellery.

Earrings

In addition to the numerous pieces of jewellery worn on the front of the headdress, there was also jewellery worn on the side of the head. Some hung down from the temples to the shoulders. There were also earrings which were hooked into the earlobes with sharp hooks, while other earrings were so heavy that they had to be supported at the right height, on the side of the head, with small bands. *Tenetchir* is the word for both earring and temple decoration. The earrings of the Tekke and the Ersari were clearly related in style. Temple decorations are called *adamlik* in the Yomud tribe, because their shape seems to have been taken from the human shape: *adam* is the Yomud word for 'man'. Yomud earrings were a completely different type of ring. Their basic form was a circle. The ring started on one side of the ear in the mouth of an animal and ended on the other side in a head with a similar design. The space at the centre of the circle was filled in at the bottom. In conformity with the decorative traditions of the Yomud this plane was decorated with gilded silver plates (lozenges, squares, circles, etc.), made in moulds.

Neck and breast jewellery

Among the jewellery worn by Turkmen women, neck and breast jewellery, collectively called *bukau*, was prominent. In essence this jewellery consisted of a narrow, flexible metal band which could be opened and closed with a hinge at one end. A pin withdrawn from the second hinge opened the piece and the band could be put around the neck. The Tekke and the Yomud seem to be the only tribes to have worn this *bukau* jewellery but unlike the Yomud bukau, the bands were used by the Tekke as the starting-point for a composite piece of jewellery

with a character of its own. They were a medium of suspension for open-work breastplates of different shapes and considerable size. To this end two small rings were added to the front of the lower end of the band, for fastening large hexagonal *göndschük* or *gursakcha* plates. Another form based on the *bukau* was a band, both ends of which ended in a hook. Suspension openings were made in the edge of the accompanying breastplates.

In the Yomud tribe the *bukau* has remained a true piece of neck jewellery. At the front it has some pendants consisting of diamond-shaped metal plates and small bells. Most *bukau* jewellery of the Yomud type is decorated with five carnelians. In the Yomud tribe this type of jewellery seems to be worn by both single girls and married women. In the Tekke tribe the *bukau* was the sole privilege of brides and newlyweds. It is not improbable that the majority of the Tekke jewellery of the *bukau* type goes back, like the *egme* tiara, to the end of the nineteenth and the first two decades of the twentieth century.

Apart from the hexagonal *göndchück* breast jewellery, which was worn suspended from the *bukau* neckband, there was another type of jewellery also called *göndchük*. This second type of *göndchük* was either square or lozenge-shaped and much smaller in size. It was worn point down, which made the filigree diagonals, crossing in the middle, look like a standing cross. This pendant too seems to have been worn by both girls and married women.

Collar buttons

The *gülyaka* or collar button was a brooch-like disk worn where neck and breast meet. On its back was a small rod, slightly wider at one end than the other. The *gülyaka* was used for closing the neck slit in a dress, more or less like cufflinks hold together the sleeves of a shirt. This collar button was developed in the late nineteenth century by the Western and probably also the Northern Yomud tribe, then spread to the Tekke and became a fairly common piece of Turkmen jewellery. For the Yomud it became the most important piece. The *gülyaka* was worn by both girls and women and was usually decorated with coloured glass beads and small gilded decorative plates, made in moulds.

Rudolph discovered that in the Tekke tribe the *gülyaka* had developed in a completely different direction. Here the collar button grew to a size which made it lose its original function as a button. Because of its weight, the Tekke *gülyaka* was worn on a small band around the neck. The rod on the back disappeared and so did the collar button function. Much of the Tekke pieces had pendants (*chelpe*) at the bottom and were called chelpeli gülyaka. The *chelpeli gülyaka* were often sewn on a textile background.

Bird's head jewellery

The breast ornament, called *dagan* ('bird's head') by the Turkmen, was quite different in design from other Turkmen jewellery. In scientific literature it is also referred to as the bird's head amulet, since it is supposed to be the image of a double eagle. Kalter thinks that the shape was taken from the Tsarist emblem, which was known all over Turkmenistan, because it was found on coins and on stamps, for example on Gardner porcelain, which was made in a factory near Moscow and exported to Central Asia. The *dagdans* come in various shapes and sizes. Their height varied between six and 12 centimetres. The largest ones were decorated with pendants at the bottom and could be over 20 centimetres long. The smaller ones were worn as parts of women's necklaces. The *dagdan* type of jewellery was only found among the people of the Tekke.

Bracelets and finger rings

There were large numbers and a large variety of Turkmen bracelets, or *bilezik*. This kind of Turkmen jewellery was also dominated by Tekke items. Characteristics of Turkmen bracelets in general were parallel, horizontal bands, separated by narrow, but thicker silver strips. These not only made the bracelets stronger, but also more regular in shape. This regularity was enhanced in the Tekke bracelets by the carnelians which were positioned in the segments. The narrowest Tekke bracelets consisted of three segments, and most bracelets were narrower towards the wrists, an adaptation to the shape of the lower arm. Tekke bracelets looked much heavier than the bracelets of some other groups because the Tekke ones had double walls, just like the Yomud bracelets. On the back the bracelets had sharp or oval points, leaving just enough space to slip the bracelet on the arm.

Turkmen rings (*yüzük*) were also widely varied. The ring itself, usually consisting of a narrow band, part of which was done in filigree work, was covered with all kinds of decorative pieces. Sometimes these decorations were partially gilded and sometimes a carnelian or a glass bead was added. Another addition was a small bell or a combination of bells, linked to the ring with small chains. A thimble was also often combined with one or more rings, an obvious combination, considering the many hours and days that young girls and women spent embroidering clothes and other objects.

Back and braid jewellery

Turkmen back and braid jewellery was characterised by a broad development, described by Rudolph in very clear terms. Rudolph's conclusion is that the number of types of back and braid ornaments was limited, but that the types themselves were characterised by a large variety of shapes and versions. Another conclusion is that Turkmen jewellery was not primarily worn to show off to strangers, a conclusion which seems fair, for why use shawls that partly cover your (back) jewellery if you want to show off? The back and braid ornaments had an altogether different function, offering protection against attacks of a magical nature. The back was 'a vulnerable place, exposed to attacks of the evil powers'. It was a part of the body that could do with a bit of extra protection.

Generally, back ornaments were braid ornaments, because back ornaments were very suitable for integration into Turkmen women's hairstyle, the plaits of long hair that they wore on their backs. Often these plaits were extended with goat's hair, to create very long, partially false plaits, the perfect medium for fastening the jewellery. In the category of back and plait jewellery several names were used, but *satchlik* and *satchmondchuk* were used most frequently. Despite their variety, however, it was not the back and plait decorations of the *satchlik* and *satchmondchuk* type that caught the outsider's eye. It was the decorations of the *asik* type that really stood out, especially since the shape of the central element of this back ornament has often been associated, quite wrongly, with a heart. Rudolph points out, though, that interpretation of this shape has paid too little attention to König's and Markov's suggestion that it is a representation of a short spearhead. After all, according to Rudolph, in the Turkmen tribe all sharp objects, or objects having that shape, were used to protect against evil. In this context an ornament symbolising a short spearhead would not be at all out of place when worn on the back.

Coat fasteners

Turkmen women's coats were decorated with ornaments too, especially coins or small gilded silver plates, but fasteners (*chapraz*) were also used for decoration. The latter were usually sewn on a black-fabric band, with some other decorative elements, such as round, ball-shaped disks. Small stitches were used to fasten the ornaments, so that they could be removed easily when the coats had to be washed. Many fasteners have become purely decorative since and often the hook and the eye have broken off.

Amulet cases

Earlier in this chapter, I referred to the protective function that some objects had in the Turkmen world. Specific colours, materials and forms were used to ward off ill fortune and attract good fortune.

In addition to the simple round, rectangular or square amulet cases the impressive tumar had also an important role. The *tumar* was a combination of the triangle, whose protective qualities date back to pre-Islamic times, and the cylinder, holding an Islam-related text. A single large *tumar* was usually worn as an ornament, on a strap on the chest, but there was another, much smaller version of the tumar as well. However, if a woman had two large amulet cases, a hip position was not uncommon: one amulet case hung down from the left shoulder to the right hip and the other hung from the right shoulder to the left hip, the two straps crossing on the chest and the back. That brings us to the pouch- and box-shaped amulet cases, called *kheykel* and *kumush* respectively, which can be told apart on the basis of the materials used (amongst other things). The basic material of the *kheykel* is leather, with a gilded or non-gilded silver decoration. The *kumush doga* is entirely made of silver.

In the Turkmen tribes profane and sacred elements were part of one and the same world. This is clear from the fact that amulet cases were not only used for storing an amulet text, but also for locking away small objects, like a key or money. Rudolph also points out that the shoulder belt of *kheykel* amulet bags was always decorated on one side, for a considerable length, with gilded or non-gilded silver ornaments. This was the part that covered the chest and was therefore the most visible. The other part was on the back, for the most part hidden by a shawl. The *kheykel* was an amulet pouch for older women. Their style makes the *kumush* doga typical Yomud pieces. Most *kheykel* jewellery has a Tekke background, while some is probably of Ersari origin.

Men's jewellery

This chapter would be incomplete without an inventory of the function that jewellery had in the life of Turkmen men. Such an inventory, however, is by definition short, for Turkmen men wore hardly any jewellery. There was the occasional ring and, hidden under garments, the occasional amulet case. The absence of jewellery, however, does not imply that the Turkmen settled for a position in society that was exclusively determined by the quantity and quality of the jewellery owned by their wives and daughters. Male prestige was primarily based on personal courage, economic means, social relationships and leadership qualities.

And yet there were two specific areas in which the male part of the Turkmen population supported its prestige and ambition in a material sense, with valuables – weapons and harnesses. Of course weapons were the attributes of the free Turkmen male, but it is apparent from the attention paid to the decoration of these weapons that they represented more than that. While bow and arrow, spear and sabre were superseded over time by the rifle, the dagger (*pitchak*) clearly was not. Although these daggers were generally of Persian origin and had probably been taken in raids on villages and caravans in the Iranian province of Khorasan, some dagger sheaths are genuine gems in the decorative traditions of Turkmen silverware. It was common practice to take a dagger captured in a raid to one's own silversmith and have a new sheath made for it. This gave the *pitchak* its specific Turkmen character.

Rudolph puts the Turkmen view of the horse in the historical context of the Turkmen version of nomadism: the horsemen-nomad culture. According to Rudolph, 'a whole different light is thrown on matters by the fact that for the Turkmen male the horse was not just a living utensil, but a being to which he devoted all his love'. This appreciation was expressed in the horse's gear and especially in the solid silver harness, which basically consisted of three parts: a bridle with neckpiece, a strap around the neck and a chestpiece. The quality of many harnesses illustrates this.

References

Andrews, P. and M., *The Turcoman of Iran*. Kendal, 1971.

Bacon, E.E., *Central Asians under Russian rule. A study of culture change*, Ithaca–London 1966.

Beresneva, L., *The decorative and applied art of Turkmenia*, Leningrad, 1976.

Blocqueville, H. de Couliboeuf de, *Quatorze mois de captivité chez les Turcomans. Aux frontières du Turkestan et de la Perse*, Paris, 1865.

Daniëls, G., *Folk Jewelry of the World*, New York, 1989.

Dupaigne, B., 'Le grand art décoratif des Turkmènes', *Objets et Mondes*, Tome 18, fasc. 1-2, 1978, pp. 3-30.

Ferrier, J.P., *Caravan journeys and wanderings in Persia, Afghanistan, Turkistan and Beloochistan*, London, 1857.

Firouz, I.A., *Silver ornaments of the Turkoman*, Teheran, 1978.

Janata, A., *Schmuck in Afghanistan*, Graz, 1981.

Kalter, J., *Aus Steppe und Oase. Bilder turkestanischer Kulturen*, Stuttgart-London, 1983.

Kalter, J. and Pavaloi, M., ed., *Uzbekistan, Heirs to the Silk Road*, London, 1997.

König, W., *Die Achal-Teke. Zur Wirtschaft und Gesellschaft einer Turkmenen Gruppe im XIX. Jarhhundert*. Berlin, 1962.

Moser, H., *A travers l'Asie Centrale. La steppe Kirghize; le Turkestan Russe; Boukhara-Khiva; le pays des Turcomans et la Perse*, Paris, 1885.

Munneke, R.J., *Van Zilver, Goud en Kornalijn. Turkmeense sieraden uit Centraal-Azië*, Rijksmuseum voor Volkenkunde, Leyden/Breda, 1990.

Prokot, I. and J., *Schmuck aus Zentralasien*, Munich, 1981.

Rudolph, H., *Der Turkmenenschmuck*, Stuttgart-London, 1984.

Stucki, A., 'Horses and women. Some thoughts on the life cycle of Ersari Turkmen women', *Afghanistan Journal*, Jg. 5, Heft 4, 1978, pp. 140-149.

Vambery, A., *Travels in Central-Asia, being an account of a journey from Teheran across the Turkoman Desert on the Eastern shore of the Caspian to Khiva, Bokhara and Samarcand performed in the year of 1863*, London, 1864.

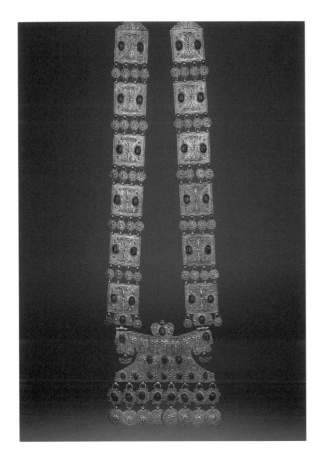

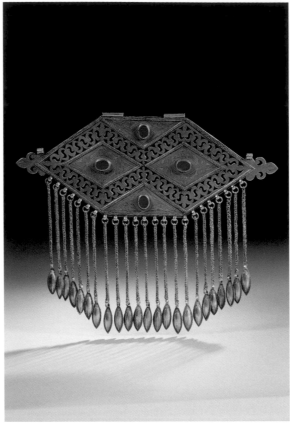

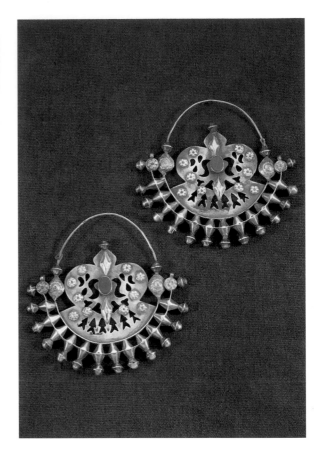

Turkmenistan
Yomud tribe
H 56.5 cm, W 15.5 cm,
478 grammes
silver gilt, glass stones
name: *acar-bag*
breast jewel
middle 20th century
silver gilt embossed plates;
signed 'gameeteka' on the
back

Turkmenistan
Tekke tribe
H 23.5 cm, W 28.5 cm,
342 grammes
silver gilt and cornelians
name: *göndschük* or
gursaktscha
breast jewel
middle 20th century
openwork

Turkmenistan
Yomud tribe
D 12.5 cm, 164 grammes
silver and gilt appliqué
work, cornelians
name: *gulak khalka*
earring
19th/early 20th century
appliqué and openwork

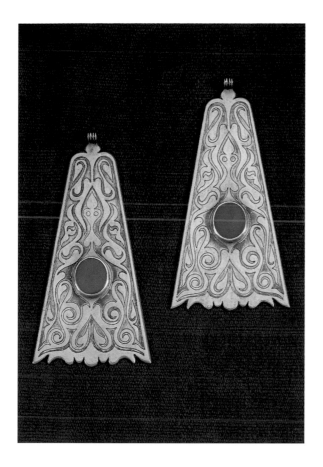

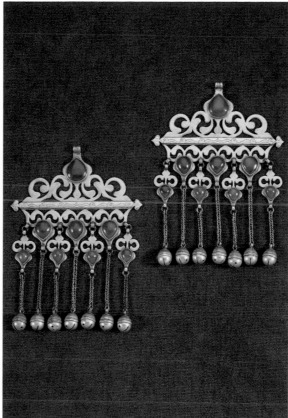

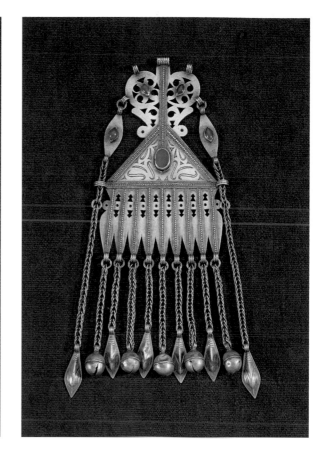

Turkmenistan
Tekke tribe
H 10.2 cm, W 5 cm,
92 grammes together
silver gilt
(most probably) shoulder
ornaments
2nd half 20th century

Turkmenistan
Tekke tribe
H 16.5 cm, W 12 cm,
274 grammes together
silver gilt and cornelians
shoulder ornaments
2nd half 20th century
openwork

Turkmenistan
Tekke tribe
H 23 cm, W 9.5 cm,
168 grammes
silver gilt and cornelians
name: *engslik*
breast jewel
1st half 20th century

Turkmenistan

Top:
Yomud tribe
L 95.5 cm, W 7.5 cm,
697 grammes
silver and cornelians
name: *tegbent*
man's girdle
early 20th century
silver plates fastened to
embroidered cloth; open-
work and appliqué

Bottom:
Tekke tribe
L 89.5 cm, W 8.5 cm,
505 grammes
silver gilt, cornelians and
leather
name: *tegbent*
man's girdle
2nd half 20th century
silver fastened to leather

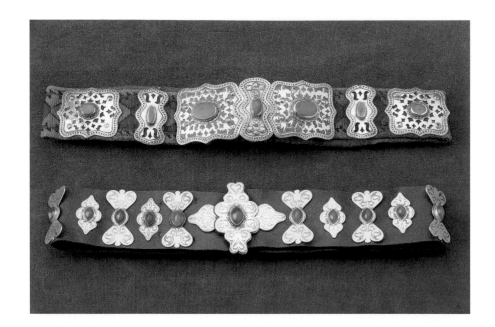

Turkmenistan
Ersari tribe
H 17 cm, W 11.5 cm, 195
grammes together
silver and cornelians
name: *tschanga* or *tschapraz*
fasteners of a woman's coat
middle 20th century
(see page 77, left)

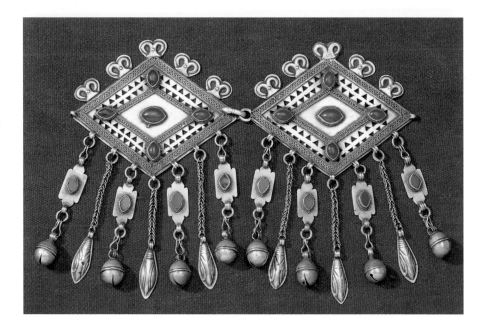

Turkmenistan
Tekke tribe
L 40.5 cm, W 11.2 cm,
224 grammes
silver gilt and cornelians
name: *öwurme*
head jewel
middle 20th century

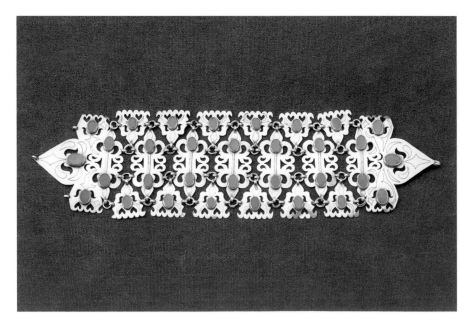

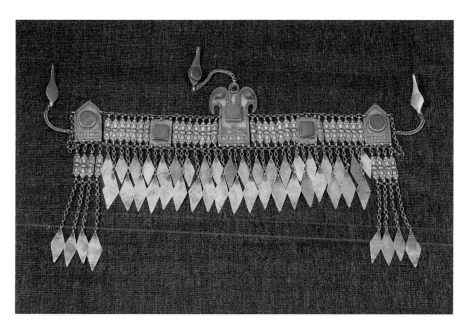

Turkmenistan
Ersari tribe
H 33 cm, W 57 cm, 273 grammes
silver, cornelians, glass
name: *sünsüle*
head jewel
middle 20th century

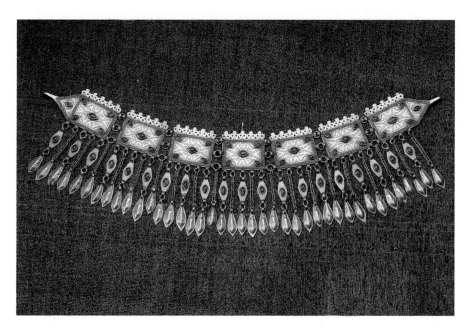

Turkmenistan
Tekke tribe
L 57.5 cm, H 14.5 cm, 545 grammes
silver gilt and cornelians
name: *manglaylik*
head jewel for married women
1st half 20th century
7 gilt strips adorned with cornelians and provided with pendants

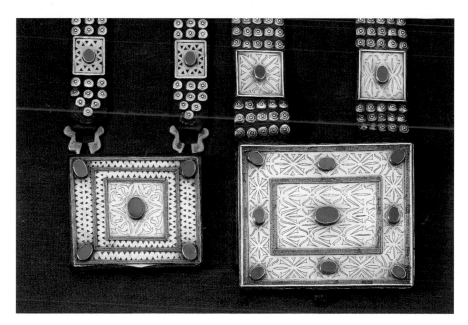

Turkmenistan
Tekke tribe
Left:
H 57 cm, W 11.5 cm, 292 grammes, 1st half 20th century
Right:
H 62 cm, W 15 cm, 608 grammes, early 20th century
silver gilt, cornelians and leather
name: *kheykel*
amulet bag
bag is worn by older women; height includes leather strap

85

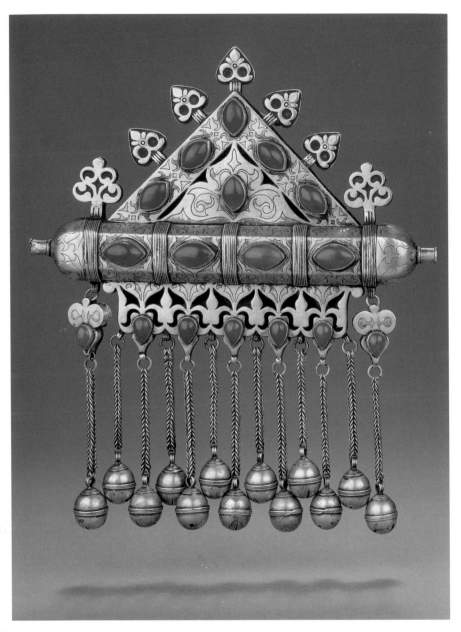

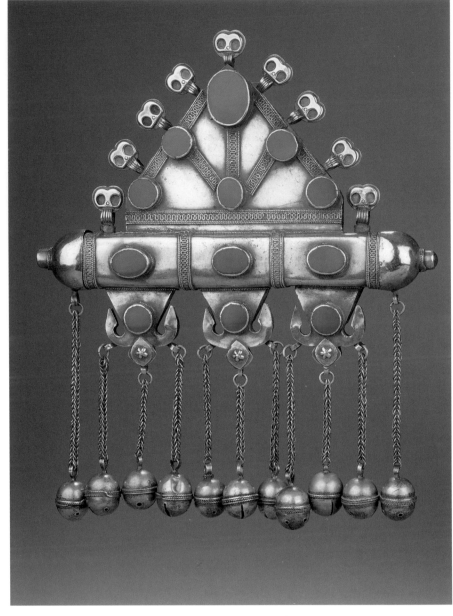

Turkmenistan
Tekke tribe
H 22.5 cm, W 18.5 cm,
391 grammes
name: *tumar*
amulet container, breast
jewel
2nd half 20th century
opens on the side
(see page 77, right)

Turkmenistan
Ersari tribe
H 25 cm, W 21 cm,
490 grammes
silver and cornelians,
2 glass beads
name: *tumar*
amulet container, breast
jewel
middle 20th century
opens on the side (2 glass
beads)
(see page 77, right)

Turkmenistan
Ersari tribe
H 65 cm, W 22 cm,
763 grammes
silver, cornelians
name: *tumar*
amulet container, breast
jewel
early 20th century
opening on the side; Ersari
jewels are always without
gilding; background
Turkmenian woman's coat
(see page 77, right)

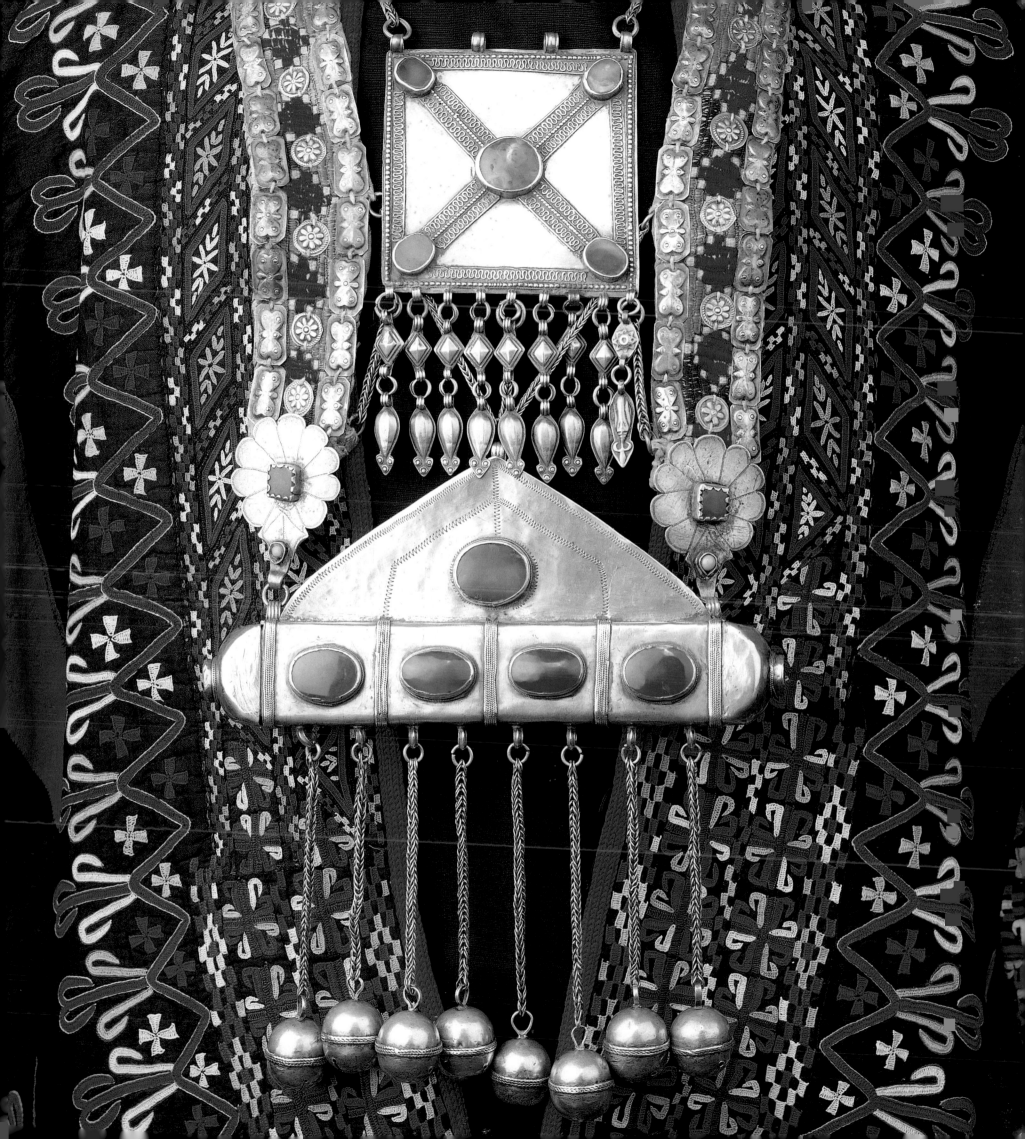

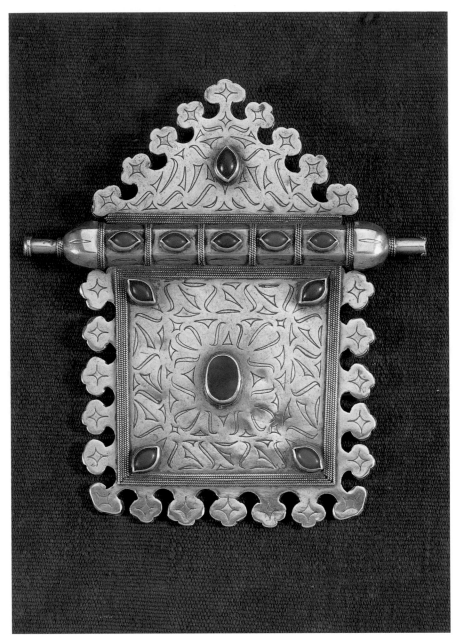

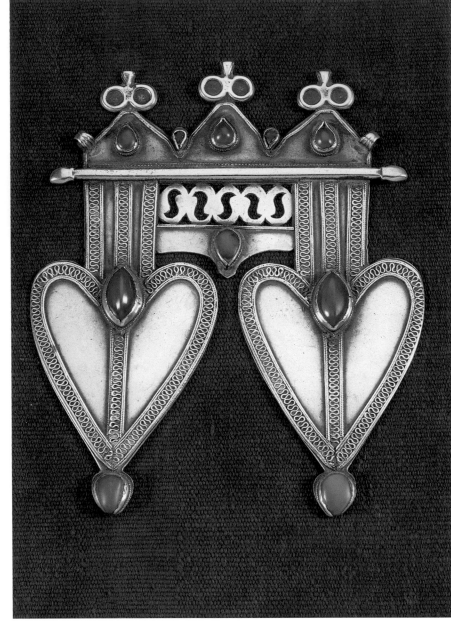

Turkmenistan
Tekke tribe
H 16 cm, W 15 cm,
168 grammes
silver gilt and cornelians
name: *tumar*
amulet container, breast
jewel
1st half 20th century
does not open

Turkmenistan
Ersari tribe
H 16 cm, W 12.5 cm, 143
grammes
silver, cornelians and glass
name: *goscha asik*
back jewel (sometimes
worn on the breast), pro-
tecting against the Evil Eye
1st half of the 20th century
double heart form (spear-
heads)

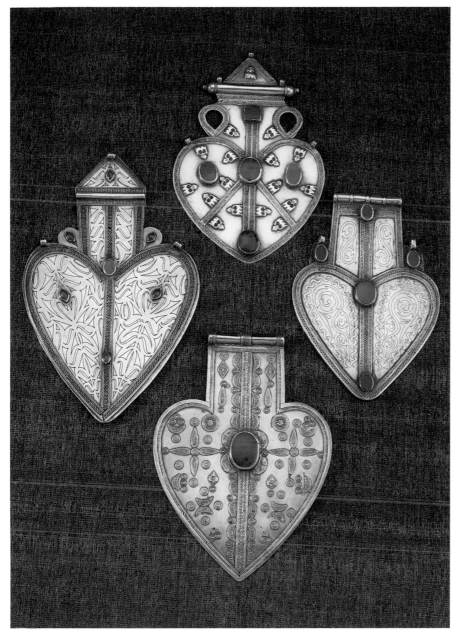

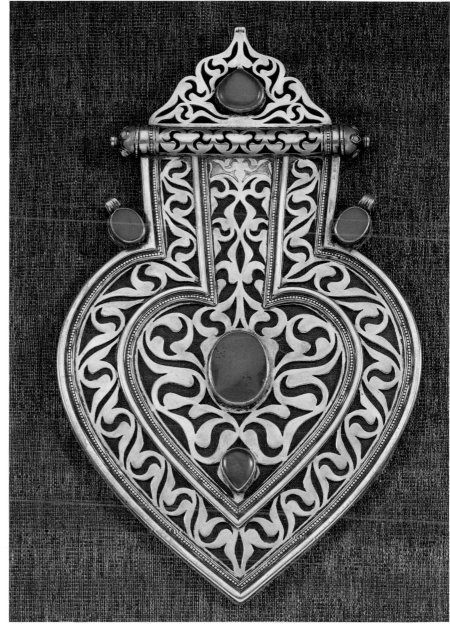

Turkmenistan

Top:
Ersari tribe
H 22.5 cm, W 15 cm, 246
grammes
silver and 4 cornelians
name: *asik*
charm against evil, spear-
head heart-shaped
early 20th century
worn on the back to repel
the Evil Eye

Left:
Tekke tribe
H 26.8 cm, W 16.5 cm, 397
grammes
silver gilt and 7 cornelians
name: *asik*
early 20th century

Right:
Tekke tribe
H 20.5 cm, W 14 cm, 207
grammes
silver gilt and 5 cornelians
name: *asik*
early 20th century

Bottom:
Yomud tribe
H 22.5 cm, W 16 cm, 320
grammes
silver and 1 cornelian
name: *asik*
early 20th century
with gilt appliqué work

Turkmenistan

Tekke tribe
H 28.5 cm, W 17 cm,
546 grammes
silver gilt and cornelians
name: *asik*
back jewel, protection
against evil spirits
2nd half 20th century
openwork; fastened to
leather covered with red
cloth

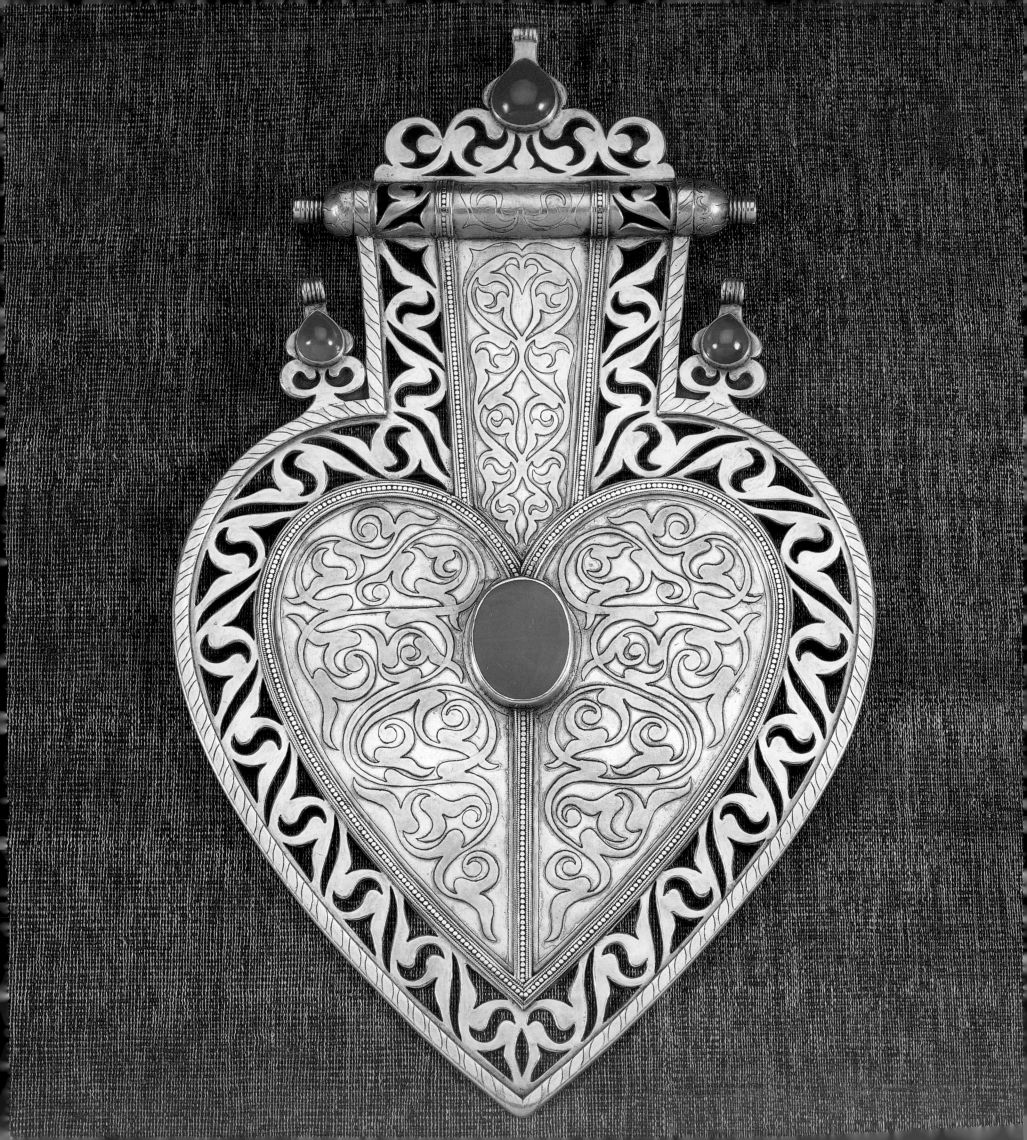

Right:

Turkmenistan
Tekke tribe
H 10.5 cm, W 25.5 cm,
274 grammes
silver gilt and cornelians
necklace consisting of five
pendants. Three pendants
are openwork heart-shaped
spearheads, alternating
with two smaller openwork
pendants
2nd half of 20th century

Left:

Turkmenistan
Tekke tribe
H 31.4 cm, W 19 cm,
607 grammes
silver gilt and cornelians
name: *asik* (heart-shaped
spearhead)
back jewel
2nd half 20th century
openwork border; this jewel
is mostly worn on the back
to protect wearer against
evil spirits

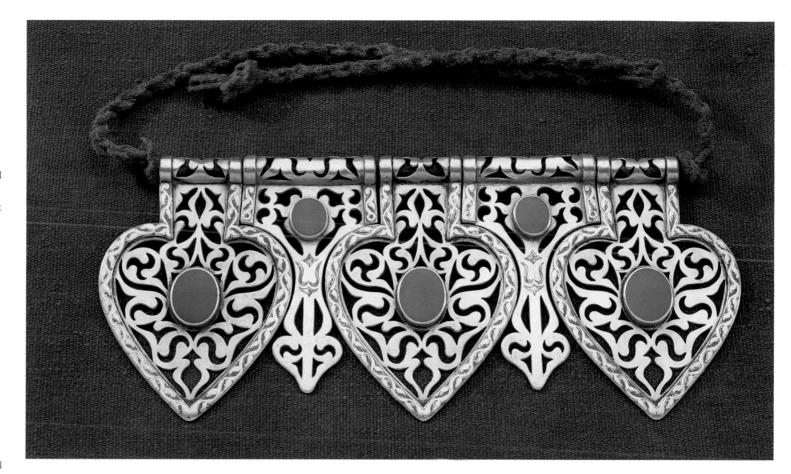

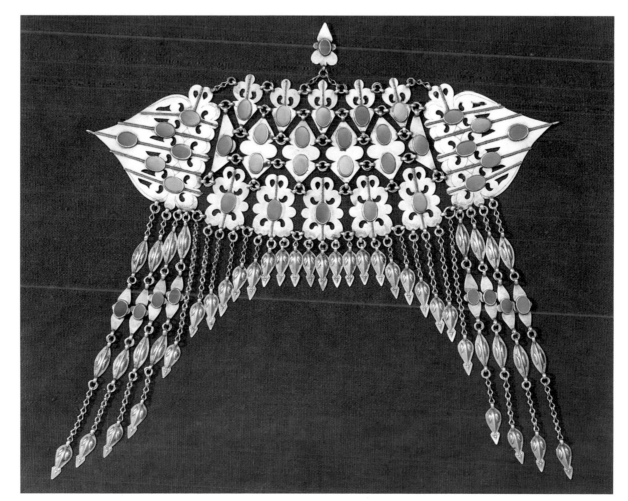

Turkmenistan
Tekke tribe
H 38 cm, W 37 cm,
423 grammes
silver gilt and cornelians
name: *ildirgitch*
head jewel
2nd half 20th century
(see page 74)

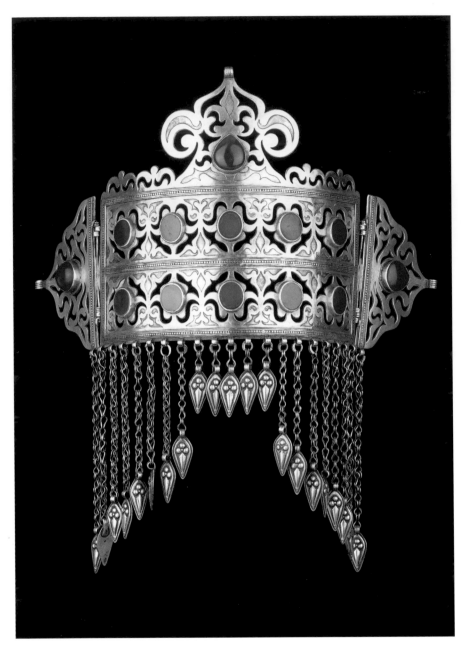

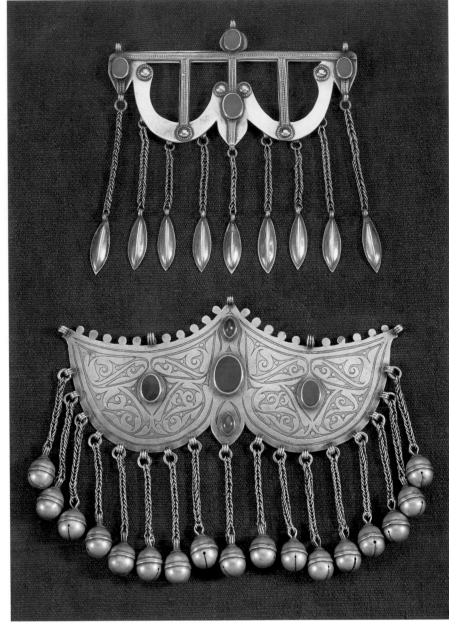

Turkmenistan
Tekke tribe
H 29 cm, W 29 cm,
396 grammes
silver gilt and cornelians
bridal diadem
2nd half 20th century

Turkmenistan

Top:
Ersari tribe
H 15 cm, W 14 cm, 81
grammes
both silver and cornelians
name: *ok-yay*
back jewel for boys
middle 20th century
both jewels are worn on the
back to protect against the
Evil Eye; the image is of a
stylised bow and arrow

Bottom:
Tekke tribe
H 15.5 cm, W 19 cm,
221 grammes
silver gilt and cornelians
name: *ok-yay*
back jewel for boys
1st half 20th century
this jewel is worn on the
back as the jewel above

Turkmenistan
Tekke tribe
H (incl. collar) 43 cm,
H (breast plate) 30 cm,
W 24 cm, 565 grammes
silver gilt and cornelians
name: *bukau*
breast jewel
1st half 20th century
collar with openwork breast
plate

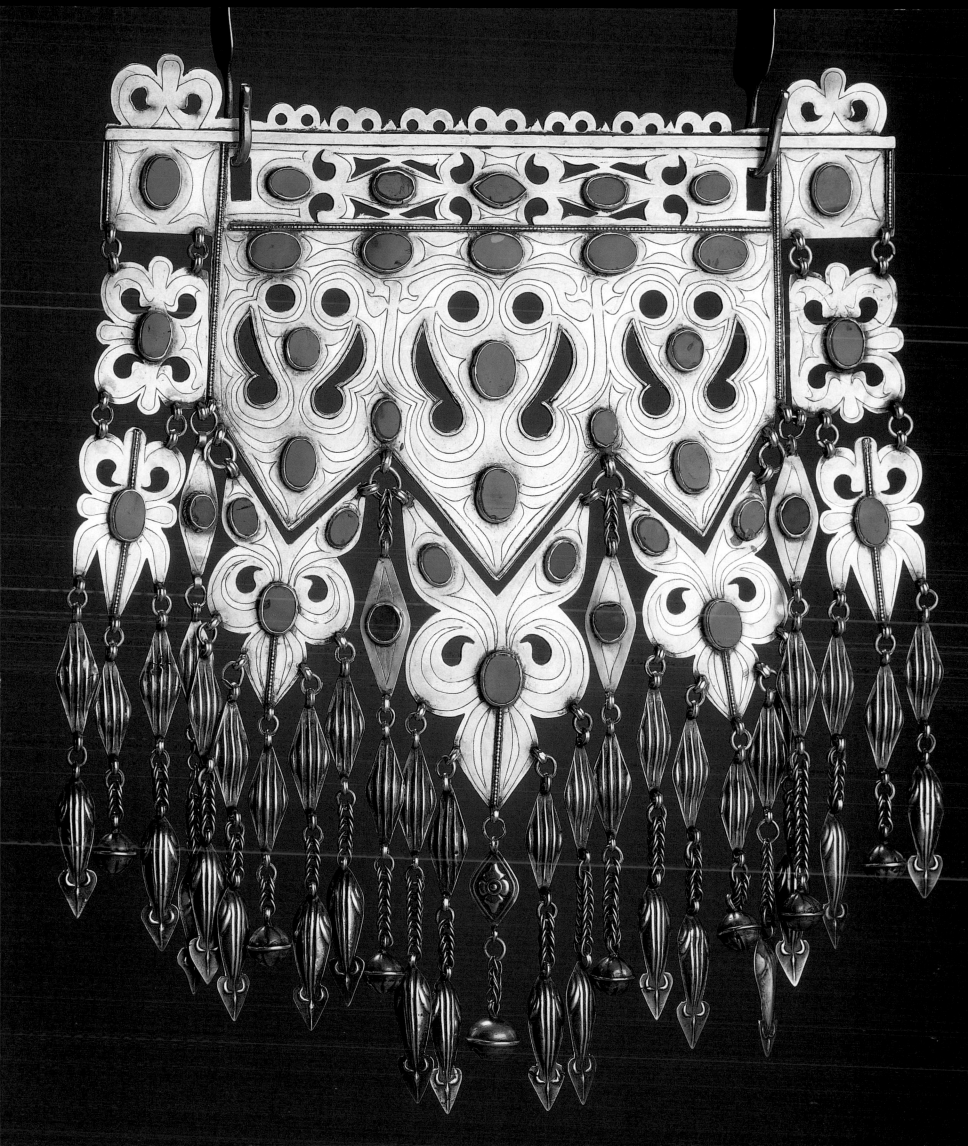

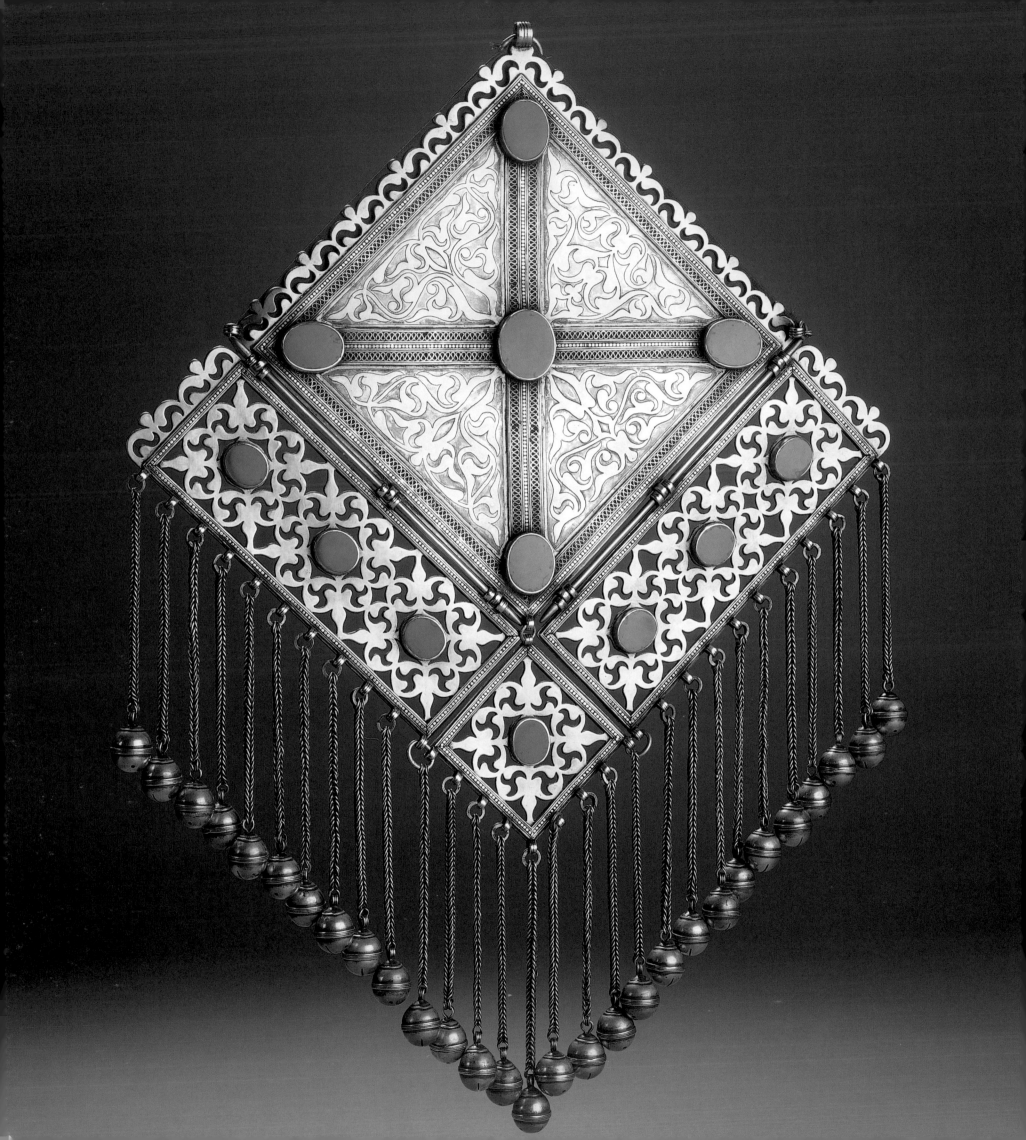

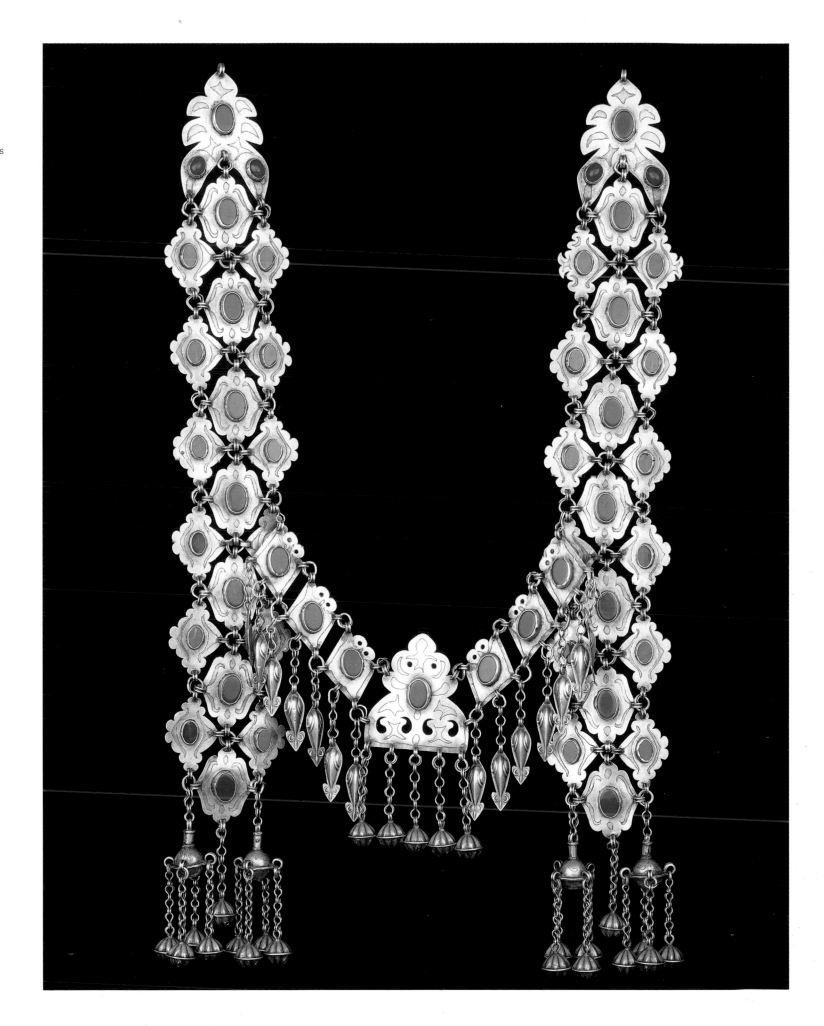

Left:

Turkmenistan
Tekke tribe
H 42 cm, W 30 cm,
920 grammes
silver gilt and cornelians
name: *göndschük*
breast jewel
2nd half 20th century
openwork; 3 separate
underplates
(see page 74)

Right:

Turkmenistan
Tekke tribe
H 47 cm, W 35 cm,
595 grammes
silver gilt, glass stones
name: *satschbag*
back jewel
middle 20th century

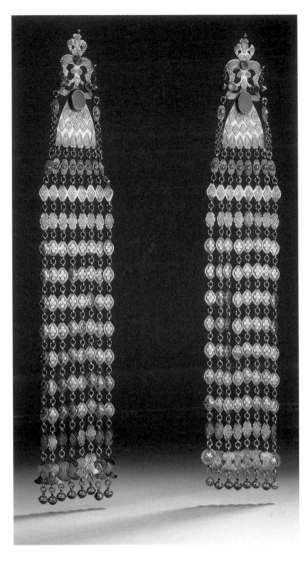

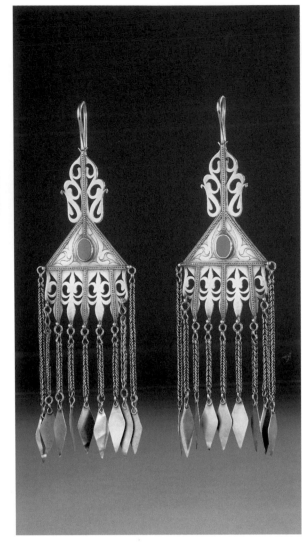

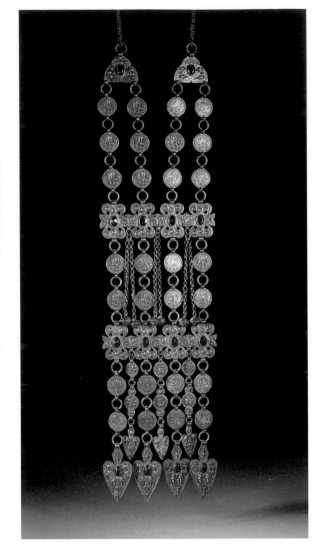

Turkmenistan
Yomud tribe
H 52 cm, W 9 cm,
465 grammes together
silver, glass, gilt appliqué
work
name: *adamlik*
temple pendants attached
to headdress
1st half 20th century
at the top an anthropomor-
phic figure can be recog-
nised
(see page 78)

Turkmenistan
Tekke tribe
H 23 cm, W 6.5 cm,
130 grammes together
silver gilt and cornelians
name: *tenetschir*
earrings
early 20th century

Turkmenistan
Yomud tribe
H 53 cm, W 14 cm,
449 grammes
silver with gold foil and
glass beads
name: *satchlik*
braid ornament
middle 20th century
plates of embossed gold foil
on silver; imitation coins

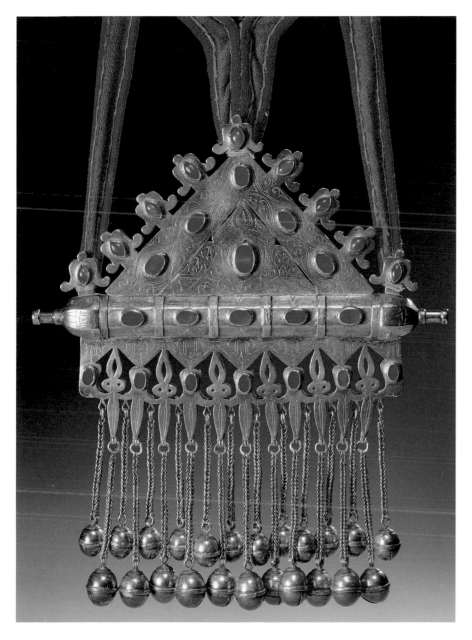

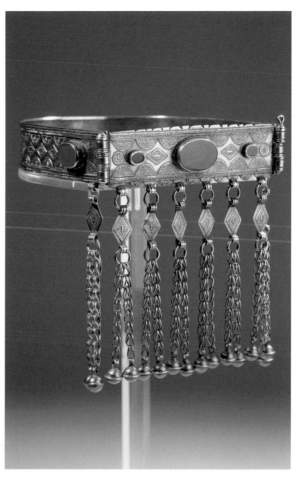

Turkmenistan
Yomud tribe
H 17 cm, W 15 cm,
430 grammes
silver, cornelians and gilt
appliqué work
name: *bukau*
neck jewel
1st half 20th century
8 appendages with bells;
peg opening on the side; at
the back engraved geomet-
rical motifs
(see page 74)

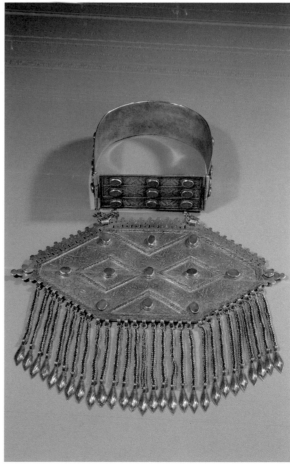

Turkmenistan
Tekke tribe
H 5.8 cm, D 15 cm, (*bukau*);
H 28 cm, W 33.5 cm, (*gönd-schük*); total weight 975
grammes
silver gilt and cornelians
breast jewel with matching
necklace
1st half 20th century

Turkmenistan
Tekke tribe
H (without cotton strap)
30 cm, W 26 cm,
1080 grammes
silver gilt and cornelians
name: *tumar*
amulet container
early 20th century
(see page 77)

97

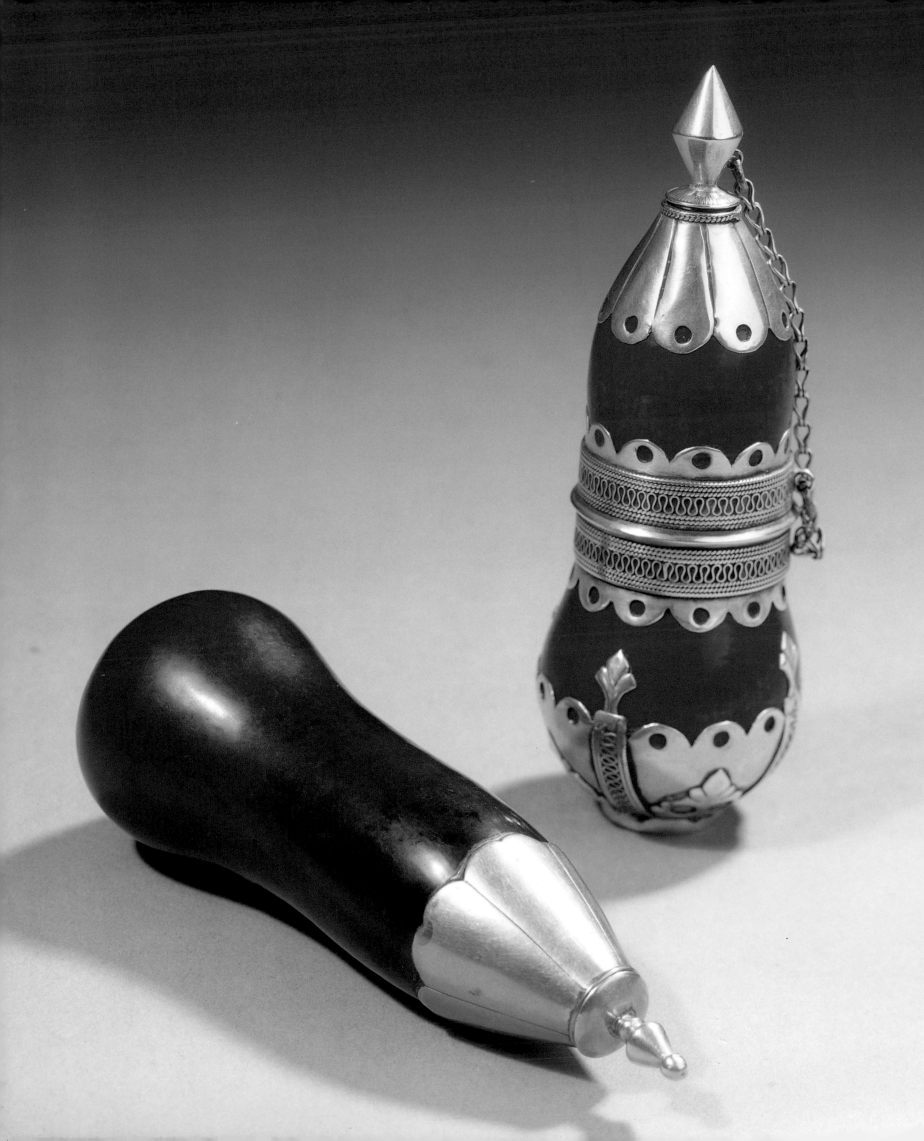

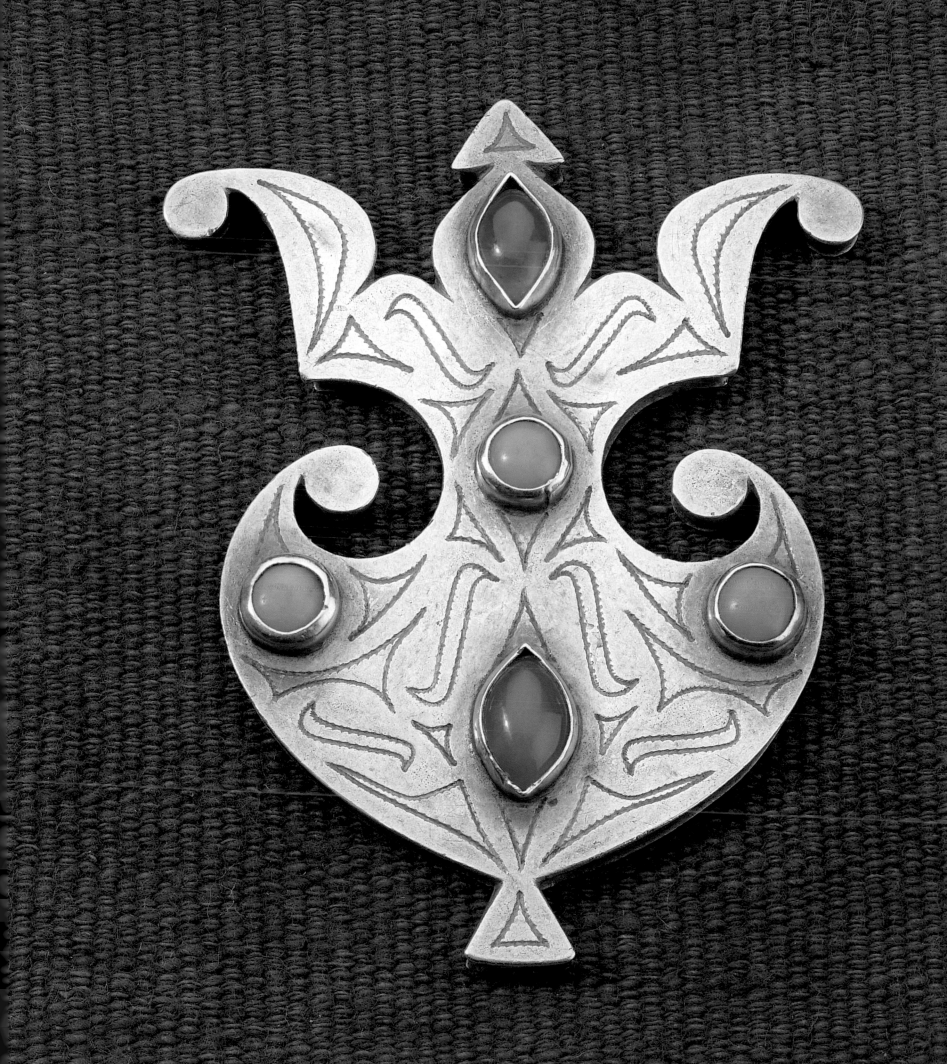

Page 98:

Turkmenistan
Left:
H 13.5 cm, 43 grammes
gourd and silver gilt
name: *nas kedi*
container for snuff tobacco
middle 20th century
top silver gilt; screw cap

Right:
H 13 cm, 76 grammes
gourd and silver
name: *nas kedi*
container for snuff tobacco
middle 20th century
gourd 3 parts decorated; sil-
ver cap attached with chain

Page 99:

Turkmenistan
Tekke tribe
H 6.2 cm, W 5 cm,
11.7 grammes
silver gilt, blue glass beads
name: *dagan*
breast jewel for boys, or
part of a woman's chain
1st half 20th century
the image is said to derive
from a Tsarist Russian
emblem, possibly a double
eagle

Turkmenistan
Tekke tribe
(see page 77)
Top:
H 19.5 cm, W (plate) 29 cm,
W (incl. cloth) 50 cm,
578 grammes
silver gilt and cornelians
name: *egme*
head jewel
early 20th century
sown on cloth; 4 rows of
cornelians; main plate

flanked by small matrix-
punched silver plates

Bottom:
H 12 cm, W 22 cm,
W (incl. cloth) 37 cm,
270 grammes
silver gilt and cornelians
name: *egme*
head jewel
early 20th century
7 cornelians

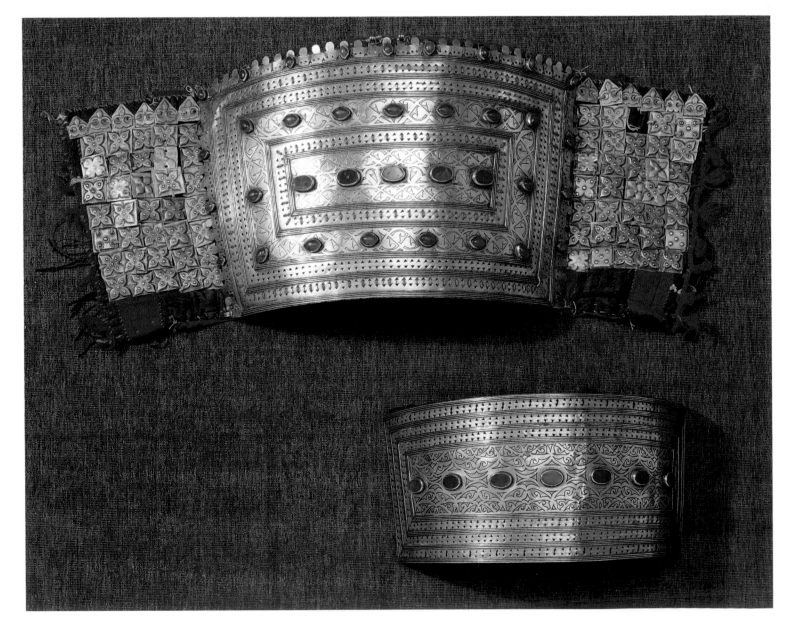

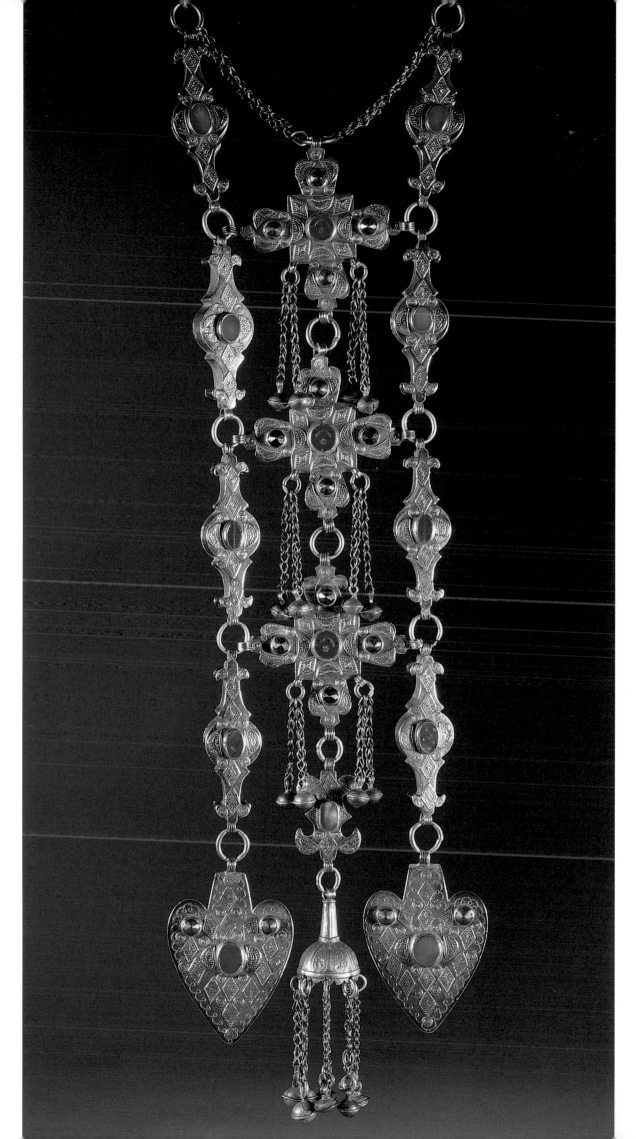

Turkmenistan
Yomud tribe
H 54 cm, W 12 cm,
570 grammes
silver, gilding, cornelians,
glass stones
name: *satchmondchuk*
back jewel
1st half 20th century
appliqué work

Turkmenistan

Top:
Tekke tribe (North
Afghanistan)
H 9.2 cm,
474 grammes together
silver and cornelians
name: *bilezik*
bracelet
early 20th century
double-walled bracelets

Left:
Tekke tribe (North
Afghanistan)
H 10.5 cm,
694 grammes together

silver, glass stones, one cor-
nelian
name: *bilezik*
bracelet
1st half 20th century
double-walled bracelets

Right:
Ersari
H 9.2 cm,
273 grammes together
silver
name: *bilezik*
bracelet
middle 20th century
single-walled bracelets,
engraved

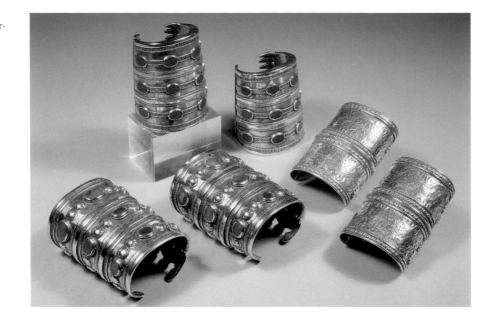

Turkmenistan
silver gilt and cornelians
name: *bilezik*
bracelet
(see page 77)

From left to right to bottom:
H 10.6 cm,
686 grammes together
1st half 20th century
double-walled bracelets, 4
tiers of cornelians

H 13 cm,
728 grammes together
1st half 20th century
double-walled bracelets, 4
tiers of cornelians

H 13.7 cm, 592 grammes
together
early 20th century
double-walled bracelets, 5
tiers of cornelians, dated
1913 in two different scripts

H 9 cm, 329 grammes
together
1st half 20th century
double-walled bracelets, 3
tiers of cornelians

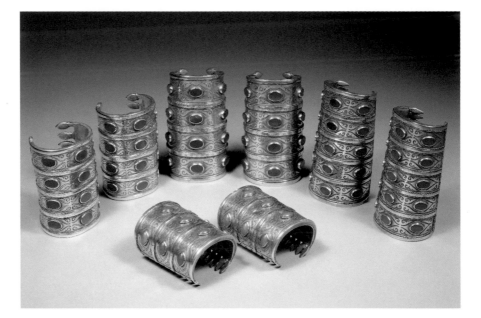

Turkmenistan
Yomud tribe
H 11.5 cm,
931 grammes together
silver, gold-foil, cornelians
name: *bilezik*
bracelets
early 20th century
double-walled bracelets, 4
rows of oval cornelians,
dividing strips in gold-foil
relief

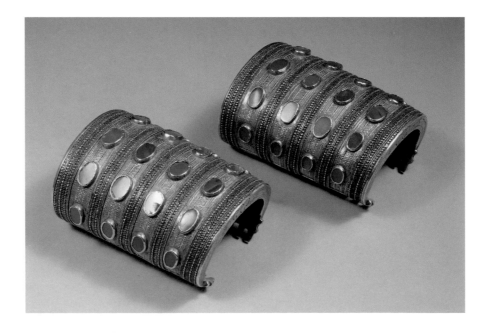

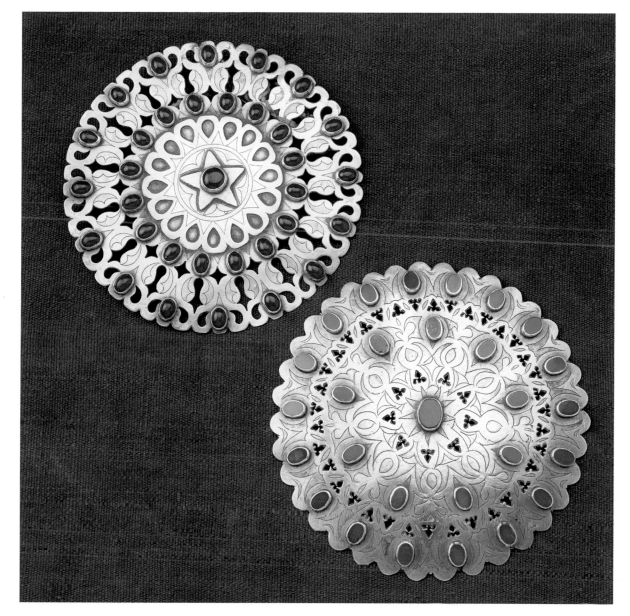

Turkmenistan
Tekke tribe
Top:
D 15 cm, 196 grammes
silver gilt and glass beads
name: *guljaka*
collar button
middle 20th century
at the back 2 raised coins,
soldered like buttons

Bottom:
D 16 cm, 173 grammes
silver gilt and cornelians
name: *selpeli guljaka*
breast jewel
1st half 20th century

Turkmenistan
Top Left:
Tekke tribe
D 13 cm, 158 grammes
silver gilt and cornelians
breast jewel
2nd half 20th century
openwork

Left:
Tekke tribe
D 14.5 cm, 186 grammes
silver gilt and cornelians
breast jewel
2nd half 20th century
openwork

Right:
Ersari tribe
D 10 cm, 108 grammes
silver and cornelian
breast jewel
2nd half 20th century
appliqué and engravings

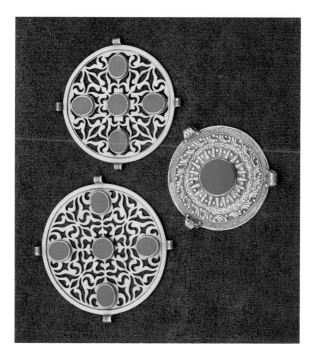

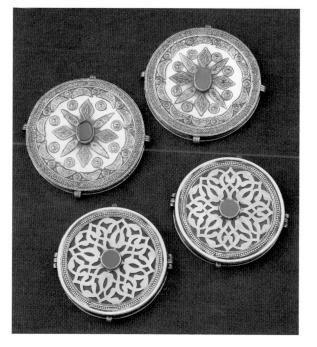

Turkmenistan
Top:
Yomud tribe
H 0.9 cm, D 9 cm, 170
grammes together
silver, cornelians, gilt
appliqué work
name: *bazbent*
amulet containers worn on
the shoulders
middle 20th century
containers can be opened

Bottom:
Tekke tribe
H 1.2 cm, 8 cm, 212
grammes together
silver gilt and cornelians
name: *bazbent*
amulet containers worn on
the shoulders
2nd half 20th century
openwork containers can
be opened

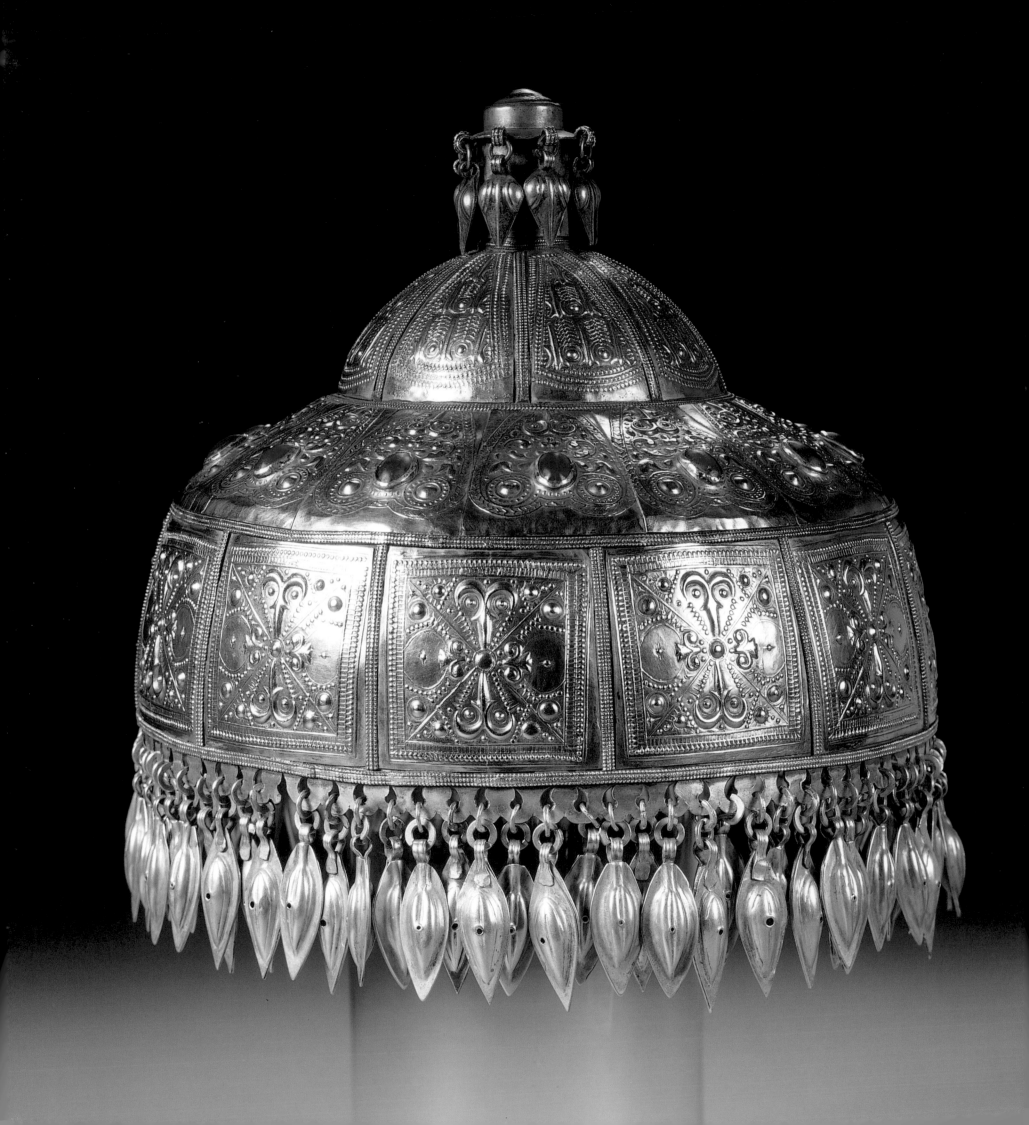

Left:

Turkmenistan
Yomud tribe
D 19 cm, H 20 cm,
852 grammes
silver gilt, glass stones
bridal cap
early 20th century
gilt embossed plates on sil-
ver

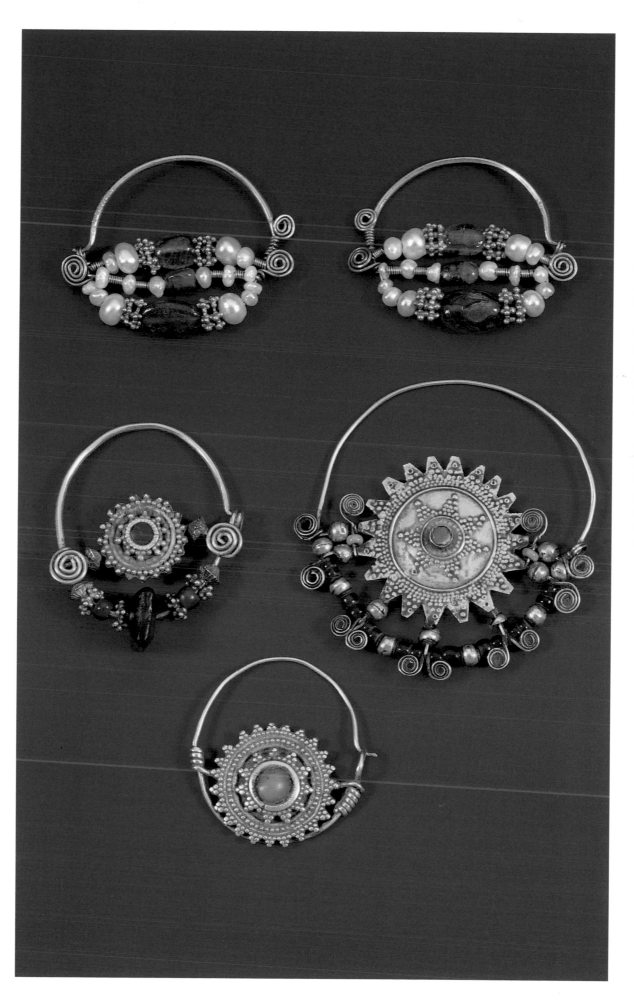

Uzbekistan, Turkmenistan
Top:
Uzbekistan
H 3 cm, W 4 cm,
9 grammes together
gold, semiprecious stones,
pearls
earrings
2nd half 20th century

Centre left:
Turkmenistan
D 3 cm, 4 grammes
gold and (blue) glass bead
name: *arabek*
nosering
middle 20th century

Centre right:
D 5 cm, 4.2 grammes
gold and glass beads
name: *arabek*
nosering
middle 20th century

Bottom:
H 4 cm, W 3.2 cm,
7.6 grammes
gold and one glass bead
name: *arabek*
nosering
middle 20th century

105

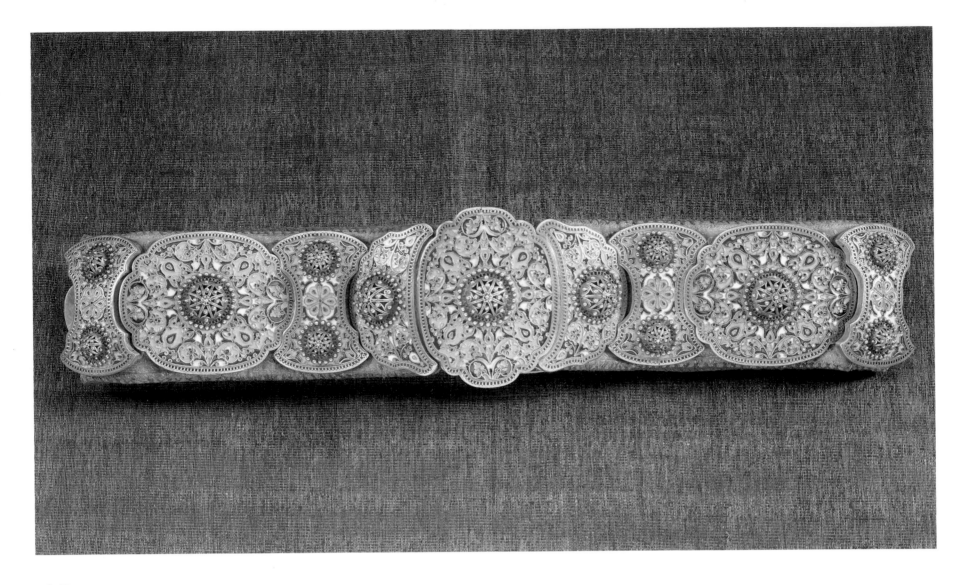

Uzbekistan

Buchara

L 109 cm, W (max.)10.5 cm,
1810 grammes
silver gilt, brocade, enamel
cloisonné, leather
man's girdle
early 20th century (between
1908-1917)
waistband with 14 round
and diabolo-form silver gilt
segments attached to bro-
cade leather; the waistband
covered with blue, green
and white enamel cloison-
né motifs of stylised flow-
ers and leaves; every seg-
ment encrusted with a
spherical filigree ornament
of silver gilt; at each end a
Russian hallmark indicative
of the period 1908–1917

Uzbekistan

Buchara

L 17 cm, H 15.5 cm,
237 grammes
silver, enamel cloisonné
name: *kosh-e-tilla*
diadem, bridal tiara
early 20th century
diadem or bridal tiara; sil-
ver, covered with blue,
green and white enamel
cloisonné with motifs of
stylised flowers and leaves

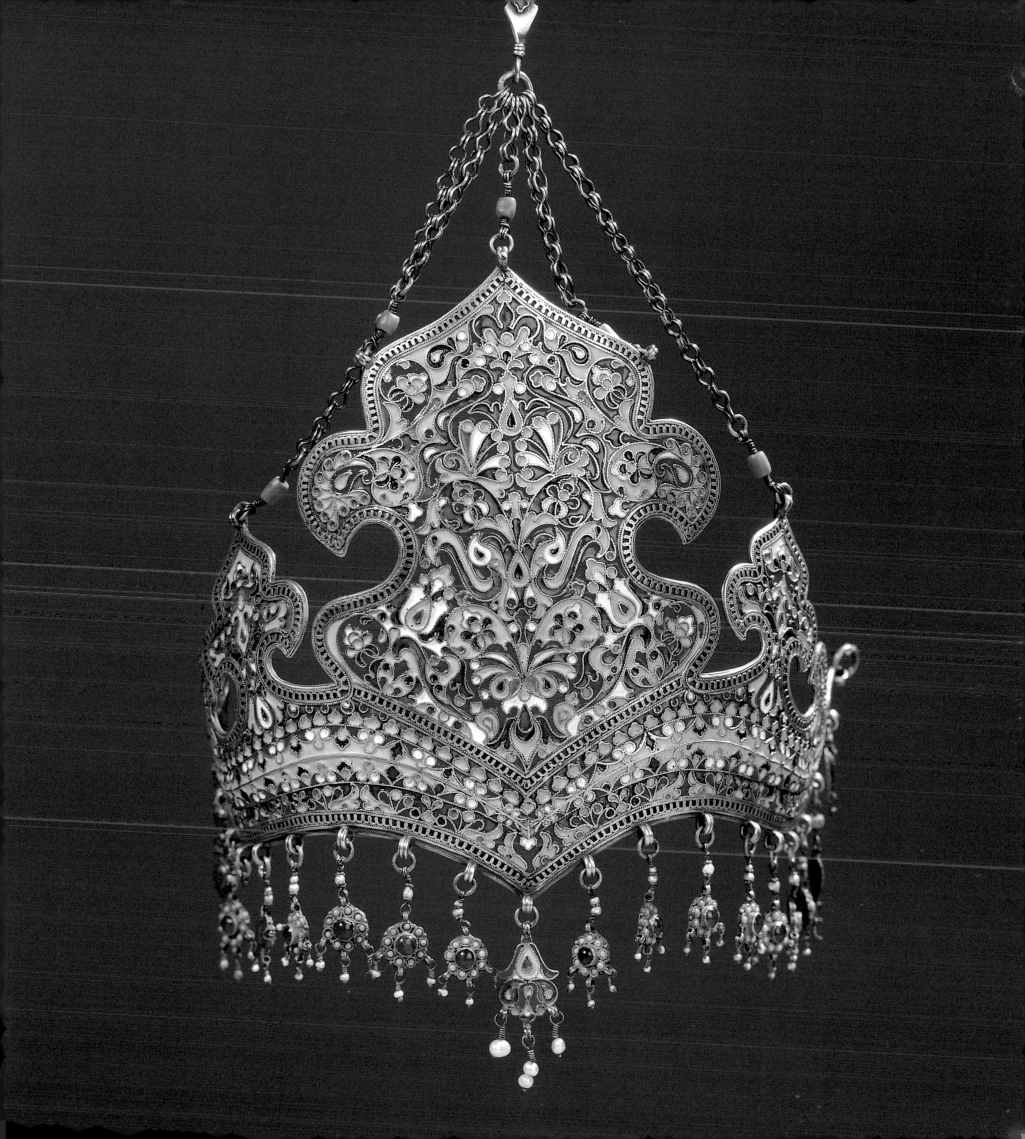

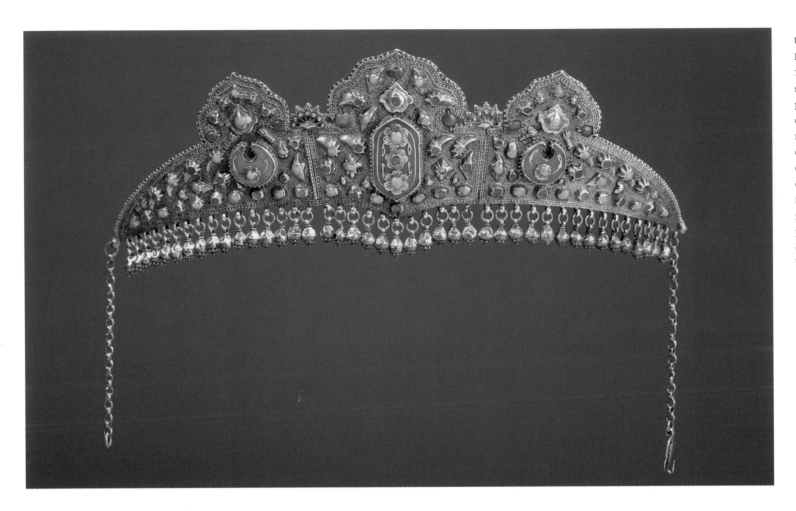

Uzbekistan
H 7.5 cm, W 22 cm,
152 grammes
silver gilt alloy, semi-
precious stones, jade, red
coral
name: *kosh-e-tilla*
diadem, bridal tiara
early 20th century
diadem consisting of 3 flex-
ible parts, encrusted with
glass, red and blue semi-
precious stones, rubies, red
coral and 3 jade tablets;
bottom round balls

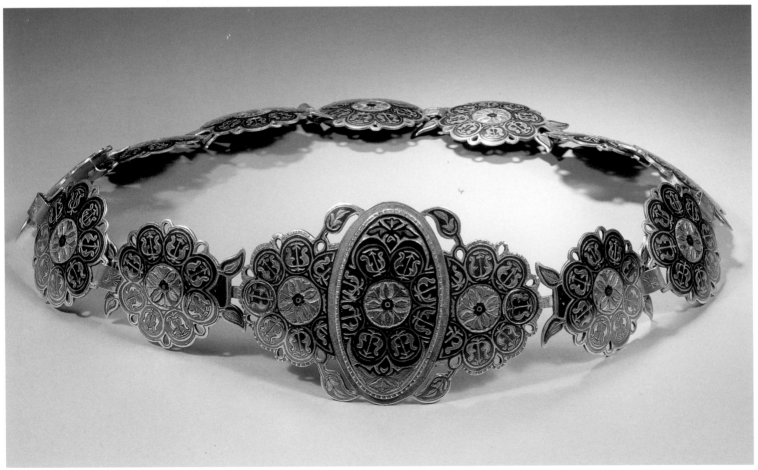

Uzbekistan
Buchara
L 88 cm, H (clasp) 8.5 cm,
H (girdle) 5.5 cm, 613
grammes
silver and niello
man's girdle
early 20th century

Kazakhstan

Top right:
D 7 cm, 121 grammes
silver, glass, lacquer
name: *zhuzik*
ring
1st half 20th century
round, with granulation

Top left:
L 6.5 cm, W 4.5 cm,
58 grammes
silver with gilding, glass,
lacquer
name: *zhuzik*
ring
1st half 20th century
oval, with granulation

Bottom left:
L 5.8 cm, W 4.5 cm, 58
grammes
silver, glass, lacquer
name: *zhuzik*
ring
1st half/middle 20th century
oval, with granulation

Bottom right:
L 4.5 cm, W 3.7 cm, 33 grs.
silver, glass, lacquer
name: *zhuzik*
ring
1st half/middle 20th century
oval, with granulation

Iran

Left:
L 18 cm, W 6.5 cm,
163 grammes together
silver and blue glass stones
armlets
early 20th century
armlets consist of 3 parts
connected by a cord and
are worn on the upper arm;
engraved inscriptions and
images

Right bottom:
H 10 cm, W 5 cm,
77 grammes
silver
amulet
early 20th century
engraved inscriptions and
depiction of a half-human,
half-peacock figure

Right top:
H 11.4 cm, W 6.7 cm,
87 grammes
silver
amulet
early 20th century
engraved inscriptions and
depictions of a human fig-
ure and lizards

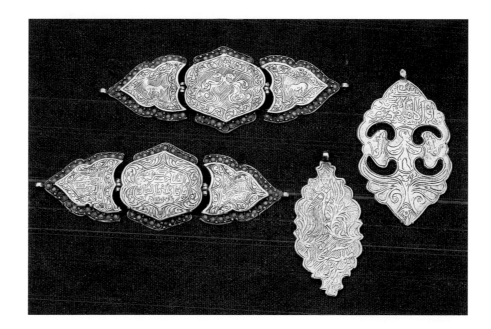

Dagestan, Azerbaijan and Armenia
(Russian Federation)

Top:
Dagestan
L 21 cm, W 8.2 cm,
365 grammes
silver and niello
man's clasp
early 20th century
silver clasp (two parts) with
engravings and floral
motifs; adorned with 3
large knobs; inside signed
in Arabic script: 'made by
Abdullah in 1338' (1919

according to the Christian
calendar)

Bottom:
Azerbaijan and Armenia
L 19 cm, W 8 cm,
294 grammes
silver and niello
man's clasp
late 19th century
silver clasp (two parts) with
floral motifs; large central
knob; Russian hallmark
(1896–1908) in the bottom
of both parts

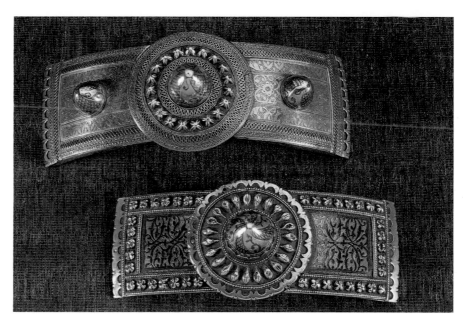

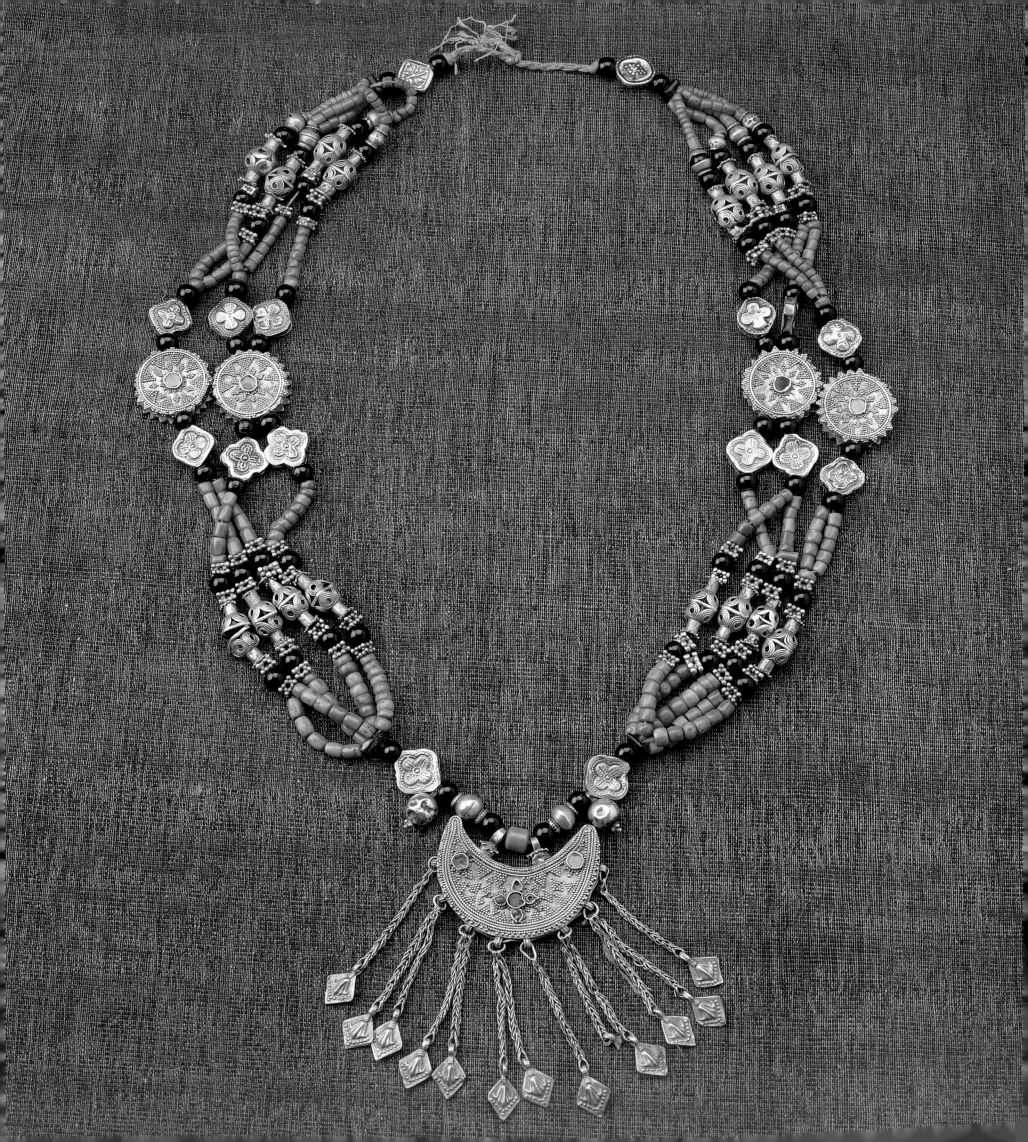

South Asia

Afghanistan
Pakistan
India
Nepal
Tibet

Tajikistan
L ±45 cm, W ±29 cm,
410 grammes
silver, coral, shell, glass
beads
bridal chain
1st half 20th century
granulation work on silver;
bottom crescent-shaped
pendant

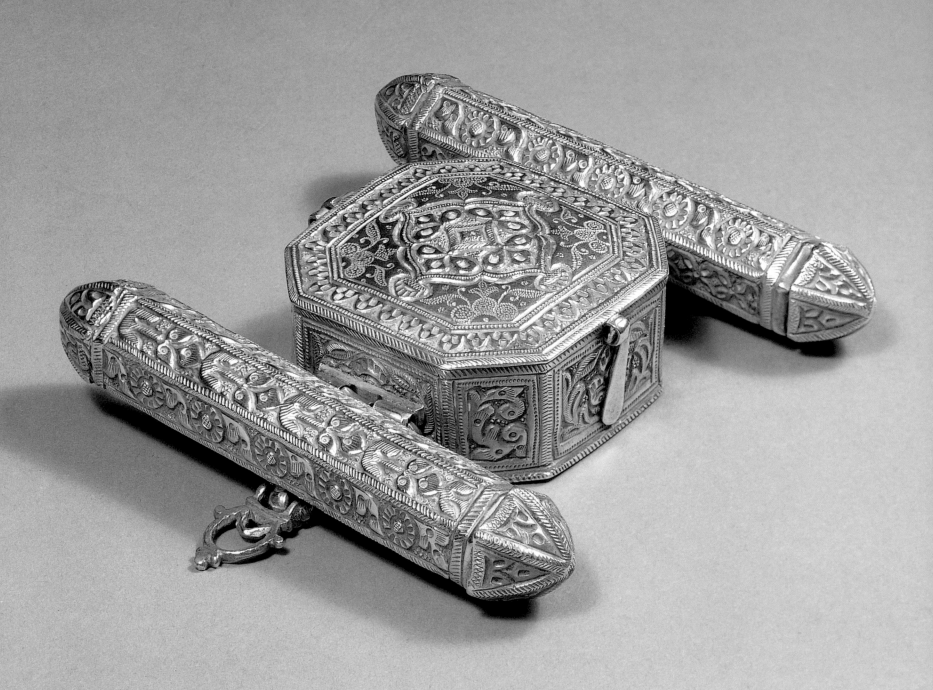

Left:

Afghanistan
L 12.2 cm, W 9.5 cm,
H 2.2 cm, 104 grammes
engraved silver
amulet box for Koran texts,
worn by men on the upper
arm
20th century
all 3 parts can open; also
the bottom is engraved;
worn by nomads in Iran as
well

Right:

Afghanistan, Pakistan
Top:
H 7 cm, W 8.5 cm, 668
grammes together
silver with engravings
pair of bracelets
1st half 20th century
stylised lion heads

Bottom:
H 8.5 cm, W 6 cm, T 0.6 cm
silver, with engravings both
sides
Islamic amulet
name: *ta'wiz* or *tulesm*
20th century
At the sides are snake
images and on the front
two crossed swords and
inscriptions representing
texts from the holy Qur'an.
The functions are to avert
the evel eye and to prevent
against illness. Painted
equivalents of this amulet
are found on the exterior of
village houses.

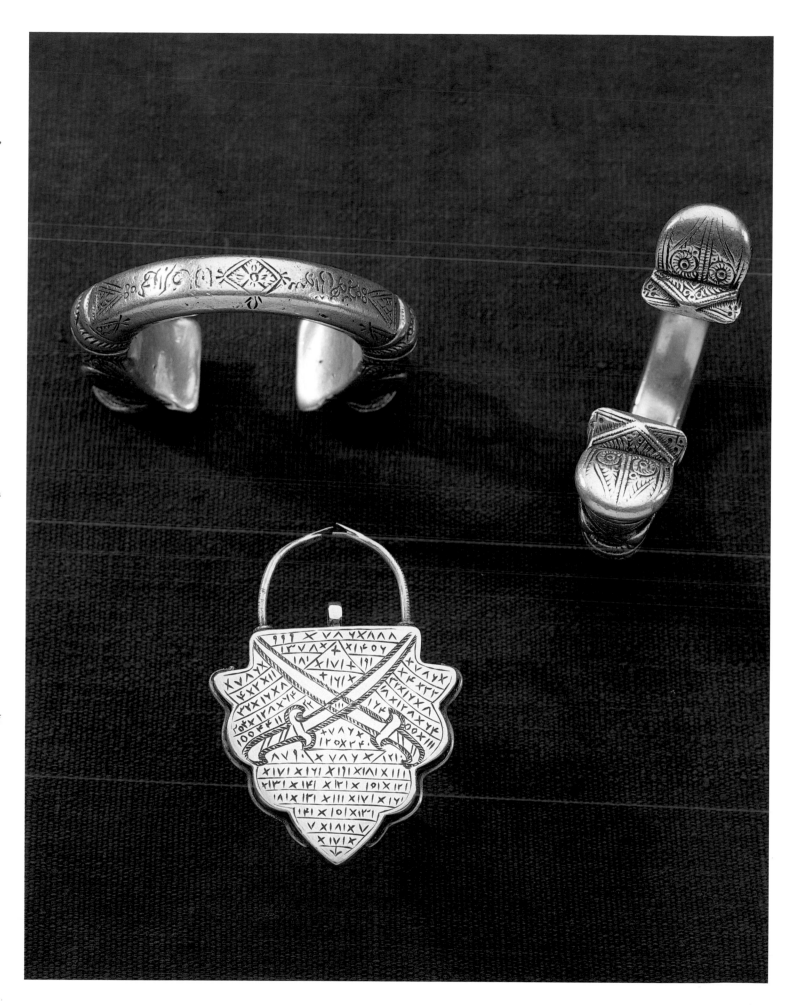

113

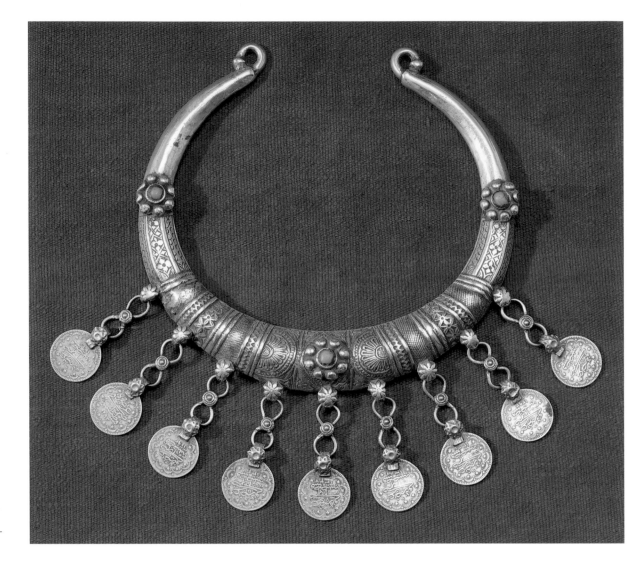

Below:

Pakistan

Top left:
Sind
H 17 cm, W 18.5 cm,
367 grammes
massive silver
neck ring
20th century
engravings; owner's name
on the back

Top right:
Sind
H 14 cm, W 14.5 cm,

285 grammes
massive silver
neck ring
20th century
engravings

Bottom:
Swat Valley and Chitral
Valley, Kalash people
H 16 cm, W 12 cm,
203 grammes
massive silver
neck ring
20th century
large round disc at the bottom; twisted band

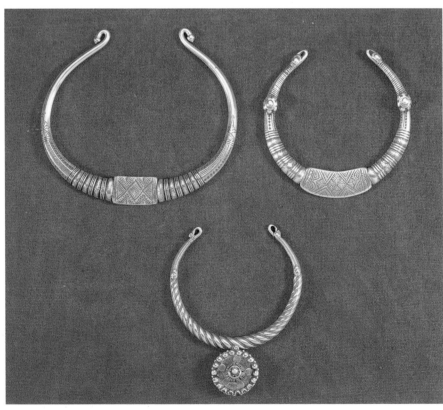

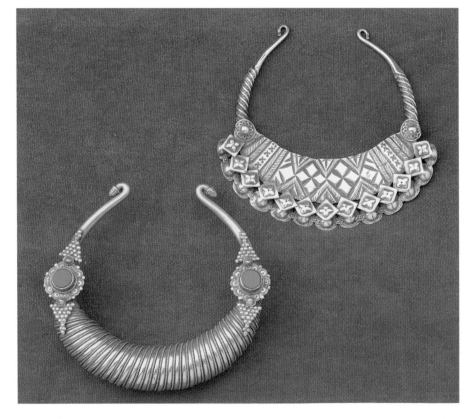

114

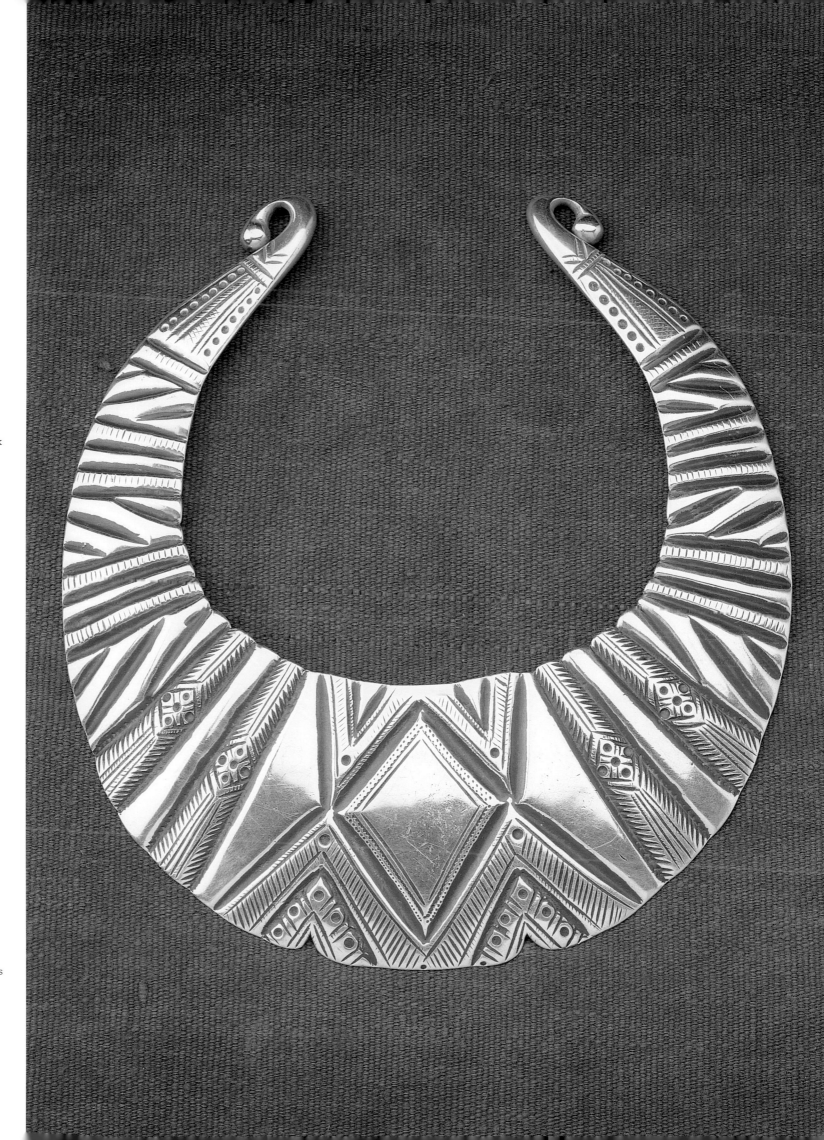

Left:

Pakistan
H 22 cm, W 17.5 cm, 278
grammes
silver, glass stones
neck ring
1st half 20th century
the coins are of Turkish
Ottoman origin

Right:

Pakistan
Swat Valley
H 17.5 cm, W 17 cm,
369 grammes
cast silver with engravings
neck ring
20th century
also engravings on the back

Left:

Pakistan
Top:
Pakistan
Swat Valley
D 17 cm, 216 grammes
silver
neck ring
20th century
cast silver and engravings

Bottom:
Nuristan, Chitral Valley
(Kalash people)
D 16 cm, 528 grammes
silver and 2 red glass stones
neck ring
20th century
2 loose intertwined bands

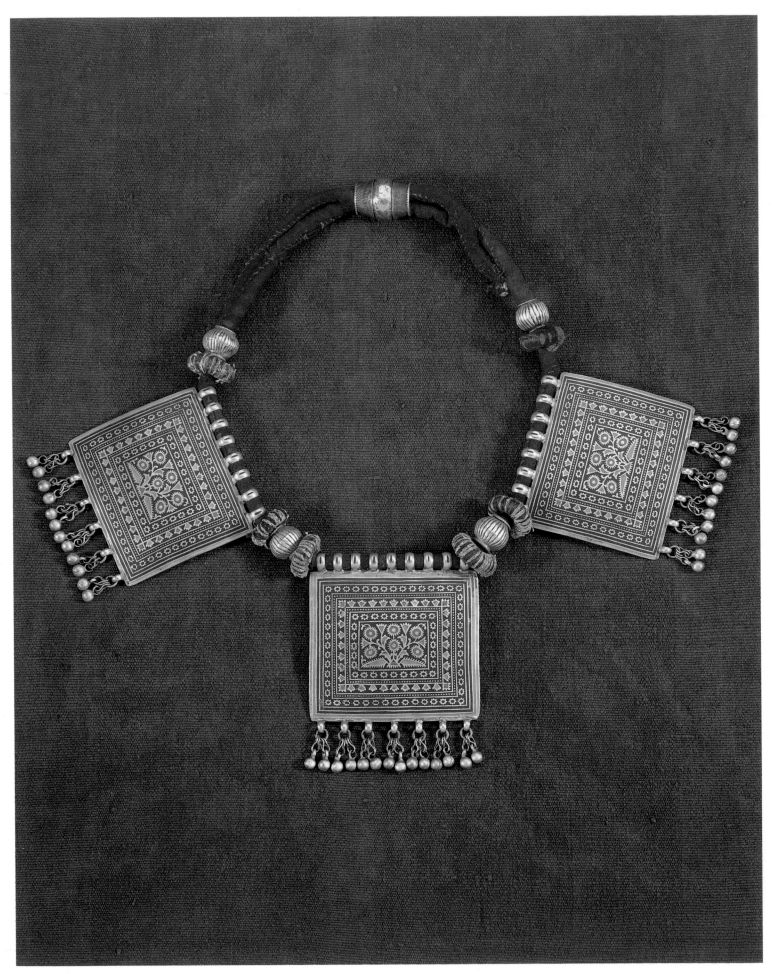

Left:

Pakistan
Multan
H 30 cm, W 35 cm,
355 grammes
silver alloy and enamel
necklace
20th century
3 enamelled plates (three-
coloured) with bells

Right:

Pakistan, Afghanistan
Ghazni (Katawaz peoples)
H 13 cm, W 7.5 cm,
205 grammes together
silver alloy, gold foil, glass
beads
temple pendants, worn
from the hair and head-
dress
20th century
worn by nomads in
Pakistan and Afghanistan

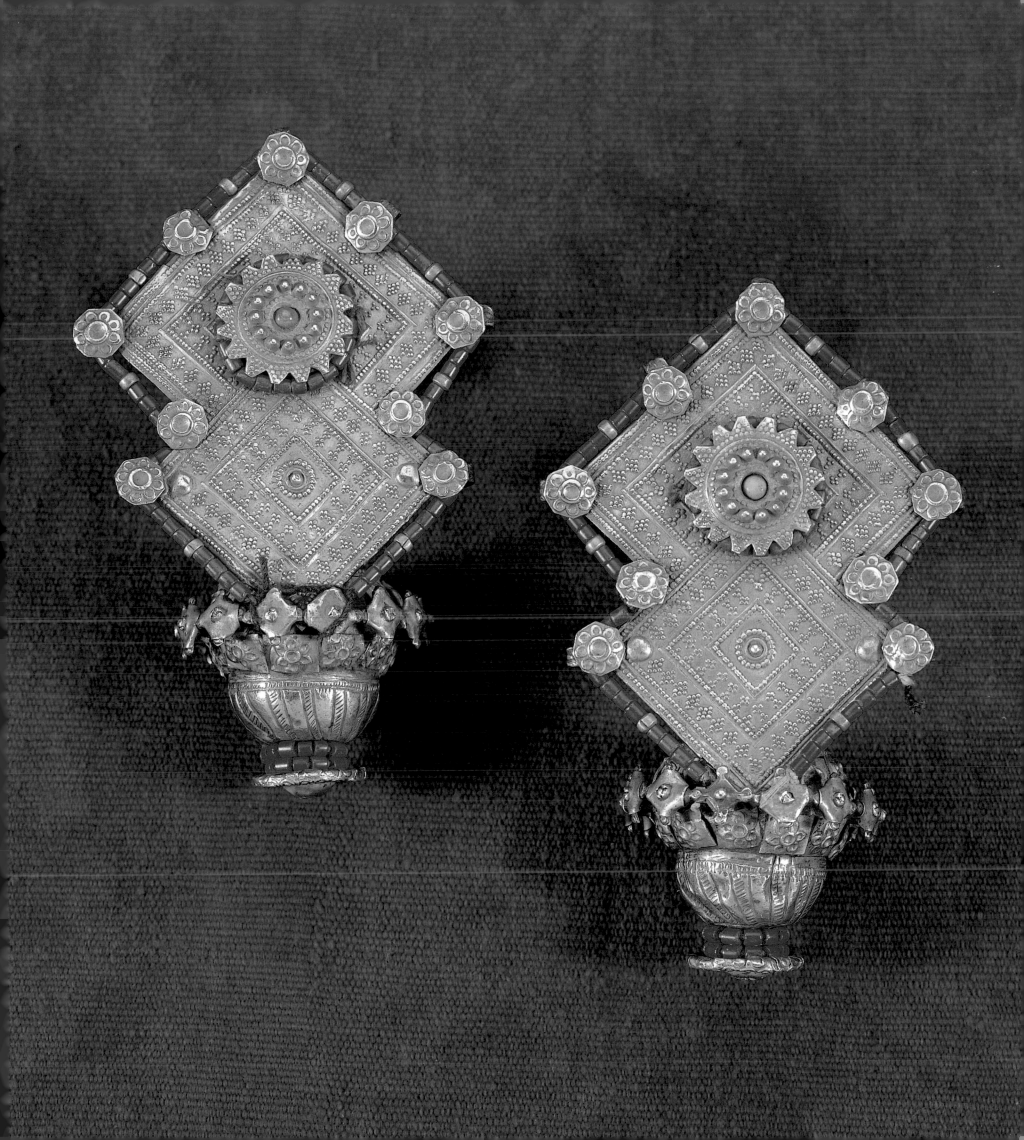

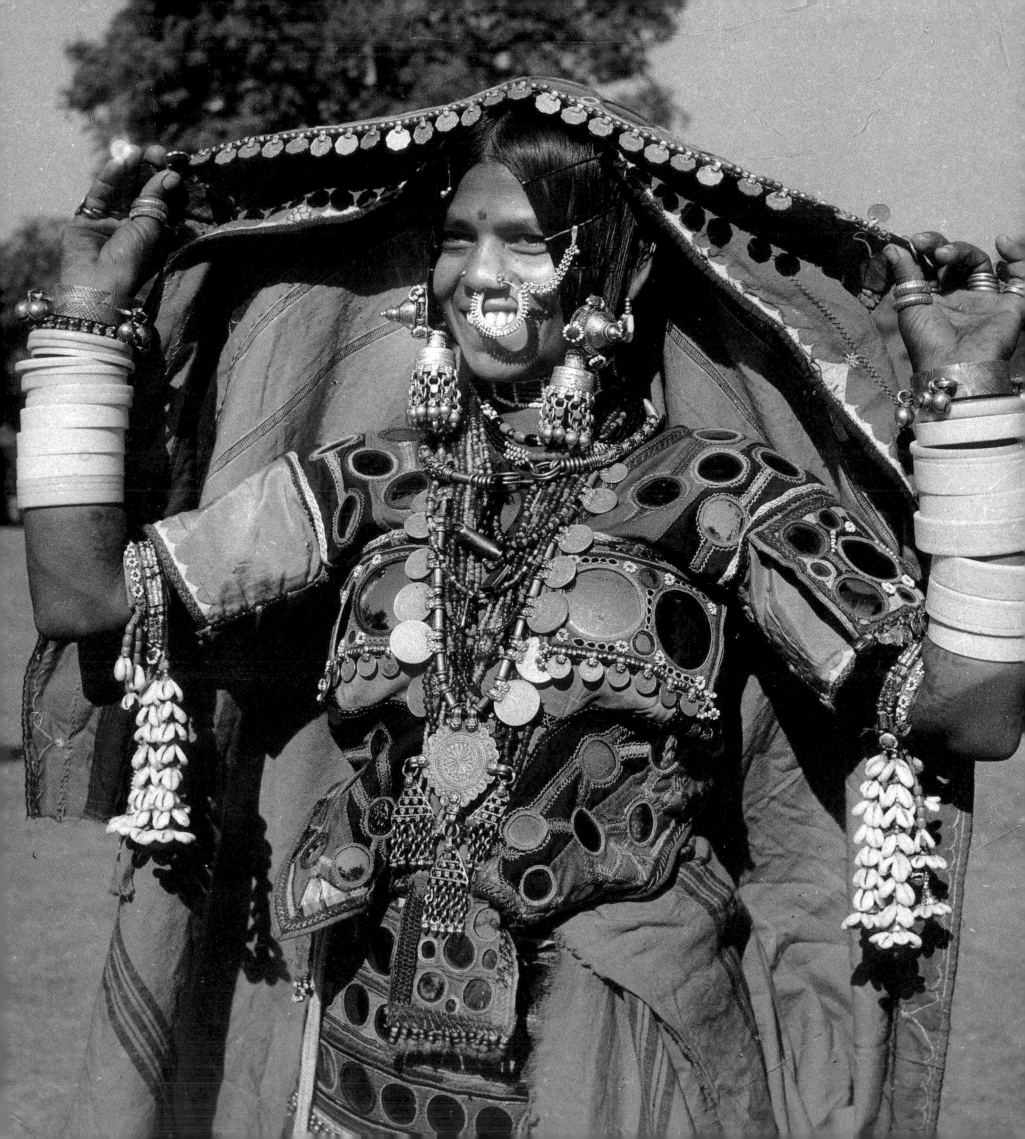

India: a rural silver jewellery odyssey

Oppi Untracht

Background: culture in continuity and flux

When a first-time visitor witnesses the endless crowds of expanding Indian cities, it may come as a surprise to know that more than 75 per cent of its current population of over one billion resides in the relatively small villages of rural India. It is there that the quintessential culture of real India endures, conserved primarily by its women, whose ethnocentric outlook enriches the lives of future generations. This is not to say that urban Indians have totally abandoned their cultural roots, elements of which are implanted in their genetic makeup. But cities, to which rural people constantly migrate, motivated by the hope of a better life, consist of a conglomerate of people who represent many of the co-existing Indian cultures. The density of urban living conditions tends to encourage the acceptance and adoption of concepts extraneous to those of one's origin, and modifies traditional patterns of thought. Consequently, rural people who emigrate to cities become alienated not just physically but also psychologically from their roots, and the perpetuation and preservation of their former communal culture becomes increasingly difficult.

Realizing this problem, almost desperate attempts are made by both urban dwellers and rural emigrés to cities to retain the basis of all culture: a sense of individual identity. This pursuit becomes dramatically apparent, for instance, when reading the many pages of small marriage proposal ads that appear in the classified section of the Sunday edition of large city newspapers. Men and woman bereft of traditional systems in which parents (H*: walidain) or matchmakers (H: ghataka(s)) arranged marriages, advertise for a suitable mate. The aim is to find someone who is acceptable in terms of religion, caste, socio-economic status and, if possible, regional origin. In rural India these concerns are equally active, but the traditional systems still exist without the benefit of modern methods of communication, including the internet which is increasingly used today.

* H: Hindu, S: Sanskrit

The function of jewellery in the Indian psyche and life

It is at the time of marriage (H: biyah; nikah), without doubt the most important event in the life of every Indian[1] that traditional cultural concepts become imperative concerns. The most important of the marriage preparations is a family's obligation to provide a daughter with a dowry (H: jakez; kanyadan) consisting of a 'woman's gifts' (H: stridan). The dowry is intended to compensate the groom and his family for the responsibility of supporting the bride after her marriage. It normally consists of the usual basic practical paraphernalia needed to establish a new home, garments for the bride and gifts to the in-laws. In rural communities in particular, the dowry also contains traditional precious metal jewellery (H: jawahir; zewarit). The amount is often specified in a written contract between both sets of parents, determining the total weight of jewellery that a bride must have. The amount and its value depend on the economic circumstances of the bride's family.

These traditional items of jewellery will establish and confirm unequivocally a rural woman's identity, a condition of considerable consequence in rural communities. The jewellery also signifies her acceptance by her husband's community, as its choice and use relates the bride to his society and motivates her to adopt and follow the customs and practices of the group. How does jewellery accomplish this? The answer is found in the various purposes that traditional jewellery serves, especially in Rural Indian society. The acquisition of jewellery is not simply a discretionary or arbitrary act of vanity, but a necessity.

Until recently, an Indian woman was not permitted to own landed property, which was inherited only by male members of the family. Her only material security therefore consisted of her stridana jewellery. Theoretically this is strictly her own, to do with as she pleases under normal circumstances. However, the significance of rural Indian jewellery lies in its various connotative meanings, which give it greater importance than its mere use as a display of wealth.

The formal design of a piece of jewellery can convey several messages about the wearer. It can indicate her religion (Hindu, Muslim, or Buddhist), geographic origin, social and economic status, and whether or not she is married or widowed (a widow wears no jewellery). Without a word being spoken, all these facts about her are instantly apparent to even a casual observer.

Traditional jewellery has other, more general functions. In the very earliest times, all Indian jewellery acted as protective amulets (H: kavach; hamula; ta'wiz). This purpose is still retained by many contemporary forms of traditional jewellery. Potent protective jewellery is generally recognisable from its form and design. The most common form is the container meant to hold various magical protective power-objects, believed to be effective when in contact with the wearer's body. An ornament may have religious decorations, such as an image of a Hindu deity, or a quotation from the Qur'an, or a traditional Buddhist symbol of good fortune, or a set of auspicious symbols. Failure to appreciate the deeper cultural significance of much Indian jewellery limits our understanding of it to a superficial level.

To summarise, the uses of traditional rural jewellery relate to marriage customs, family and social life and structure, religious practice and beliefs, economic life, and cultural and political systems, not to mention the expression of psychological group traits, behavioral patterns, and a wider, general world view. Urban jewellery, on the other hand, tends to emphasise concepts of status and decorative qualities, though it too can include charms and amulets.

These diverse functions are to a considerable extent what keeps contemporary traditional rural jewellery alive, and explains its continued production and popularity in India. Considering that many traditional jewellery forms have been produced for a period of at least 2000 years, their fully developed, distinctive forms which vary regionally exhibit a remarkable stylistic consistency, illustrating the power of traditional ideological and design concepts, once established.

Silver

Due to the circumscribed economic condition of most rural Indians, their jewellery is mainly of silver (H: chandi; rupiya) as is most of the Indian jewellery in this exhibition. The price of raw silver has always been far below that of gold (H: sona), the other precious metal widely used for jewellery. This is especially true in India where gold ornaments are required to be made of almost pure gold, usually 22 karat or 91.6 per cent (pure gold, 99.9 per cent, is 24

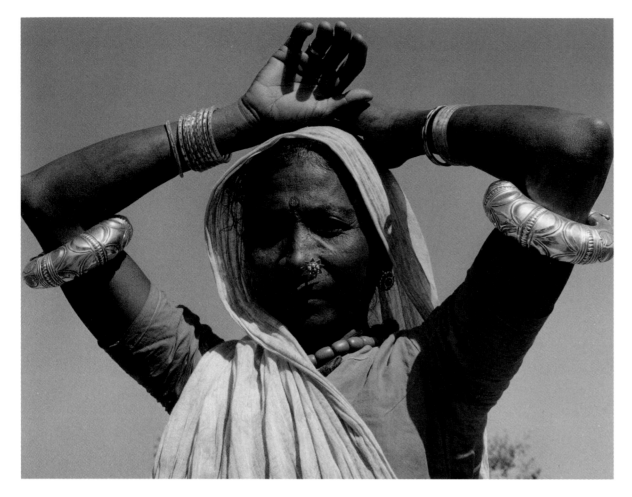

Page 118:

Banjara gipsy woman wearing traditional silver ornaments, Secundera Bad, Andhra Pradesh.

Left:

Woman wearing a pair of matching silver, hollow-embossed, sheet metal armlets, Bahraich, Uttar Pradesh.

Page 121 left:

A gipsy woman in typical dress with traditional silver ornaments of her tribe on all body parts, from head to toe, Adilabad District, Andhra Pradesh.

Page 121 centre:

Rural woman wearing a pair of silver bracelets (*bandaria*), whose design incorporates long, sharp spikes that are used for self-protection, Sambal Pur, Orissa.

Page 121 right:

Gujar woman wearing traditional ornaments of silver including a torque (*sira, hansuli*), and a kamiz silver button chain (*sangli*), Chamba, Himachal Pradesh.

carat). By weight, pure gold is ten to 15 times higher in cost than pure silver, its price fluctuating with availability and demand[2].

Perhaps because of its high intrinsic value, in most cases scholars and writers who study traditional Indian jewellery have paid greater attention to gold than to silver, even though this is just as artistic and significant. This lopsided emphasis is probably due to the fact that gold jewellery often incorporates impressive, expensive stones such as diamonds, rubies, emeralds, sapphires and pearls, the five classic gems of Indian jewellery, certainly seductive in their glamour and appeal. In Sanskrit the ancient term for this group is the *maharatnani* or 'highest gemstones', while other or 'lesser gemstones' are termed the *uparatnani*. The result is that despite the actual overwhelming dominance of silver jewellery in Indian usage, it is almost overlooked in most current literature on the subject.

If one considers the enormous total volume of jewellery produced in India, by numbers alone it is silver jewellery that most typically expresses the Indian ethos. Gold jewellery remains in the domain of the economic élite such as major rural landholders (H: *zamindars*), and the urban wealthy (H: *taliwar*), a decided minority in India.

This overwhelming use of silver jewellery in India is especially surprising as the country's deposits of raw silver are decidedly low compared with other silver producing countries. One wonders, therefore, what is the origin of this silver and how such a preference for silver became established.

Since ancient times India was an important goal of foreign trade, primarily in textiles, dyes and spices (Guy, p. 39). These highly desirable goods were purchased by traders from Mesopotamia, Africa, Middle Eastern countries, Rome, Persia, the Ottoman Empire and eventually Europe. These products were generally paid for in specie (coin), as Indian merchants would accept no other kind of payment. This explains why 68 hoards of Roman coins dating from the first century AD have been excavated at archaeological sites[3] such as former trading centres like Arikamedu in Southern India. Historians such as the Roman Pliny the Elder (23–79 AD) tell us of the anguish felt in Ancient Rome at the draining of its treasury that resulted from its submission to the irresistible attraction of Indian luxury goods[4].

This practice continued throughout Indian history. It characterised the interchange between India and the Dutch East India Company (VOC, *Verenigde Oostindische Compagnie*), which was founded in 1602 for Asian trade, the Portuguese trade established earlier, and the other European East India Companies founded about the same time by England, France, Denmark and Sweden.

Fifty per cent of Dutch trade with the East during the seventeenth and eighteenth centuries was with India, the rest with Indonesia, China and Japan. Payment for goods purchased from India was almost always in silver. In other places such as Indonesia, where the Dutch arrived in 1596, a certain amount of barter took place in which goods such as Indian textiles, purchased en route, were exchanged mainly for Indonesian spices (Guy, p. 78). The abundance of silver available during this time can be traced to its primary source: the rich silver mines of the New World nations of Mexico, Columbia, Peru and Bolivia conquered by the Spanish and Portuguese in the sixteenth century. The gold, silver and emerald resources in these countries were ruthlessly exploited and established Spain and Portugal in a position of economic dominance in Europe (Pers, pp. 47–51)[5].

In the process of this global trade, silver underwent a fascinating sequence of transformations before finally becoming the ornaments of rural India. At its origin in Mexico (and also in Seville) the Spanish and Portuguese minted an amazing quantity of raw silver into *reales de ocho* (pieces of eight), which became international currency. These coins, and silver ingots, were shipped to Spain or Portugal in sailing vessels convoyed by warships because European nations preyed upon one another in a government-

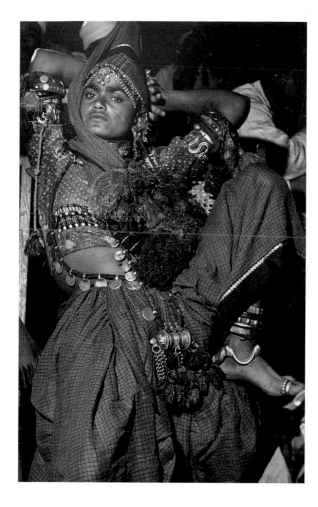 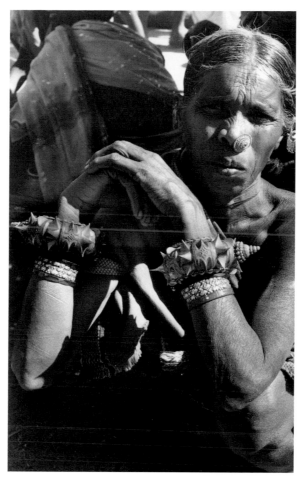 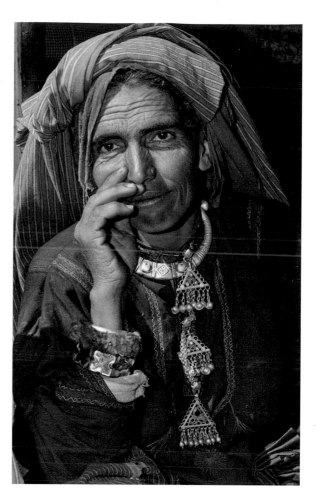

approved form of piracy. A long maritime journey, it was not without other dangers such as storms in which some vessels sank with their precious metal cargoes, some of which are now being recovered by adventurous underwater archaeologists.

From Cadiz or Seville surplus coinage was transported to Amsterdam which by then had become an important banking centre for the distribution of precious metal to the rest of Europe. The Dutch in turn melted some of the Spanish and Mexican minted coins into Dutch *guldens* (guilders) or florins for use in the Netherlands and into standard sized ingots for shipment to the East. Both coins and ingots were tightly packed in specially-made reinforced pinewood chests. Because of their great weight, the chests were sometimes used as ballast to lower the ship's draught in the water and prevent capsizing.

What typically happened when this silver (Dutch or otherwise) arrived in India is described by the intrepid French gemstone merchant Jean Baptiste Tavernier (1605–1689) who made six journeys to India in the late seventeenth century and fortunately recorded his experiences and findings in his famous book (see bibliography):

'Gold and silver [brought to India] ... as soon as they have been [submitted for taxation (*sulka*) and] counted at the (Indian) custom house, the Mintmaster [H: *darogha*] comes to take them and coin them into money of the country, which he hands over to you, in proportion to the amount and standard of your silver. You settle with him on a day when he is to give you the new coins ... You may carry all sorts of silver [in the form of ingots or specie] into the Empire of the Great Mogul, because there is a mint in each of the frontier towns, where it has to be refined to the highest standard ... [and converted into local currency] by order of the King. ... It does not do to carry to India ... gold pieces coined of late years [in Europe] because there is too much to be lost by them ... as Indians make a profit on them when they refine the gold.' (Tavernier: vol. I, pp. 8–10, p. 22).

With these locally-minted silver coins, the Dutch (and others) paid competitive prices for their purchases of Indian goods for export. When this newly-minted silver coinage came into circulation in India it was available to gold and silversmiths who considered it raw material and converted it into ingots, then into sheet metal, wire and other forms suited to jewellery and other objects.

It is estimated that over a period of about 200 years, the Dutch East India Company (VOC) shipped about 1.5 million kilograms of pure New World silver to the East. About half or more of this staggering amount was absorbed by India (Pers, p. 49). If one adds to this amount the silver that other European trading nations also brought to India, the total is almost beyond conception. It is fascinating to contemplate that the Indian jewellery in this exhibition quite possibly contains some of this New World silver which in the process of the creation and destruction of jewellery has been arrested in its present form.

Jewellery produced in the nineteenth century, on the other hand, may consist in part of silver (and gold) discovered in the USA and Alaska during the gold rush days of the 1850s and, later, silver discovered in the Comstock Lode in Nevada and Australia. A close relationship exists between the maximum production of silver jewellery in India which occurred in the latter half of the nineteenth century and reached a peak in the 1890s to 1914, and the world's production of silver. Contemporary records in India state that the amount of silver jewellery manufactured then was six to nine times greater than earlier. It was inevitable that the unprecedented increase in world silver production and its availability would cause a fall in the world market price of silver. This meant that the cost of silver jewellery and other objects also fell in India. At a time of relative economic improvement, due to the administration of the British Raj, rural Indians could make greater purchases of jewellery than was formerly possible. Lower prices were compounded by deflation in the

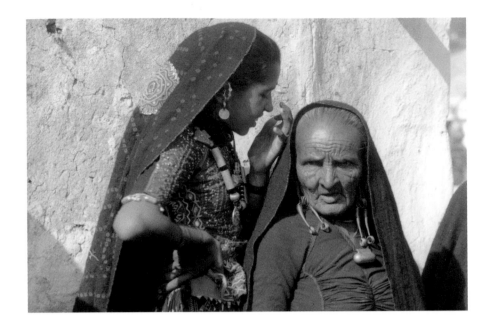

Women with golden and silver jewellery, Gujarat, Gulf of Kutch.

Page 123:

Maruari married woman's set of silver foot and toe ornaments, Bikaner, Rajasthan.

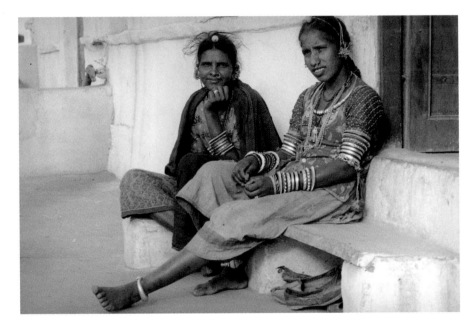

Women wearing bracelets, necklaces, earrings, noserings and anklets, vicinity Chitorarh, in the village Bhawa, Rajastan.

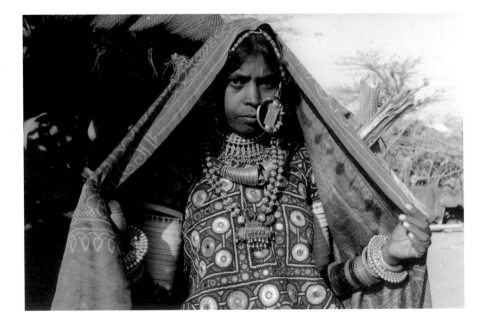

Rabari woman wearing embroidered cloths with mika mirrors, and traditional jewellery, including a silver and gold nose-ring. The big white armlets on her upper arm used to be made of ivory, but nowadays synthetic material is used, Gujarat, Gulf of Kutch.

late nineteenth century.

By these devious routes, a large percentage of the world's silver eventually came to India. A large part of this treasure is still secured there in the form of jewellery which will not be used in commerce, in order to keep it in India.

The Indian passion for precious metal jewellery can be explained by its use as a form of security against emergencies when it can easily be sold for its bulk value and converted into life-sustaining cash. Past experience taught rural Indians that man-made disasters such as wars or economic crises, and natural calamities such as floods or droughts were inevitable, and the possession of precious metal jewellery became a contingency for surviving their dire effects[6]. If necessary, even dowry jewellery could be surrendered and sold to assure a family's survival until better times when surplus earnings could again be converted into precious metal jewellery.

The silver jewellery of rural India was never worn by urban Indians, who in general wore gold. Urban women did not wish to be thought of as low caste rural provincials. This attitude is due to the old Hindu caste system in which every Hindu at birth automatically became a member of one of the four occupational caste groups. Even today, when there is national legislation against discrimination, inter-caste prejudices occasionally erupt into violence. In recent years, however, among younger, more liberal-minded urban women, it has become fashionable to replace the traditional sari or one-piece wrap with the practical the tunic and trousers (H: *salwar-kamiz*) typical of some rural women, especially those of the Punjab. With this style of dress it has become acceptable to wear neutral forms of silver rural jewellery, much as exotic ethnic jewellery is worn by a fashion-conscious Western woman.

The design of rural silver jewellery is characterised by a robustness of form and decorative detail, and is often ingeniously functional in construction because of its need to withstand rough daily use. It is common practice to wear jewellery daily as it is reassuringly safe on the wearer's body. Daily life chores result in rapid surface wear and the jewellery quickly acquires a softened edge and a naturally oxidised patina[7]. These signs of use give a history of extended physical contact with the wearer, which bestows the vitality of 'soul' on the jewellery. This tacit inference has in the past been an important factor in the rejection of old silver jewellery by Indian women unrelated to the original owner as such an association may be unacceptable. For someone who purchases old jewellery the life and condition of its former owner is unknown, and may possibly be associated with unlucky events. For this reason, a rural family often will sell the jewellery of a relative who died of sickness, or in tragic circum-

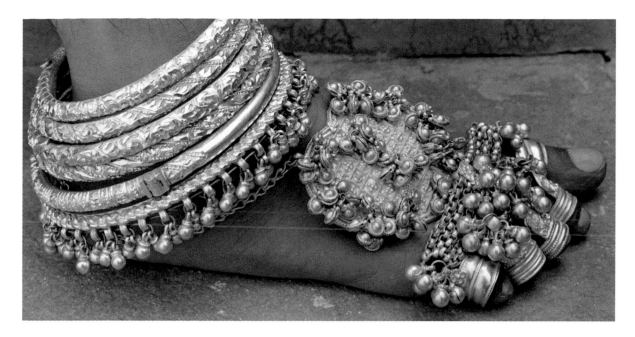

stances. Eventually this jewellery is melted down to an ingot and refined, a process that obliterates its former identity and it is then converted into acceptably new jewellery[8].

This process of creation, preservation, destruction and recreation is a concept and tenet of the life cycle of Hinduism which involves metempsychosis or the doctrine of the repetitive passing of the soul of the dead into another body. Thus the destruction of a piece of jewellery, the destiny of a large percentage of rural silver jewellery, parallels that of human beings and is understandable and acceptable. From the Western point of view this loss is something to be regretted. However, today the situation is changing and some of this jewellery escapes destruction. This is due first of all to the growing interest of foreigners and Western museum curators, and now, also Indian private collectors who have come to realise the technical, aesthetic and cultural values embedded in traditional silver ornaments. Saved from an ignominious fate, the work of many anonymous Indian jewellers is now happily being preserved for posterity.

Silver jewellery production

At most production centres of its production, a cooperative of anonymous artisans supply local and wider markets. A single jeweller (H: *sonar*) is rarely responsible for the fabrication of an entire object unless he resides in a small, isolated village in the so-called interior. Usually the various stages in the making of a piece are divided into tasks executed by a community of full-time trade specialists whose work is restricted to a particular phase of fabrication or decoration. Much rural silver jewellery is designed in unit construction, that is, the object is composed of identical pre-fabricated or mass-pro-

duced parts which are assembled into a complete piece, such as a necklace, bracelet or belt. These parts are joined by soldering or other processes. The pieces are kept in sequence in their final arrangement by stringing them onto a cord that passes through them all, onto a wire or braided chain, or by joining them with links.

A typical silver workshop (H: *karkhana*) team of artisans (H: *karigar*; *dastkar*) may include the maker of identical small parts that will become elements of which a single unit may be composed; the fabricator who assembles and joins these parts into units; the decorator who uses various techniques to ornament the unit; the polisher who carries out his work by hand; and the stringer. Some decorative techniques such as granulation and filigree wire work are the tasks of a separate specialist who does nothing else[9].

In the case of gold jewellery, the team might also include a specialist engraver, enamellist and gemstone setter, all processes which are carried out less frequently on silver jewellery, though occasional regional exceptions are found.

This process means that it is impossible to credit the manufacture of a piece to any single artisan, as is commonly done in the case of Western jewellery. The group effort has the advantage of creating an object that incorporates the mature skill and experience of all the specialists involved. As a result of this organised cooperation, the object benefits technically and aesthetically from their combined expertise. Also, its selling price may be lower than if it were produced by a single individual who would probably require longer to make it.

Purchasing traditional silver jewellery in India

In India, the cost of any precious metal jewellery

depends first of all on the total weight (H: *wazn*) of the metal, which is determined at the stage of its manufacture when all metal parts are completed. To this is added a percentage by weight, called the working charge. The amount of this percentage depends on the degree of complexity the work demands. Certain designs or skills are more labour-intensive than others and are therefore given a higher value. The weight unit in use in India is the (H:) *tola*. One *tola* equals 180 grammes troy or 11.712 grains, which equals one silver rupee coin (the latter was withdrawn from use in 1947, when its value as precious metal exceeded its monetary face value). Basic rates for the tola and other forms of precious metals appear daily in every newspaper and are widely followed by many interested Indians, even those not immediately concerned with jewellery purchase.

As there is no hallmark or quality-of-metal stamping system in operation in India, every such purchase carries an element of risk. Ultimately, knowing the quality of the object depends on accepting the word of the maker and the seller[10].

The purchase of jewellery often takes on the aspect of a ritual. In Indian cities it is usual for many jewellers' shops to exist side by side on a street or to occupy a whole area. For this exciting event, the parents and the bride are often accompanied by female relatives or close friends. Together they form a consensus of opinion in the process of arriving at a final decision. There is no need for a rural goldsmith to advertise his wares: purchases are often made during the active marriage season (winter and spring) when jewellery establishments are thronged with clients, all patiently waiting their turn to be served.

When making their purchases, the uppermost concern is what constitutes a desirable collection of forms[11]. This can be achieved immediately if the family is sufficiently affluent. If not, future purchases will probably be made to supplement the initial selection. In both cases, the total sum to be spent may be considerable in relation to a family's resources. When this is insufficient to cover the cost, a family may have to resort to taking a loan from a money lender or jewellery dealer (H: *sarraf*). The decision to do this is often motivated by the family's desire to maintain its social prestige. This explains why parents with several daughters are usually the objects of pity.

Rural Indian wedding jewellery and beyond

Rural as well as urban weddings are celebrated with as much pomp as the family can muster. The focus of the attention of the many invited guests (often hundreds) is the bride. If Hindu, she is attired in red, the traditional colour for a bride's costume, and she

is loaded literally from head to toe with her dowry ornaments. A splendid sight, on this important occasion she is at the peak of her life's promise.

After numerous ceremonies are completed (Thomas, pp. 90–93), a rural bride finally arrives at her husband's family home where she becomes a member of his joint family of relatives who usually reside together to pool their resources. Her ornaments, all worn at least during the first year of her marriage, come under the serious scrutiny of all her husband's female relatives. Their quality, value and suitability to their group identity are discussed intently. Approval, or lack of it, may determine the nature of the bride's future treatment in that household (see Jacobson for a detailed discussion on this subject)[12].

In rural communities, it is common practice for jewellery, when not worn, to be placed in a strong storage box and secretly hidden, often in the earth floor of a rural house, to guard it from robbery. Thereafter, it is exhumed for special occasions, for example, attending the wedding of a family member (always an occasion for personal display) or at festival times, when rural people don their best dress.

In these ways rural silver jewellery, often acquired as a result of strenuous labour in the fields, repays its owners' efforts by playing an essential role in the significant life events of its possessor. Jewellery, however, seems to have a life and destiny of its own. Whether it becomes a family heirloom, experiences apotheosis and transformation by fire into another form, or, if very fortunate, is conserved as a cherished object in a collection, remains to be determined by fate.

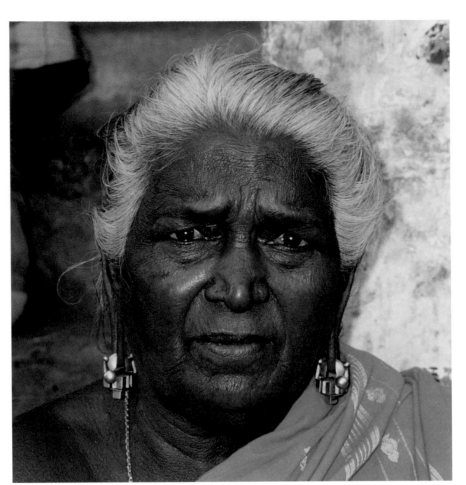

Left:

Woman wearing *thandatti* earrings (see page 148), Tamil nadu, 1990s.

Page 125 left:

Woman with large silver, bracelets, Patan, Gujarat, 1995.

Page 125 centre:

Banjari women with traditional jewellery, Maharashtra, 2001.

Page 125 right:

Gujarati couple near Bhuj. The woman wears a large ivory bracelet, 1995.

Notes

1 According to Hindu thought, the life of an individual is divided into several stages (S: *samskaras*), one of which is marriage (S: *vivaha*), the most important of all.

2 Silver used in rural jewellery is never pure, i.e. 99 per cent. It is always alloyed with copper whose percentage may vary from eight to 20 per cent or more per 100 parts. Copper also acts to harden the alloy as pure silver is too soft for normal use.

3 *Jewelry and Ornaments in India – a historic outline*, p. 2

4 'Silver [coinage: the denarius] was first struck [in Rome] in 269–268 BC in the consulship of Quintus Ogulnius and Gaius Fabius' (Pliny the Elder, p. 292). In Roman times the best source of silver was Asturia in Spain, although Pliny mentions another source: 'Roman people always imposed tribute on defeated nations in silver rather than in gold' (p. 294). He comments: 'The mind boggles at the thought of the long-term effect of draining the earth's resources and the full impact of greed' (p. 286).

5 'Scholars estimate that Cortez took 759 pounds of silver and 8055 pounds of gold out of Mexico [and] Pizarro as much as 134,000 pounds of silver and 17,500 pounds of gold from Peru' (Knauth, Percy, *The Metalsmiths*, p. 140).

6 This kind of disaster occurs even today. At such a time, big city merchants of curios and antiques send agents to the disaster area where they buy precious metal and ethnic jewellery that local victims are selling to convert them into survival money. The author has seen the results of such forage: jute sacks full of jewellery emptied on a shop floor for assortment and sale.

The same thing occurs when a drastic change in cultural outlook takes place. As recently as the 1970s the Naga tribes of Northeastern India sold their traditional jewellery which in the past denoted the fact that the wearer was a warrior who had 'taken heads' of victims. This change, due to the missionary activity of Christian Baptists, made their ornaments obsolete.

7 New rural Indian silver jewellery is white and totally without any oxidation, which, when it occurs, is a sign of age.

8 Because of the universal practice among Hindus of cremating the dead, jewellery is never buried with the body, as in other cultures.

9 Specialist techniques of jewellery ornamentation are often practised at specific centres of production. Examples are filigree work which is centred at Cuttack in Orissa and Karimnagar in Andhra Pradesh, and enamel work which is a speciality of Jaipur in Rajasthan, but is also done elsewhere.

10 For this reason generations of a family often patronise the same goldsmith who, over time, has proven himself to be honest. Conversely, the family, when placing an order, may ask the jeweller to bring his tools, which are easily portable, to their home where the objects will be made under the watchful supervision of a family member or representative.

11 The rural jeweller will manufacture the kinds of ornaments that are traditionally worn by his local clientele. These forms, often used for centuries, are repeated with relatively little variation. The jeweller is not interested in creating unique, original designs since his clientele patronises only those traditional forms worn by members of their community, for reasons explained earlier.

12 Additional jewellery may also become hers. This includes a wedding gift to the bride from the groom or his family. Her family will usually present her with a gift of jewellery upon the birth of a child, especially if it is male.

13 For an extensive bibliography see Oppi Untracht, *Traditional Jewelry of India*, pp. 410–417.

References

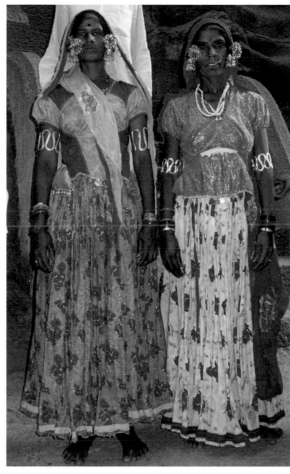
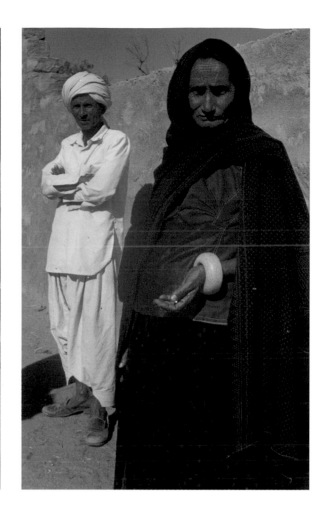

Borel, France, *The Splendor of Ethnic Jewelry: The Colette and Jean-Pierre Ghysels Collection*, New York, Harry N. Abrams Inc., 1994, pp. 104–109; 134–157; 162–170.

Butor, Michel, *Adornment: The Jean Paul and Monique Barbier-Mueller Collection*, London, Thames and Hudson Ltd., 1994 pp. 100–130.

Hendly, Thomas Holbein, *Indian Jewellery: Reprints from the Journal of Indian Art*, 2 volumes. New Delhi, Cultural Publishing House, 1989.

Jacobson, Doranne, 'Women and jewellery in rural India', in Gupta, Giri Raj (ed.), *Main Currents in Indian Sociology. Vol. 2, Family and Social Change in India*, New Delhi, Vikas Publishing House, 1976, pp. 135–183.

Guy, John, *Woven Cargoes: Indian Textiles in the East*, London, Thames and Hudson, 1998.

Jewellery and Ornaments in India: A Historic Outline, Census of India, Series No. 1, Paper No. 1. New Delhi, Office of the Registrar General, India, Ministry of Home Affairs, 1970, p. 2.

Knauth, Percy, *The Metalsmiths*, Netherland BV, Time Life International, 1974, p. 140.

Mukherjee, Meera, *Metalcraftsmen of India*, Calcutta, Anthropological Survey of India, Government of India, 1978.

Pliny the Elder, *Natural History (A Selection)*, Translated by John F. Healy. Book xxxiii: 'Gold and Silver' Harmondsworth, Penguin Books, 1991.

Postel, Michel, *Ear Ornaments in Ancient India*, Project for Cultural Studies, Publication No. 2, Bombay, Franco–Indian Pharmaceuticals Ltd, 1989.

Stronge, Susan, et al., *A Golden Treasury: Jewelry from the Indian Sub-Continent*, exhibition catalogue, Victoria and Albert Museum, Mapin Publishing, 1988.

Tavernier, Jean Baptiste, *Travels in India*, Translated by V. Ball from the French edition of 1676, London, Macmillan and Co., 1889, vol. 1, chapter 2, pp. 8–38.

Thomas, P, *Hindu Religious Customs and Manners*, Bombay, D.B. Taraporevala Sons & Co. Private Ltd, 1956.

Untracht, Oppi, *Jewelry Concepts and Technology*, Garden City, New York, Doubleday and Co., 1982; London, Robert Hall Ltd, 1982.

Untracht, Oppi. 'Jewellery of India', in *Ethnic Jewellery*, pp. 65–93; 173–179, London, British Museum Publications; New York, Harry N. Abrams, Inc., 1988.

Untracht, Oppi, *Traditional Jewelry of India*, New York, Harry N. Abrams, Inc., 1997.

Walberg Pers, 'Silver for Export; the VOC and the Global Money Market', *Dutch Enterprise 1602–1799 and the VOC Amsterdam*, Stichting Rijksmuseum Amsterdam, 1998, pp. 17–51.

India, Pakistan

Top left:
Rajasthan/Punjab
H 16.5 cm, 1035 grammes
together
silver
tubular armlets for the
forearm
20th century
closed tubes
(see page 125, left)

Top right:
India
Rajasthan/Gujarat
H 16.5 cm, 654 grammes
together
silver
tubular armlets for the
forearm
20th century
closed tubes

Middle left:
India
Rajasthan/Gujarat
H 13 cm, 684 grammes
together
silver
tubular armlets for the
upper arm
20th century
closed tubes

Middle right:
India
Rajasthan Gujarat
H 13.5 cm, 346 grammes
silver
tubular armlet for the fore-
arm
20th century
tube fastens in the front by
means of a peg; hinge at
the back

Foreground:
Pakistan
H 8 cm, 294 grammes
together
silver
tubular armlets for the
forearm
20th century
closed tubes

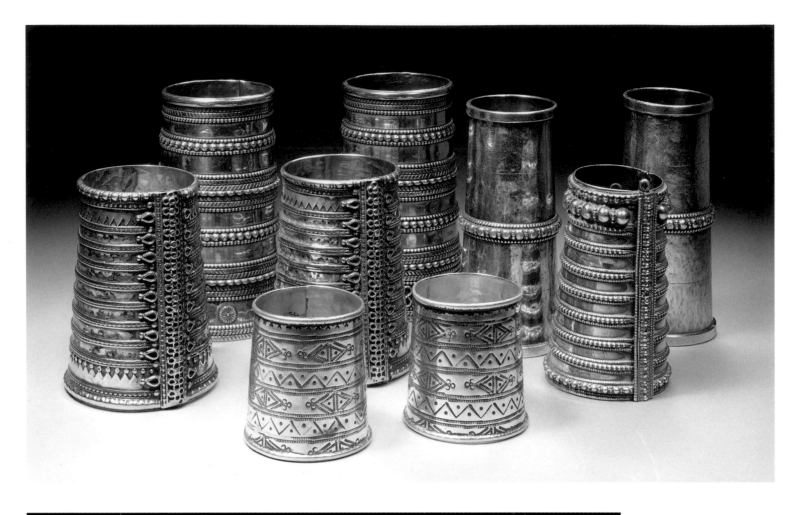

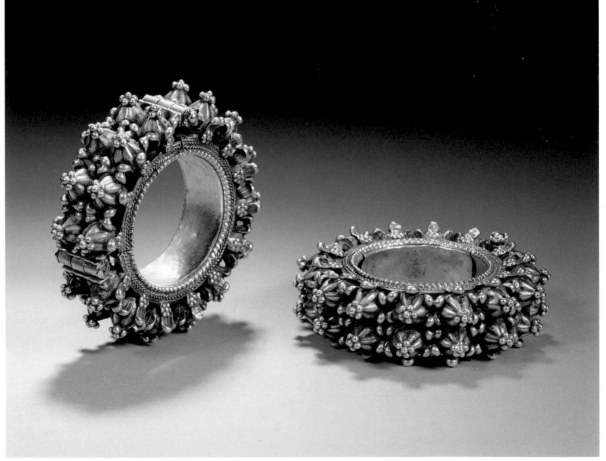

India
Rajasthan
D 10 cm,
428 grammes together
silver
woman's bracelets
20th century
double row of flowers

India
Rajasthan
D 14 cm,
670 grammes together
cast silver, hollow
woman's anklets
20th century
floral motifs and a bird

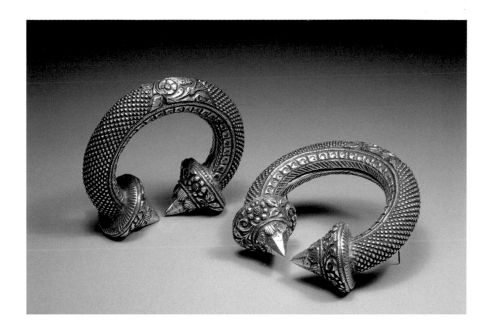

India
Gujarat
Top:
H 8.2 cm, D 9 cm,
967 grammes together
cast silver
anklets
20th century
owner's name engraved on
the top of the back; 2 parts
joined by a screw

Bottom:
(Porbandar, Saurashtra)
H 8 cm, D 12 cm,
2470 grammes together
cast silver
name: *jeram damgi* or *kadla*
anklets
20th century
worn by Harijan, Koli and
other women; two parts
joined by a screw

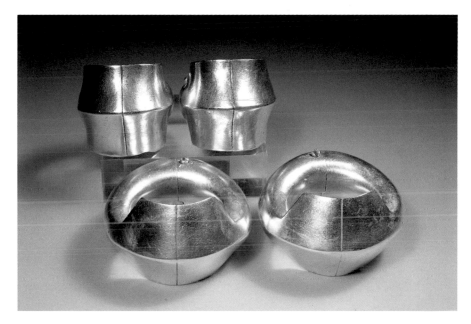

India
Gujarat
L 11.8 cm, W 10.5 cm,
H 5.5 cm,
1118 grammes together
cast silver
anklets
20th century
sloping front and back; 2
parts with 2 screws

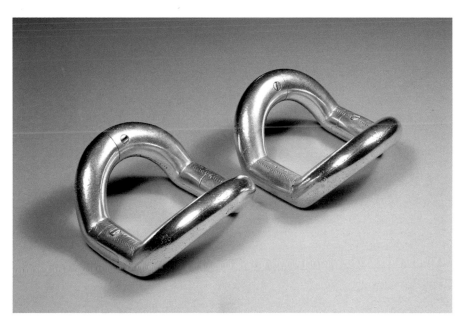

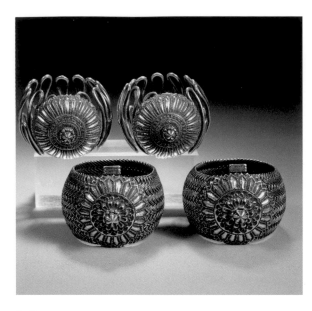

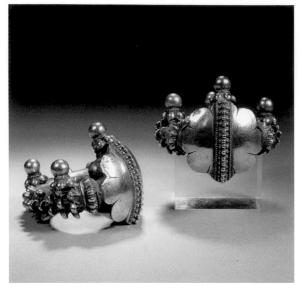

India
Top:
Madhya Pradesh
H 6 cm, D 8.5 cm, 397
grammes together
silver
name: *vauk*
bracelets
20th century
open spiral; floriform
rosette; peg fastening in the
front

Bottom:
Madhya Pradesh
H 6.5 cm, D 9 cm,
537 grammes together
silver
name: *vauk*
bracelets
20th century
plaited silver wire; floriform
rosette; peg fastening in the
front; worn by Mahratta
and Gujarat women of the
Raval community

India
Gujarat
H 9 cm, D 11 cm,
754 grammes together
silver
woman's anklets
20th century
hinged; peg fastening on
the side

India
Gujarat (Kutch)
D 19 cm, 847 grammes
silver
name: *vadlo* or *vaidlah*
neck ring; bridal jewel
20th century
drawn from one silver wire;
worn by women (Rabari,
Mutra Muslim, Vaishnavite-
Hindu-Meghval and
Harijan)
(see page 122, bottom)

India
Gujarat
D 18 cm, 254 grammes
silver
name: *hansuli*
woman's neck ring
20th century
a.o. two engraved peacocks,
familiar birds in India

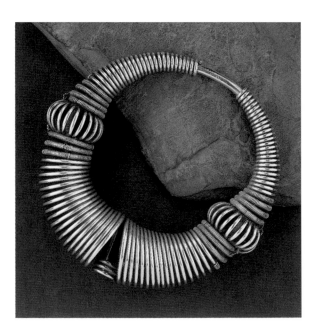

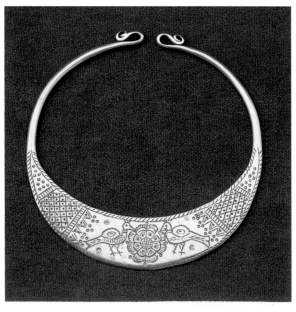

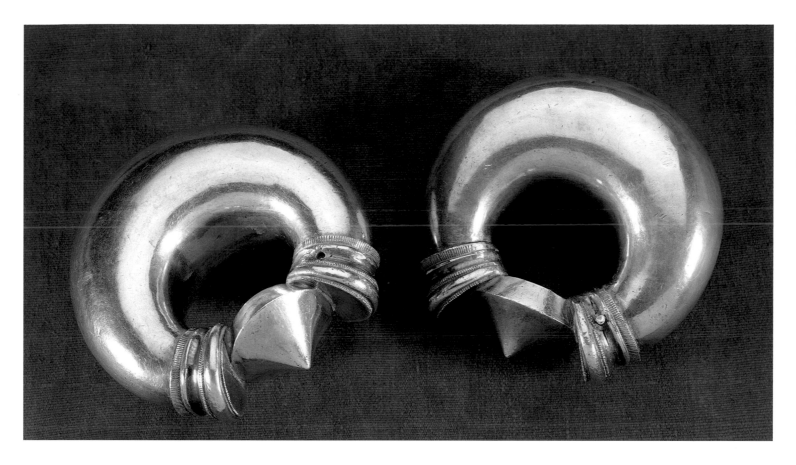

India
Rajasthan (Shekhavati)
D 16.5 cm, maximum
height: 7.5 cm, maximum
thickness: 7 cm, 2935
grammes together
cast silver
woman's anklets
20th century

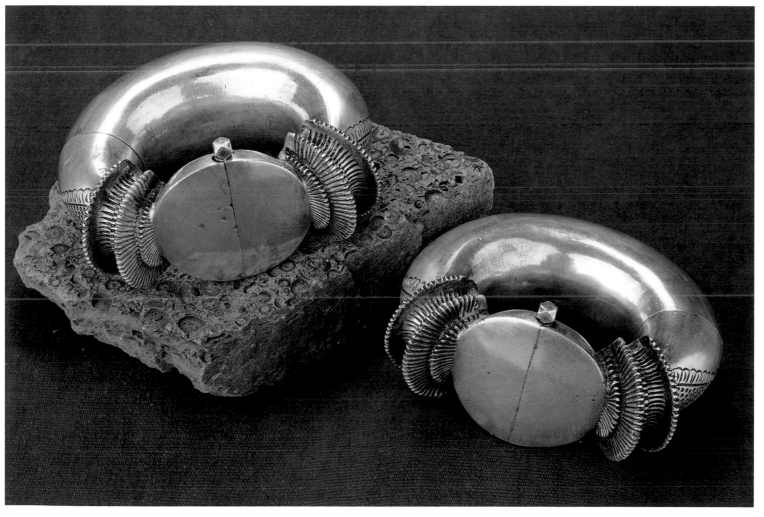

India
Rajasthan (Jaisalmer)
H 6.4 cm, W 13 cm,
D 10.5 cm, 2370 grammes
together
cast silver
woman's anklets
20th century

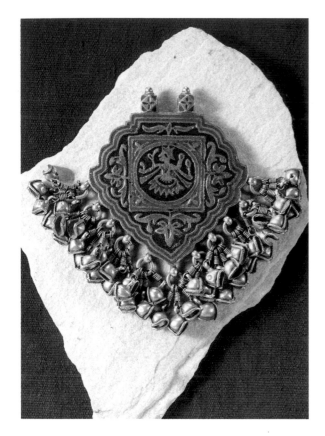

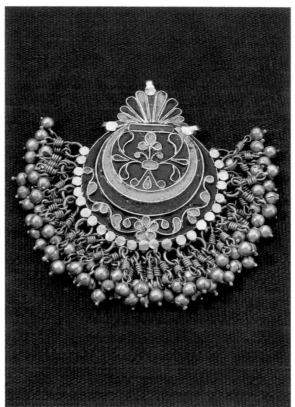

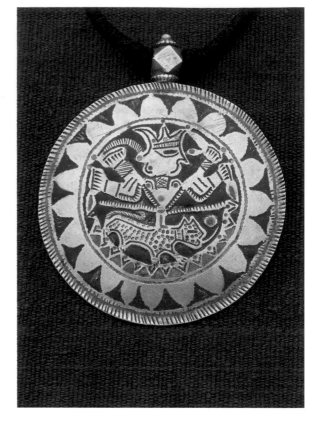

India
Himachal Pradesh (Nurpur,
or Jagat-Sukh, Kangra dis-
trict)
H 10 cm, W 10 cm,
176 grammes
silver gilt + blue and green
enamel
pendant
20th century
four arms, crowned Vishnu

India
Himachal Pradesh
H 10 cm, W 10 cm,
95 grammes
silver and enamel
name: *chiri tikka*
forehead ornament
20th century
blue, yellow, green and
turquoise enamel

India
Himachal Pradesh
(Nurpur or Jagat Sukh,
Kangra district)
H 9.6 cm, D 8 cm,
60 grammes
silver and enamel (green,
blue, yellow)
amulet
20th century
four-armed, crowned
Vishnu with a tiger, or pan-
ther

India
Himachal Pradesh (Nurpur,
or Jagat-Sukh, Kangra dis-
trict)
H ±44 cm, W ± 30 cm,
887 grammes
silver + enamel in 4 colours
woman's necklace
20th century
geometrical floral motifs

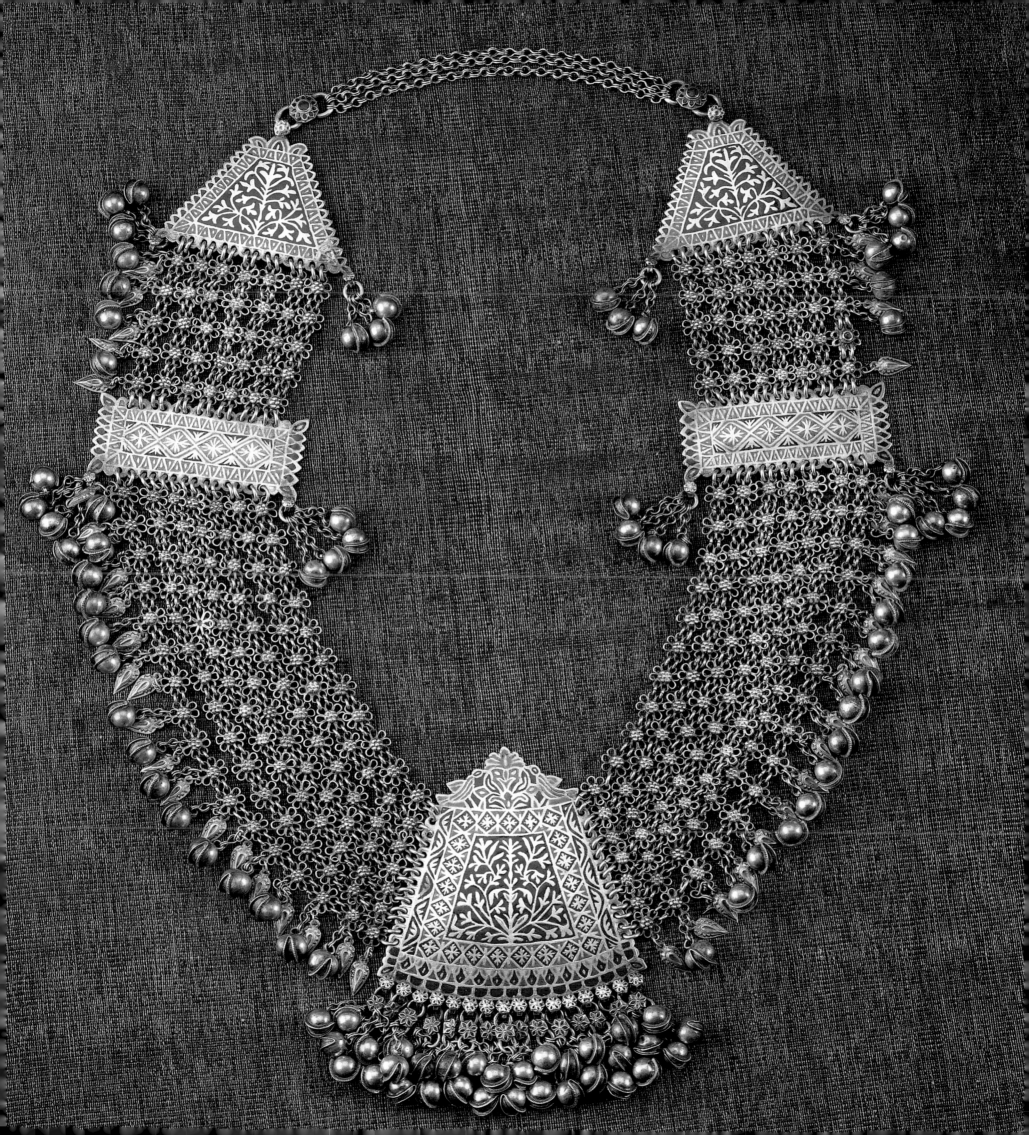

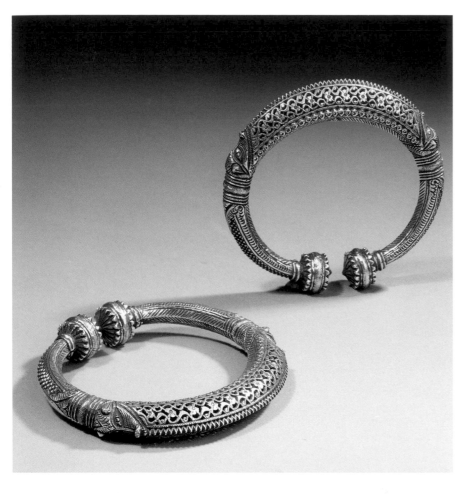

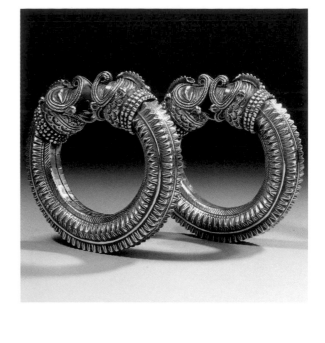

Left:

India
Punjab/Himachal Pradesh
D 13 cm,
286 grammes together
silver
name: *jhanjar*
anklets
middle 20th century

Right:

India
Madhya Pradesh/Rajasthan
D 13 cm,
518 grammes together
silver
anklets
1st half 20th century
2 makara heads, opening in
the middle

Left below:

India
Himachal Pradesh
D 17 cm, 693 grammes
silver and gilding
name: *hansuli*
neck ring
1st half 20th century
massive silver; owner's
name engraved in Urdu
(see page 121, right)

Below:

India
Left:
Himachal Pradesh
D 12.5 cm, 483 grammes
silver
name: *hansuli*
neck ring (torque)
middle 20th century
massive cast silver; open at
the top and ending in 2
dragon/lion heads; flower

motifs in the middle

Right:
Himachal Pradesh
D 7.5 cm, 233 grammes
silver and gilding
bracelet
20th century
massive cast open silver
bracelet; dragon heads at
either end, with gilded
eyes, ears and tongue

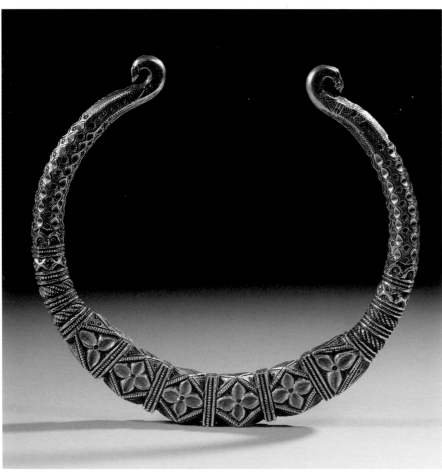

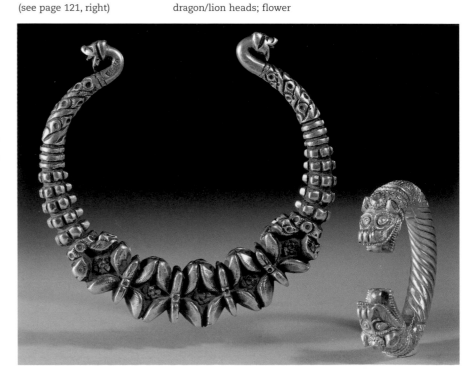

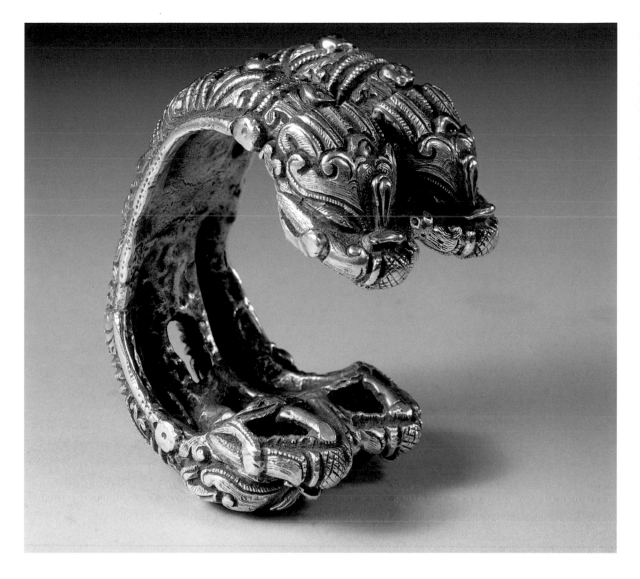

India
Himachal Pradesh
L 8 cm, H 6 cm, W 4.5 cm,
400 grammes
silver and rock-crystal
bracelet
1st half 20th century
cast four-headed dragon
bracelet with 8 inlaid pieces
of rock-crystal

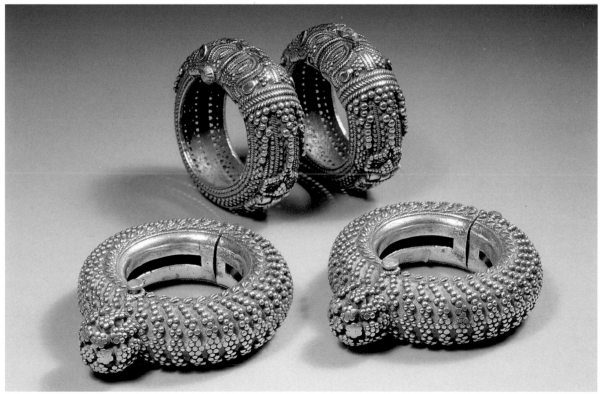

India
Madhya Pradesh
Top:
D 8.5 cm,
629 grammes together
silver
anklets
20th century
2 touching makara heads;
peg fastening

Bottom:
L 12.5 cm, D 10 cm,
882 grammes together
cast silver
anklets
20th century
encrusted with balls; peg
fastening in the front

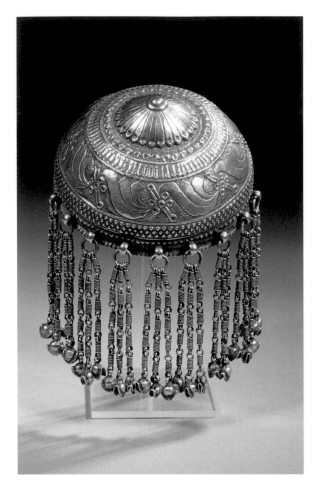

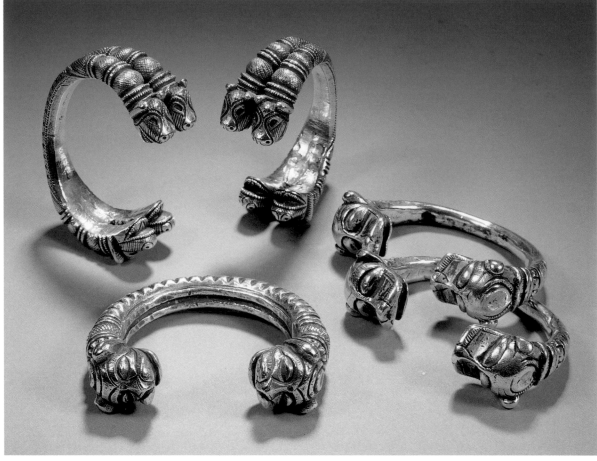

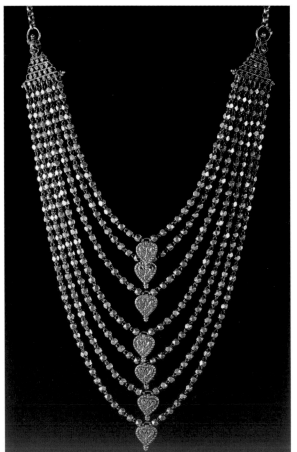

Left above:

India
Himachal Pradesh
H 7 cm, W 11 cm,
283 grammes
silver
name: *chak*
woman's head covering
20th century
27 chains plus bells as
appendages (each chain 8
cm)

Left:

India
Himachal Pradesh
H 43 cm, W 31 cm,
808 grammes
silver
name: *pathachong, kachong*
or *kath mal*
chain
1st half/middle 20th
century
chain consists of 2 triangles
connected by 7 tiers of
facetted silver beads; in the
middle of each tier a heart-
shaped plate with two birds

India
Left:
Himachal Pradesh
H 5 cm, W 7 cm,
364 grammes together
silver and enamel
woman's bracelets
20th century
double head of a lion or
dragon; eyes and faces with
blue and green enamel

Centre:
Himachal Pradesh
H 7 cm, W 8 cm,
248 grammes
silver
woman's bracelet
20th century
worked central part; lion's
head at the end

Right:
Himachal Pradesh
H 6 cm, W 8 cm,
332 grammes together
silver
woman's bracelets
20th century
smooth central part; lion's
head at the end

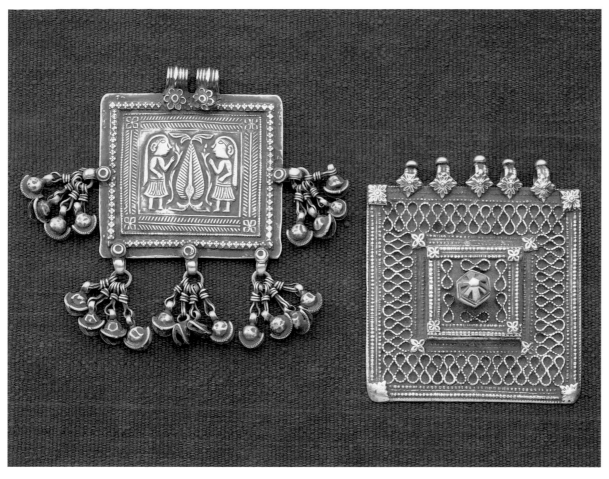

India

Left:
Himachal Pradesh
L (without bells) 7.5 cm,
H (without bells) 7.5 cm,
75 grammes
die-stamped silver
amulet
middle 20th century
square amulet with bells on
the sides and bottom;
depiction of the tree of life
flanked by two guardians
Right:

Rajasthan
L 7.5 cm, H 8.5 cm,
82 grammes
silver
amulet
middle 20th century
silver house amulet; a sym-
bol of family unity repre-
sented by a walled-in rec-
tangle

India

Top:
Gujarat
H 5.5 cm,
82 grammes together
silver
name: *vedhala*
earrings
1st half 20th century
worn by Bhopa women

Left:
Orissa/Assam
H 5.5 cm,
25 grammes together

silver alloy
name: *nagula*
earrings for the upper ear
1st half 20th century
twisted cobra earrings; spi-
rally inserted into 5 or 6
holes in the upper ear

Right:
Gujarat
H 4.5 cm,
43.8 grammes together
silver
earrings
1st half 20th century

India
Rajasthan
D 12.5 cm, 190 grammes
silver
name: *knatria* or *bangri*
gokru
bracelets
1st half 20th century
(see page 122, bottom)

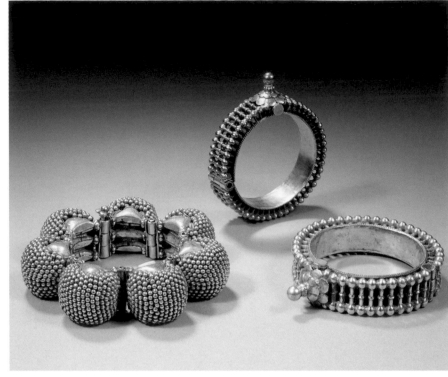

India

Top:
Rajasthan
D 7 cm,
480 grammes together
silver
bracelets
1st half 20th century
bracelets with semi-flexible
links; front: screw thread
fastener

Bottom:
Rajasthan (Jaisalmer area)
H 10 cm, W 7 cm,
458 grammes together
silver
bracelets
1st half 20th century
massive silver

India

Left:
Rajasthan
H 2 cm, D 9 cm,
311 grammes
silver
bracelet
early 20th century
7 flexible links consisting of
half balls, each built up

from small balls fixed on
firmly plaited silver wire

Right:
Gujarat/Rajasthan
H 8.3 cm, D 7 cm,
121 grammes
silver
bracelet
middle 20th century

Top:
Gujarat / Rajasthan
H 7.5 cm, D 6 cm,
56 grammes
silver
bracelet
middle 20th century
inside: engraved owner's
name

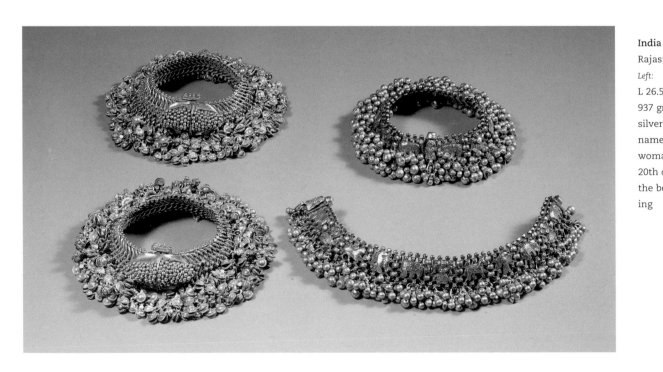

India
Rajasthan

Left:
L 26.5 cm,
937 grammes together
silver
name: *paizeb*
woman's anklets
20th century
the bells jingle while walk-
ing

Right:
L 27 cm,
692 grammes together
silver
name: *paizeb*
woman's anklets
20th century
adorned with the images of
4 women, 4 elephants, 1
horse, 1 lion & 2 birds; the
bells jingle while walking

India

Top:

Rajastan (Jaisalmer)
H 10 cm, W 4.5 cm,
162 grammes together
silver
name: *karanphul-jhumka*
('earflower-bell')
pair of earrings
20th century
front: floral motifs; consist-
ing of two parts; fastener at
the back

Bottom:

Gujarat
H 6.5 cm, D 8 cm, 183
grammes together
silver and gold foil
earrings hanging from a
chain fastened to the head-
dress
20th century
front: squares with gold
foil; back: 2 pendants

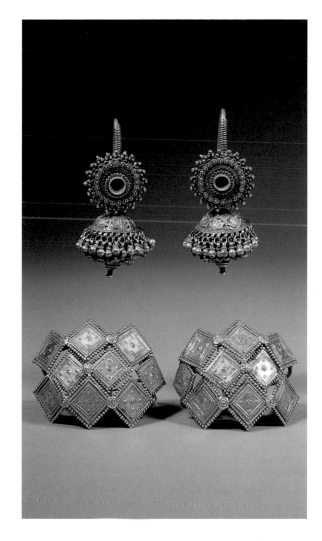

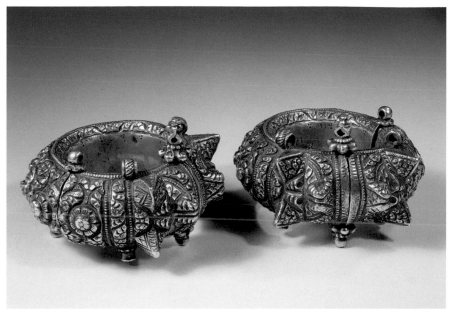

India

Gujarat
H 8 cm, D 11.5 cm, 1325
grammes together
silver
name: *todo* or *kalla*
anklets
1st half 20th century
repoussé and chasing work;
the design represents two
opposing *makara* heads

India

Rajasthan (Bikanair area)
D 20 cm, 293 grammes
silver
name: *hansuli*
neck ring
1st half 20th century

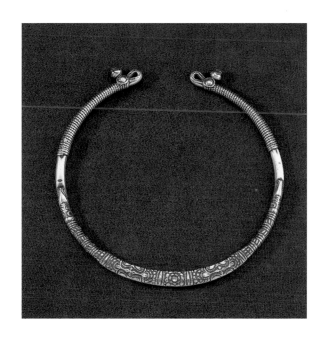

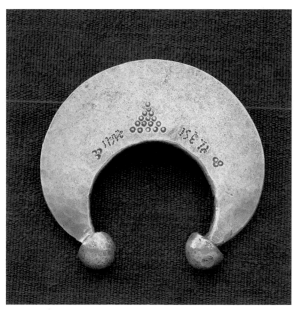

India

Gujarat
H 9.5 cm, W 10 cm,
218 grammes
silver
woman's bracelet, also used
for self-defence
middle 20th century
front: engraved owner's
name

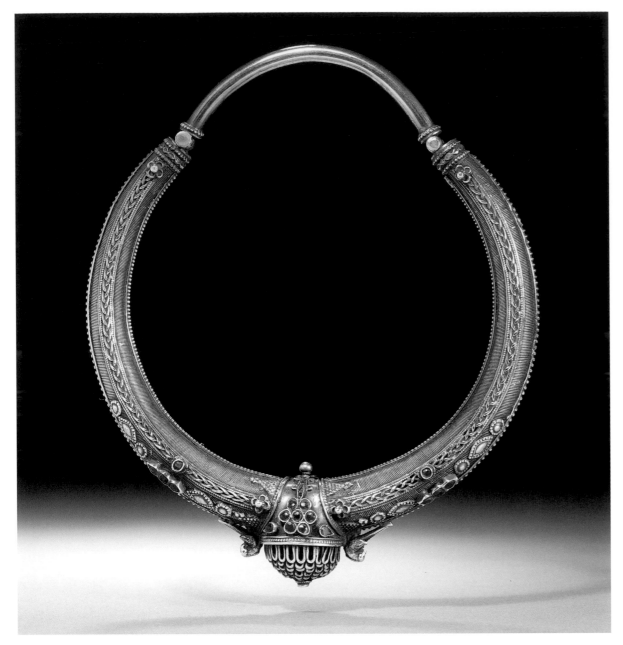

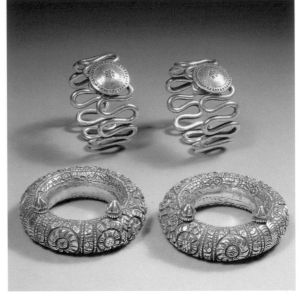

India

Top:
Madhya Pradesh
H 3.8 cm, D 8 cm, 503
grammes together
silver
name: *nagmuri*
bracelet for the upper arm
on flat round disc (front)
engraved owner's name

Bottom:
Rajasthan
D 9.8 cm, 643 grammes
together
silver
anklets
20th century
consists of two parts, linked
by means of two screws;
knob at the top; floral
motifs

India
Rajasthan (Bikanair area)
H 19 cm, W 16 cm,
232 grammes
silver and glass stones
name: *hansuli*
neck ring
middle 20th century

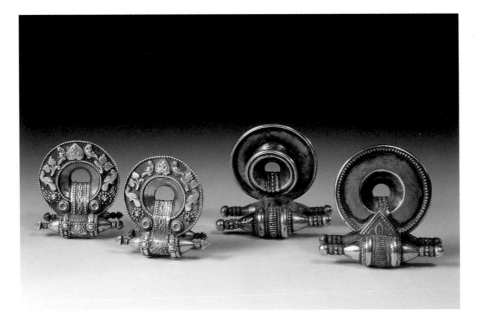

India

Left:
Gujarat (Saurashtra)
H 5 cm, W 5 cm,
67.2 grammes together
silver with parcel-gilded
stamped units
name: *akota*
woman's ear ornaments
middle 20th century

Right:
Gujarat (Saurashtra)
H 6 cm, W 6.2 cm,
83.4 grammes together
silver
name: *akota*
woman's ear ornaments
middle 20th century

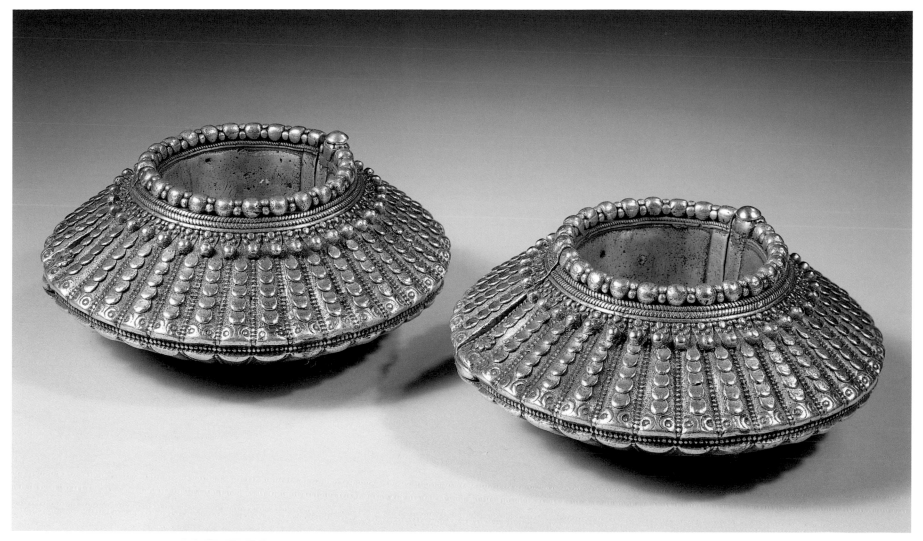

India
Madhya Pradesh
H 7 cm, D 15.5 cm,
2000 grammes together
silver
anklets
1st half 20th century
cast silver hollow anklets,
the two parts are joined by
means of pegs

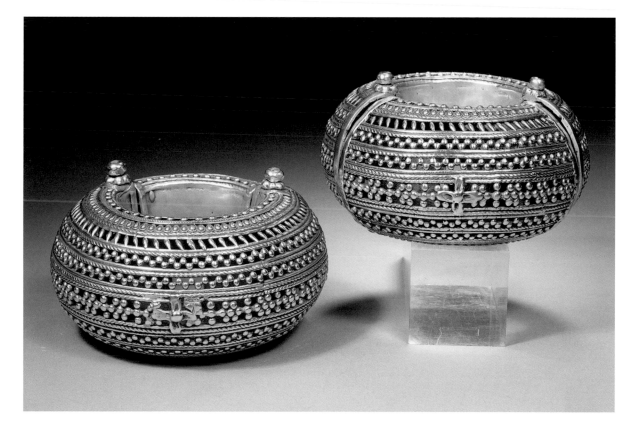

India
Madhya Pradesh
H 8.5 cm, D 14.5 cm,
1730 grammes together
silver
anklets
1st half 20th century
opens into 2 parts by
means of 2 screws

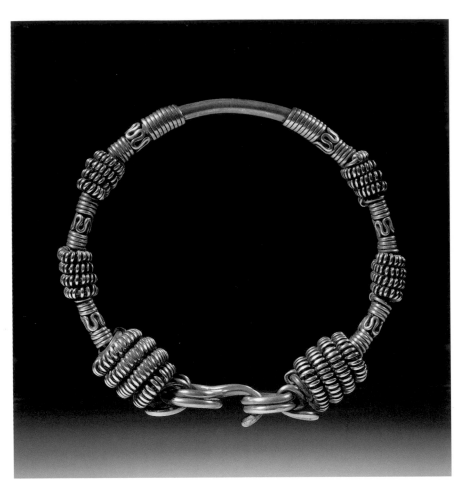

India
Maharashtra
D 15.5 cm, 393 grammes
silver
neck ring
20th century
rigid and wrapped wire

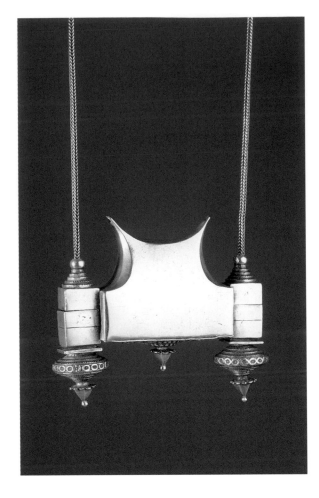

India
Karnataka
H 10.5 cm, W 12 cm,
D 3.5 cm, 374 grammes
silver
lingam casket in square
(chauka) form
20th century
top part in the shape of
stylised buffalo horns,
referring to Shiva's nandi
bull, protecting against evil

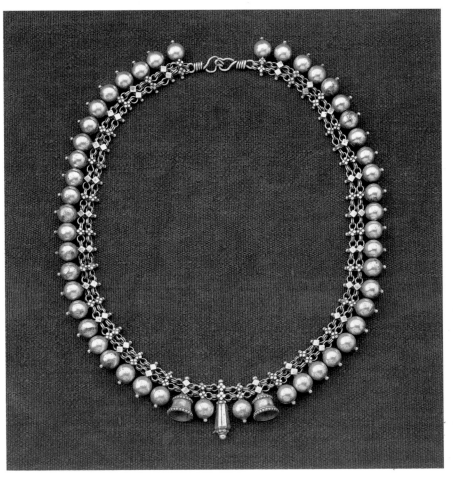

India
Maharashtra
H 25 cm, W 19 cm,
175 grammes
silver
woman's necklace
20th century
silver balls on links; bottom
2 bells and a pendant

Detail of the bottom of
lingam container, compara-
ble with the one depicted
above

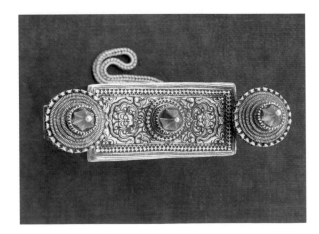

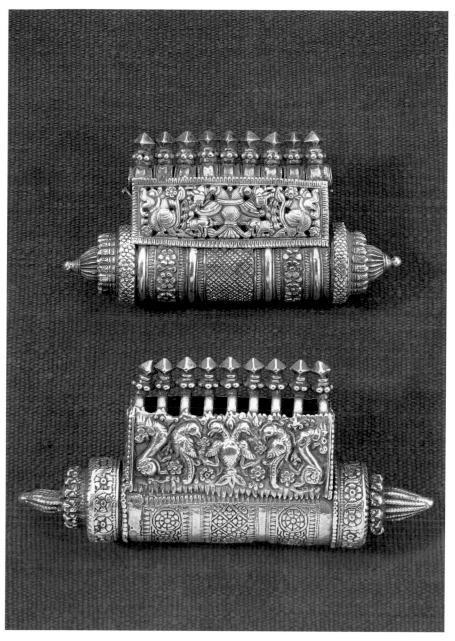

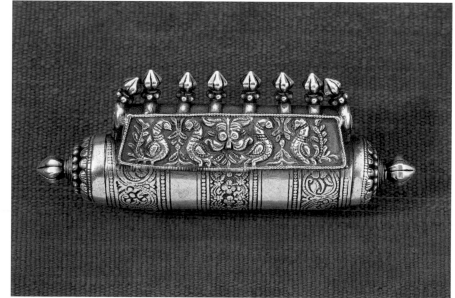

India
Karnataka
L 11 cm, H 4 cm,
113 grammes
silver
name: *ta'wiz*
amulet container
early 20th century
opens on the side by means
of a screw thread; in the
middle a depiction of the
head of Kirtimukha, flanked
by birds

India
Top:
Karnataka
L 10.5 cm, H 5 cm,
93 grammes
silver
name: *ta'wiz*

Bottom:
Karnataka
L 12.5 cm, H 5.5 cm,
184 grammes
silver
name: *ta'wiz*
amulet container
1st half 20th century
opens on the side by means
of screw thread
worn from a chain by

India
Karnataka
H 5.5 cm, L 12 cm,
123 grammes
silver
name: *ta'wiz*
amulet container
1st half 20th century
opens on the side by means
of screw thread, in the mid-
dle 2 birds flanked by 2
lions, also geometrical and
floral motifs

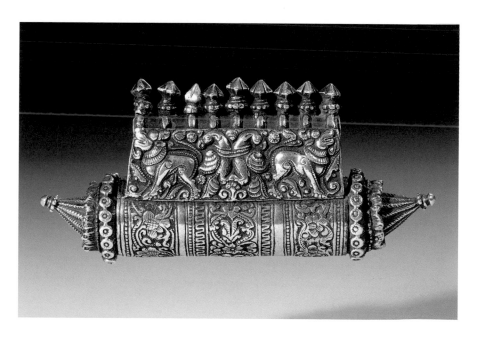

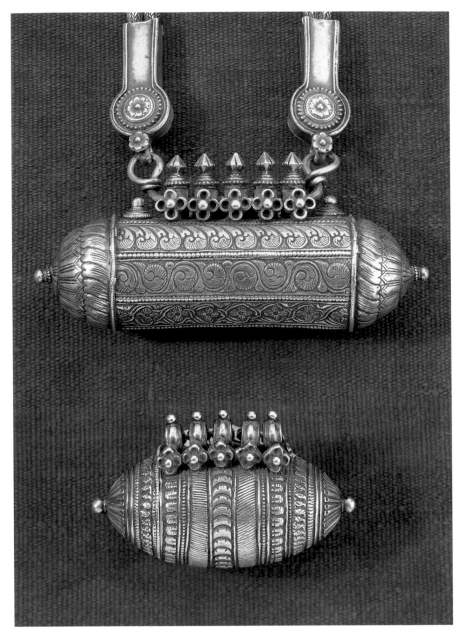

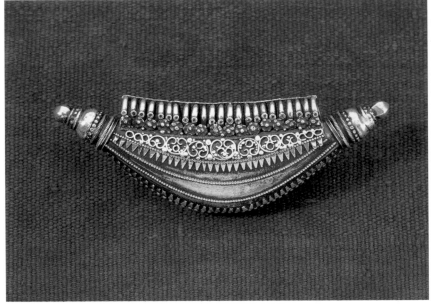

India
Kerala
L 10.2 cm, H 3.6 cm,
45 grammes
silver and lacquer
name: *ta'wiz*
amulet container
1st half 20th century
fertility amulet; milk bottle
with 2 teats at the end,
worn by women wishing to
become pregnant

India
Uttar Pradesh
H 11 cm, W 12 cm,
49 grammes
silver and glass stones
nosering
middle 20th century
consisting of 3 fixed silver
plates plus various silver
beads; nosering is worn by
Bothia and Jaunsari
women; it is also worn con-
nected to the headdress by
means of a chain

India

Top:
Andhra Pradesh
L (chain) 80 cm,
L (container) 11.5 cm,
H 5.3 cm,
total weight 240 grammes
silver
name: *ta'wiz*
amulet container
1st half 20th century
worn by Muslim women;
geometrical and floral
motifs

Bottom:
Andhra Pradesh
L 8 cm, H ±4.8 cm, 116
grammes
silver
name: *ta'wiz*
amulet container
1st half 20th century
opens on the side by means
of a screw thread; worn by
Muslim women; geometri-
cal motifs

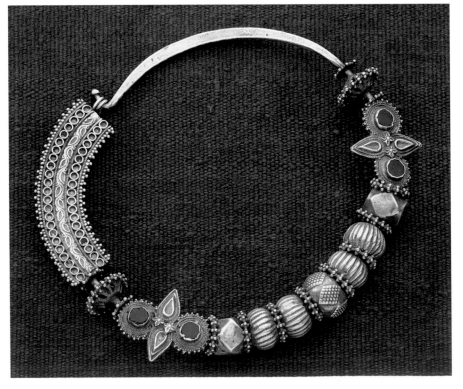

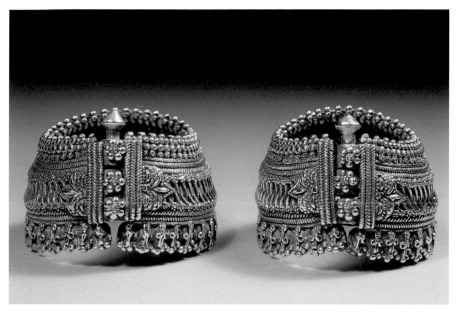

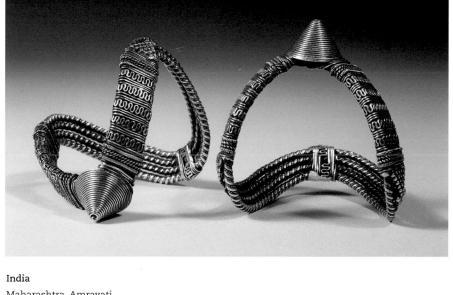

India
Maharashtra
H 5 cm, D 8.5 cm,
778 grammes together
cast silver
anklets
20th century
encrusted with balls at the
bottom; peg fastening in
the front

India
Left:
Orissa
L 13 cm, W 9 cm, H 5 cm,
371 grammes together
silver
name: *goda bala*
anklets
middle 20th century
back and front turned
upwards; adorned with a
total of 4 knobs

Right:
Madhya Pradesh
D 10 cm
silver
anklets
middle 20th century
cast hollow anklets, con-
sisting of 2 parts

India
Maharashtra, Amravati
region, Korku tribe*
H 9 cm, W 8 cm,
355 grammes together
silver
name: *vanki*
woman's armlets
middle 20th century
V form armlets; rigid twist-
ed-and-wrapped wire, worn
on the upper arm

(*source: Tribal Research
Training Institute and Museum
in Pune, Maharashtra)

India
Orissa
H 7.5 cm, W 7 cm, L 15 cm,
316 grammes together
silver
anklets
20th century
back and front curving
upwards; engraved sides;
knob in the front

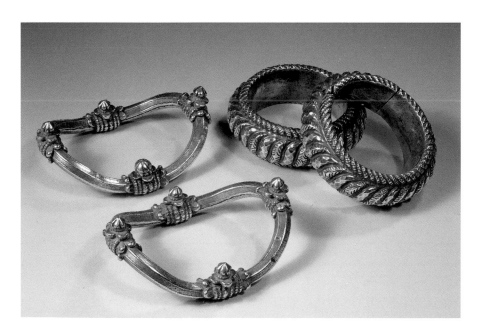

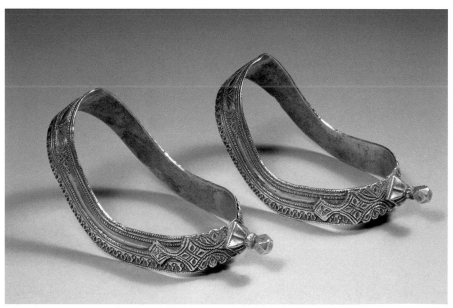

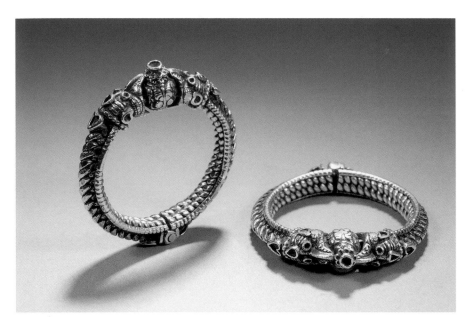

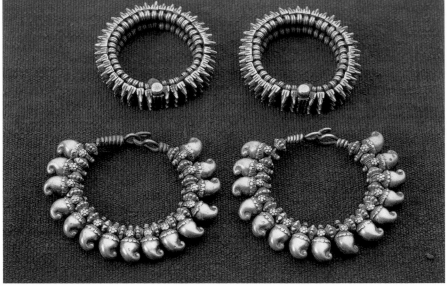

India
Tamil Nadu (Madras)
D 6.5 cm,
220 grammes together
silver
woman's bracelet

20th century
opens by means of a central
screw at the top; 2 *makara*
heads, a magic 'jewel'
between the two *makara*
mouths

India
Top:
South India
D 6 cm, 158 grammes
together
silver
children's anklets
middle 20th century
flexible anklets consisting
of separate units with 3
points per unit on cotton
thread; front: screw thread
fastening

Bottom:
Karnataka
D 8.5 cm, H 7 cm,
109 grammes together
silver
name: *painjin*
children's anklets
middle 20th century
consists of mango-shaped
beads

India
Top:
Tamil Nadu
L 79 cm, W 2.5,
450 grammes
silver
name: *araipatti*
early 20th century
Hindu girdle

Bottom:
Tamil Nadu
L 72.5 cm, W 4.5 cm, 926
grammes
silver
name: *araipatti*
early 20th century Hindu
girdle

Right:

India
Outside:
Tamil Nadu, Toda tribe
L (silver chain) 78 cm,
2030 grammes
silver, cowrie shells
adornment of a water
buffalo
1st half 20th century
diameter of shell disc 19
cm; from the bottom hangs
a Chinese coin; the shell
discs hang across the buffa-
lo's back as a counterweight

Inside:
Tamil Nadu, Toda tribe
L 43 cm, 169 grammes
silver, lacquer beads, glass
woman's necklace
this chain was worn during
the buffalo procession

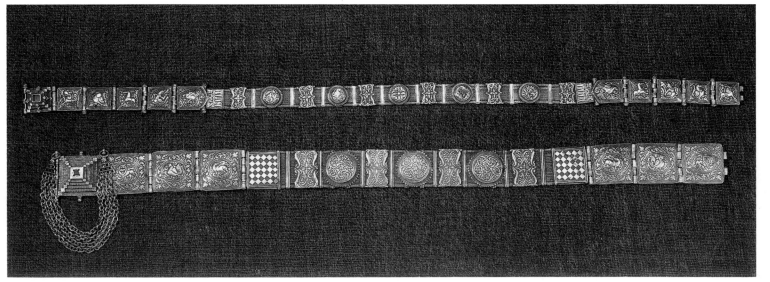

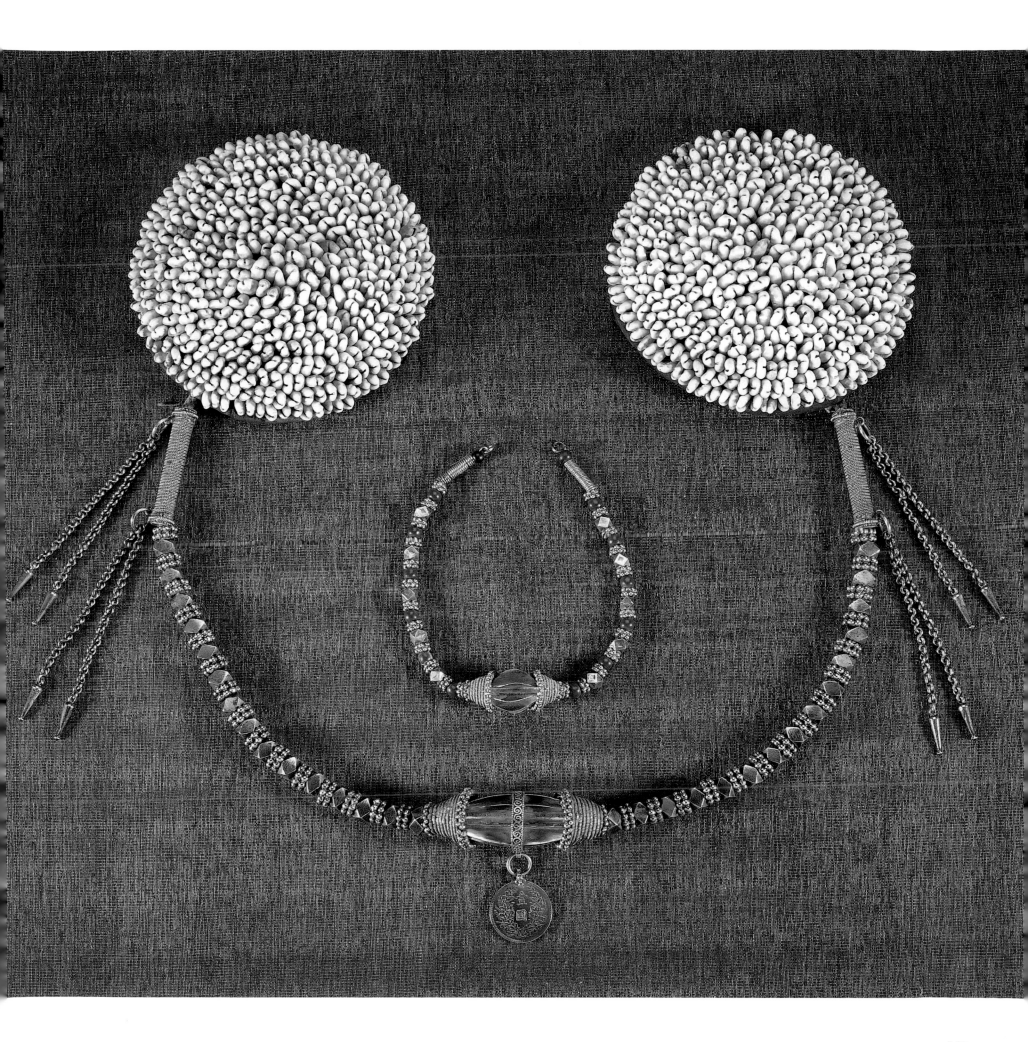

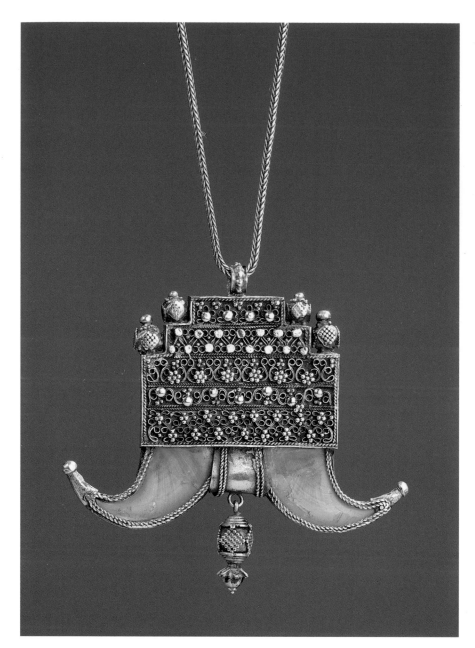

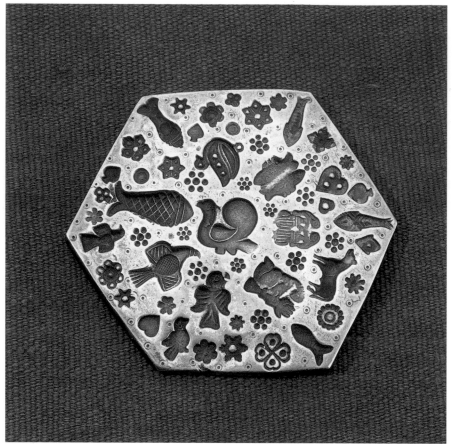

India
H 7.5 cm, W 8.5 cm
cast brass
name: *thappa*
mould
early 20th century
hexagonal jeweller's mould

India
Tamil Nadu
H 7.8 cm, W 8.1 cm,
38 grammes
silver and tiger claws
name: *viagra naka*
amulet
late 19th century
2 tiger claws set in silver

India
Kerala
L 18.5 cm, W 16 cm,
1645 grammes together
cast bronze with the inclu-
sion of bells
name: *kal chilampu* or *pujari
kai chilabu*
anklets
1st half 20th century
worn by priests; the sym-
bols depicted on the
anklets are: the sun, the
moon and the holy sword
(*baliyagiya katam*)

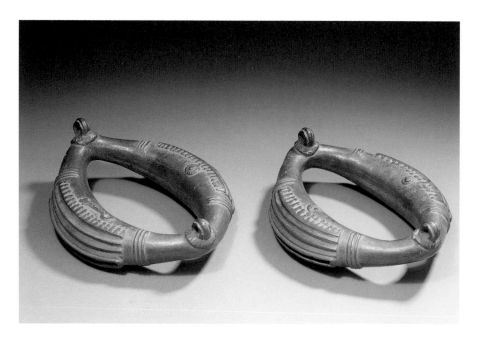

India

Kerala (Kozhikode, Calicut)
L 114 cm, W 6 cm, 825
grammes
silver
name: *arapatta*
girdle
20th century
girdle worn by Muslim
women

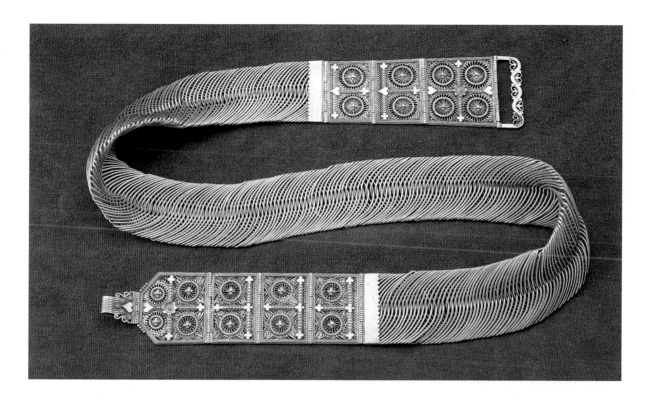

India

Top:
Andhra Pradesh
L (girdle) 106 cm; box: H 5.5
cm, W 8.5 cm, 308 grammes
silver
girdle with amulet box
early 20th century
box opens on top

Bottom:
Maharashtra/Andhra
Pradesh
L 87 cm, 576 grammes
silver
name: *kamarpatti* or *kandora*
girdle
early 20th century

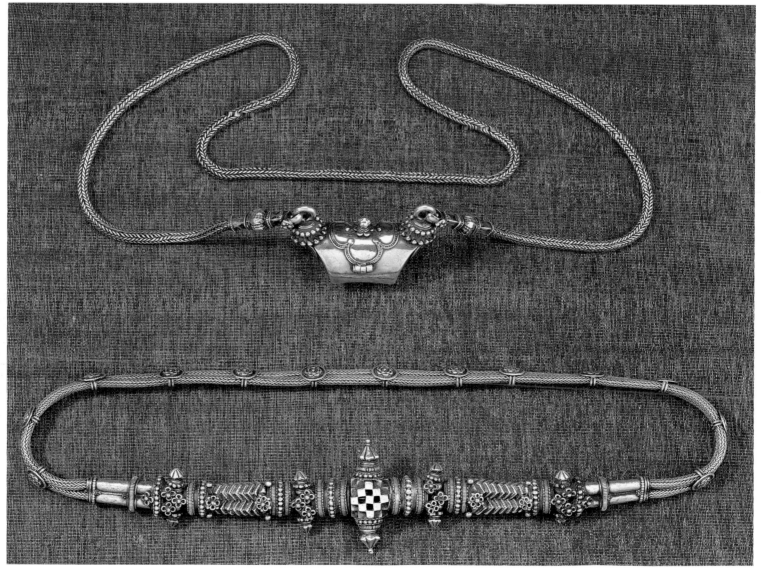

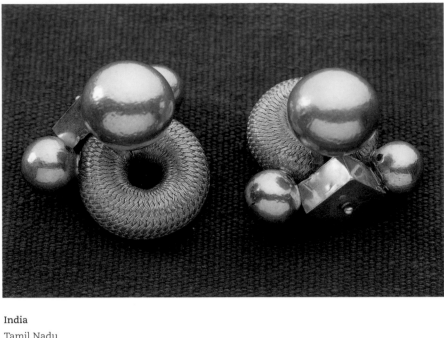

India
Tamil Nadu
H 4 cm, W 4 cm,
64.8 grammes together
gold and lacquer-filled balls
name: *mudichu*
woman's earrings
1st half 20th century
plaited flexible gold wire;
front: geometrical motifs
and 2 round balls; top fas-
tening of round ball on
screw thread

India
Tamil Nadu
H 5.2 cm, 85.2 grammes
together
gold and lacquer
name: *pampadam*
1st half 20th century
earrings: geometrical motifs
plus balls; looks like an
abstract bird's figure

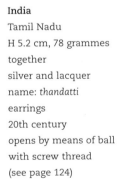

India
Tamil Nadu
H 5.2 cm, 78 grammes
together
silver and lacquer
name: *thandatti*
earrings
20th century
opens by means of ball
with screw thread
(see page 124)

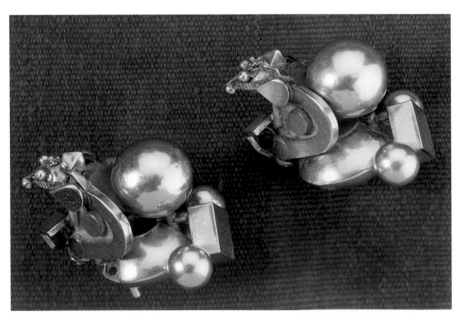

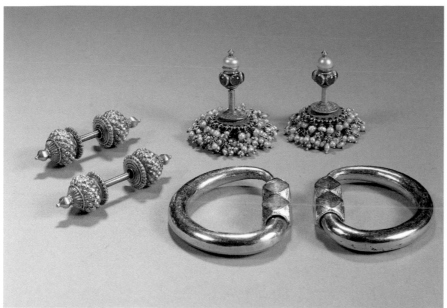

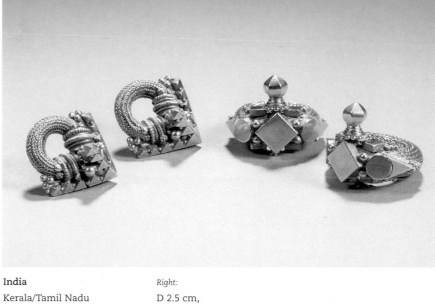

India

Left:

Tamil Nadu

L 4.2 cm, 8.8 grammes together

gold and silver

earrings for the upper ear

20th century

bar-shaped with a gold ball on either side of the silver bar; fastening by means of a screw thread

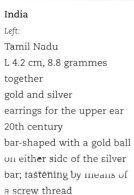

Top:

Maharashtra

H 3 cm, D 3 cm, 19.4 grammes together

gold, rubies, pearls

earrings for the upper ear

first half 20th century

Bottom:

Kerala (Cochin; Ernakulam and Alleppy area)

H 4.2 cm, W 3.9 cm, 11.3 grammes together

gold filled with lacquer

name: *kunuk*

earrings for the upper ear

20th century

worn by Indian-Syrian Christian older women; now out of fashion

(see page 3)

India

Kerala/Tamil Nadu

Left:

D 2.5 cm, 16.2 grammes together

earrings

20th century

plaited flexible gold wire; front: conical surfaces ending in a point; fastening by means of a screw thread

Right:

D 2.5 cm, 20.4 grammes together

gold

earrings

20th century

plaited flexible gold wire; front: round and geometrical surfaces; fastening by means of a screw thread plus knob (front)

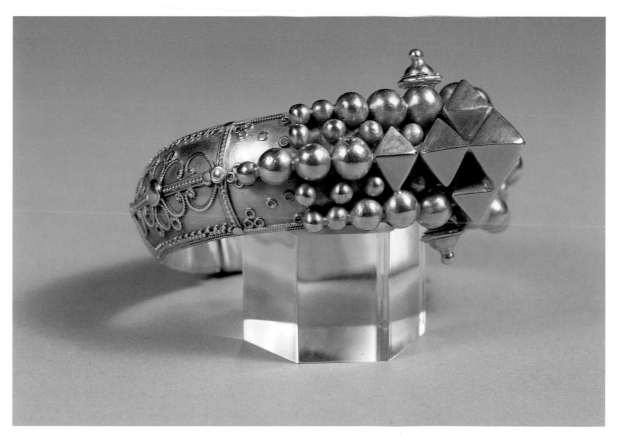

India

Kerala/Tamil Nadu (Coimbatore)

H 8.5 cm, D 7 cm, 97.6 grammes

gold and lacquer

woman's bracelet

20th century

appliqué work, balls and conical shapes

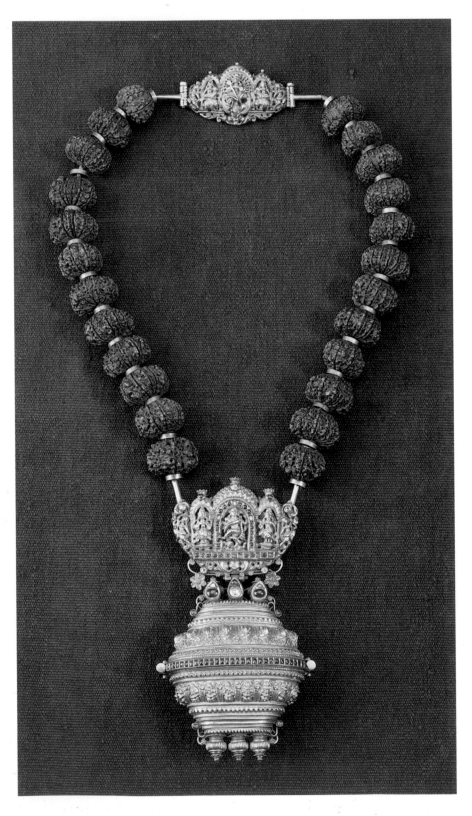

India
Tamil Nadu
L 36.5 cm, W 16 cm,
305 grammes
gold, silver, precious stones
(rough diamond, rubies,
emeralds, crystal), rudrak-
sha nuts, lacquer
name: *rudrakshamalai*
temple chain worn by the
head of a Brahman family
and by Shaivite priests
19th century
this type of chain is worn
when taking important
decisions; on the back can
be read: 'S.P.S.R.M.', indicat-
ing the former owner; the
first S ('son of') was added
later

Below:
lock at top of chain
depiction of 3 figures:
left: Valli, Karthik's wife
middle: Karthik , God of
War (riding a peacock) ,
Nataraja's son
right: Theyvayani, Karthik's
wife

Right:
upper part of pendant,
lingam (bottom of chain)
depiction of 3 figures:
left: Appar (a poet)
middle: Nataraja (god of
dance, dancing Shiva)
right: Gauri, one of the
many names of Shiva's wife

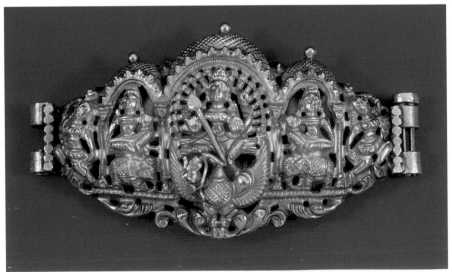

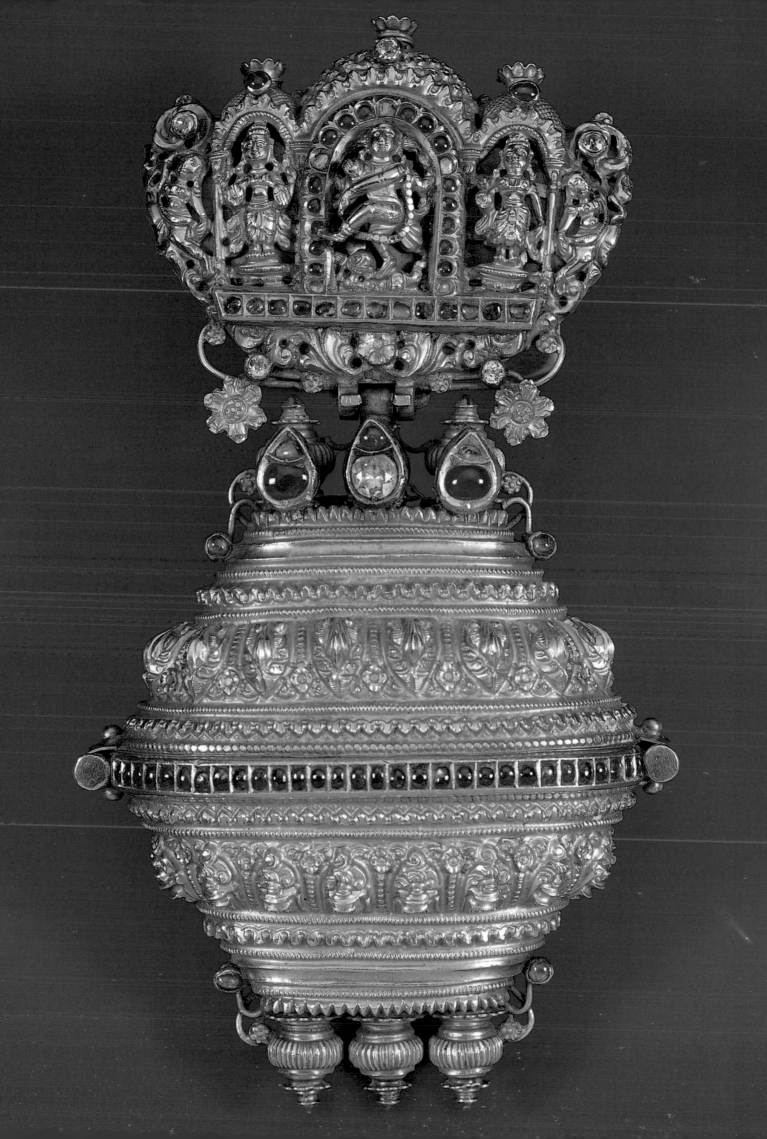

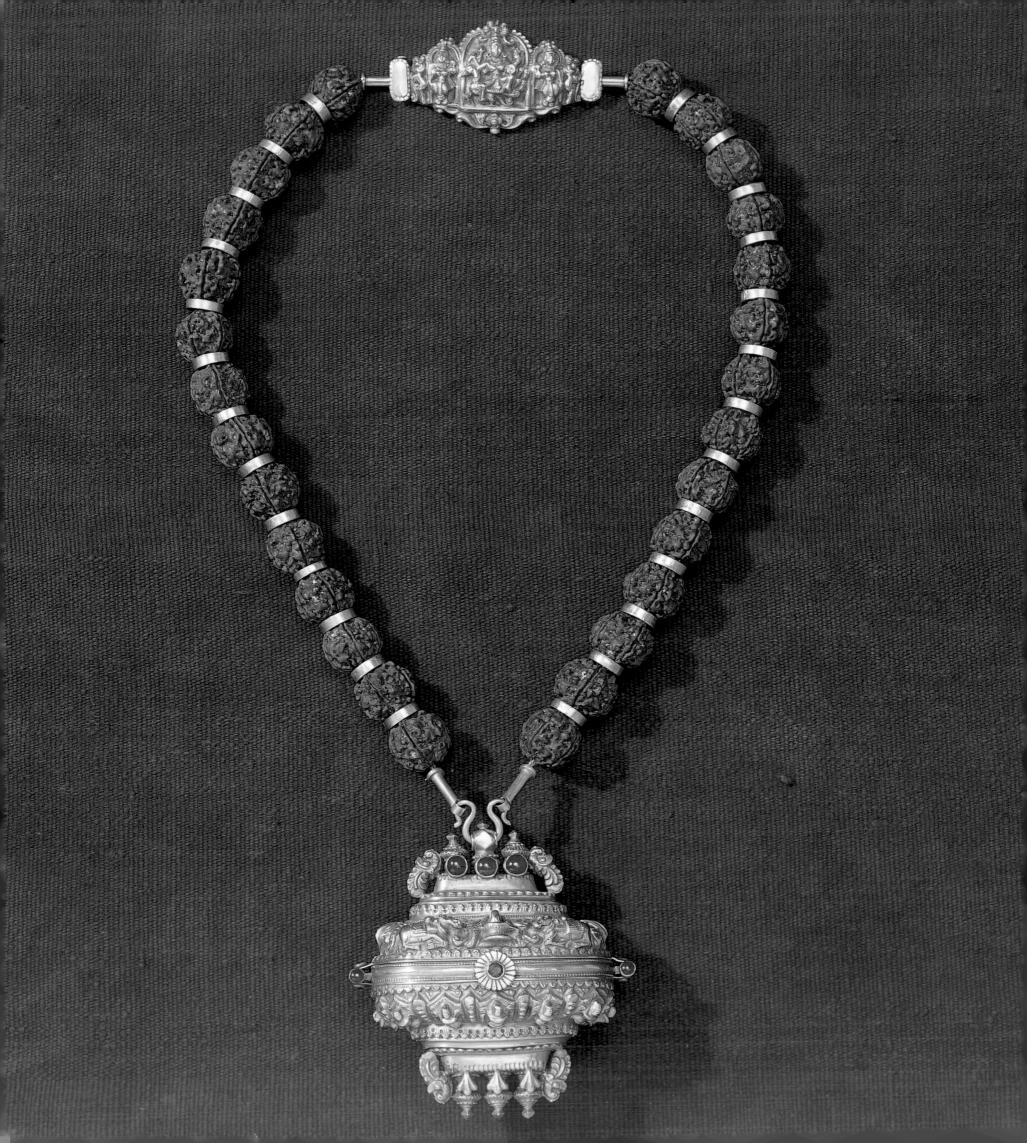

India
Tamil Nadu
H 33 cm, W 17 cm,
271 grammes
gold, silver, rudraksha nuts,
rubies, green glass stone
name: *rudrakshamalai*
temple chain worn by the
head of a Brahman family
and by Shaivite priests.
late 19th, early 20th century
on the lock at the top of the
chain: Karthik, the God of
War, Shiva's son, flanked by
two goddesses, Valli and
Theyvayani; the *lingam* con-
tainer is richly adorned a.o.
with two *nandis*, Shiva's
bull.
A *lingam* is a phallic symbol
– a phallus being the sym-
bol of the God Shiva.

Below:

India
Top:
Tamil Nadu
H 4.5 cm, W 5 cm,
28 grammes
gold, silver, lacquer
hair ornament worn at the
top of a woman's braid
20th century
depiction of Shiva and
Parvati, a five-headed cobra
and nandi on the bottom;
on the back the name of
the former owner

Bottom:
Tamil Nadu
H 5.5 cm, W 5.2 cm,
33.3 grammes
gold, silver, lacquer, rubies,

2 green glass stones
hair ornament worn at the
top of a woman's braid
20th century
depiction of Krishna
between his brother
Balarama and his sister
Subhadra; above Krishna a
five-headed cobra, a lion's
head below

Right:
Tamil Nadu
H 5.2 cm, W 4.5 cm,
26.6 grammes
gold, silver, lacquer
hair ornament worn at the
top of a woman's braid
20th century
depiction of Vishnu on a
Phoenix and a five-headed
cobra behind him

India
Karnataka, Bangalore
D 15 cm, 125 grammes
gold, one ruby, lacquer, cot-
ton
woman's necklace
19th century
gold on cotton plaiting; 4
strings of gold balls with
lacquer; above it U-form
gold segments

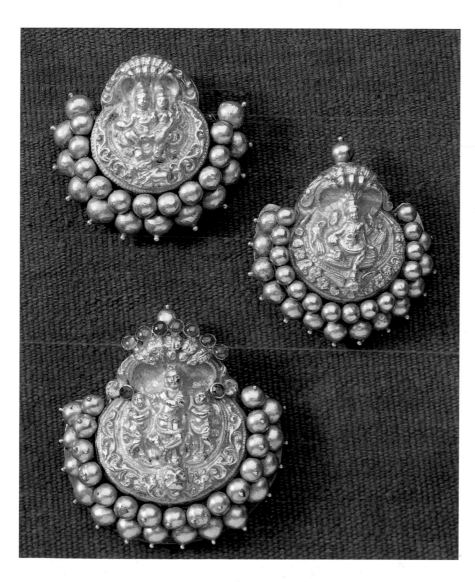

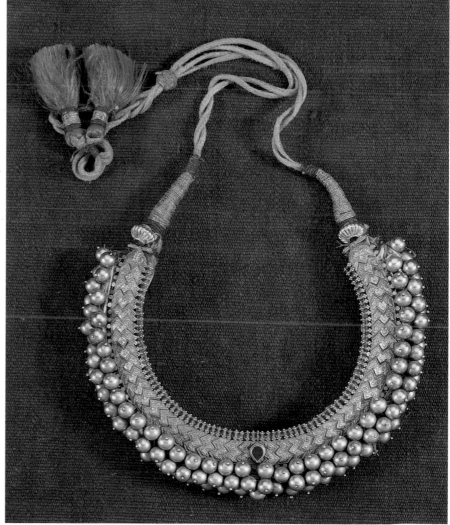

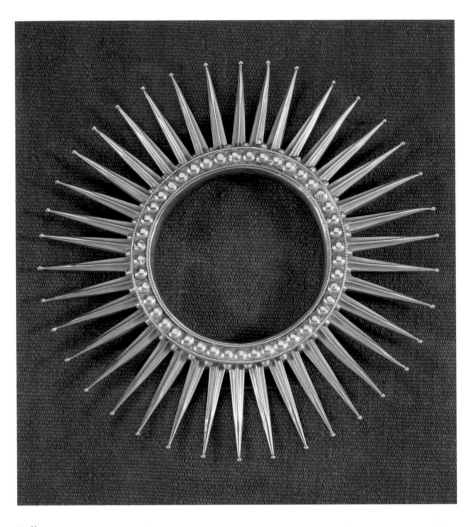

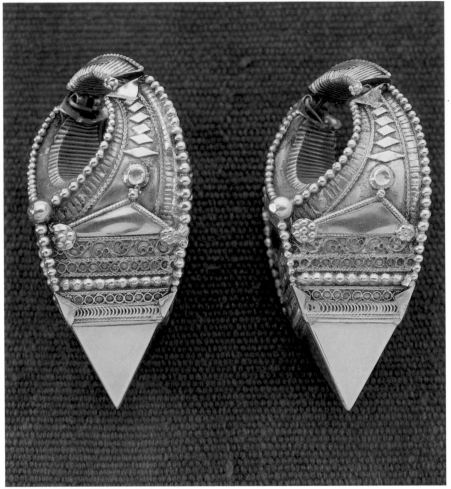

India
Tamil Nadu
D 16 cm, 156 grammes
gold with lacquer
bracelet, possibly also head
ornament
20th century
sun-shaped bracelet,
closed, 38 points; inside
diameter 6.8 cm

India
Kerala
H 6 cm,
76.6 grammes together
gold and lacquer
name: *andi bhaden kathija*
earrings
early 20th century
worn by Muslim women in
the Cochin Division

India
Karnataka
D ±26 cm, 138 grammes
(gold weight 123.8
grammes)
gold and rubies on cotton
string
name: *thali*
woman's wedding necklace
19th century
gold wedding necklace,
consisting of 31 gold beads,
each with one ruby (a total
of 16 different beads); this
particular type is called *kho-
lapuri saj*; the beads are
good luck symbols; a com-
parable thali is in the
Victoria and Albert Museum
in London

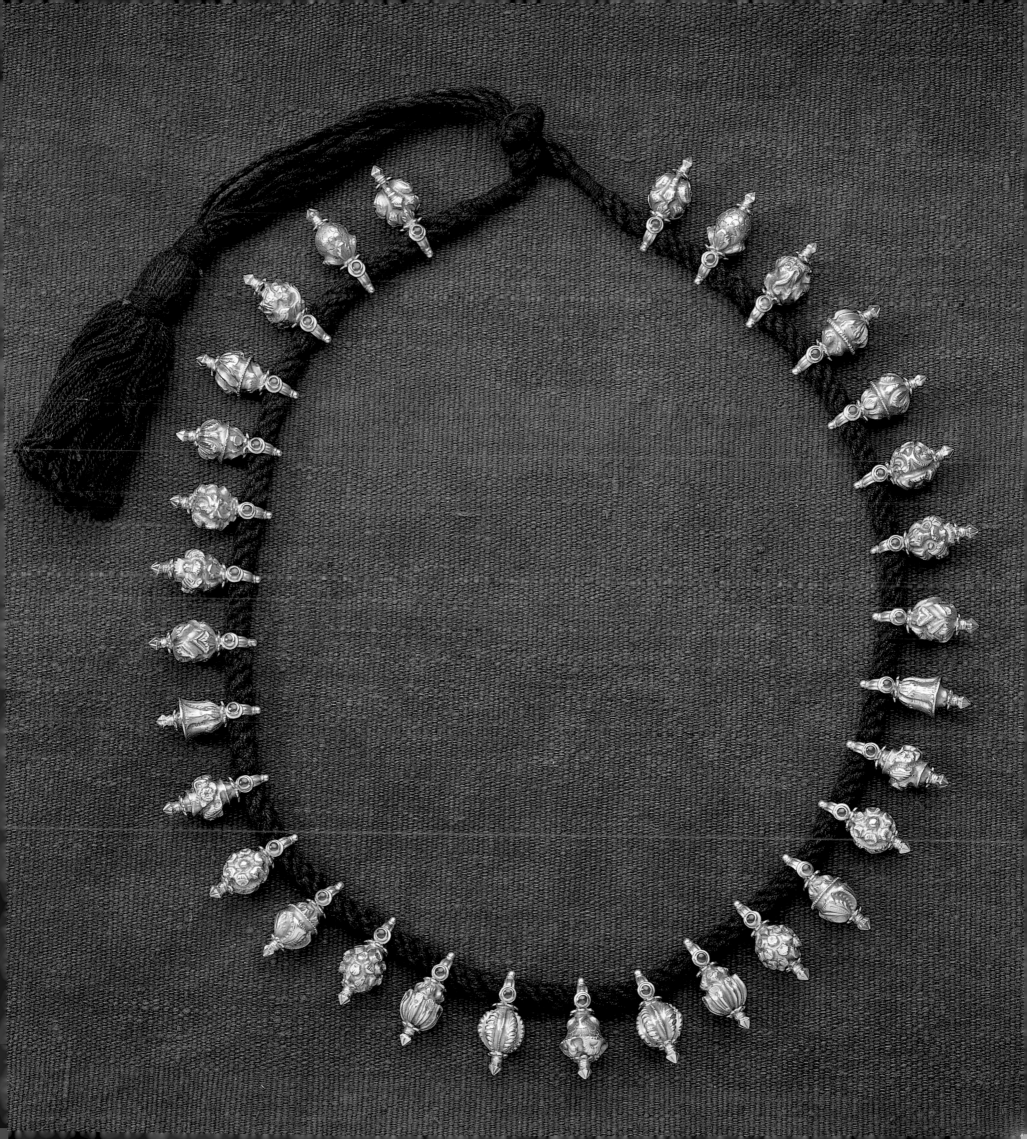

India

Rajasthan (Jaipur)

D 9.3 cm, 81.8 grammes
together

gold

woman's bracelets

late 19th century

inside: openwork floral
motifs with a wonderful
turned spiral trimmed with
facetted balls, a technical
tour de force, characteristic
of Indian craftsmanship

India

Left:

Rajasthan/Gujarat

H 4.4 cm, W 3.7 cm, 17.6
grammes

gold

man's amulet plate

20th century

depiction of Ganesha and
Parvati (his mother)

Ganesha the elephant-god,
son of Shiva and Parvati

Right:

Rajasthan/Gujarat

H 4.7 cm, W 2.9 cm, 11.1
grammes

gold

man's amulet plate

20th century

depiction of Vishnu's feet

Vishnu the Hindu god

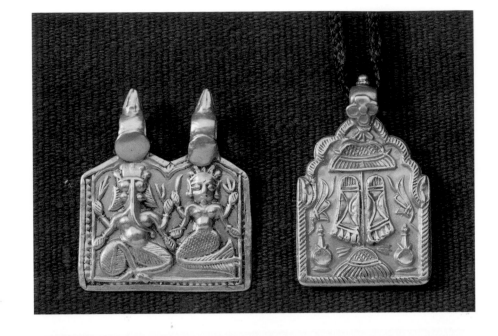

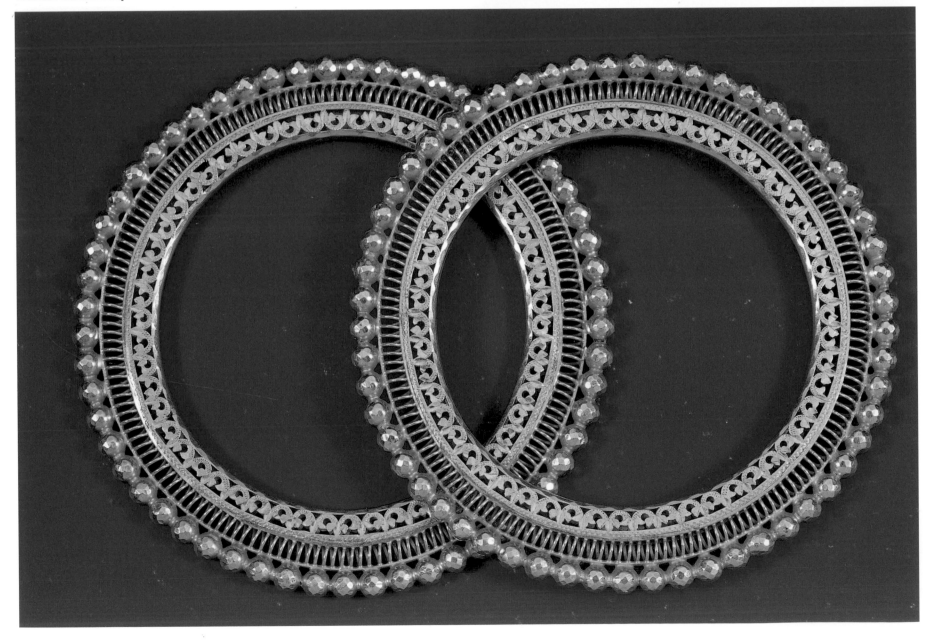

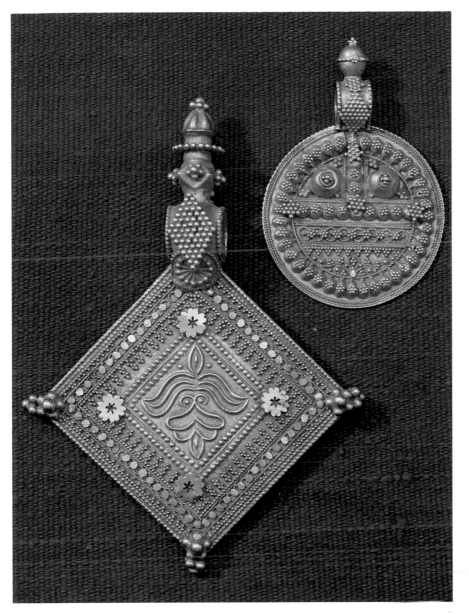

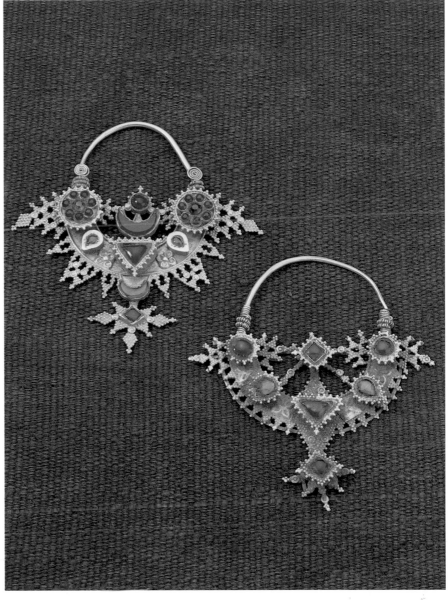

India

Left:

Gujarat (Bhuj region)

H 12 cm, W 8.5 cm, 43.6
grammes
gold
pendant
20th century
in the middle the depiction
of a stylised dancing god-
dess; rosettes and granula-
tion

Right:

Gujarat (Bhuj region)

H 6.8 cm, D 4.5 cm, 19
grammes
gold
name: *jibi*
pendant
20th century
depiction of two breasts;
rosettes and granulation
The pendant hangs from a
cotton cord with big cylin-
drical silver beads; mostly 2
gold beads are seen on
either side of the pendant.
(see page 122, top)

India

Rajasthan (Jasailmer area)

H 6 cm, W 5.8 cm, 12.2
grammes (left)
H 6.8 cm, W 5.6 cm, 11.2
grammes (right)
gold plus glass stones
name: *bulaq*
2 noserings
20th century
hanging straight down from
the middle of the nose

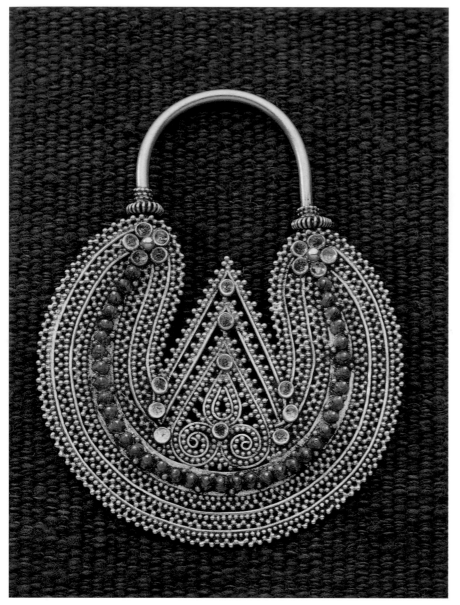

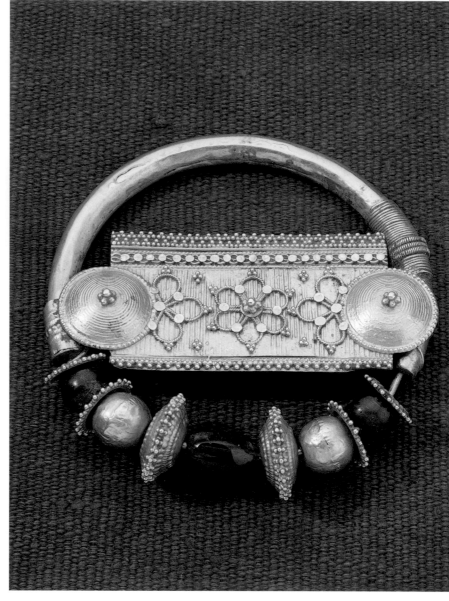

India
Himachal Pradesh
H 5.4 cm, W 4 cm, 11.8
grammes
gold
name: *bulaq* or *kundu*
nosering worn by married
women
20th century
technically perfect granula-
tion work

India
Gujarat
D 7.2 cm, 36 grammes
gold, glass beads and
lacquer
nosering
1st half 20th century
apart from being attached
to the nose, the ring was
also attached to the hair by
means of a cord
(see page 122, bottom)

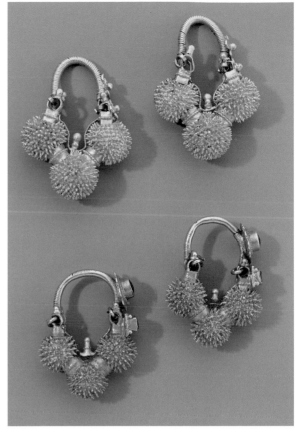

India

Top:

Gujarat

D 3 cm, 26.1 grammes

together

gold filled with lacquer

woman's earrings

middle 20th century

front and back ending in a

point; back provided with

rings

Bottom:

Gujarat / Rajasthan

H 2 cm, D 2.8 cm, 34.2

grammes together

gold plus 1 blue glass stone

woman's earrings

early 20th century

consists of 2 parts connect-

ed by means of screw

thread; back: depiction of

peacock

India

Top:

Gujarat

H 2 cm, D 4 cm,

35.4 grammes together

gold

name: *bhungri* or *phul*

man's earstuds

20th century

front: granulation work;

back: rod with screw thread

plus plate; worn in the

upper part of the ear

Bottom:

Himachal Pradesh

H 4.5 cm, W 3.5 cm,

0.8 grammes together

gold

woman's earrings

20th century

round twisted loop ending

in a closed spiral

India

Rajasthan (Jaisaimer region)

H 3 cm, W 2 cm,

18.6 grammes together (top)

H 2.5 cm, W 2 cm,

14.3 grammes together

(bottom)

gold and small glass stones

name: *babulkam*

man's earrings

1st half 20th century

the 3 balls per earring are

wholly covered with small

gold thorns, like in acacia

trees (*babul* meaning aca-

cia)

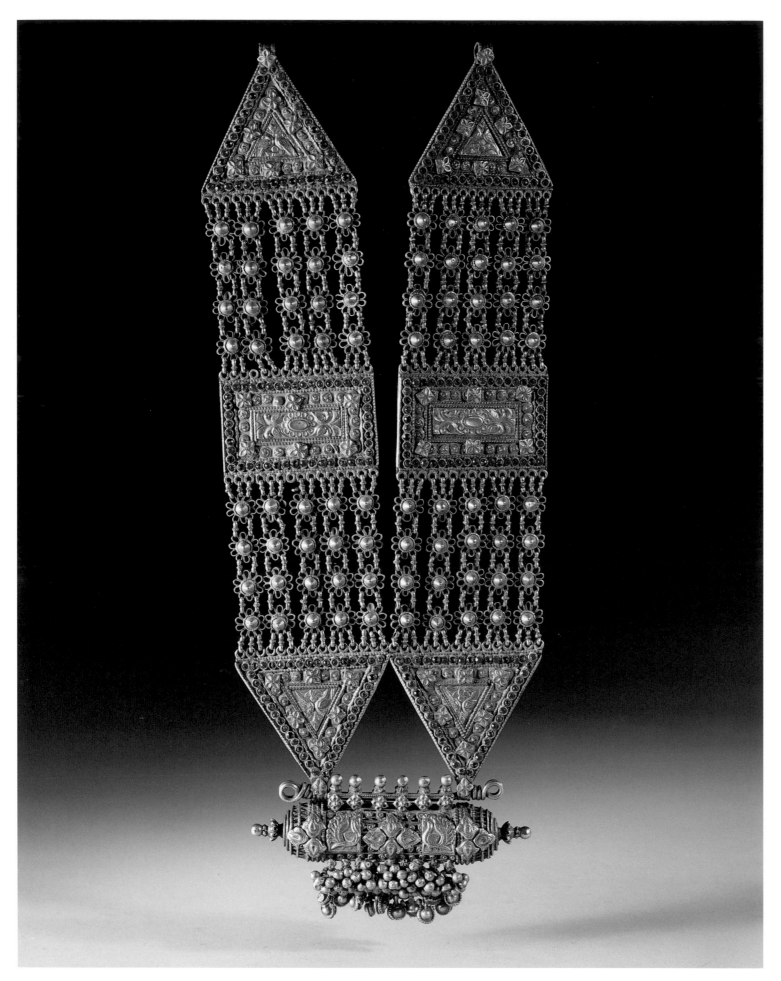

India
Rajasthan (Jaisalmer)
H 37 cm, W 13 cm,
530 grammes
silver, gilding and glass
stones
name: *chandan har, gallegi*
necklace
1st half 20th century
silver necklace consisting of
triangular spacers, of con-
necting chains, flower links
and loops, with central
amulet container and bells;
applied stamped units are
gold-plated and set with
red-and-green glass
facetted stones

Right:

India
Rajasthan
D 3.8 cm, 47.5 grammes
gold, silver, precious stones,
pearls
name: *bhor*
woman's forehead jewel
19th century
fastened by means of a sil-
ver eyelet; rough diamond,
crystal, ruby, turquoise, and
1 purple glass ring; lacquer
inside

160

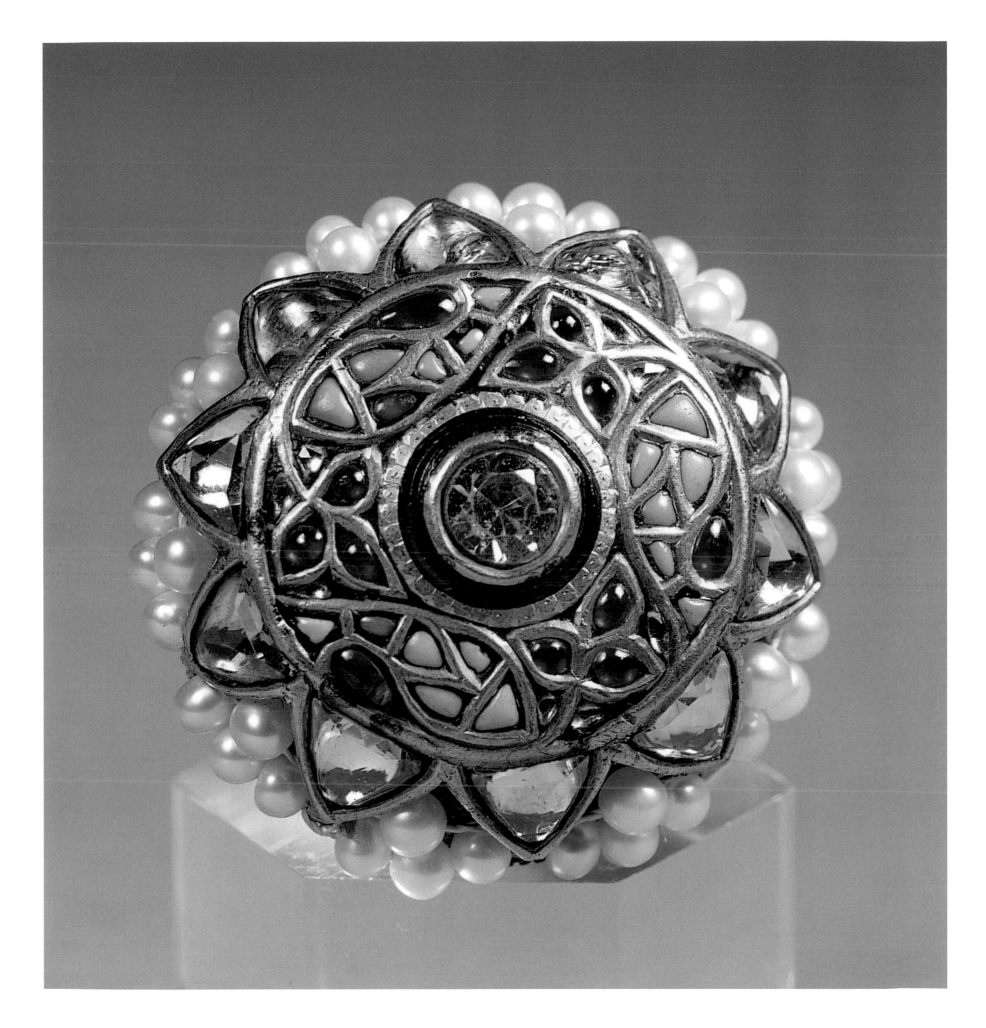

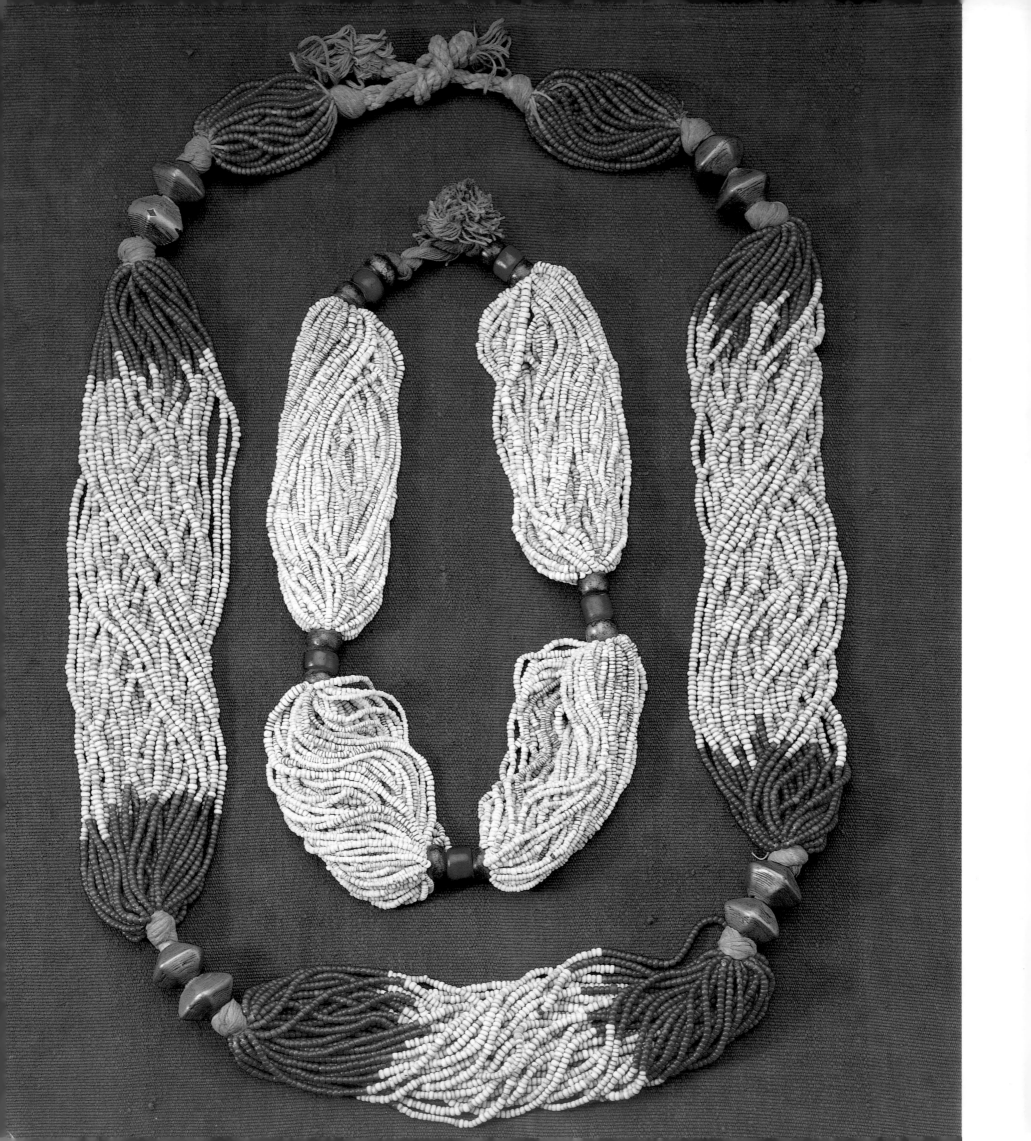

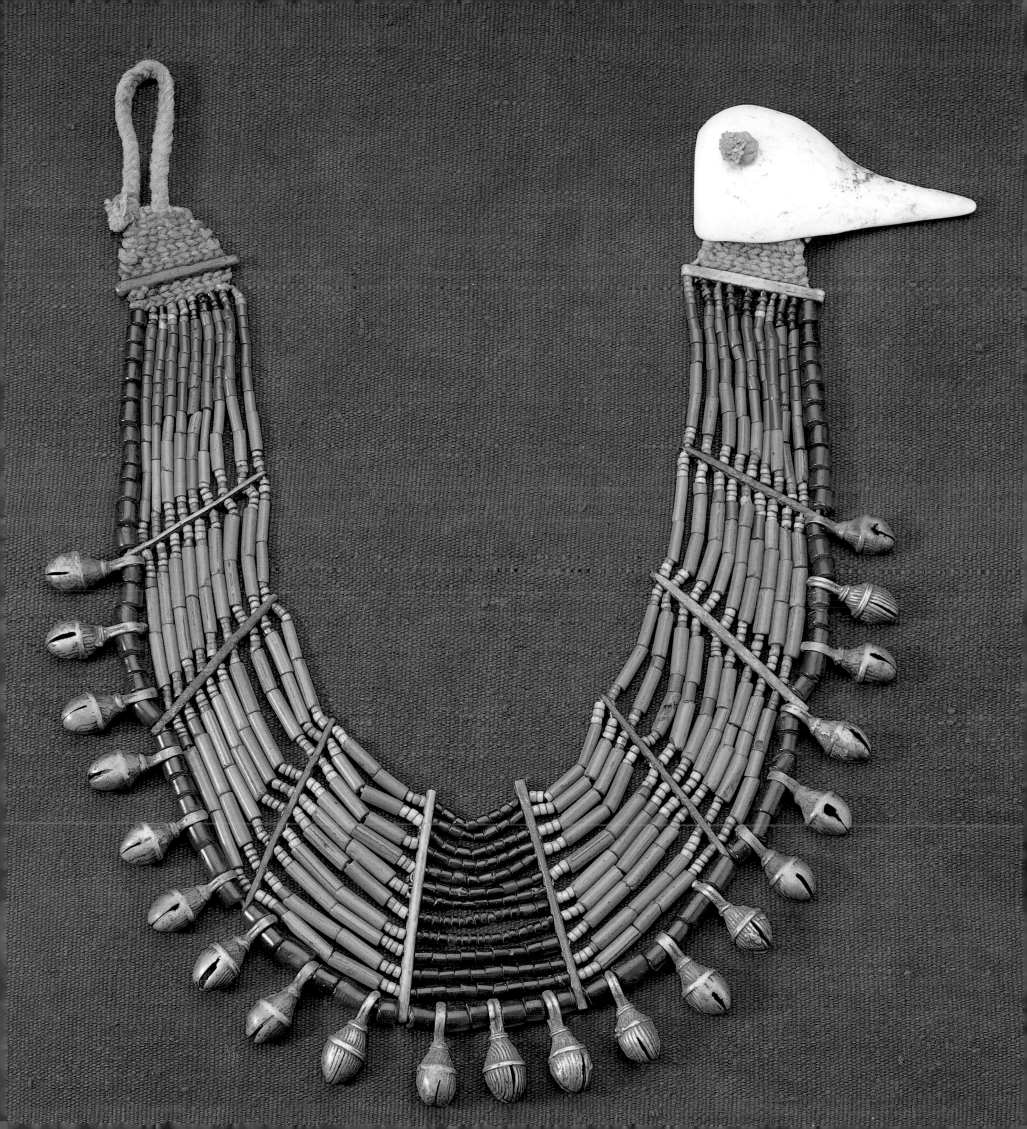

Page 162:

India
Outside:
Andhra Pradesh and Orissa
H 52 cm, W 26 cm,
752 grammes
glass beads and 8 bronze
collars
necklace
middle 20th century
worn by Gondh women

Inside:
Andhra Pradesh and Orissa
H 26 cm, W 19 cm,
450 grammes
glass beads and 8 bronze
collars
necklace
middle 20th century
worn by Gondh women

Page 163:

India
Nagaland
D 30 cm, 303 grammes
glass beads, bronze, shell
necklace
middle 20th century
Angami tribe

India
Top:
Nagaland
D 30 cm, 303 grammes
glass beads, bronze, shell
necklace
middle 20th century
Angami tribe

Bottom:
Nagaland
L 37 cm, 145 grammes
glass beads and an Indian
coin as fastening
necklace
middle 20th century

India
Nagaland
L 54 cm, 481 grammes
glass beads and a Chinese
coin as fastening
necklace
middle 20th century

India
Nagaland
L 10.5 cm, W 9.5 cm,
H 5.8 cm,
676 grammes together
ivory
name: *ketoh* or *chethoh*
man's armlet
late 19th century
worn on each upper arm by
successful headhunters;
wonderful brown patina,
cut from a single piece of
ivory

India
Nagaland and Assam
W 42 cm, H 14 cm (three
rows of nails), H 36 cm
(with nails and glass beads)
cloth, glass beads, shell and
claws
Naga *pangolin* claw ban-
dolier, worn diagonally
late 19th century
pangolin = ant-eater, so 'ant-
eater claws'

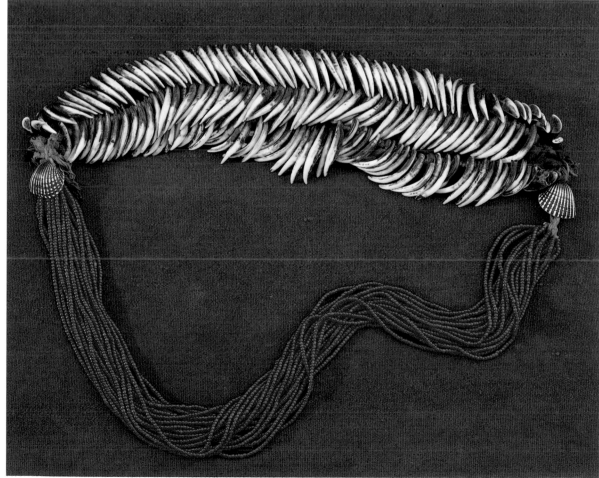

165

India, Burma

Outside:
Mizoram
L 33 cm, W 22 cm,
195 grammes
burmite
name: *thihna* or
puan chei mala
necklace
early 20th century
burmite = Burmese amber,
a fossile resin used by the
Chinese as early as the Han
dynasty (206 BC–22 AD)

Inside Top:
India (Mizoram) and Birma
(Kachin State)
L 3.2 cm, 27 grammes
together
burmite
ear ornaments (ear plugs)

Inside Left:
Mizoram
L 2.5 cm, 19.6 grammes
together
glass
ear ornaments (ear plugs)
early 20th century
ear plugs made in imitation
of burmite (Burmese
amber)

Inside bottom:
India (Mizoram) and Birma
(Kachin State)
L 9 cm, 31.6 grammes
together
burmite
ear ornaments (ear plugs)
early 20th century
worn in the ear lobes
through large holes

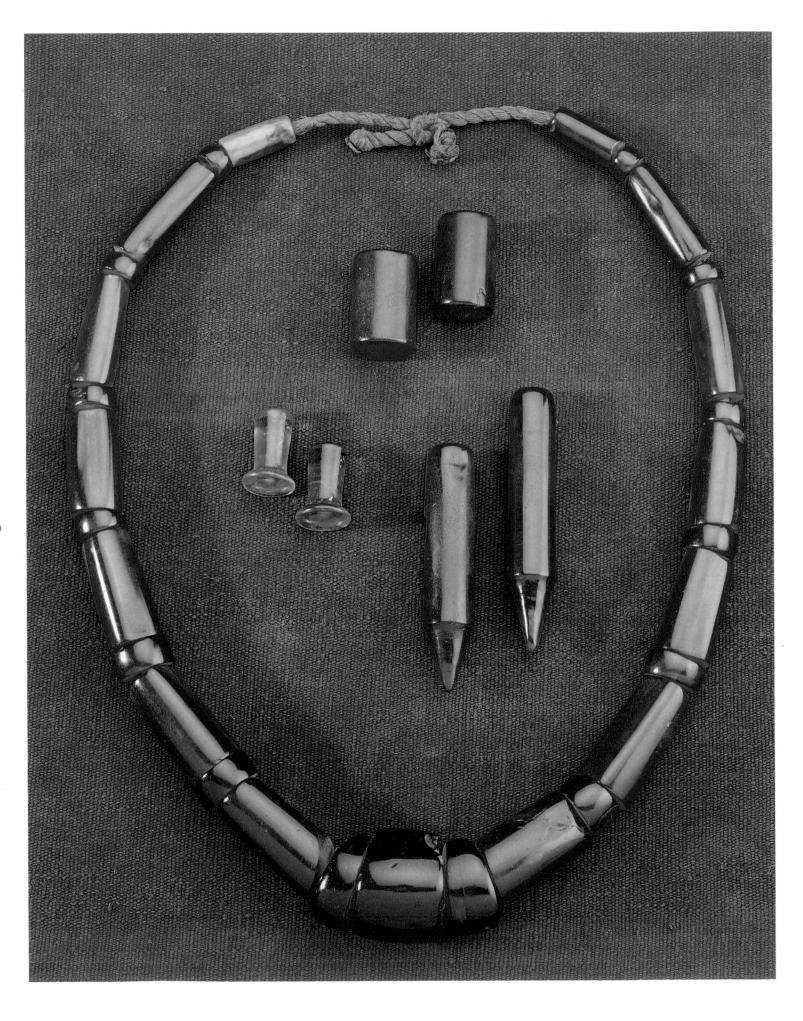

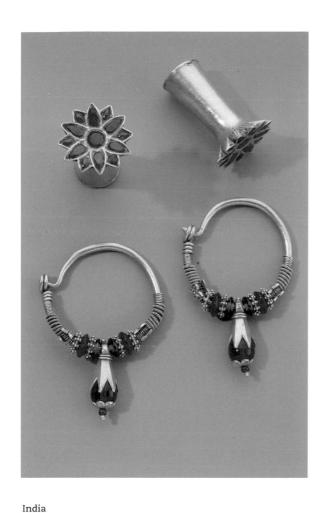

India

Top:
Assam (East India)
H 2.9 cm, 9.6 grammes
gold, lacquer and rubies
earrings
late 19th century

Bottom:
Himachal Pradesh, Kulu
people
H 5 cm, W 3.5 cm,
20.4 grammes together
gold plus glass beads
woman's earrings
middle 20th century
these earrings are also
found in silver

India

Left:
Assam (Sibsagar)
H 6.5 cm, W 6.5 cm,
115 grammes
silver and gilding (gold)
name: *gamkharu*
bracelet
middle 20th century
two-part hinged silver cuff
bracelet with parcel-gilded
stamped sheet metal orna-
ment, opening by means of
a removable peg

Right:
Nagaland
L 5.5 cm, W 4 cm, 154
grammes together
rock-crystal
woman's earrings
1st half 20th century

India
Top:
Assam
L 6.8 cm, W 2.8 cm, 113
grammes together
silver
earrings
20th century
2 parts; screw thread in the
middle

Bottom:
India
Assam
L 5.5 cm, W 2 cm, 46
grammes together
silver
earrings
20th century
2 parts; screw thread in the
middle

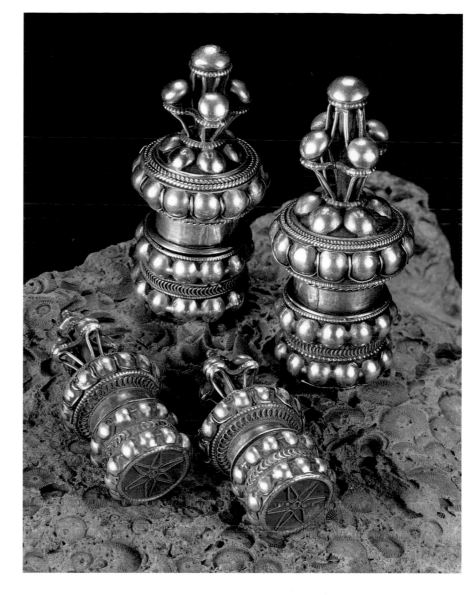

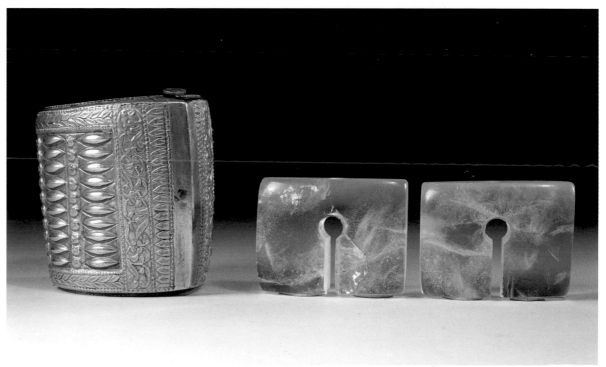

Page 168:

India
Gujarat (Kutch and
Saurashtra)
H 11 cm, D 9 cm,
543 grammes
ivory
name: *baloyun*
married woman's bracelet
late 19th /early 20th
century
a single piece of hourglass-
form ivory; worn by mar-
ried women (Dhebaria,
Vaghadia and Jhalavadi
Rabari women) on the left
arm until widowhood or
death

Page 169:

Tibet and Nepal
H 12 cm, D 6.5 - 7.5 cm,
150 grammes
shell (shank shell, xancus
pyrum)
name: *dhung kar*
bracelet
1st half 20th century
worn in a.o. Nepal by Dolpa
and Lhomi women on the
wrist of the right hand;
symbol of purity and for-
tune, protects against evil;
the xancus pyrum is only
found in the Gulf of Bengal
and is used by Hindus and
Buddhists in India, Nepal
and Tibet for jewellery and
in temples

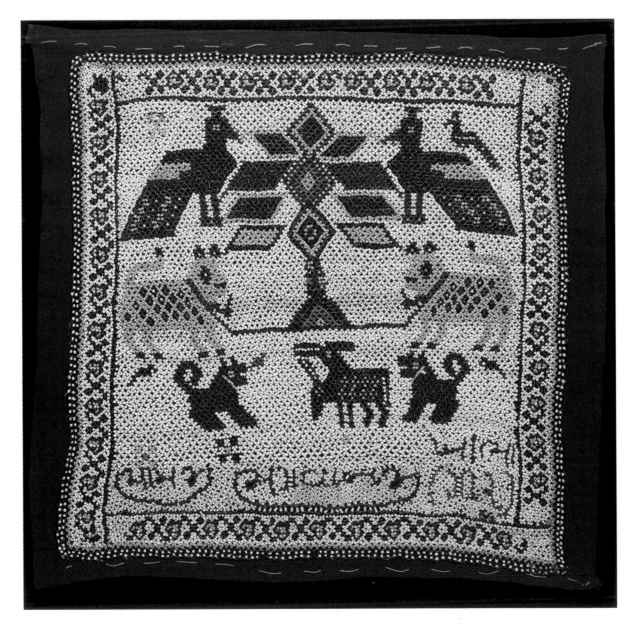

India
Gujarat (Kutch and
Saurashtra)
L 116 cm, H 51 cm,
1450 grammes
glass beads on cloth
late 20th century
ornament hung above door
or tent opening; depicted
a.o. 2 lions, horses, pea-
cocks and Ganesha in the
middle

India
Gujarat (Khamba in Gir dis-
trict)
H 46 cm, W 45 cm
glass beads and cotton
bead work made by Rabari
woman
contemporary
3 peacocks on either side of
a tree; below that 2 tigers,
then 2 lions, a two-headed
deer in between; at the bot-
tom in the language of
Gujarat the maker's name:
Bhimji Bhagwanji; set off
with a bead border
The Gir district is the only
remaining habitat of the
Asian lion.

Right:

India
Ladakh
H 30 cm, W 24.5 cm
cloth, coral, turquoise, bone,
mother-of-pearl
ceremonial gorget worn
around the neck
20th century
worn by the chief lama

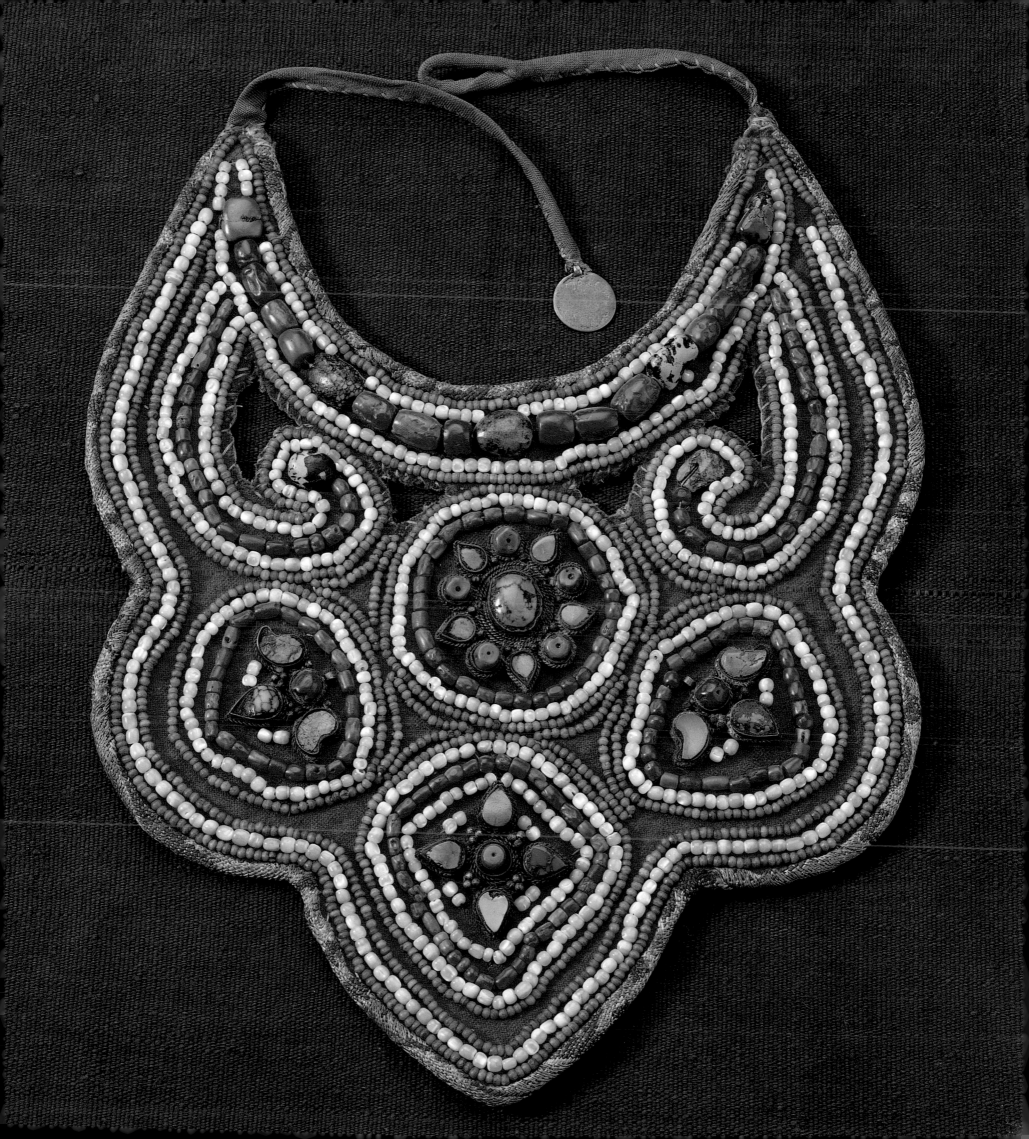

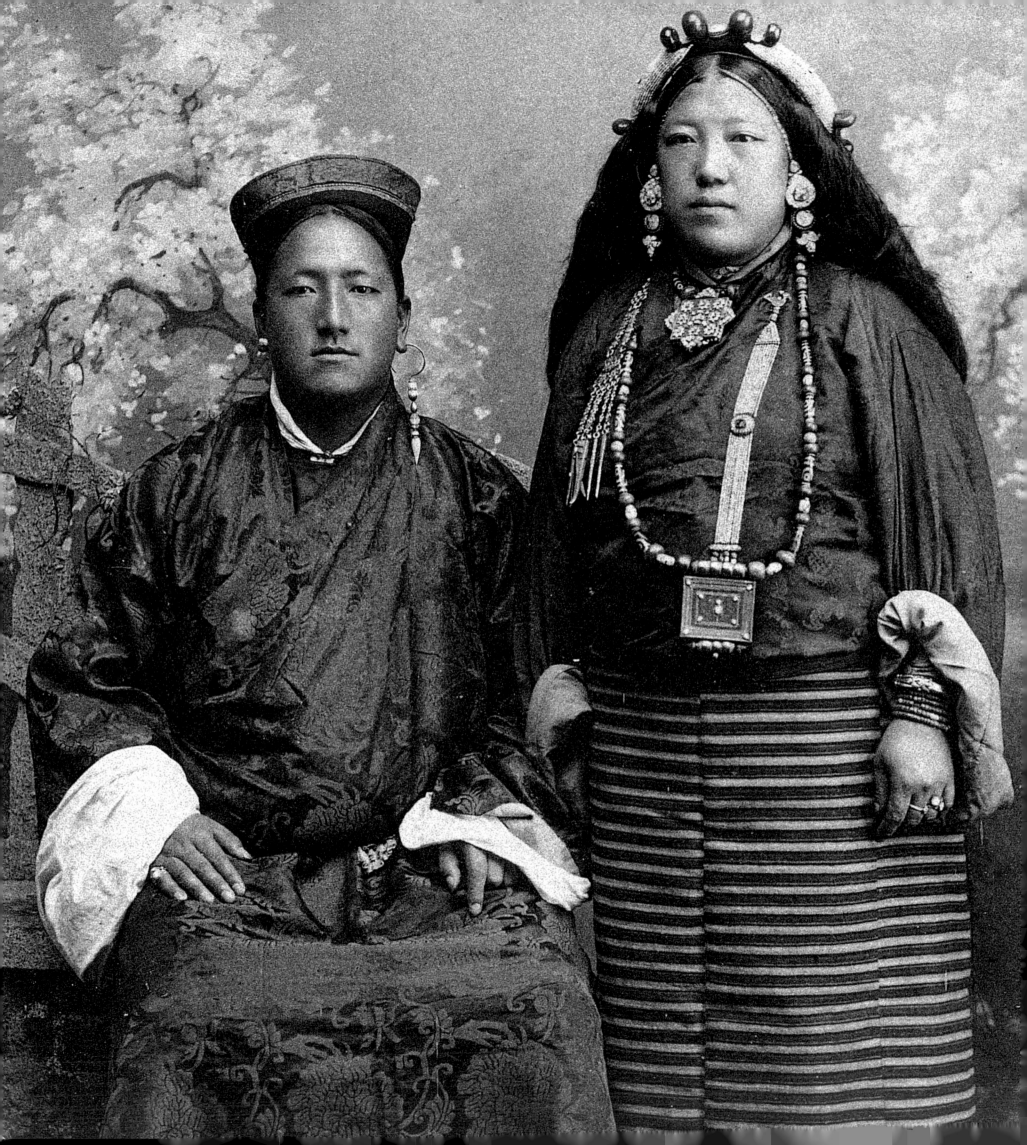

Tibet

Left:

L 4.2 cm, H 4.2 cm, W 3 cm, 30.1 grammes
silver and coral
name: *ga tshi-ko*
man's hair ring ('saddle' ring)
early 20th century
worn by men in the hair, often in combination with the two ivory rings in this illustration

Right:

D 5 cm, 56.4 grammes (top)
D 4.7 cm, 44.2 grammes (bottom)
Ivory
name: *pa-so tre-kho*
hair rings
19th century
hair rings for men; sometimes worn as a thumb ring during meditation

Tibet

H 21 cm, W 13 cm, 391 grammes
bone, red coral, turquoise
container for snuff tobacco
late 19th century
stopper on top

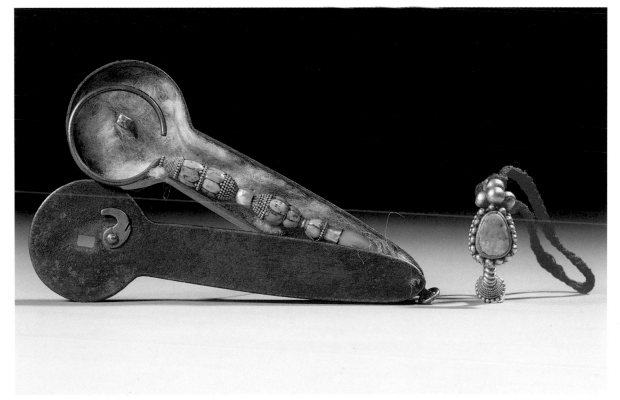

Left:

Tibetan married couple: A Kaizi and wife with traditional jewellery. Among other things male and female earrings (see photo on the right), c. 1890.

Tibet

Left:

L 13 cm, 17 grammes
gold, turquoise, ceramic, pearl
early 20th century
man's earring; only worn one at a time; ceramic point; matching iron box (see page 172)

Right:

H 4.5 cm, W 5 cm, 43.3 grammes
gold and turquoise
name: *aylong*
early 20th century
man's earring, only worn one at a time; the turquoise used (called *beyu*) is from the South of Lhasa

Tibet

L 8 cm, W 5 cm, H 1.3 cm,
63 grammes
silver, gold, turquoise, red
coral
name: *ga'u*
hair ornament for men,
fixed in their hair-plaited
topknot (*pachok*)
1st half 20th century
front: gold filigree plate;
this hair ornament was
worn by government offi-
cials of the 4th rank and
above as an indication of
high rank and distinction

Tibet

H 11.5 cm, W 8 cm, 123
grammes
silver and turquoise
name: *gau*
amulet container
1st half 20th century
box consists of two sepa-
rate parts; 2 of the 8
Buddhist emblems are
depicted: in the middle the
victorious banner erected
on the summit of Mt Meru,
the centre of the Buddhist
universe; in every corner a
seashell, symbol of the
blessedness of turning to
the right.
(see page 172)

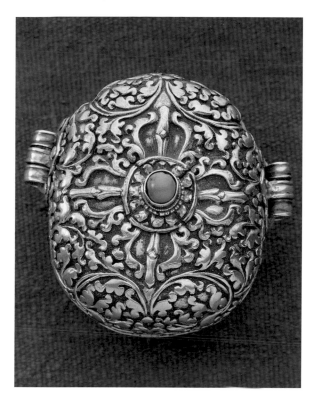

Tibet

H 4 cm, L 7 cm, W 7.5 cm,
86 grammes
silver, copper alloy and a
green turquoise
name: *gau*
amulet container
1st half 20th century
lid: repoussé in copper
alloy; floral motifs and a
double vajra (visavajra,
thunderbolts);
the vajra is the weapon of
the god Indra (god of thun-
der and rain). In Buddhism
he represents the Absolute.

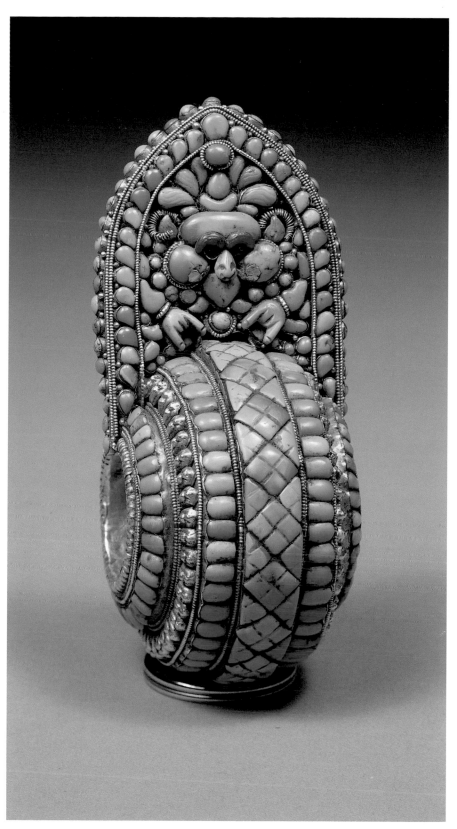

Tibet

L 11.5 cm, W 6 cm,
D 6.5 cm, 217 grammes
gold, lacquer, turquoise,
lapis lazuli, rubies
breast jewel with counter-
weight (see page 177, right)
middle 20th century
jewel for high government
official, hanging on his
breast; upper part with
Kirtimukha ('face of glory')
in the form of a leaf, eye-
brows inlaid with lapis
lazuli, gold turned horns
and ruby eyes; spherical
lower part with hole; two
hooks at the back of the
upper part

Kirtimukha is called 'mooneater'
in Nepal and Tibet; it refers to
an old myth with the following 3
leading figures:
1. Jalandhara, a Titan king, who
had conquered all the gods and
controlled their realms in a
tyrannical fashion
2. Rahu, his emissary, the Hindu
demon
3. Shiva, the Hindu god
Jalandhara sent Rahu, his emis-
sary, to Shiva to demand Parvati,
Shiva's wife, for himself. In the
beginning of time Rahu, togeth-
er with other gods, had made an
elixir of immortality. When he
took the first sip he was imme-
diately beheaded by Vishnu. The
elixir having already passed
through Rahu's head and neck,
they became immortal, whereas
the rest of his body decayed.
Since Rahu's head wanted more
elixir he was condemned to for-
ever chase the moon, the cup
containing the immortal elixir.
When he catches the moon, we
people witness the moon's
eclipse. Rahu having no stomach
the elixir passes through him
and the moon reappears.

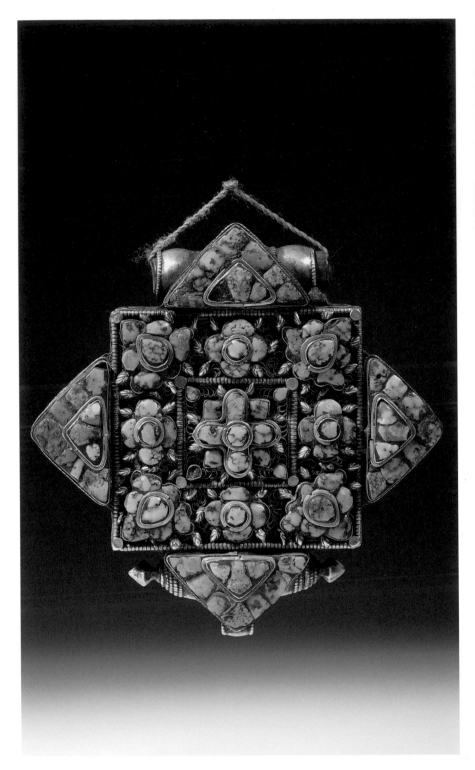

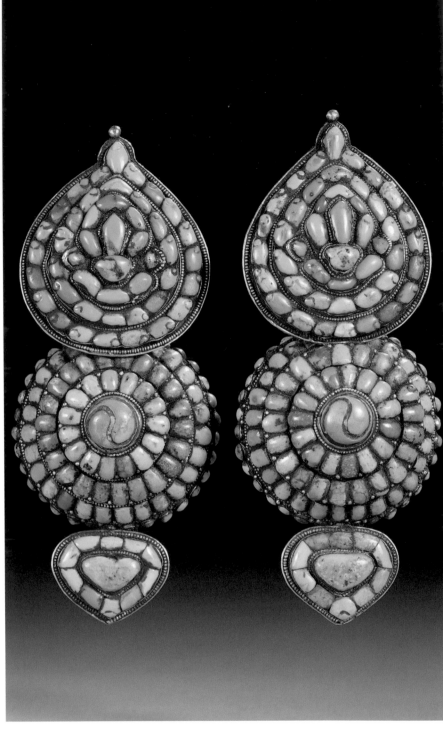

Tibet
H 2.5 cm, L 10.3 cm, W 10.3
cm, 120 grammes
silver and turquoise
name: *gau*
amulet container
1st half 20th century
the box is in the shape of a
yantra, a mystical diagram
to which occult powers are
attributed; it protects the
wearer
(see page 172)

Tibet
H 10.5 cm, W ±4 cm,
127 grammes together
gold, turquoise, silver (hook
at the back)
woman's ear jewels (fas-
tened to the hair)
early 19th century
a face can be recognised in
the upper part; in the mid-
dle yin/yang motif

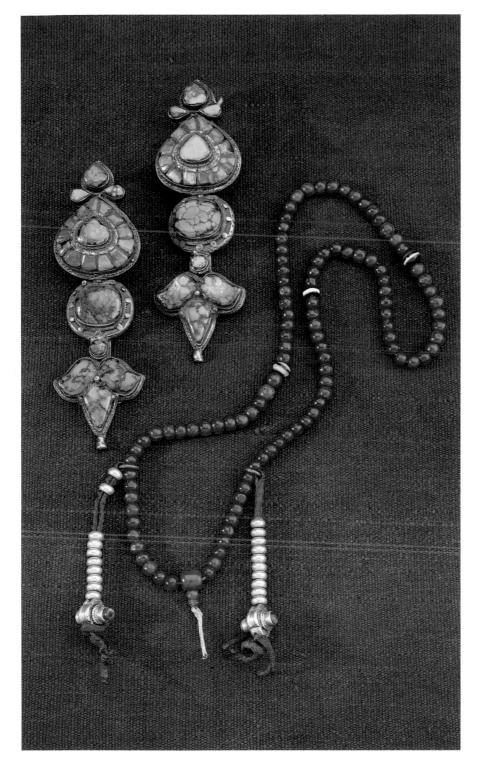

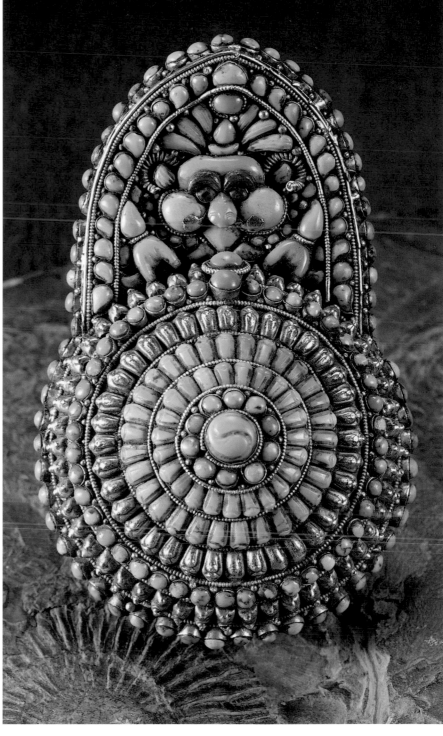

Tibet

Left:
H 13 cm, W 3.8 cm, 132
grammes together
silver and turquoise
name: *ekhor*
woman's ear jewels (fas-
tened to the hair)
1st half 20th century
(see page 172)

Right:
H ±30 cm, W 16 cm, 58
grammes
coral, silver, turquoise (not
visible, at the back of dan-
gle), eye agates
name: *sin-phen*
Buddhist rosary
string of beads for counting
prayers
early 20th century

Such rosaries invariably
have a total of 108 beads

Tibet
L 10.2 cm, W 6 cm, D 4.5 cm
(silver peg 1.5 cm),
197 grammes
gold, lacquer, turquoise,
lapis lazuli, rubies, silver
breast jewel with counter-
weight (see page 175, right)
middle 20th century
jewel for high government
official, hanging on his

breast (with counter-
weight); upper part with
Kirtimukha, eyebrows inlaid
with lapis lazuli, gold
turned horns and ruby
eyes; the lower part a round
medallion in the form of a
double lotus; back: 8
Buddhist symbols inlaid
with turquoise with a silver
peg in the middle

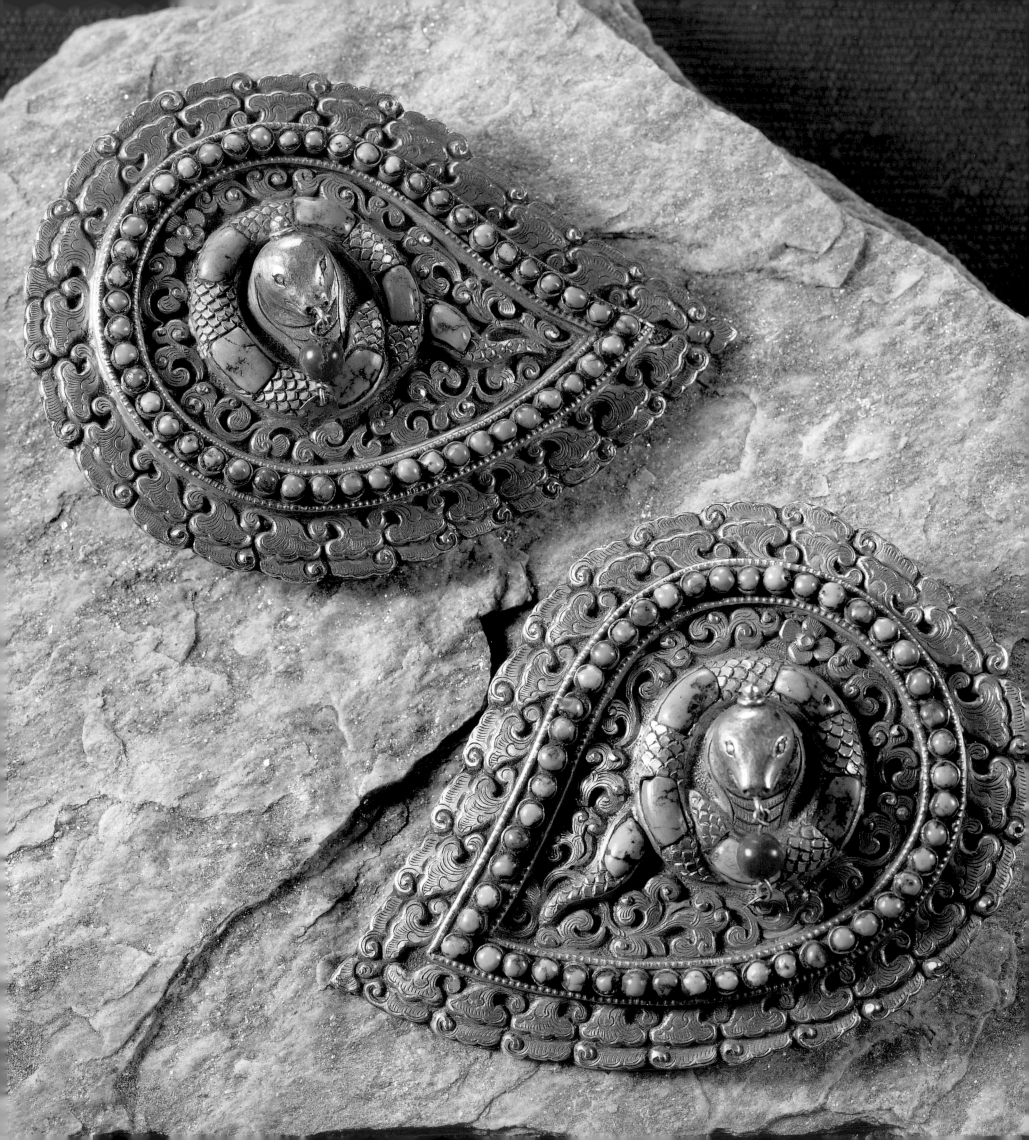

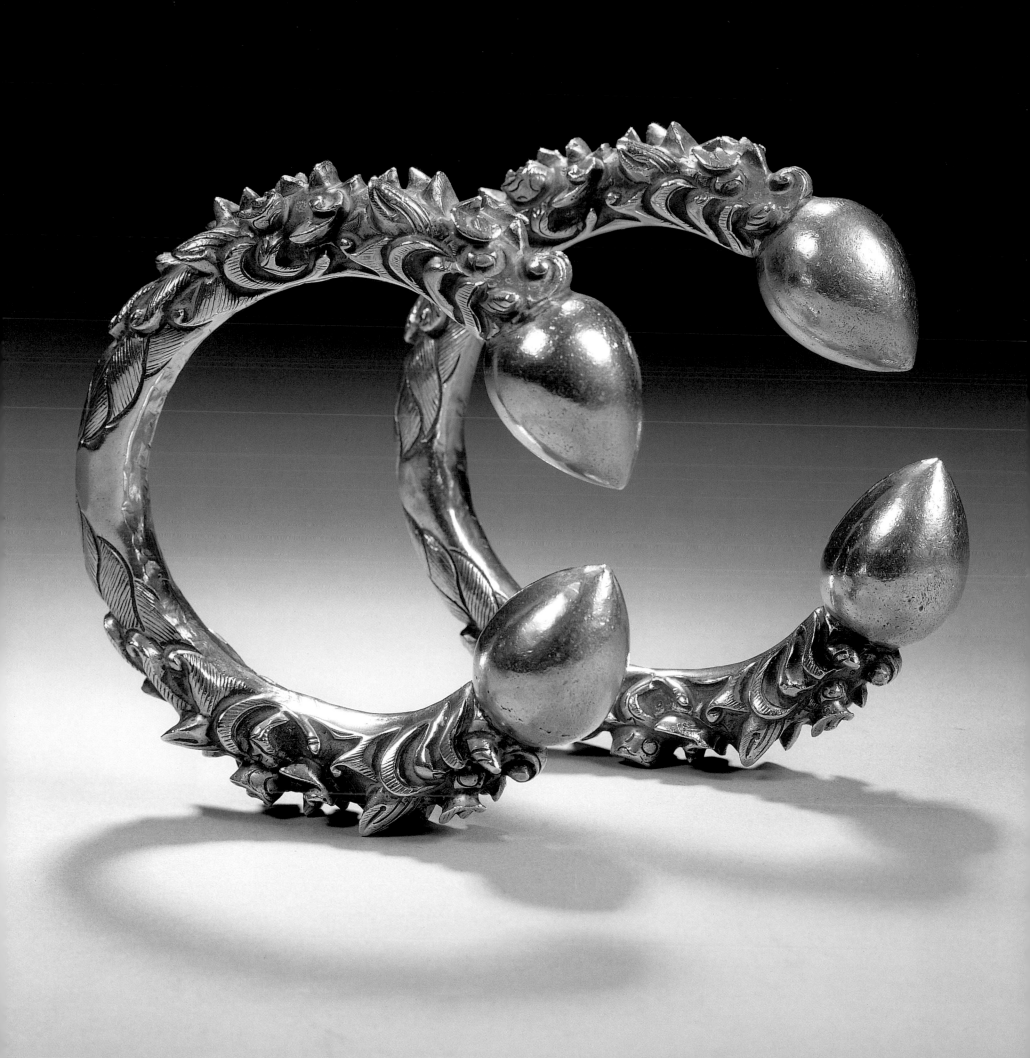

Page 178:

Nepal
L 9 cm, W 6.5 cm,
132 grammes together
gold, silver, turquoise and
red coral
earrings for the image of a
god (Mahakala, the fierce
shape of Shiva)
early 20th century
back: silver and silver hook;
front: gold, floral motifs; in
the middle coiling naga,
turquoise inlay

Page 179:

Nepal
H 11.5 cm, W 13 cm,
318 grammes together
silver
anklets
middle 20th century
hollow, silver anklets worn
by married women until
the birth of their first child;
depiction of 4 dragon faces;
2 oval pointed ends

Nepal
D 6.4 cm, 39.5 grammes
together
gold, silver, turquoise
name: *mendog kogde*, usually
called *godwari*, meaning
marigold
ear disks for Sherpa woman
1st half 20th century
front: gold repousse work
on silver
back: silver rod with screw
thread plus plate

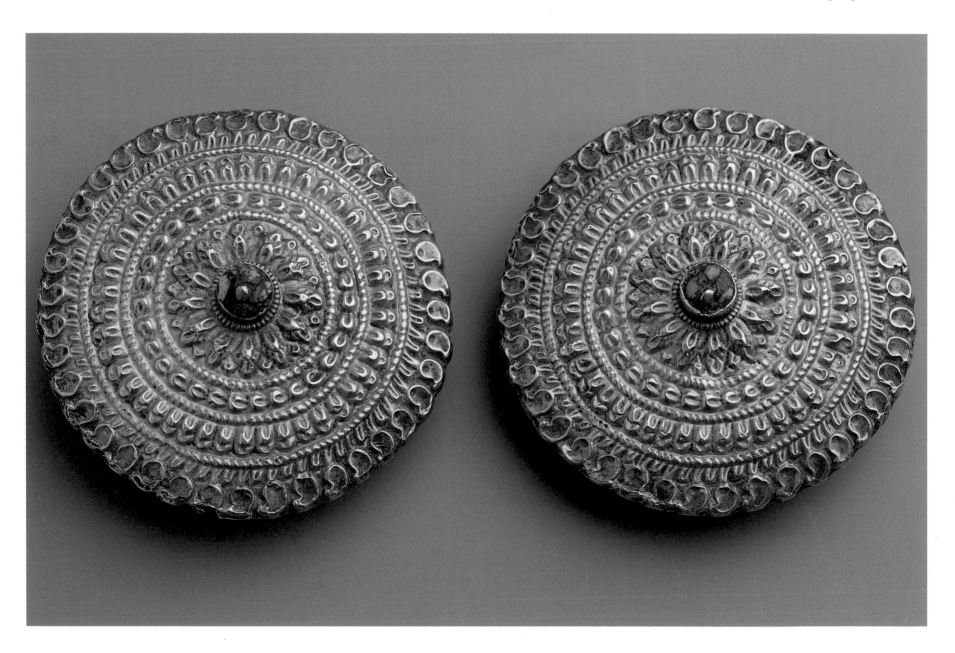

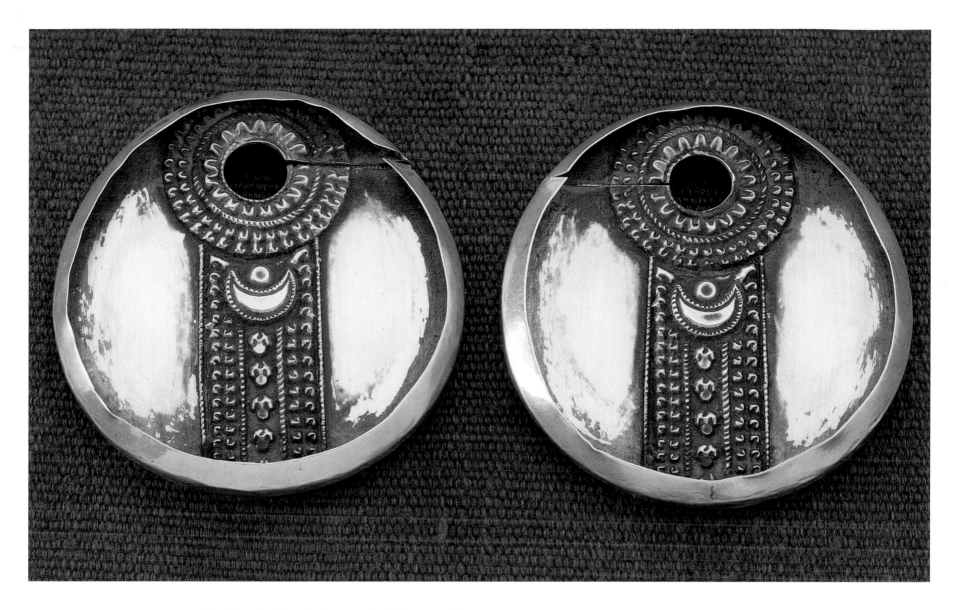

Nepal
H 6 cm, W 5.6 cm, 22
grammes
alloy of gold and silver
parts
name: *cheptisun*
woman's earrings
middle 20th century
worn by Gurung and
Tamang women
The design is the combined
sun and moon symbol.

Left:

Woman wearing *cheptisun*
earrings, Nagakot, Nepal,
1999.

Page 182:

Nepalese girl wearing
kantha necklace, c. 1890.

Page 183:

Nepal
Gurung and Tamang people
H 32 cm, W 25 cm,
483 grammes
gold, lacquer, felt
name: *kantha*
necklace
1st half 20th century
21 round, lobed, gold beads
filled with lacquer, plus 2
elongated beads; red felt
between the beads; fasten-
ing made of an Indian
rupee coin

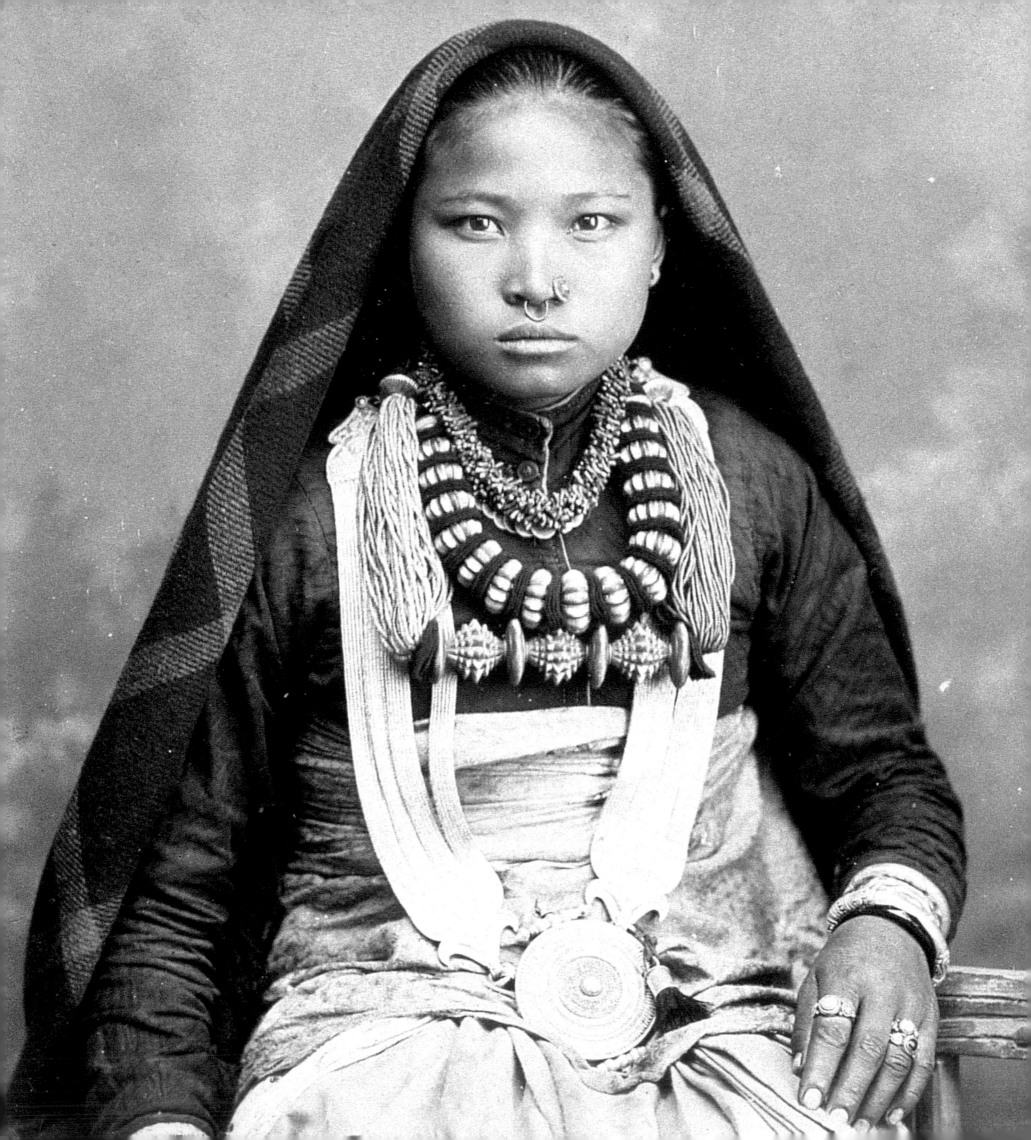

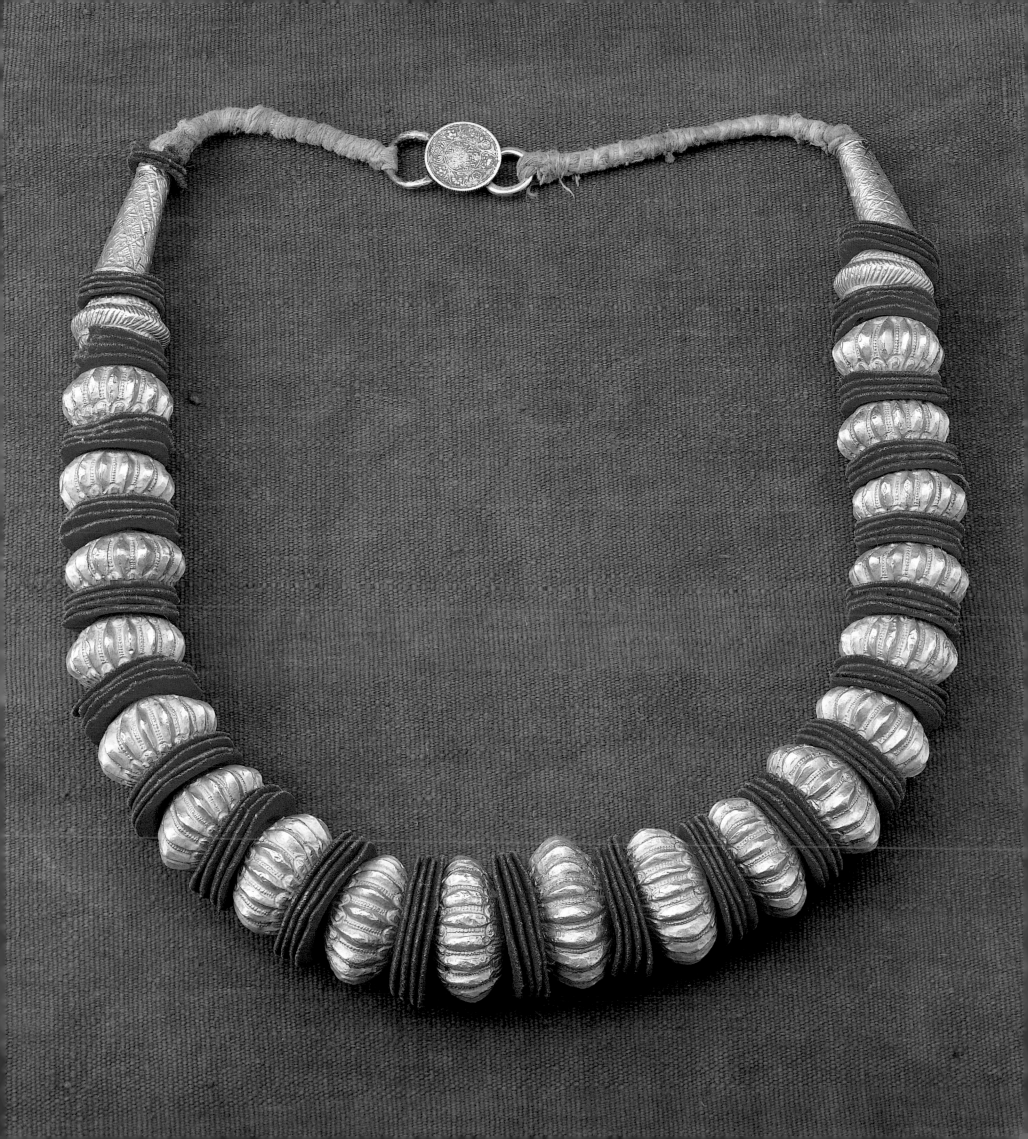

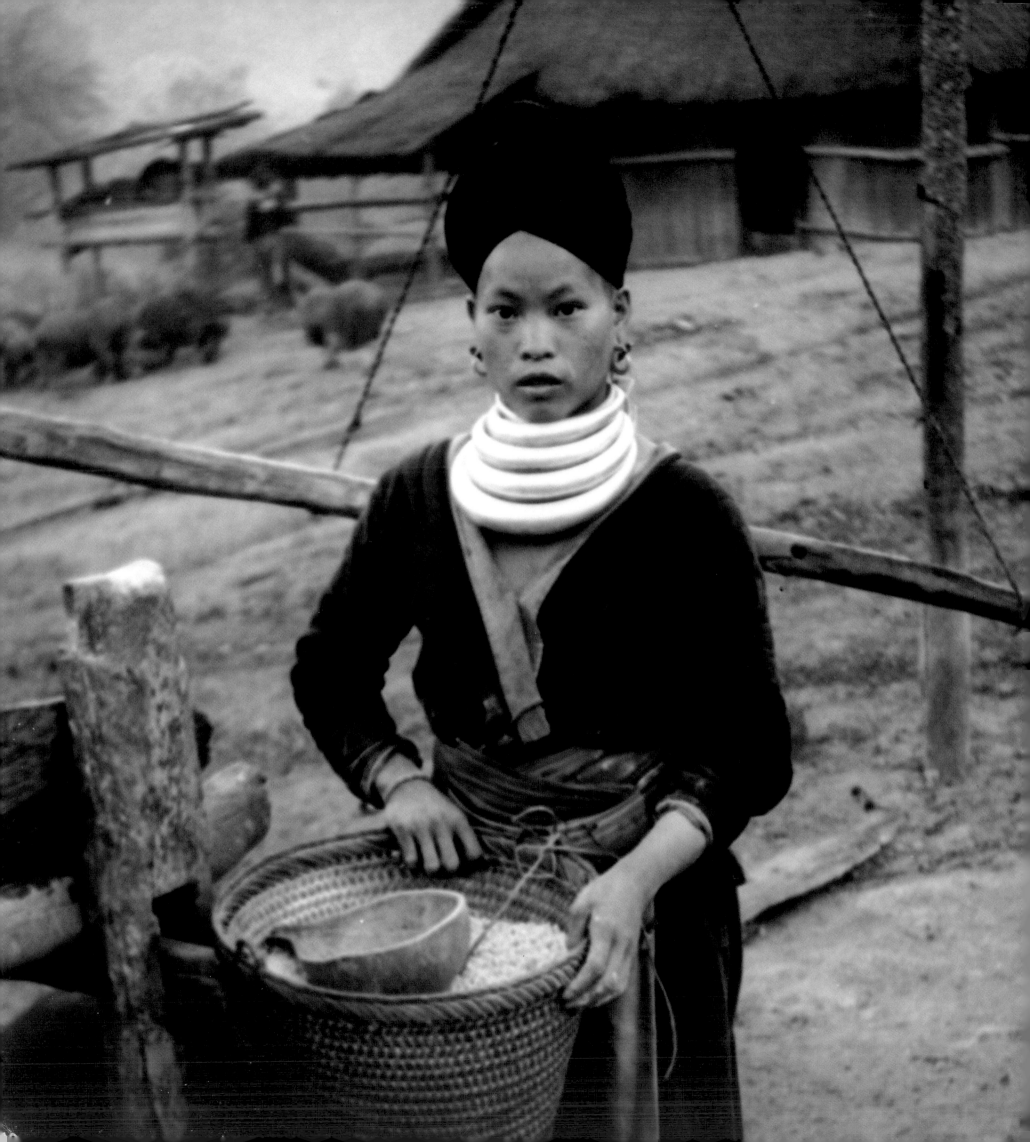

Southeast China and the Golden Triangle

China
Mongolia
Thailand
Burma
Laos

Hmong woman wearing sil-
ver earrings and four hol-
low silver neck rings,
Laos, 1956.

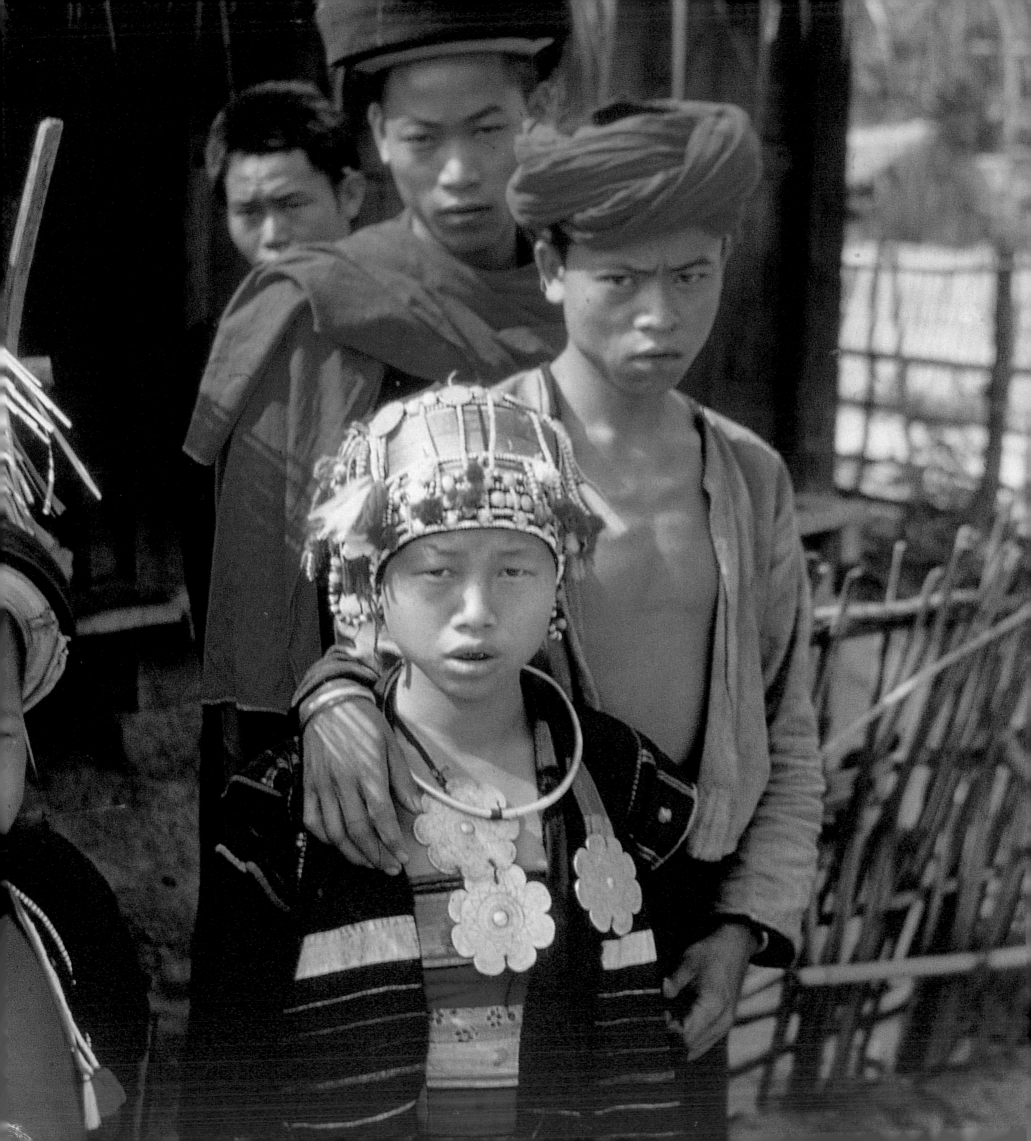

Silver jewellery from Southeast China and the Golden Triangle

René van der Star

This chapter is about the peoples of Southeast China and those that left the area to earn a living by growing opium. The so-called Golden Triangle, the mountainous border area of North Thailand, Burma and Laos, is populated by a number of small tribes. Each of them has its own language and culture. Their binding element is their shared love of silver jewellery and the meaning it has in their lives.

The peoples of Southeast China

In China there are 26 minority groups, of which the greatest number is found in the southeast of the country, in the provinces of Yunnan, Guizhou, Sichuan and Hunan. Most of the silver jewellery is worn by the Miao and the Dong. The Miao wear about 70 per cent of all the jewellery and the Dong about 25 per cent, while five per cent is worn by other groups. The Miao have no written language. All their traditions are passed down orally and find expression in the art of weaving and in jewellery. There are about five million Miao and about one million Dong. Both groups are among the poorest in China. If they can no longer afford silver, they wear jewellery made of a silver alloy or of alpaca, an alloy of zinc, nickel and copper that originated in China.

Some pieces of jewellery have marks. During a visit to China in the autumn of 2000, I discovered that these marks do not indicate the silver content. The marks indicate who the maker was or in what town it was made. Sometimes the mark tells you who owned a piece of jewellery. The quality and crafts-manship of marked jewellery is often very high. Silver marks are seldom found on older Chinese jewellery. Silver jewellery continues to be important to the Miao and the Dong. The Miao have about 50 different kinds of jewellery. While clothes vary between regions, the jewellery does not. A complete set of jewellery, worn on the occasion of a festival, may weigh between six and nine kilograms. The jewellery is hand-made by local silversmiths. The most common themes in Chinese jewellery are dragons, the phoenix, animals and plants.

The tribes of the Golden Triangle

The Thai government recognises six mountain tribes. Within some of them a division can be made into sub-groups, all of whom speak a different dialect and wear different clothes. The six tribes are the Karen, Hmong (also called Meo), Mien (also called Yao), Lahu, Akha and Lisu. They originate from the southwest and south of central China, which means that Chinese influences can be found in their cultures. With the exception of the Karen, large groups of these peoples still live in China. The mountain tribes have not been in the Golden Triangle for a very long time. The migration to Thailand, through Burma, and later to Laos did not start until the early years of the twentieth century. The migration was caused by turmoil and war in their country of origin. Many mountain tribes fought against the Communist regime in China and had to flee. To this day immigration continues, but at a slower pace. The Burmese government treats the mountain tribes badly and the Karen in particular, about four million of whom have settled in Burma, continue to suffer. In 1991, when we visited a Karen village on the border of Thailand and Burma, recent bullet holes in the houses were silent witnesses of action by the Burmese army. No exact figures can be given for the mountain tribes of North Thailand. In the early 1980s there were about 400,000 mountain people, a population which grew by an average of four per cent a year. They make up under one per cent of the Thai population.

The mountain people are animists. Thus the entrance to an Akha village is invariably a wooden gate, meant to keep out the evil spirits. The gate is flanked by groups of wooden figures, to ensure both male and female fertility. Nowadays many mountain people are being converted to Christianity, by mainly American missionaries. Life in the mountains is hard. Most of the mountain tribes used to be wealthy because of the opium they grew, but this trade has been effectively combated by the Thai government. Nowadays opium is grown illegally and on a small scale. Instead of opium, tobacco, tea, tomatoes and cotton are now grown. However, these products are less profitable and the income of the mountain population has dropped considerably.

There is a clear difference between men's work and women's work. Generally it is the women who do the heavier work. They plant and harvest the crops in the fields and look after the pigs and the chickens. They also take care of the children and practise the crafts of spinning, weaving and making clothes. Decorating the clothes (embroidery) is a woman's job too. This craftsmanship gives a woman status in the village and also makes her attractive as a bride. Men lead slightly easier lives. They perform the non-daily activities, such as housebuilding, trap- and crossbow making and basket weaving.

The houses are sober and provide little comfort. The sparse furniture is made of easily transportable, cane or woven bamboo. In the old days when the fields were no longer productive, the people simply moved and took their belongings with them. Nowadays moving is a problem, because there is too little land for everyone.

Silver jewellery

In the culture of the mountain tribes silver has a number of functions. It is believed to offer protection against illness and misfortune. Illness is seen as a signal that the soul wants to leave the body. When silver jewellery is worn, the soul will stay in the body. Even when mountain people are admitted to hospital, they dislike removing their jewellery. For this reason necklaces and bracelets are placed on children immediately after birth. This jewellery is then enlarged or melted down and remade as the child grows older. The protective function of silver is strictly personal. A silver jewel protects only its owner, so stolen goods will never prosper the thief.

Silver is also a powerful economic factor and paper money is not regarded highly. In the past paper money sometimes lost its value overnight but silver coins were always available from travelling merchants and their value could be determined by weighing. Silver jewellery is the generally accepted form of saving. As silver represents the savings of the family, the price of a pig, horse, or even a bride is often expressed as an amount of silver.

Thirdly, silver represents prestige. It gives a family a certain status. The wearing of silver proves one's membership of a wealthy family. New Year's Day and other festive days are perfect opportunities for covering oneself with silver jewellery.

The increase in poverty makes it dangerous to wear one's silver on a daily basis, something that people were not afraid of doing some 30 years ago. Now the jewellery is usually safely stored away and sometimes buried in the jungle. Only during festivities is it taken out again. On New Year's Day all jewellery is worn. First every bit of silver is cleaned thoroughly,

Page 186:

Young Hmong couple in Laos. The girl wears a silver necklace and large flower-shaped clothes fasteners.

Right:

Young woman with a large ivory ear stud, Laos or Burma, c. 1956.

Far right:

Young Karen girl from Shan State in Burma. At the age of five, girls get the first ring around the neck. Every year a ring is added until the girl is mature. She will have a maximum of twenty-one neck rings. Comb and hair pins are made of aluminium, this used to be silver, 2000.

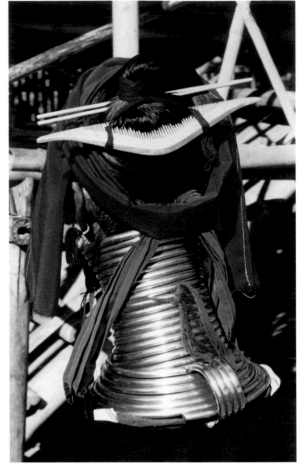

rubbed in ashes and then polished with a cloth. Some tribes cook their silver with sour berries before polishing it.

The silver used to be made from coins, such as Indian rupees and French Indo-Chinese coins. Nowadays bars of silver are imported from Hong Kong, via Bangkok. These bars have a very high silver content and are thus softer and easier to work. Indian rupees have a silver content of 85 per cent and are therefore harder and more difficult to work. There are several reasons why the mountain people prefer silver to gold. Gold is much more expensive and its possession makes the owner more vulnerable to robbery. Since silver is cheaper, more and heavier jewellery can be bought, which in its turn gives more status to the wearer. The list of jewellery materials used by the mountain people includes bronze and copper (though these were used less frequently than silver), glass beads and even seeds. In the past ivory was used as well. Enamel decorations on pipes, rings, pendants and sword sheaths are rare, and precious stones are hardly ever used. The fact that there is just one word to describe all kinds of stones demonstrates that people are not very interested in them.

Since the Second World War even aluminium, originally taken from planes that had crashed in Burma, has been used. Nowadays aluminium is bought through neighbouring Thai villages. This is often the only material poor people can afford.

Working silver is a man's job. In the old days each village had its own silversmith, but nowadays there is one smith to an average of ten villages. Except for the village chief, the silversmith is one of the richest people in the village. In the village the smith is also the financial advisor and the pawnbroker. Through his contacts with the other villages he is the man to turn to for the latest bits of news and he is familiar with the latest fashion trends in silver jewellery. In earlier times styles could be more easily distinguished because of the isolation of the tribes. Nowadays the smiths copy each other's work and also make jewellery for other groups, which makes it more difficult to determine its identity.

The silver is worked by drawing wires and by hammering. The silver wire is drawn to its final thickness through progressively smaller holes in a steel draw plate. The hammering is done with hammers made of wood or buffalo horn, because iron hammers are too hard. Four techniques are used.

One technique is engraving. Sharp tools are used to scratch the decoration into the silver. Initially this technique could only be used on solid jewellery but one generation ago the silversmiths learned to work hollow objects as well.

Appliqué is a technique to weld with the help of fire and bellows small pieces of silver to a silver surface. A third method is repoussé. From the back of the piece, the silver is hammered into the proper shape. Moulds are used in this technique as well.

The last technique is the lost-wax method. First of all, a model is made from beeswax (often mixed with resin), to which a stick of wax is mounted, which will be used as a pouring duct. A number of smaller sticks of wax are added too, for the discharge of air and gases. The wax model is covered with a layer of clay, often mixed with sand. This mass is left to dry. When the clay has hardened, the mould is heated in a fire or an oven. The wax in the clay will melt and run out. Liquid metal is then poured into the now hollow shape through the pouring duct. The metal fills all the empty spaces and holes. When the metal has cooled down, the clay-cover is smashed to pieces, the metal object comes out and the finishing touches are made. The ducts are sawn off and filed smooth. Then the object is polished.

For larger objects the method of core pouring is often used. First a rough mould is made from a mixture of sand and clay. This core is covered with a layer of wax in which the relief ornamentation is marked. The mould is then covered with clay, dried and heated. The wax runs out and the metal is poured in. When it has hardened, the clay is

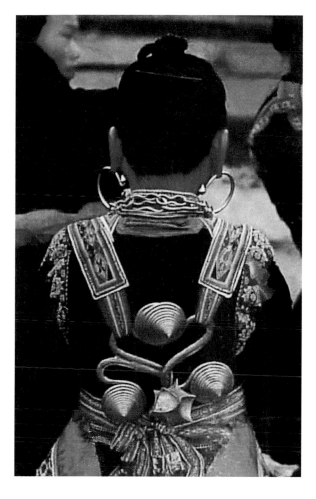

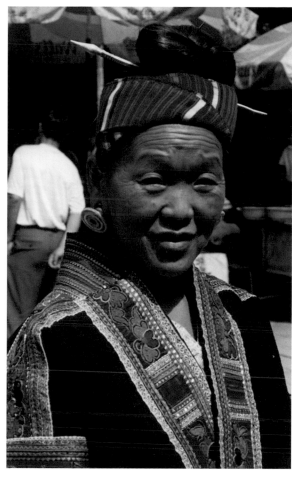

Far left:

Miao woman in China with
two silver or silver alloy
back pieces.
(see page 192 and 194)

Left:

Miao woman on a market
in Beijing, wearing tradi-
tional clothing, a big silver
hair pin, and heavy silver
earrings, 2000.

smashed to pieces. The wax model is lost in the process, which makes these objects unique.

The lost wax method has been used for a very long time for making hollow bracelets and neck ornaments, like the ones worn by the Hmong people. The various peoples have preferences for the shape and weight of their jewellery. The Hmong and the Mien like their jewellery large, round and heavy. The Lisu like to cover themselves with several layers of neck ornaments, while the Akha and the Lahu wear a lot of silver on their clothes.

Pipes and tobacco boxes

Silver pipes and tobacco boxes are very popular among men, although women and even children smoke a pipe every now and again. If an Akha man wants to court a woman, he must own or borrow a pipe and a tobacco box. Without these objects his courting will be in vain. Some pipes are made of wood or buffalo horn, with decorations of silver. The Karen and the Lahu are the only ones who make their entirely silver pipes themselves. The tobacco boxes, and most of the pipes, are made by silver-smiths of the Burmese Shan people.

Rings

Finger rings are not usually worn on a daily basis, probably because they get in the way when people are at work. At festivals and feasts they are worn, and in very large quantities, with occasionally even one on each finger.

Bracelets

Bracelets come in all shapes and sizes and are worn by both men and women. Men's bracelets tend to have a more austere, more straightforward and plain design. In some tribes, so-called spirit bracelets and necklaces are worn, which are meant to ward off evil spirits. When people are very poor, a cotton thread is worn around the wrist. When a person wearing this pseudo-bracelet dies, the thread must be broken, to set the soul free. Women also wear rows of simple bracelets, which can be up to ten centimetres wide. Karen women wear these bracelets everyday.

Neck rings

For some tribes heavy, silver neck rings are a real must. They are worn by both men and women. The opening is so narrow that the neck ring must be slipped on from the side of the neck. It is not easy to lose neck rings like these, but sometimes they are closed with a simple hook. Simple, flat neck rings (some of them engraved) are typical of the Akha. Large, festive neck rings with numerous pendants are worn by the Lisu, especially on New Year's Day. The Hmong and Mien like wearing several neck rings at a time (sometimes as many as six). These rings, which are linked and sometimes vary in size, come in hollow and solid versions and can be very heavy (up to a kilo and more).

Earrings

There is a large diversity of earrings. Most women have had holes in their ears since they were babies. As the girls grow older, the holes are stretched by putting in bigger and bigger pieces of wood or bone, until in the end they can wear earrings with a diameter of up to 2.5 centimetres. In the Karen tribe several earrings are sometimes worn in the same hole. The Yao and the Hmong have long, narrow, crescent-shaped earrings. Men (especially of the Lisu and Lahu tribes) often wear a simple silver ring in their left ear. Karen men, on the other hand, sometimes wear large, cylinder-shaped earrings, in pairs. Ivory earrings are worn as well, but they have become very rare.

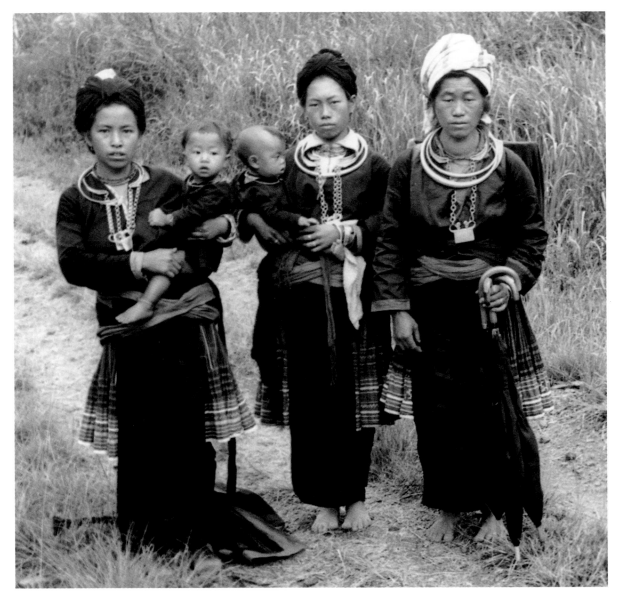

A group of Hmong women and children in Laos. The women wear massive silver necklaces with pendants in the shape of a lock, the so called 'soul lockers'. The two children also wear necklaces, 1956.

Buttons

Silver buttons are worn by almost all tribes, except for the Hmong women who use pins to fasten their clothes. The Lahu and Akha use the largest buttons to button up their coats. Usually the buttons are large, round, engraved disks, but flower shapes are used as well.

In the middle is a hole that fits a silver knob; this is the heart of the fastener. The two separate parts of the fastener are sewn onto the garment. The diameter of the buttons may range from two or three to as much as 20 centimetres. Small hollow balls, often holding a little stone, are used as buttons too. The stones make a soft, tinkling sound when walking.

Future of Golden Triangle tribes

The tribes in the Golden Triangle are unique in their lifestyles. Unfortunately this is changing rapidly, for various reasons. There is much more contact with other sections of the population. As there are few uninhabited areas left, migration has gradually come to a halt. The cultivation of opium is almost a thing of the past now, in North Thailand anyway, and this has brought about some drastic changes in the economic foundation of most mountain tribes. Much of their original identity is also being lost under the influence of missionary work. This makes many traditions disappear. Although silver has not lost its prestige with some tribes, the number of silversmiths is decreasing because of increasing poverty. And for fear of too much competition, the smiths are not inclined to teach apprentices the skills of the trade. The result is that the mountain tribes in their present form will probably and very sadly soon be a relic of the past.

References

Bernatzik, Hugo Adolf, *Akha und Meau*, Volumes 1 and 2, Wagner'sche Universitäts Bucherei, Innsbruck, 1947.
Campbell, Margaret, Chusak Voraphitak and Nakorn Pongnoi, *From the hands of the hills*, Media Transasia, Hong Kong, 1978.
Lewis, Paul and Elaine, *People of the Golden Triangle*, Thames and Hudson, London/New York, 1984.
The Cultural Palace of Nationalities, *Clothing and Ornaments of China's Miao People*, The Nationality Press, Beijing, 1985.

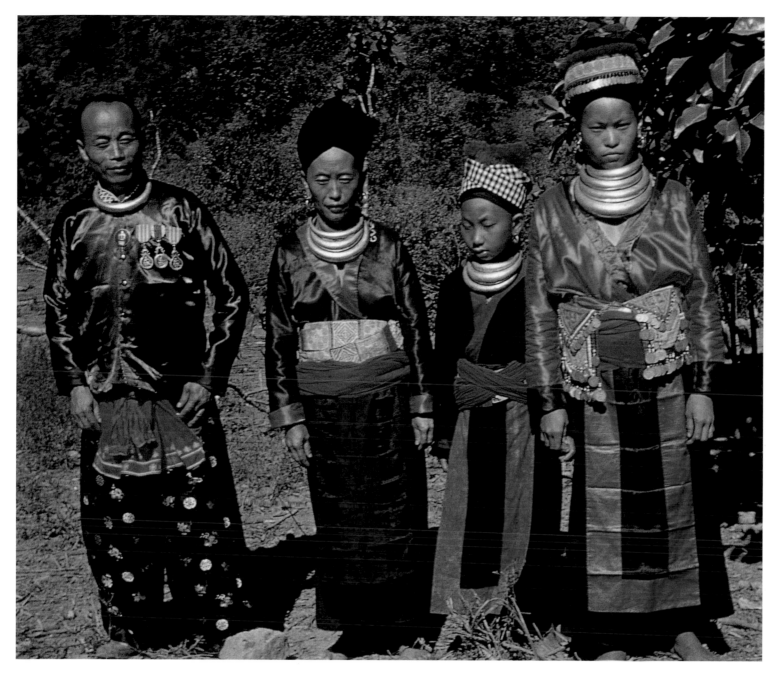

Hmong people in festive clothes with big hollow silver necklaces, Laos, 1956.

Page 192:

China
Miao and Dong tribes
H 10 cm, W 14.5 cm,
D 12 cm, 430 grammes
silver alloy
back ornament
middle 20th century
fastened to the back of the
coat by means of a belt; 2
pyramid-shaped spirals
ending in a strip; a 12-
pointed hollow knob at the
end
(see page 189)

Page 193:

China
Miao tribe
Left:
H 10 cm, W 7.4 cm, 100
grammes
silver
back ornament
middle 20th century

Right:
H 15.5 cm, W 13 cm, 198
grammes
silver alloy
back ornament
middle 20th century

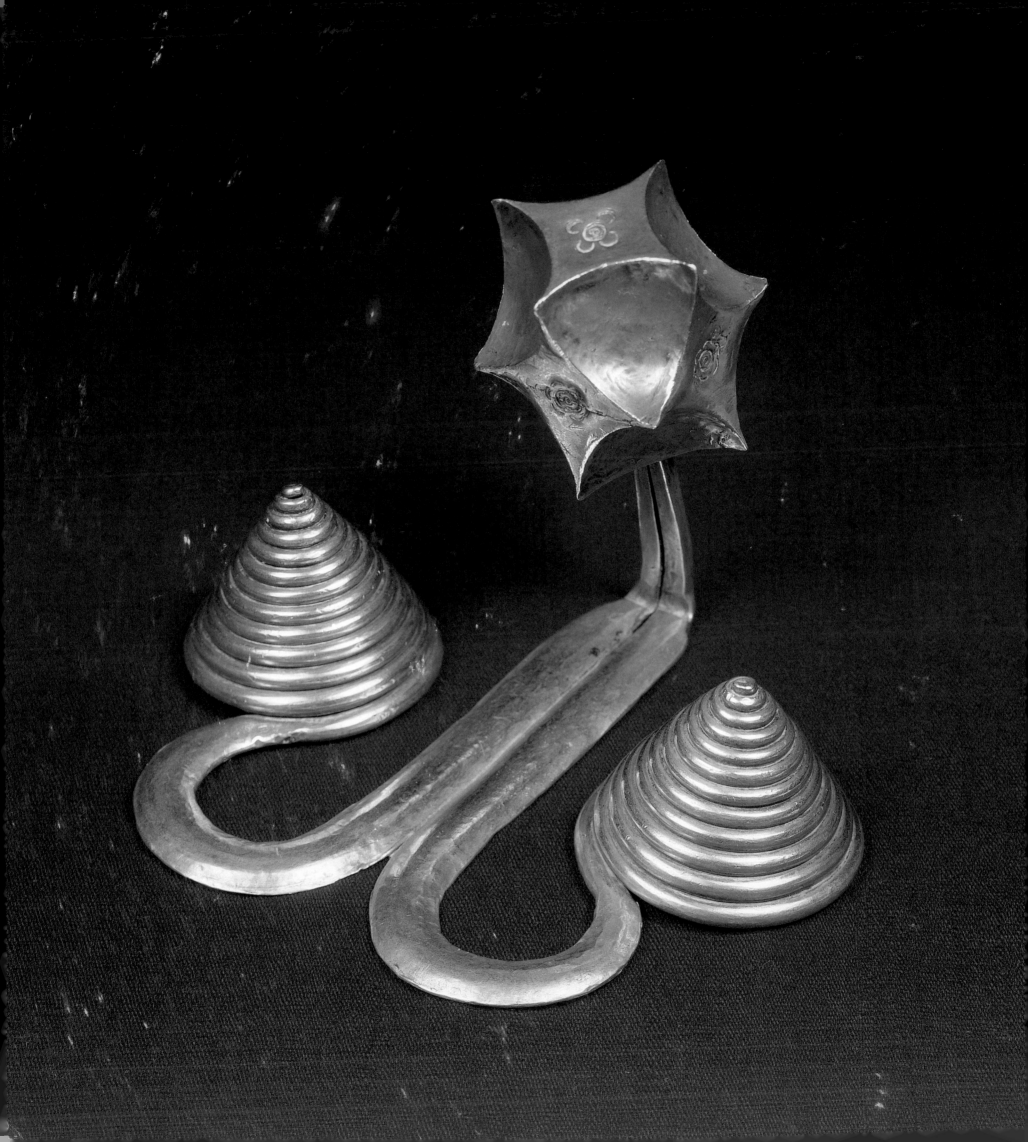

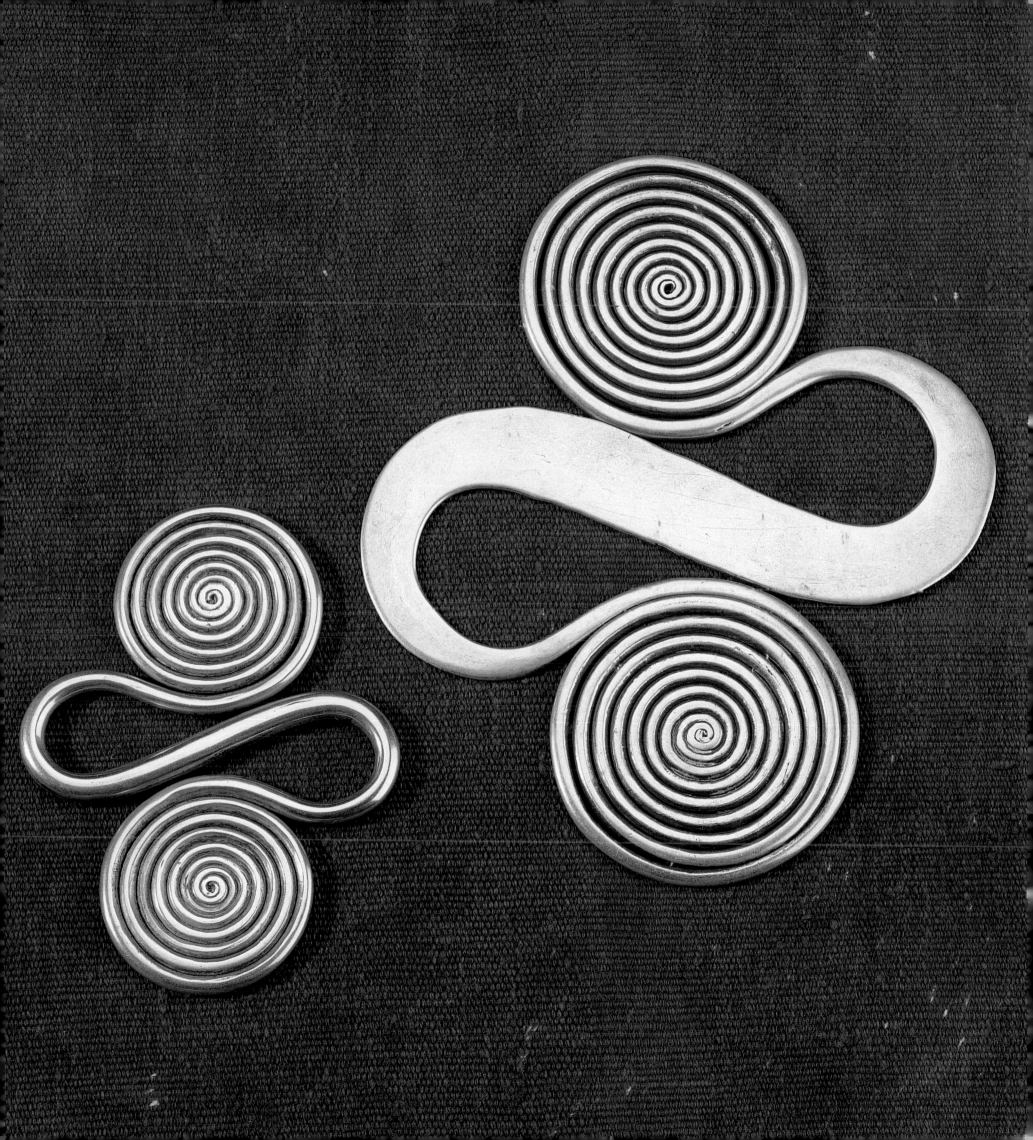

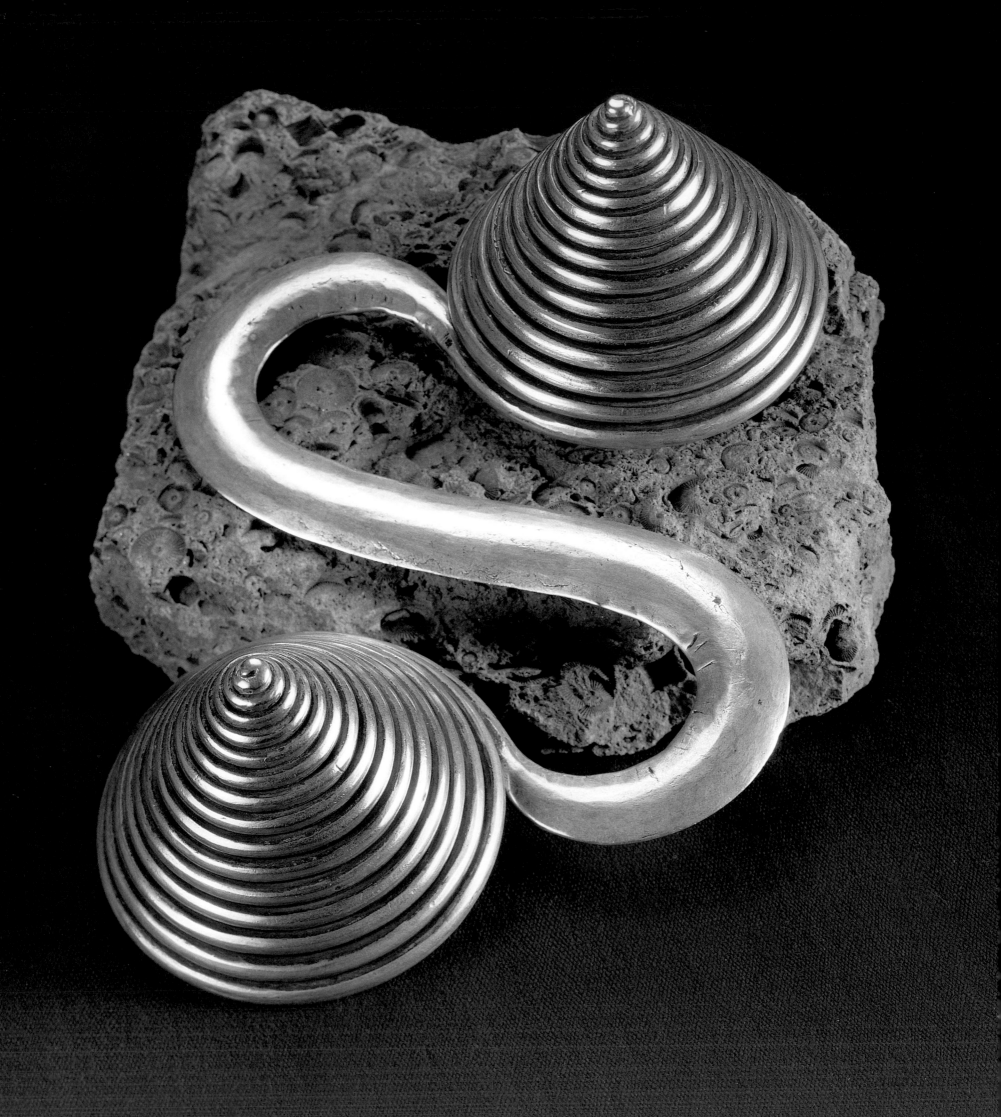

Left:

China
Miao and Dong tribes
L 20 cm, H 5.2 cm, W 14 cm,
670 grammes
silver alloy
back ornament
middle 20th century
S-shaped jewel with two
pyramid-shaped points
(see page 189)

Right:

China
Miao tribe
alpaca
Top:
D 8.5 cm,
154 grammes together
matching pair of bracelets
with neck ring below.

Bottom:
H 25 cm, W 26 cm,
435 grammes
neck ring
contemporary
Alpaca is a zinc, nickel and
copper alloy, originally
invented in China

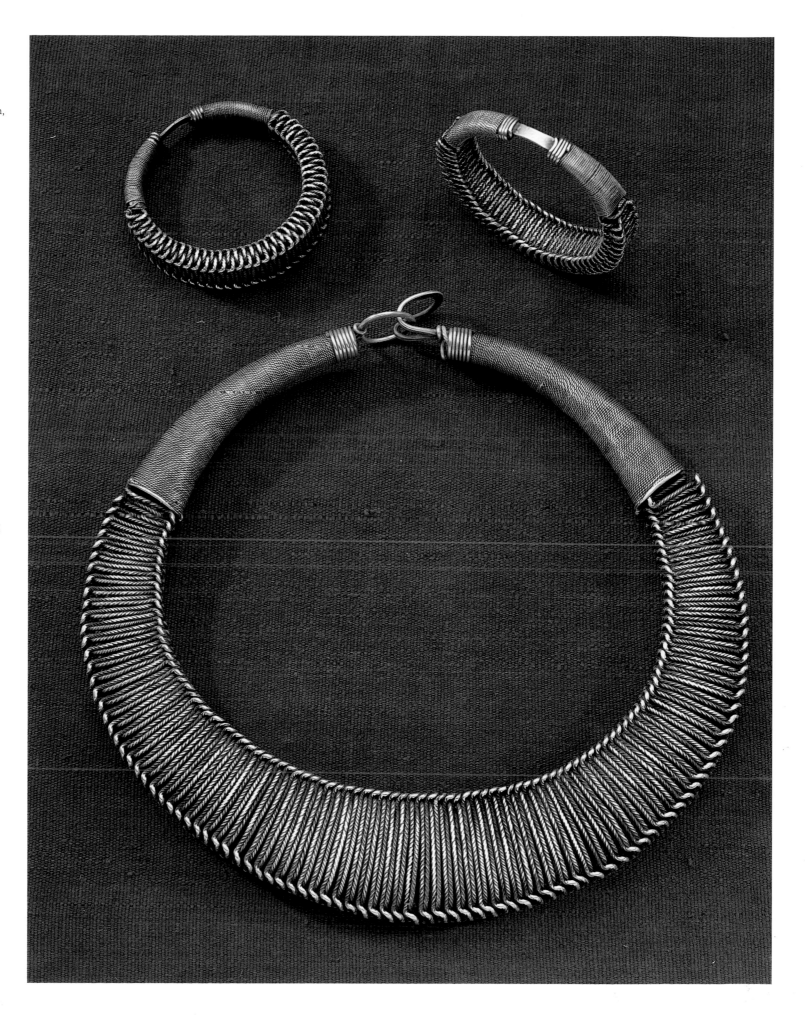

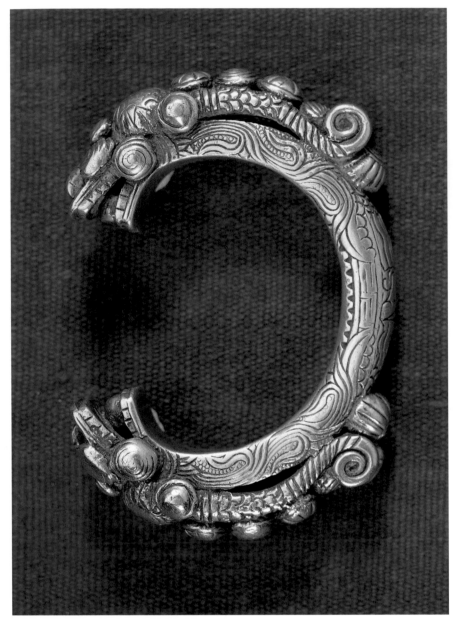

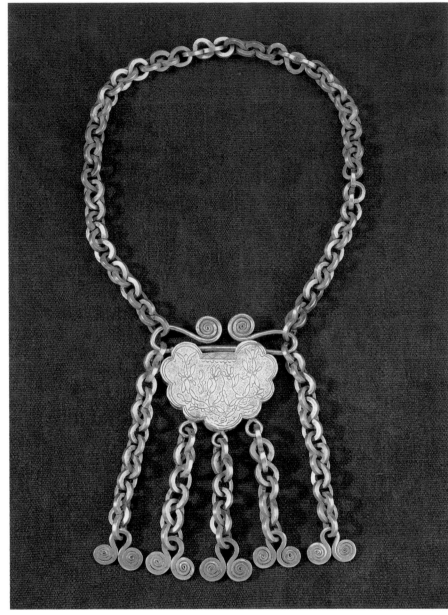

China
Miao tribe
H 6.8 cm, W 9.5 cm,
278 grammes
silver
man' s bracelet
early 20th century
massive silver; 2 dragon's
heads with curled horns;
a ball in either mouth

China
Dong tribe
H 36 cm, W 18 cm,
559 grammes
silver alloy
necklace
middle 20th century
chain necklace; central part
with engravings

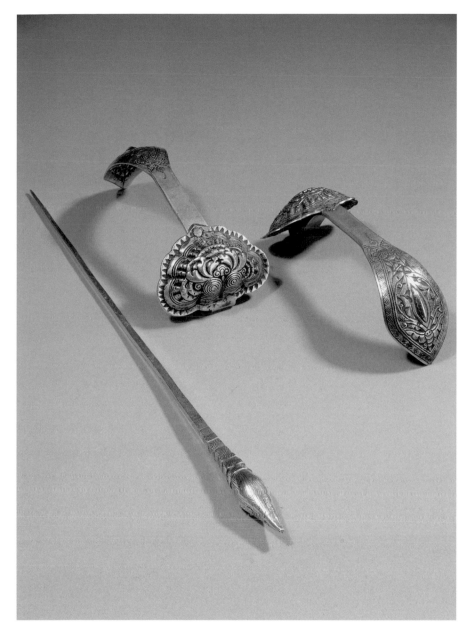

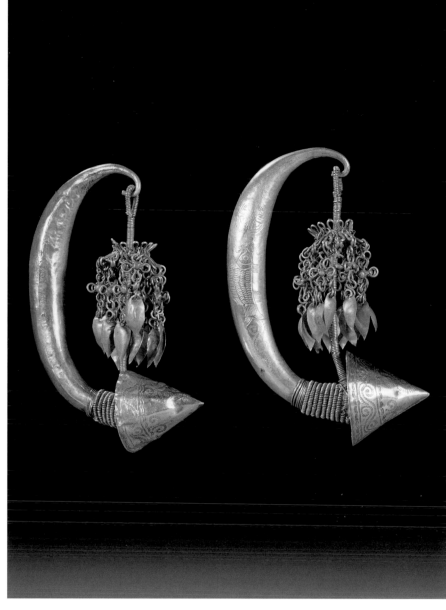

China

Left:
Miao tribe
L 28.5 cm, 74 grammes
silver
hairpin
middle 20th century
(see page 189, right)

Centre and right:
Bai tribe
L ±12 cm, W ±6 cm,
58 and 48 grammes
silver alloy
hair ornaments
middle 20th century
not a pair, but very compa-
rable; worn on the back of
the head

China
Miao tribe
H 10 cm,
70 grammes together
silver
earrings
middle 20th century

China

Miao tribe

Top:

H 17 cm, W 15 cm,
360 grammes
silver alloy
neck ring
middle 20th century
opens at the top; hinge on
one side; flat bottom

Left:

H 16 cm, W 19 cm,
458 grammes
silver

neck ring
1st half 20th century
plain silver massive neck
ring; open at the top; twist-
ed chain fastening

Right:

D 14 cm, 161 grammes
silver
neck ring
1st half 20th century
hook opening at the bot-
tom; short spiral on either
side of the hook; slight tor-
sion

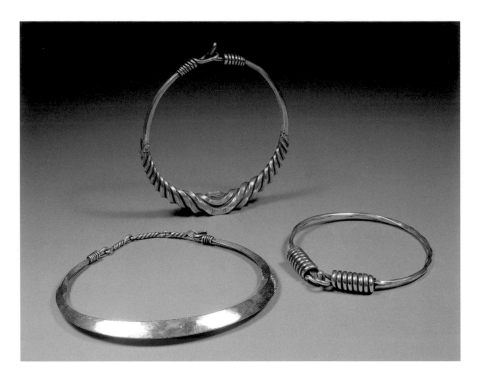

China

Miao tribe

Top:

D 21.5 cm, 663 grammes
silver
neck ring
middle 20th century

Bottom:

D 8 cm, 353 grammes
together
silver
bracelets, matching the
necklace
middle 20th century

China

Miao tribe
D 25 cm, 581 grammes
Alpaca
neck ring
contemporary
4 countertwined wires

alpaca is a zinc, nickle and cop-
per alloy, invented in China

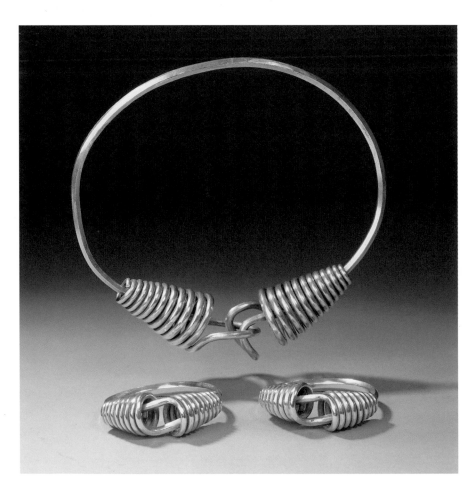

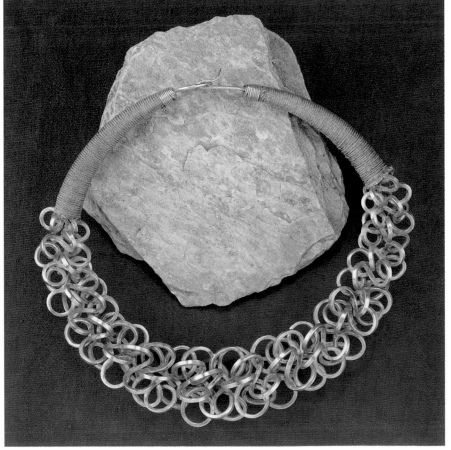

China, Mongolia

Top:
Mongolia
H 16 cm, W 6 cm,
70 grammes
silver and enamel
set for personal care
1st half 20th century
silver enamelled (green and
yellow) butterfly, with 5
attached instruments for
personal care

Bottom:
China
paper and kingfisher feath-
ers
late 19th/early 20th century
cap ornaments; 2 in the
form of a bat (H 2.7 cm, L 6
cm), 1 in the form of a lotus
flower (H 4.2 cm, W 6 cm)

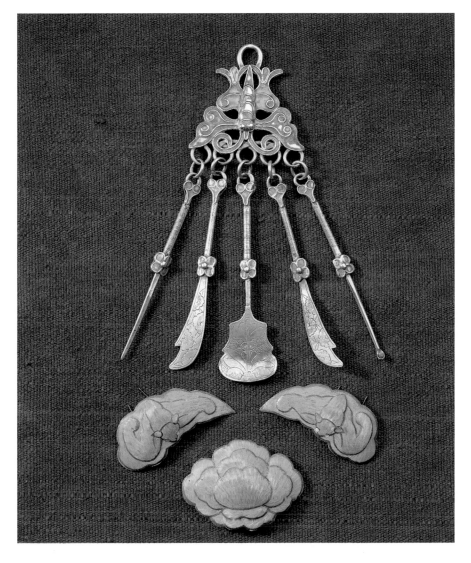

Mongolia

Top:
L 58 cm, 1140 grammes
yak horn, silver, red coral
man's tobacco pipe
19th century
engravings, 9 pieces of red
coral

Bottom:
L 12.2 cm, H 9 cm, 222
grammes
leather and iron
tinderbox
early 20th century
a piece of flint is kept in the
box

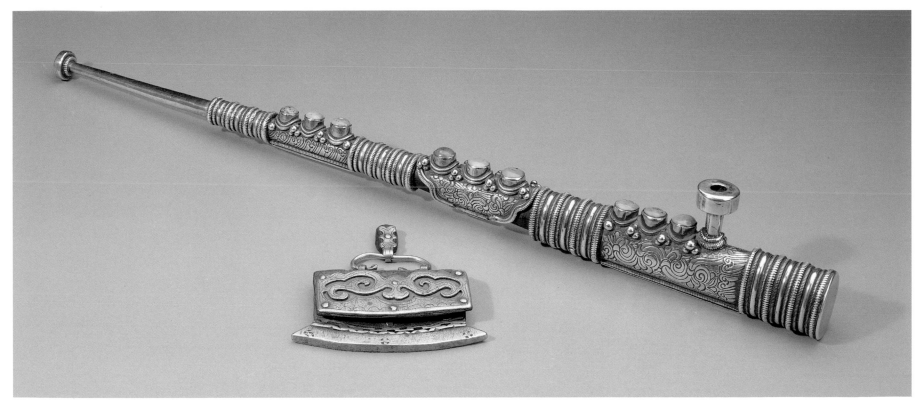

199

China
Miao tribe
Top right:
D 7 cm,
417 grammes together
silver
bracelets
middle 20th century
engravings

Top left:
H 7.3 cm, W 8 cm,
376 grammes
silver
bracelet
1st half 20th century
engravings

Bottom left:
H 6.8 cm, W 8 cm,
274 grammes together
silver
bracelets
1st half 20th century
front: narrow opening

Bottom right:
H 7 cm, W 8 cm,
300 grammes
silver
bracelet
1st half 20th century
2 countertwined silver
bands

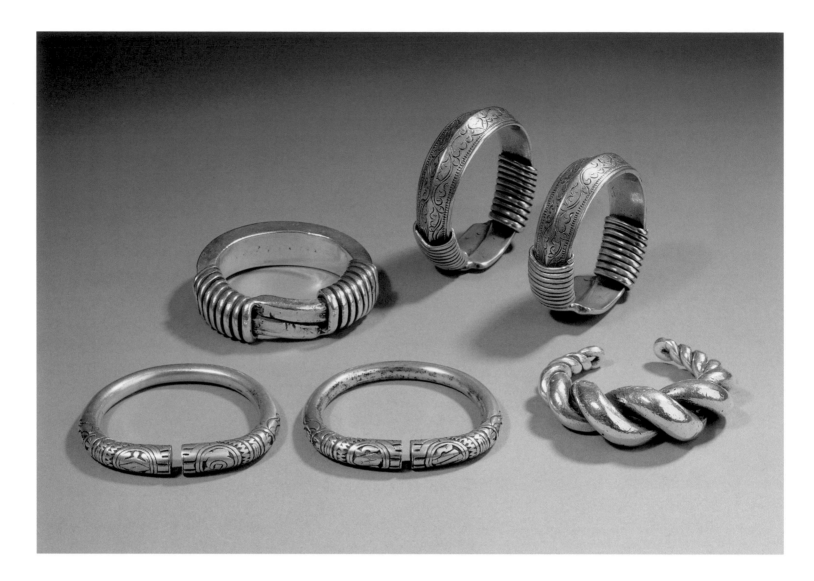

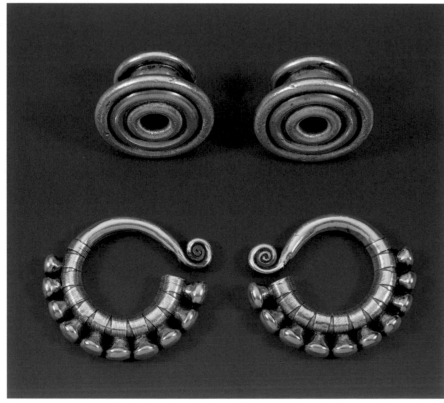

China
Miao tribe
Top:
H 2 cm, D 4 cm,
186 grammes together
silver
earrings
1st half 20th century
side: Chinese stamps;
top: 3 circles, back: 2 circles
(see page 189, right)

Bottom:
D 6 cm,
102 grammes together
silver
earrings
1st half 20th century
round earrings with 10
small balls at the bottom
(these earrings are depicted on
the Chinese 1 yuan banknote)

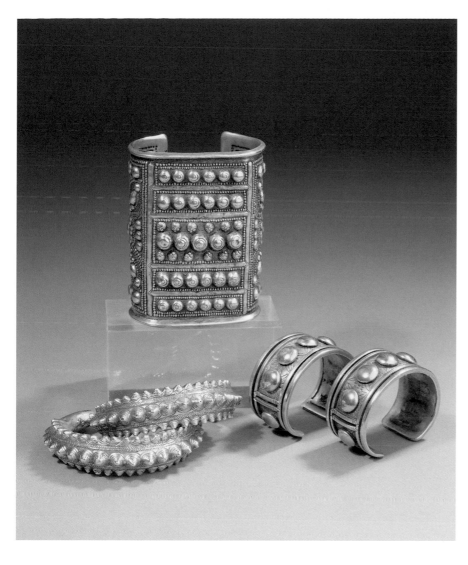

China
Miao tribe
Top:
L 10.2 cm, W 7.8 cm,
H 4.9 cm, 100 grammes
silver
bracelet
1st half 20th century
repoussé work

Left:
H 5 cm, W 6 cm,

164 grammes together
silver
bracelets
1st half 20th century

Right:
H 7.6 cm, W 8.8 cm,
138 grammes together
silver filled with lacquer
bracelets
1st half 20th century

China
Miao tribe
H (without attachments)
14.5 cm, (with attachments)
32 cm, W 13.2 cm,
206 grammes
silver and enamel
neck ring
middle 20th century
two stamps in the upper
part of the necklace; one
stamp at the back of the
dragon; attachments show
remnants of enamel

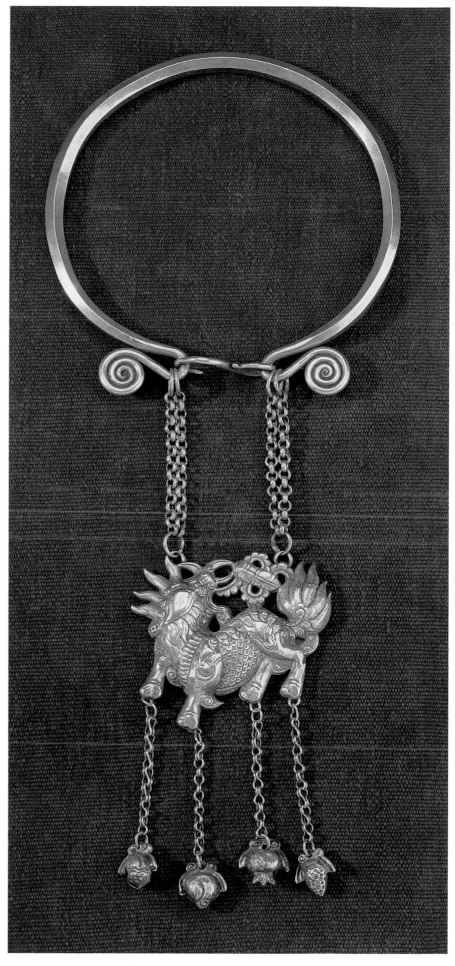

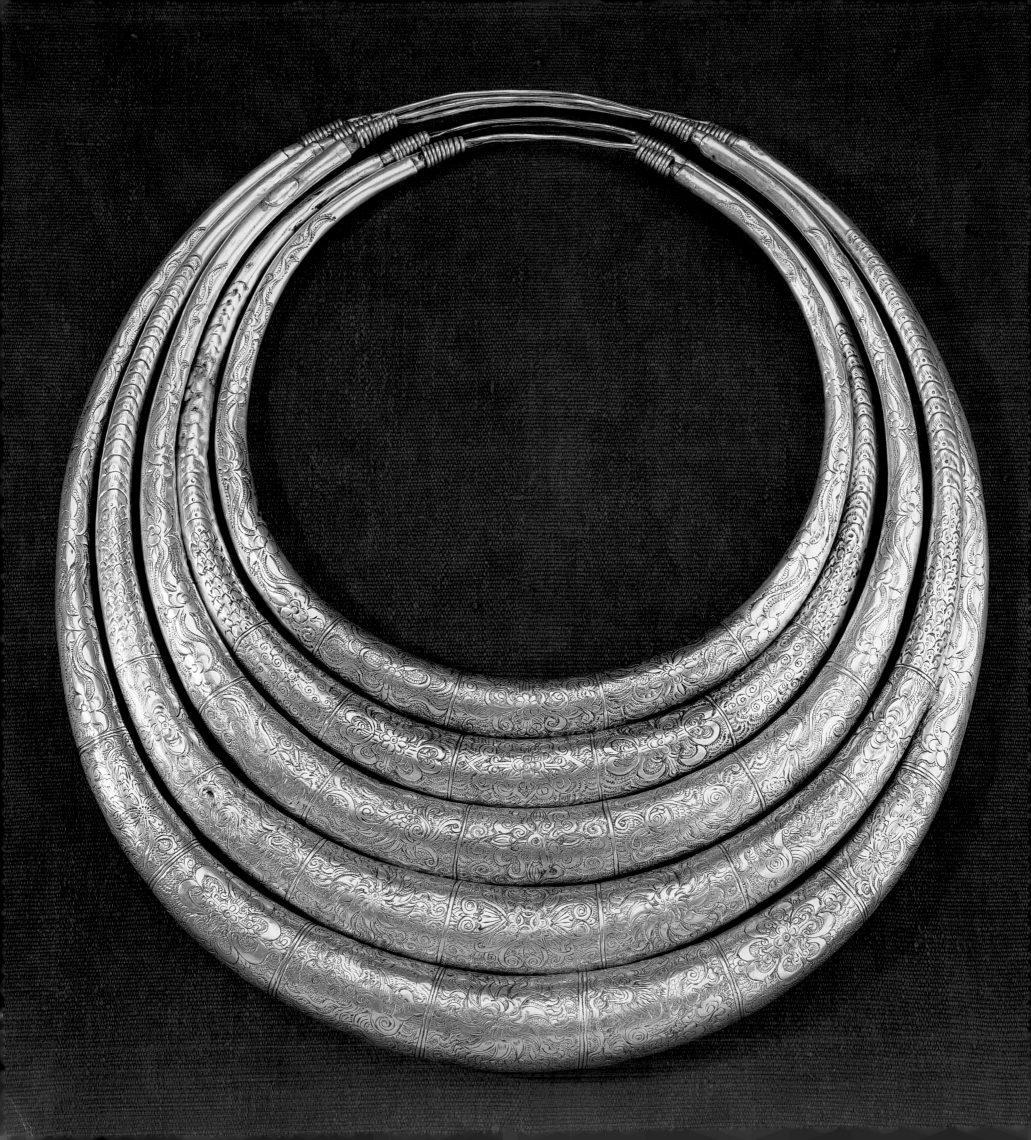

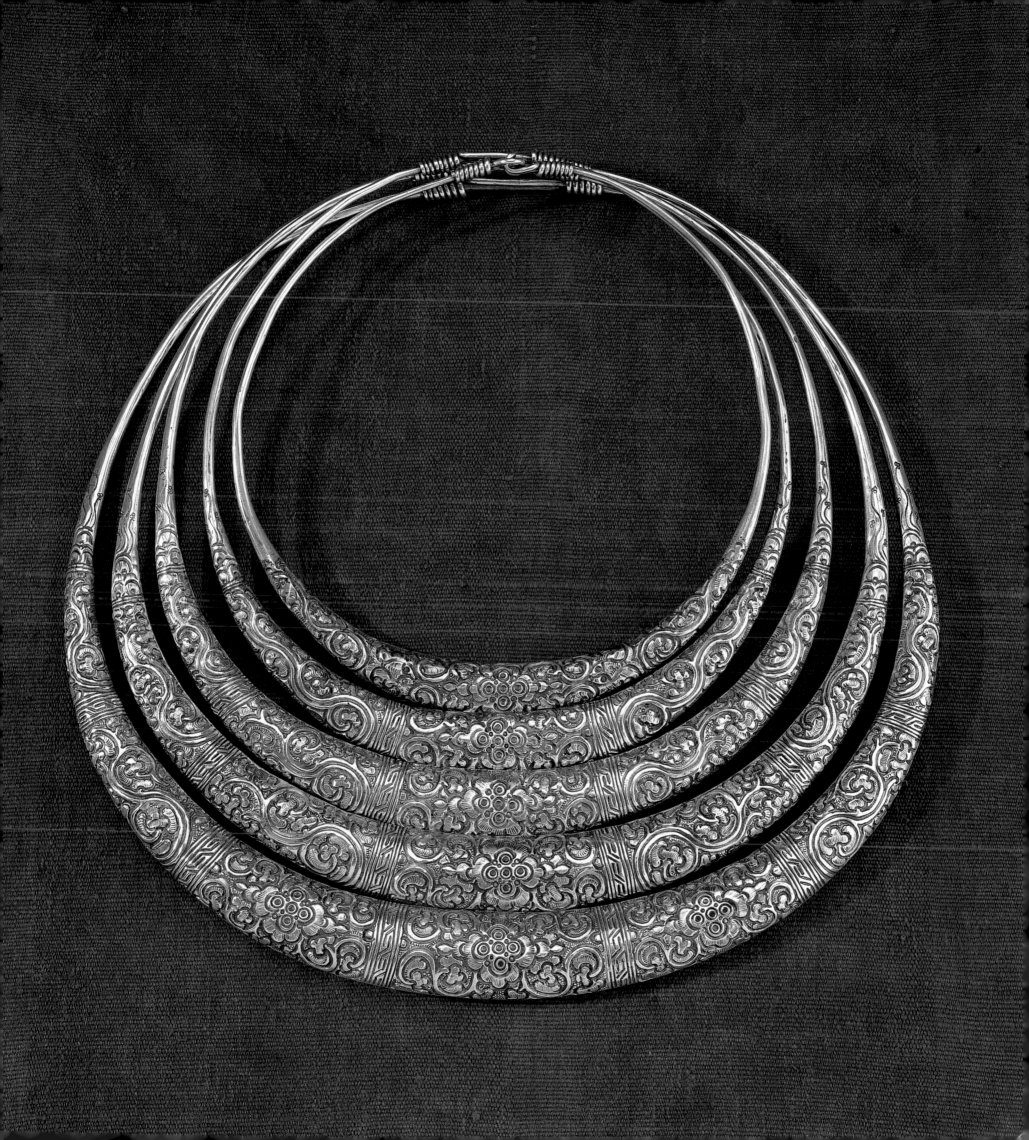

Page 202:

China
Miao tribe
D 22.5 cm, - ±35 cm,
712 grammes together
silver
woman's neck rings
1st half 20th century
set of 5 separate closed hollow engraved neck rings

Page 203:

China
Miao tribe
D ±19 cm - 29.5 cm,
2845 grammes together
silver
woman's neck rings
1st half 20th century
set of 5 separate massive
engraved neck rings; of
which 4 neck rings are
closed and 1 (the smallest)
opens at the top

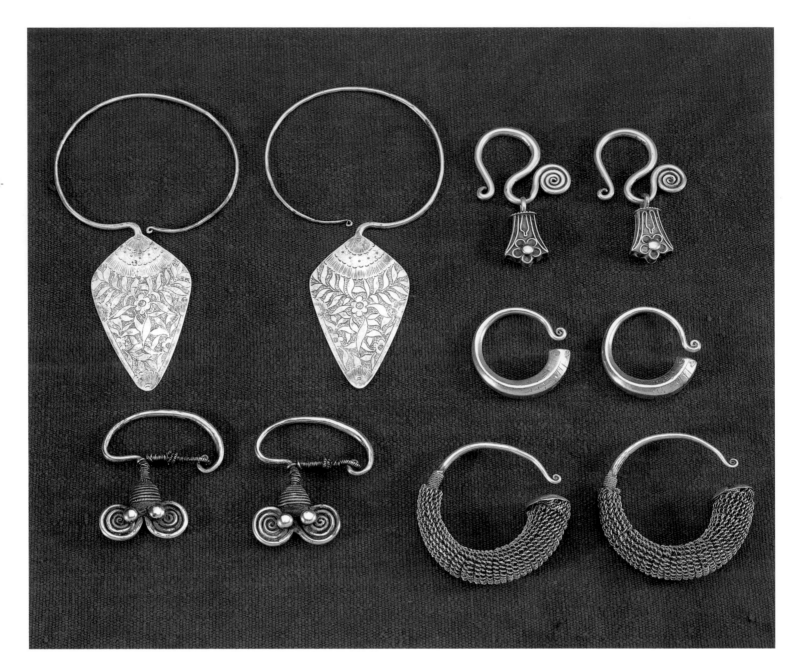

China
Miao tribe
smallest earring has a
diameter of 4 cm, the
biggest earring has a height
of 14.5 cm and a width of
8 cm
weight per pair between 43
and 140 grammes
silver
earrings
1st half/middle 20th
century
5 pairs of earrings

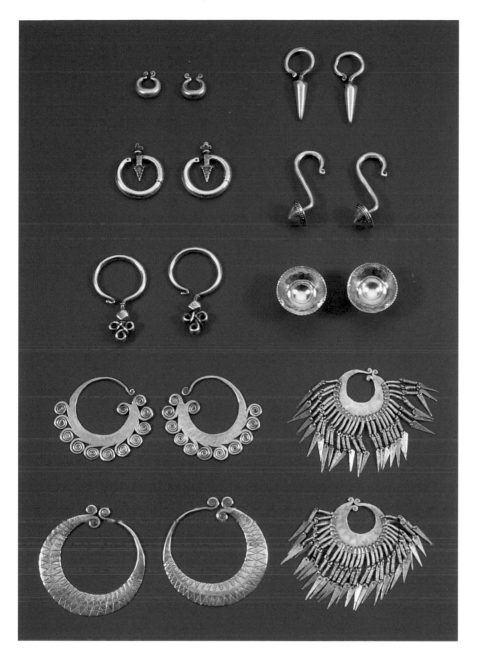

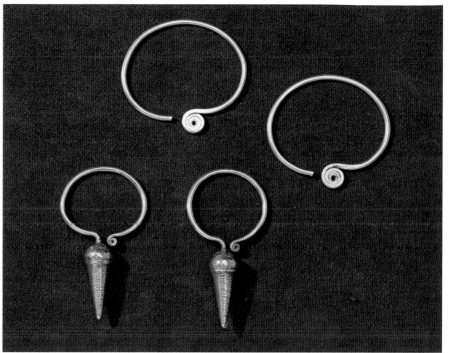

Thailand, Burma, Laos
Golden Triangle
Akha tribe
Top:
H 10 cm, W 5 cm,
58 grammes together
silver
temple pendants
1st half 20th century
temple pendants attached
to headdress or cap

Bottom:
D 7 cm,
58 grammes together
silver
temple pendants
1st half 20th century
temple pendants attached
to headdress or cap

Thailand, Burma, Laos
Golden Triangle
D 1.5 - 6.5 cm,
9.5 - 41.6 grammes per pair
silver
earrings
1st half 20th century
9 pairs of earrings

Burma, Laos
Karen tribe
From top to bottom:
L 15.5 cm, 57 grammes
silver and wood
pipe
1st half 20th century
2 parts

L 32 cm, 172 grammes
silver and wood
pipe
1st half 20th century
3 parts

L 42.5 cm, 194 grammes
silver
pipe
1st half 20th century
2 parts

L 68 cm, 430 grammes
silver
pipe
1st half 20th century

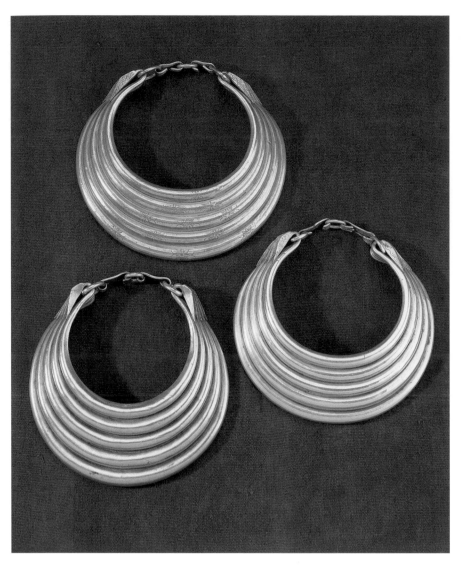

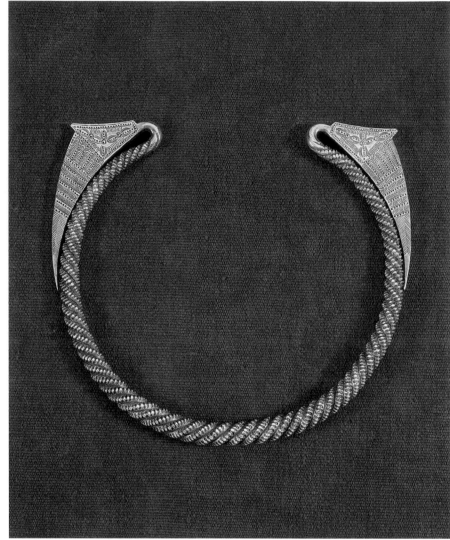

Thailand, Burma, Laos
Hmong tribe
Top:
D 18 cm, 1460 grammes
silver
neck ring
1st half 20th century
multi-tiered massive silver
neck ring (the 5 rings are
connected); engraved floral
motifs

Right:
D 17 cm, 1320 grammes
silver

neck ring
1st half 20th century
multi-tiered massive silver
neck ring (the 5 rings are
connected); wings with
engravings

Left:
D 16.5 cm, 725 grammes
silver
neck ring
1st half 20th century
multi-tiered plain hollow
silver neck ring (the 5 rings
are connected)

Thailand, Burma, Laos
Golden Triangle
H 16.5 cm, W 16 cm,
371 grammes
silver
neck ring (torque)
1st half 20th century
twisted neck ring with long
engraved wings
(see page 190)

Thailand, Burma, Laos
Lisu tribe
H 28 cm, W 37 cm,
874 grammes
silver
neck ring
1st half 20th century
ring with engravings and 87
dangles

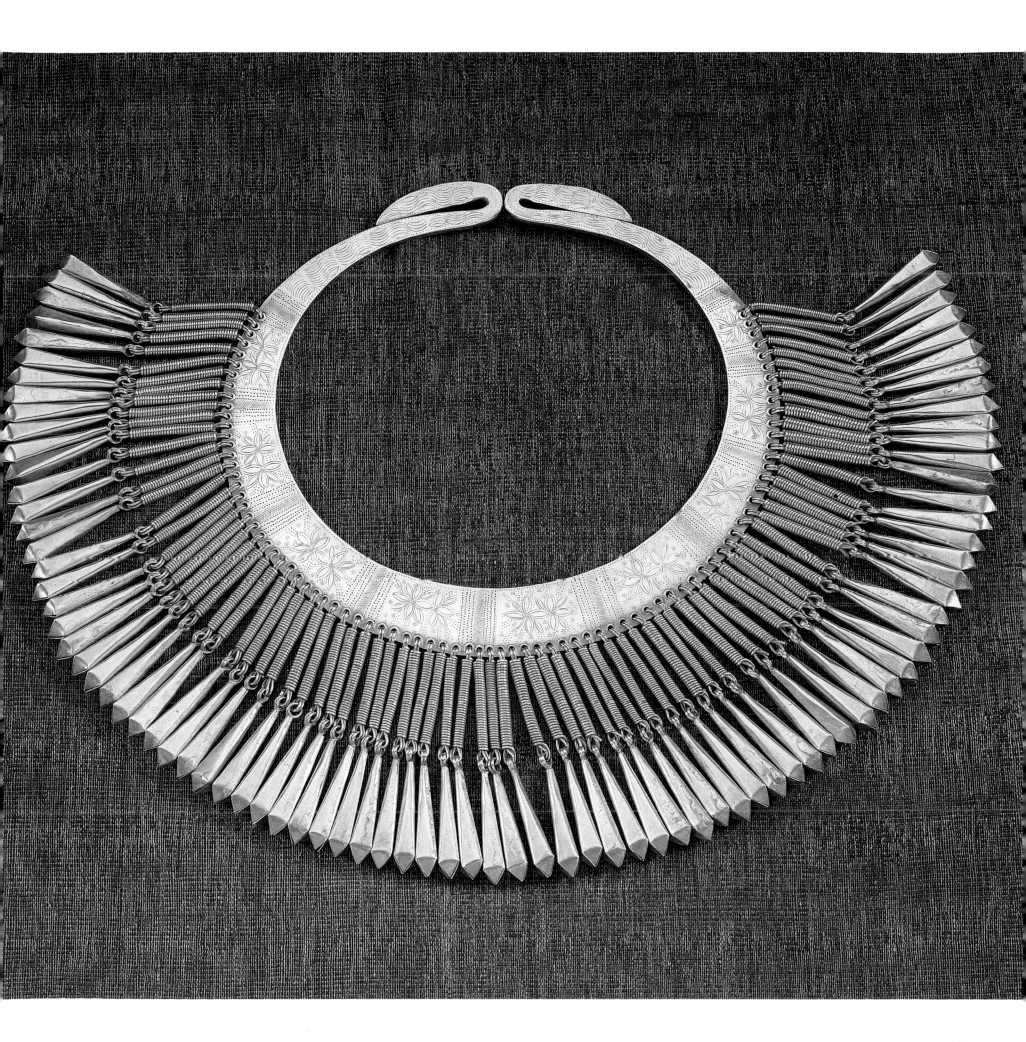

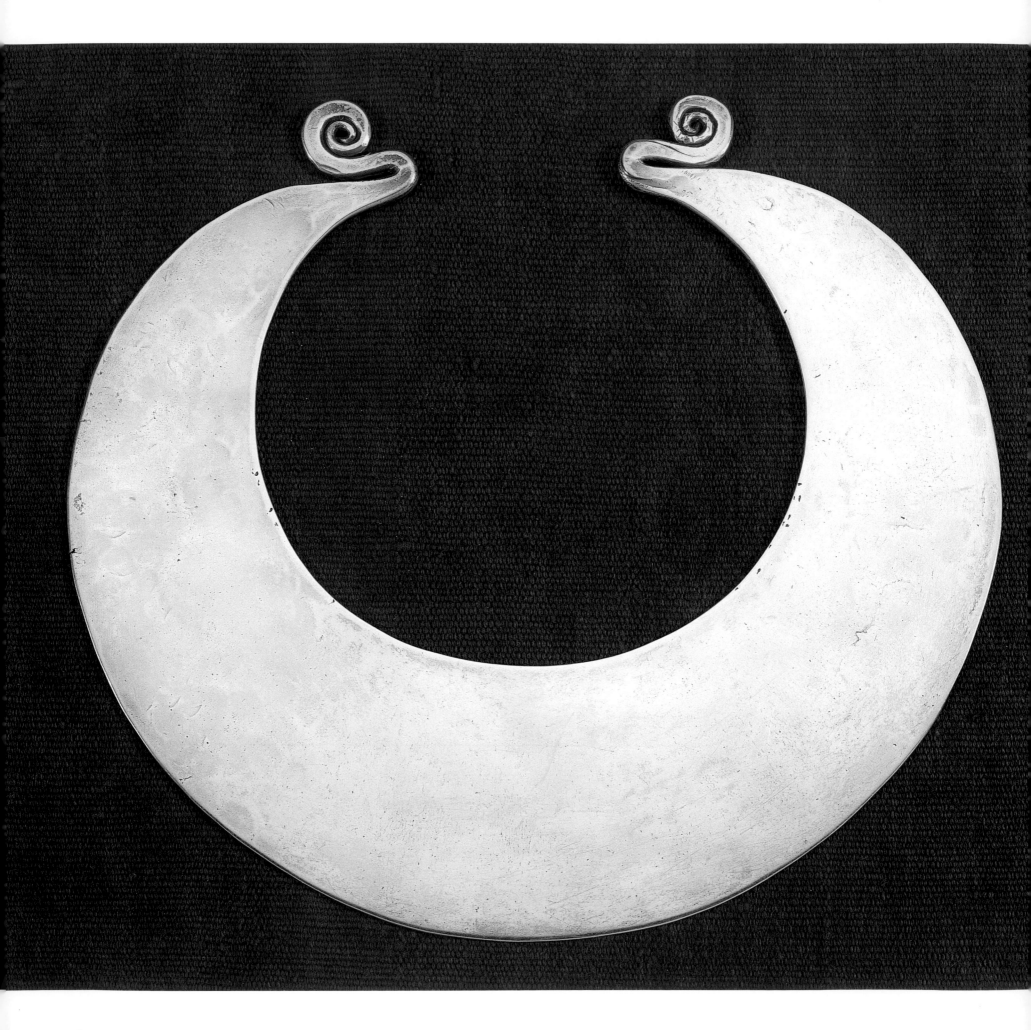

Thailand, Burma, Laos
Golden Triangle
H 20 cm, W 19 cm,
364 grammes
silver
neck ring
1st half 20th century
thick hollow facetted ring
(see page 184 and 191)

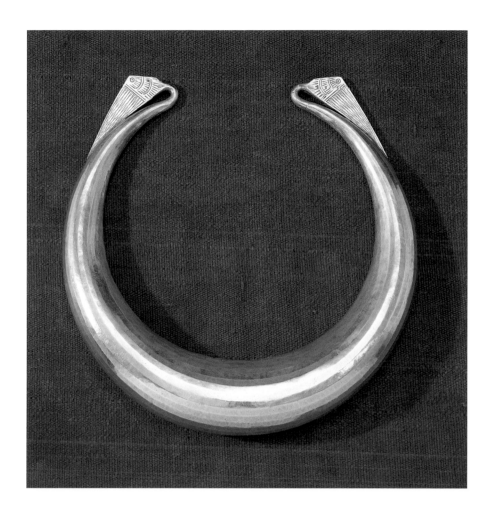

Thailand, Burma, Laos
Golden Triangle
H 21 cm, W 23 cm,
768 grammes
silver
neck ring
1st half 20th century
massive closed facetted sil-
ver ring; widely spread out
wings
(see page 190)

Left:

Thailand, Burma, Laos
Akha tribe
D 19.5 cm, 242 grammes
silver
neck ring
1st half 20th century
chased plain silver

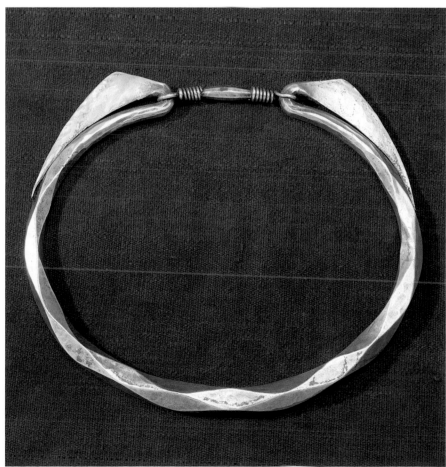

Thailand, Burma, Laos
Shan tribe
Top:
L 42 cm, 585 grammes
silver, ivory
dagger (worn for status)
1st half 20th century
these daggers were worn by
various groups; always
made by Shan silversmiths;
ivory grip

Bottom:
L 42 cm, 698 grammes
silver, ivory
dagger (worn for status)
1st half 20th century
ivory grip

Thailand, Burma, Laos
Golden Triangle
D (round earrings) 2.5 - 5.6
cm, 58 - 232 grammes per
pair
L (long earrings) 6 - 10 cm,
17.1 - 31 grammes per pair

ivory
earrings
late 19th century
7 pairs of earrings; all ele-
phant and sperm whale
ivory
(see page 188)

Thailand, Burma, Laos
Golden Triangle
Left:
H 6.5 cm, W 7.5 cm,
629 grammes together
silver
bracelets
1st half 20th century
bracelets are each other's
mirror image; this includes
the spirals

Right:
H 7.5 cm, D 7 cm, 627
grammes together
silver
bracelets
1st half 20th century
spirals slightly expanded

Bottom:
D 7.5 cm, 271 grammes
together
silver
bracelets
1st half 20th century
closed round bracelets;
plain middle part; each spi-
ral each other's mirror
image

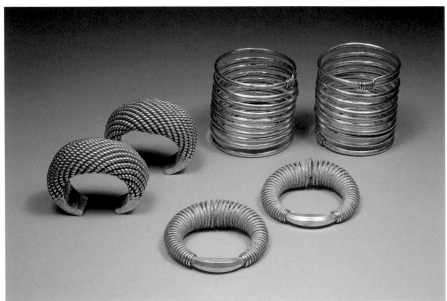

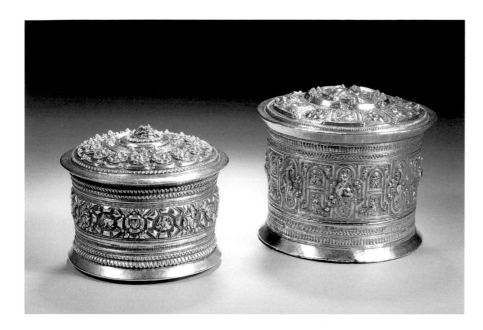

Thailand, Burma, Laos
Golden Triangle
Shan tribe
Left:
H 9.4 cm, D 10.4 cm,
367 grammes
silver
betel-nut box
1st half 20th century
repoussé work; box with
inner box; on the bottom of
the outer box engraved
mythological animal

Right:
H 10.5 cm, D 11.7 cm, 372
grammes
silver
betel-nut box
1st half 20th century
repoussé work; engraved
mythological animal
engraved on the bottom

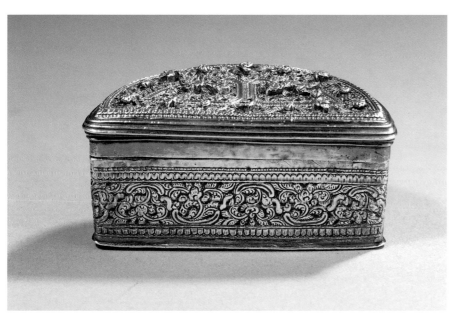

Thailand, Burma, Laos
Golden Triangle
Shan tribe
L 7 cm, H 3.5 cm, D 4 cm,
80 grammes
silver
lime container
1st half 20th century
silver box in the form of a
semicircle; extremely fine
repoussé work; probably
the property of a tribal
chief; 2 mythological lions
on top

Thailand, Burma, Laos
Golden Triangle
D 15.5 cm, 11.8 cm, 10.2 cm,
8.2 cm;
225, 154, 108, 84 grammes
respectively
silver and engravings
disc-shaped buttons
fastened to clothing; con-
sisting of flat disc, round
button plus silver extension
(see page 186)

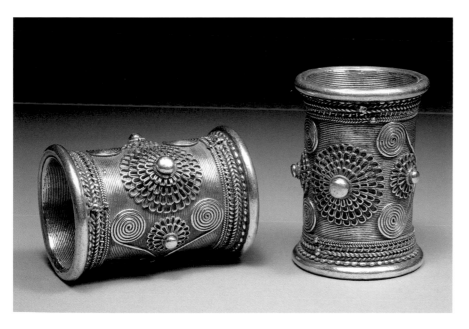

Burma
H 10 cm, D 7 cm,
857 grammes together
silver
bracelets
1st half 20th century
closed tubular bracelets,
adorned with floral motifs
and spirals

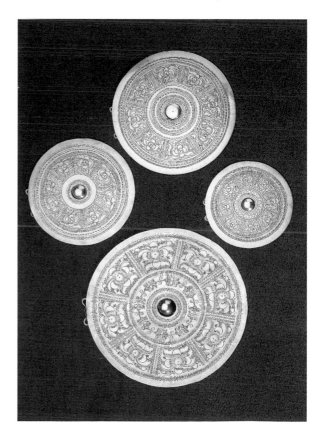

Thailand, Burma, Laos
Karen tribe
H 35 cm, W 19 cm, 169
grammes
silver and wood
necklace
1st half 20th century
necklace consists of silver
beads with a wooden core

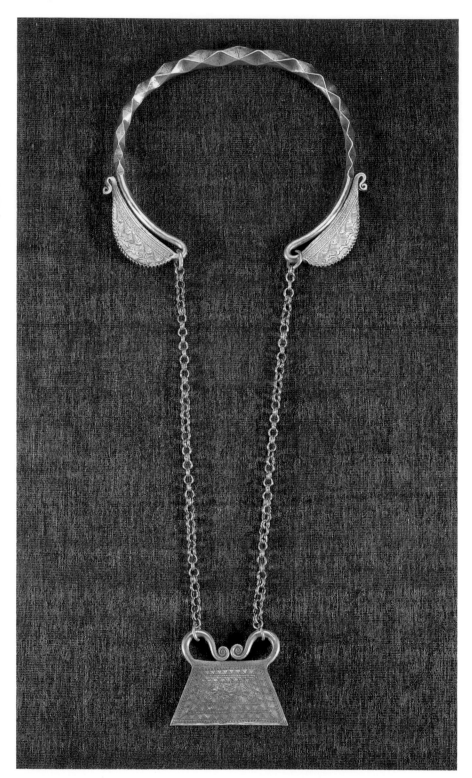

Thailand, Burma, Laos
Golden Triangle
H 54 cm, W 21 cm,
672 grammes
silver
neck ring
1st half 20th century
massive silver facetted neck
ring; lobed and engraved
wings; silver chain and
pendant
(see page 190)

Sarawak and Indonesia

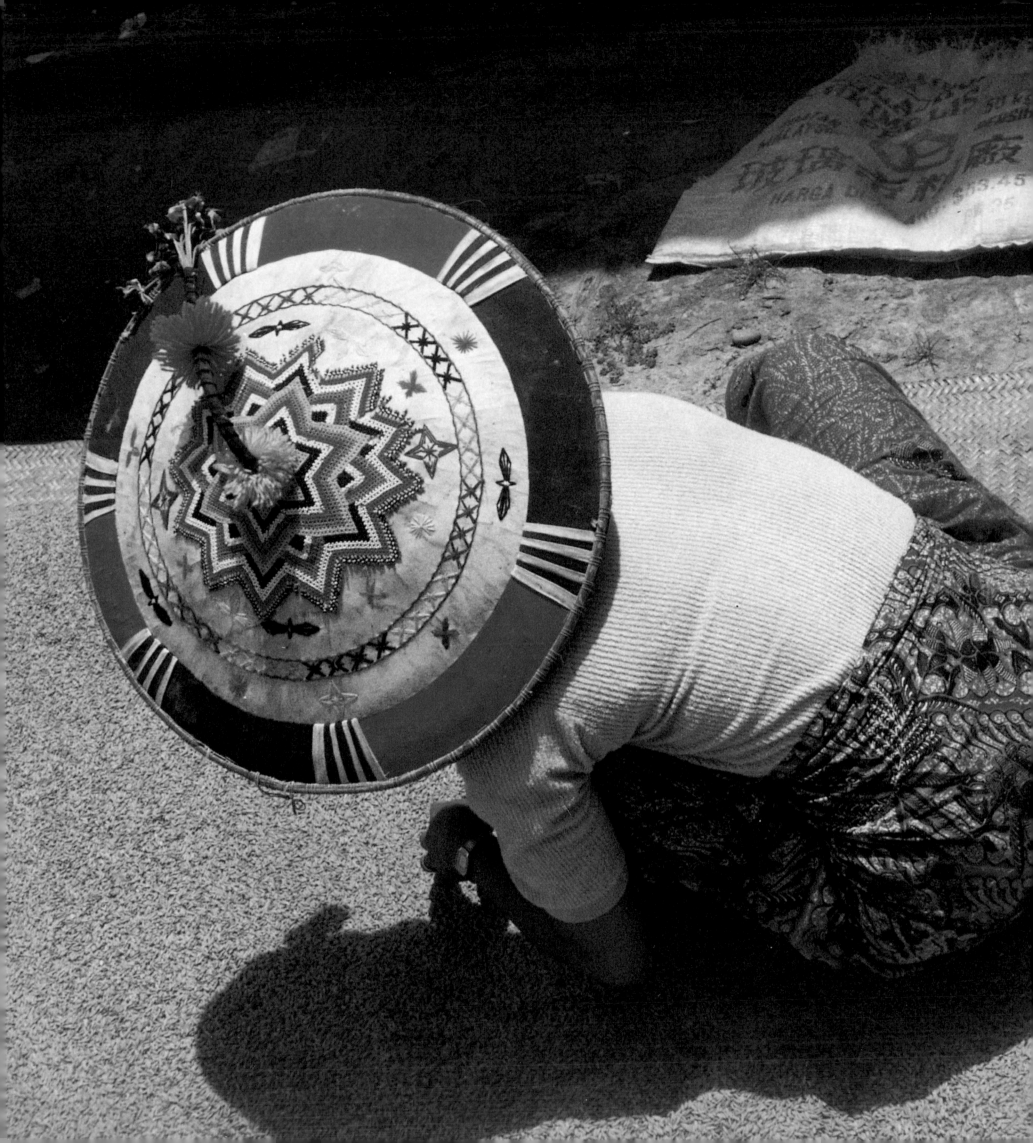

Beadwork in Central Kalimantan
An introduction to the colours and motifs used by the Dayak

Pim Westerkamp

'And automatically one is reminded of the many references in travel accounts, to glass beads being an indispensable means in exploratory expeditions, to the passion of the 'savages' for these children's toys.'[1]

This quotation represents a view which was common during the colonial past of the Netherlands and other European powers. 'Natives' were fond of beads, round gadgets with little or no value in the eyes of many 'developed' Westerners. With these beads these 'savages' could be persuaded into selling valuable merchandise or making contracts.

Many centuries before the arrival of the Europeans, however, Asian beads had been part of the comprehensive network of trade between the powerful states in Asia. They were very old beads, sometimes as big as pigeon's eggs, more beautiful and valuable than the beads imported by the Europeans from the seventeenth century onwards. The thought that it is strange for attractive pieces of polished glass to represent a high value, is probably not more odd than pieces of printed paper having monetary value.

This book on the jewellery collection of Van der Star's shows some Indonesian beadwork that represents a very special form of arts and crafts. With my focus on the beadwork of one specific section of the population, the Dayak[2] of Central Kalimantan, I want to prove the limited view of the lines quoted above.

On the basis of a number of objects illustrated in this book, I will describe the beadwork and the use and meaning of certain colours and motifs. I will be able to show the changes that took place over time, since this collection covers beadwork from several periods. The objects can also easily be compared with examples from literature and from the collection of the Museum Nusantara in Delft (The Netherlands), where I work as a curator.

The Dayak of Central Kalimantan and western research

Kalimantan, the Indonesian part of the island of Borneo, takes up 28 per cent of the Indonesian territory. The area is populated by seven Dayak tribes, each divided into subgroups. Central Kalimantan is populated by the Kenyah and Kayan[3] tribes. In Van der Star's collection these groups are represented very well, with beadwork of the Bahau in the southern Mahakam area, the Lepo Tau people in the town of Long Nawang in the centre and the Maloh[4] in the western part. In the past these areas were visited and described by a number of scientists. One of them, the Dutch scientist Dr A. W. Nieuwenhuis, travelled through Borneo on several occasions in the late nineteenth century and wrote his famous book *Quer durch Borneo*. In his very detailed report he also presents a number of pictures of beadwork for headwear of the Mahakam-river Bahau people. The Museum Nusantara has two comparable pieces and two objects from the Nieuwenhuis collection. An amulet with very small beads[5] for a sword, mandau, and a round decoration with larger beads[6] for a sun hat.

There is much information about the Lepo Tau, a Kenyah subgroup. One of the first Dutch researchers was J. M. Elshout, who conducted studies in Long Nawang in 1913, 1914 and 1915. The Dutch film-maker and traveller Hendrik Tillema (1870-1952) did some research in the same place ten years later and donated many of the items he had collected to the National Ethnological Museum in Leyden (The Netherlands). The Museum Nusantara in Delft also has a number of items from this village, collected by Willem Spruitenburg, who had worked there as a colonial government doctor in 1933 and 1934. In the 1970s the American anthropologist Herbert L. Whittier was a resident of the village and studied the beadwork. In their descriptions we learn about the three groups identified in Kenyah society. This classification is important, as I will show later on, because it is related to the various motifs on the beadwork. The nobility, the free people and the slaves were the three groups identified. Elshout[7] calls them the Paran, the Panyin and the Panyin Ula of Salut respectively and comments on the superficial nature of this subdivision. Thus the slaves were the enemies that had been taken prisoner or the 'debt slaves', a group which could buy back its freedom. Whittier[8] describes yet another group, the Paran Lot, the offspring of mixed marriages between Paran and Panyin. He reports that the various terms still exist, but that, due to government regulations, the class system is no longer officially used.

The Maloh at the Kapuas river are well-known for their garments, decorated with large quantities of beads. The fact that they were tradespeople might explain this abundance of beads.

Kayan woman with big sun hat covered with beadwork, Sarawak, 1988.

Beads and beadwork of the Kenyah and Kayan

Beads can be made of all kinds of natural materials and minerals such as seeds, pips, bone, ivory, mother of pearl and precious stones. They can also be made of clay, porcelain, glass, silver and gold. The value of a bead depends on the rarity of the material. Materials that must be imported from afar are more expensive by definition.

In Indonesia this has been true for beads for centuries. The East-Javanese Majapahit period (twelfth to sixteenth century) has given us some beautiful large beads, imported via the trade routes, just like the glass beads of a later date. In 1436 AD a Chinese Muslim, Fei Hsin, discovered that glass beads were imported into South Sumatra, but he was not sure about their country of origin. Later Venetian tradesmen took along beads from Murano (a small island near Venice) to the Far East. The VOC[9] bought its glass beads from a factory in Amsterdam. When in the early nineteenth century they were very much in demand, Bohemia became the new bead production area. The Bohemian beads were small and very suitable for making twined or threaded beadwork[10]. This made the beads a very popular commodity.

In the entire Indonesian archipelago the beads were used for jewellery, to decorate clothes and goods, and as an instrument of exchange or payment. Red, white and black are very popular colours with a number of tribes. The Angkola (Batak) in North Sumatra used them for jackets, jewellery and consumer items. The inhabitants of Alor (near Timor) and West Timor used these colours in their belts and head ornaments[11]. They are quite different from the *sirih* bags of the Timorese which have many different colours. This multicoloured aspect is also present in the Kendaure, ritual decorations of the Toraja of Central Sulawesi, the East-Sumbanese bead bands for women's clothes, the aprons[12] of the people of Yellow Finch Bay in Papua and the beadwork of the Dayak. Each population group in Central Kalimantan has its preference for certain colours.

The origin of the beads in Central Kalimantan

The majority of the beads were imported by tradesmen from China, India, the Arab world and Europe. In the coastal towns of Borneo they traded them against forest products of the Dayak tribes. But not all beads were imported. In the small town of Tanjung Selor, on the east coast, Tillema found a workshop for beads in 1928. Here European glass beads were crushed and melted down by the local craftsmen. The melted glass was poured into planks with numerous little holes. They were larger than the Bohemian beads, so that thicker beads could be made. When the glass was still liquid, the men made a little hole in the ball with the vein of a palm-leaf, turning it into a bead.

In Whittier's[13] time there were various ways of obtaining beads. The first method was importation from Czechoslovakia, the new name of the former Bohemian region. These beads were imported via Sarawak, the Malaysian part of Borneo. The second method was trading ethnographic objects for beads of non-resident Kayan tradesmen. These goods were then sold in the tourist markets via the tradesmen. Another method was obtaining the beads through a fellow-villager, usually a female relative. The final method was unpicking old pieces of beadwork.

Making the beadwork (aban)

The design

Designing the motif has always been a man's job. Elshout[14] gives a description of how they carved the beadwork motifs onto a plank. Some years later, Tillema discovered that these planks were no longer used. The men cut the motifs from newsprint[15] and pasted them onto undecorated planks. Another design method was copying existing beadwork motifs. Nieuwenhuis[16] describes how he had hat decorations copied from existing decorations.

Threading the beads

Threading the beads was an activity performed by the women, after a day's work, usually at night. To make the threads they stripped away the mesophyll of the pineapple plant with a scraper. On their knees they then rolled the fibres of the veins into a thread. These threads were strong, flexible and durable, especially when covered in beeswax. Nowadays women sometimes use nylon thread, but the disadvantage of this material is that beads slip from position.

The basis for the beadwork is one single thread. On this thread are loops which hang down in two threads. The number of loops and the length of the threads are determined by the size of the beadwork. The loops are knotted half a centimetre apart and horizontal rows of beads are added. The pattern that is created looks like a pattern of a net, but the threads never cross. The beads of the odd rows have one thread per bead. The beads in the even rows have two threads: the right thread of a loop and the left thread of the next loop. This is done to prevent the beadwork from falling apart when it is damaged. In the work of the skilled craftswoman the curves of the pattern are smooth and round. A tightly controlled design, consisting of a single-bead line, reveals the hand of the professional.

For the sun-hat decoration, *aban sa'ong*, the loops hang on a small circle which is the pointed part of the hat. Here the women work from the inside out-wards, the hat itself being the basis. In the baby carrier decoration, the *aban ba'*, the first, elementary thread which holds 80 to 90 loops is at the top of a plank. Here the women work from top to bottom. For this decoration they need 16 packs of *ikats* beads (in a pack there are 1000 beads)[17]. Because of the protective function of the baby carrier, there are only a few people who are allowed to make this decoration; an (older) friend of the mother's or the resident grandmother-to-be[18]. It takes them approximately three months.

The Bahau hats consist of approximately 6000 beads each[19]. Nieuwenhuis noted that it took the Bahau over a year to make them, since obtaining beads of the right colours took a lot of time. Nowadays it is probably less time-consuming. Some women sort the beads according to colour. Others have a box with all the beads of different colours mixed together[20]. It is possible that the sorting women use prepacked beads and that the other women use beads from unpicked beadwork.

Beadwork colours and motifs

As mentioned above, each Dayak group has its own preference for colours. In the late nineteenth century beadwork for women's hats, *lawong apang*, was made by the Bahau in the Mahakam area, showing a large diversity of colours: black, yellow, green, blue, red and orange. The motif on this beadwork was a highly stylised panther's head, the *tap kule*. The eyes, nose and mouth of the panther are in black and red. Nieuwenhuis[21] believes this motif to be a mythical figure or a reference to a real panther; both assumptions seem to suggest that the Bahau, just like the Kenyah, opted for motifs from the animal world.

The Maloh had a preference for yellow, blue, black and orange. Their women's jackets, *sape manik* and skirts, *kain lelok*, were richly decorated with beads. On these jackets the squatting human figures, the *kaletau*, were yellow or blue. They are set against a background of dragon and hook figures in black and orange. According to textile anthropologist Brigitte Khan[22] the Maloh took over the beadwork techniques and motifs from the Kenyah and Kayan.

Kenyah beadwork reveals a preference for three colours: black for the background and yellow and white as the dominant colours for the human and animal motifs[23]. Pale yellow was considered to be more beautiful than dark yellow (but sometimes it was simply a matter of colours being available). Red, green or blue were used for single accents, and too much blue was considered unattractive.

Of course the preferences mentioned above were just a guideline. Nieuwenhuis[24] notes that the women sometimes had not got enough beads of a particular colour, so had to cheat with other colours,

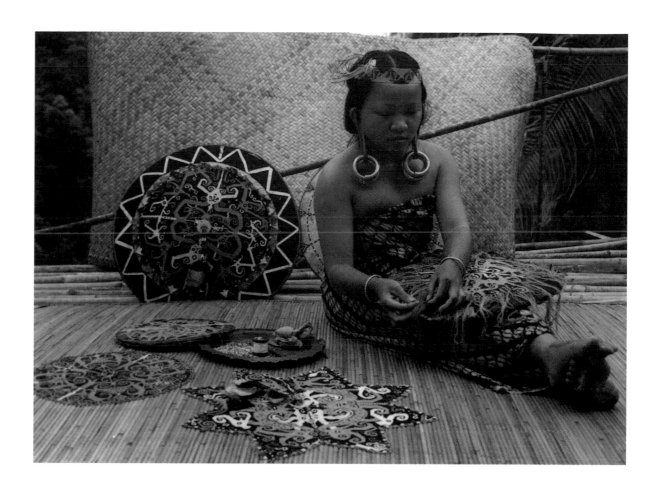

Kenyah Dayak woman threading glass beads for sun hats.

which might explain the asymmetry of the colours in some of the work.

This cheating is evident in several pieces of the Spruitenburg collection in the Museum Nusantara. In the two baby carrier decorations and in the sun hat[25] the black (or mustard yellow) background has been cheated with. Dark blue or dark green has sometimes been used for the background. Different colours are used for the mouths of the human motifs on the sun hat itself and for the motifs on the edge. Different colours are also used for a baby carrier decoration[26]. Here black dragon (asu) motifs have been used against a mustard yellow background, while there is a preference for a black background with yellow or white motifs. In the other baby carrier decoration[27] the background and the animal motifs are the right colour, but the human figure is light grey instead of white. An explanation, which unfortunately we cannot prove, of the different colours in the Spruitenburg collection is the assumption that these pieces might have been made to order.

I want to dwell upon the Kenyah motifs a bit longer, since a change over a longer period of time can be noticed here. Loeber shows some beadwork with stylised fat-dragon motifs, but unfortunately the photos are in black and white. The objects from the Tillema and Spruitenburg days show a number of motifs: the dragon motif (asu), the hornbill motif (rimau), the human head with arabesques (kalong ulu), and the squatting human figure with arabesques surrounding the head and springing from the limbs (kalong kalunan or kelunan). Apart from these four motifs, some other motifs were found by Whittier[28] in the 1970s: the tiger motif, the deer motif (payau) and the lizard motif (kabok). According to Whittier the latter two and the dragon motif bear a very strong resemblance and are difficult to tell apart. This means that they have been stylised, as opposed to the tiger motif and the new version of the hornbill, which are very realistic and have lost all signs of stylisation[29].

I discovered a new version of the squatting human figure on a baby carrier in the collection of an Amsterdam dealer and on the Internet[30]. Here the human figure is wearing a pair of yellow and red short pants, respectively, and a white singlet, showing two nipples and a navel. In my opinion this new element was inspired by the fact that the traditional human figure represents a naked person, having arabesques where his genitals should be. This is against the standards of the government and the (Islamic) religion. Naked is primitive and old-fashioned and symbolises animism, an unofficial faith. The garments represent progress and modernity; they are in conformity with the standards of the Islam and Christianity.

Beadwork motifs as signs and symbols of social differentiation

The noble elite of a village had the means to exchange goods and obtain beads. That is why beadwork has been part of the noble-family heirlooms for a long time, giving the elite its status. In the nineteenth century the relationship between the beadwork motifs and status was not quite clear[31]. Whittier throws some light on this relationship by stating that the nobility and their relatives had the privilege of certain motifs. The thoroughly aristocratic paran were the only ones who used the complete human figure, or hornbill or tiger motifs, and combined them with dragon motifs. The not purely aristocratic paran lot were only allowed to use the human head and combine it with dragon motifs. The other groups were not entitled to any motifs and did not decorate their baby carriers[32]. Thus the motifs were a manifestation of the social status and differentiation among the Lepo Tau tribe. The (colonial) missionaries did not allow symbols expressing status, for one of the rules of Christianity is that people are supposed to lead egalitarian lives and climb the social ladder through achievements of their own and not through hereditary position, power and status. A too-strict class differentiation was also disapproved of by the Indonesian government, which had also 'vetoed' the class of the slaves.

Nowadays marriages between the various groups and new social positions make class differentiation more diffuse and less important. When the differences between the classes disappear, the motifs lose their function as class differentiation symbols. The nobility, the *paran*, do not have to give up their privilege. For them the symbolism of the motifs does not lose its importance. The motif ceases to be an indicator of status. It becomes a signal, showing that the users of a (noble) motif belong to the same group, a signal strengthening the social function of the motif.

Another way in which status was indicated through the beadwork, was the quantity of the beads that were used. Khan[33] interpreted the enormous quantity of beads on the Maloh jackets and skirts as a sign of wealth. This made the beaded garments the privilege of the upper (noble) class, the *sagagat*, giving their owners power and a long life. The lower class, the *pankam*, were not allowed to wear any beads. So here too, beads were a way of differentiating between the classes.

The Dayak beadwork in the collection

There are several beadwork objects in the Van der Star collection. The beautiful headwear decorations were made by the Bahau. Of Maloh origin are the jackets, skirts and a bracelet for the upper arm, decorated with human figures. The dragon-motif hat is part of the Kenyah tribe headwear and the *sirih* bags and pouch were made by the Kayan of the Mahakam region. There is also a number of beadwork headbands, belts, amulets and narrow decorations, probably for the sheaths of swords.

The beadwork was made in various periods. The Bahau beadwork has a very strict symmetry but is sometimes slightly different on the side and at the bottom. The beads are very small (and so are the beads on the sheath decorations and on a number of amulets). Because of the strong resemblance with the pictures in Nieuwenhuis, I assume that these objects were made in the late nineteenth century. This makes me conclude that the beadwork with the smaller beads is generally older than the work with the larger beads. But I must be careful here, since Nieuwenhuis' sun-hat decoration in the Museum Nusantara has remarkably large beads. The motifs of the sun-hat decoration in the van der Star collection resemble the Tillema and Spruitenburg masks and dragon figures, but there is also a stylised tiger motif on this hat. The mixture of *paran* lot and *paran* motifs suggests that the hat was worn by a person of mixed marriage. The threadwork is slightly less precise. That is why I think the hat was made after 1940.

There are also some *sirih* bags with striped dragon motifs, which I think were made in Central Kalimantan, although I am not sure about the subgroup. The dragon motifs are stubby, insect-like figures, with striped bodies and some single lines for the antennae and the legs. These motifs and the brightly-coloured beads suggest that these objects were made after 1940. The beads, the threadwork and the age of the fabric in the Maloh jackets and skirts bears a strong resemblance to the ones in the Museum Nusantara collection and the jacket in Khan's book[34]. I think they were made in the early twentieth century.

As I mentioned above, beads are sometimes recycled. This means that in research the (estimated) age of the beads must not be the only starting-point for dating the objects. The motifs and the threads must be taken into account as well.

Beadwork and authenticity

The beadwork of the collection covers the years between 1880 and 1950. In this period there was a change of motifs and colours, especially in the Kenyah beadwork. The large majority of the collection consists of objects and clothes that have been used. This is not always true for the Spruitenburg collection in the Museum Nusantara. Some of those objects show no traces of wear and tear and no colour deviations, which makes one wonder whether these are genuine traditional used objects. And are the realistic tiger and hornbill motifs, of a more recent date, real or just made for the tourists? And what about the adaptation of the clothes on the human figures? Is it genuine? It is all a matter of judgement. Is it all right for objects to be called traditional or authentic when colours and motifs change over time?

The final comment I would like to make is about authenticity. What is authenticity and is it a notion that can be used in this context? In the Van Dale dictionary[35] the following definition is given: 'a culture's own nature, bearing no traces of foreign influences'. In my view, however, there are no cultures that do not bear any 'traces of foreign influences' Originally the Dayak came from Asia[36] and they have always been in touch with other peoples, from Borneo and beyond. The origin of the human and animal figures on the beadwork and other objects cannot be traced. Are they indigenous or have they been influenced by other tribes? Khan suggests a Chinese origin for the dragon motif[37]. For me authenticity is clearly not a useful term. In my view culture is a dynamic entity. The beadwork is part of the Dayak culture and just gives an impression of a preference for colours and motifs in a given period, which keeps changing, because it is affected by all kinds of internal and external influences. But most of all the beadwork is a manifestation of tremendous skills and a representation, in motif and colour, of the native views of the universe and society. In other words this beadwork is more than 'just a simple child's toy for the savage player'.

Notes

[1] *Und unwillkürlich muss man zurückdenken an die vielen Erwaünungen in den Reiseberichten, wie Glasperlen bei Entdeckungsreisen ein unentberliches Hilfsmittel sind, wie vernarrt die 'Wilden' sich auf diesen Kinderspielzeug zeigen.* Loeber, 1911 III,5; 175
[2] The spelling is in accordance with the spelling in Professor Dr A. Teeuws's dictionary. The Indonesian and Dayak words are in italics; no italics are used for the geographical terms and the names of the tribes.
[3] These two peoples are considered to be one.
[4] In Sellato's definition the Maloh are in the Kenyah/Kayan category, 1989, 7.
[5] These are called *ino buku timei*.
[6] These are called *membat*.
[7] (1923: 15)
[8] (1973: 44, 52–55, 69,70)
[9] The Dutch East Indian Company, founded in 1602.
[10] Wassing-Visser 1984; 38
[11] Present in René van der Star's collection.
[12] Present in René van der Star's collection.
[13] 1973: 195–197
[14] 1923: 24, 195
[15] Malaysian newspapers, taken by the European soldiers and civil servants; the Spruitenburg collection of the Museum Nusantara has a newsprint motif from a Dutch newspaper
[16] 1904, p. 275
[17] Whittier: 197
[18] Elshout, 1923: 195, Whittier: 193.
[19] Information René van der Star.
[20] B. Sellato, 1989, pic. 222 and 240
[21] 1904, p. 278
[22] 1984: 146
[23] Tillema, 1989: 42, 43; Whittier: 194, 195
[24] 1904, p. 274
[25] The hat, S 2200–5 is present in the permanent collection of the museum.
[26] S 2200-4
[27] S 2200-3
[28] 1973: 169-172
[29] Sellato; 178, 184 and Muller, Periplus travel guide; 50, 88, 89
[30] Seen on 3 January 2001 at Italiaander's in Amsterdam and on the website of Asiafoto.
[31] Picture Library: <www.asiafoto.com/dayak_art.htm>
[32] Nieuwenhuis, 1904, vol. II: 274; Elshout, 1923: 195.
[33] 1973: 202
[34] 1984: 146
[35] 1984: 645

36 Van Dale 1984
37 Belwood, 38
38 1984: 139

References

Belwood, Peter, 'Eerste Boeren', in Dr J. Miksic, ed., *Geschiedenis van Indonesië*, Abcoude, Uitgeverij Uniepers, 1998.

Elshout, J.M., *Over de geneeskunde der Kenja-Dajak in Centraal-Borneo in verband met hunnen godsdienst*, Amsterdam, N.V. Johannes Muller, 1923.

Elshout, J.M., *De Kenja-Dajaks uit het Apo-Kajan gebied*, The Hague, Martinus Nijhoff, 1926.

Khan-Majlis, Brigitte, *Indonesische Textilien, Wege zu Göttern und Ahnen*, Cologne, Rautenstrauch-Joest-Museum, 1984.

Loeber, J.A., 'Muschel- und Glasperlenarbeiten', in *Textile Kunst und Industrie*, III,5

Loeber, J.A., 'Indisch Kralenwerk', in *Elseviers Geillustreerd Maandschrift*, XXII, 3, 1912.

Loeber, J.A., 'Schelpen en kralenwerk uit Indonesië', in *Bulletin van het Koloniaal Museum te Haarlem*, vol. 51, Amsterdam, de Bussy, 1913.

Muller, Karl, *Kalimantan, Borneo*, Singapore, Periplus Editions, 1991.

Munan, H., *Sarawak Crafts, methods, materials and motifs*, Singapore, Oxford University Press, 1989.

Nieuwenhuis, Dr. A.W., *Quer durch Borneo*, Leyden, Brill, 1904.

Sellato, B., *Hornbill and Dragon; Arts and Culture of Borneo*, Singapore, Sun Tree Publishing, 1992.

Sumarah Adyatman, *Manik-manik di Indonesia, Beads from Indonesia*, Jakarta, Penerbitan Djambatan, 1993

Tillema, H.F., *Apo-Kayan, een filmreis naar en door Centraal Borneo*, Amsterdam, Van Munster, 1938.

Tillema, H.F., *A journey among the peoples of Central Borneo in word and picture*, Singapore, Oxford University Press, 1989.

Whittier, Herbert Lincoln, *Social organisation and symbols of social differentiation: an enthographic study of the Kenyah Dayak of East-Kalimantan*, Michigan University Press, Ph.D. private publication, 1973.

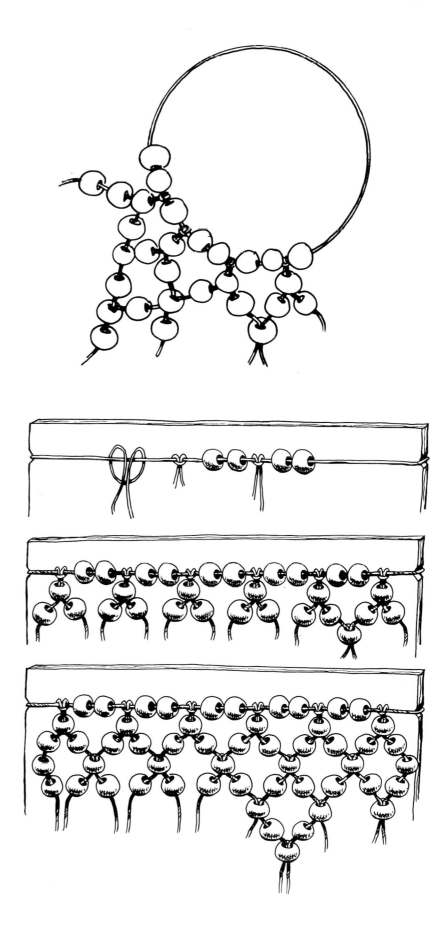

Structures of Dayak beadwork.

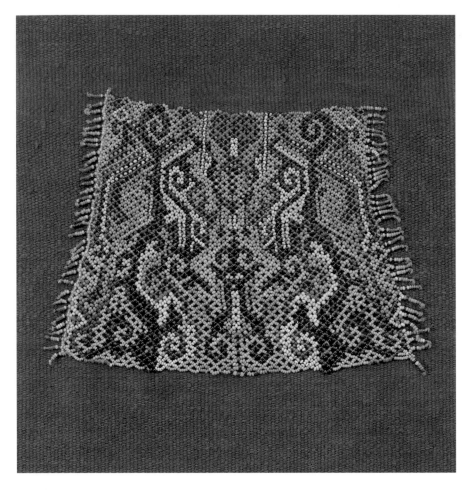
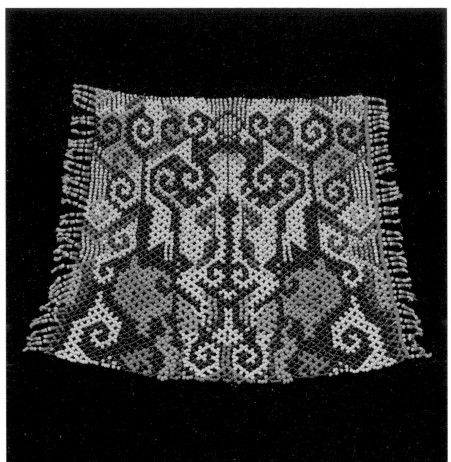
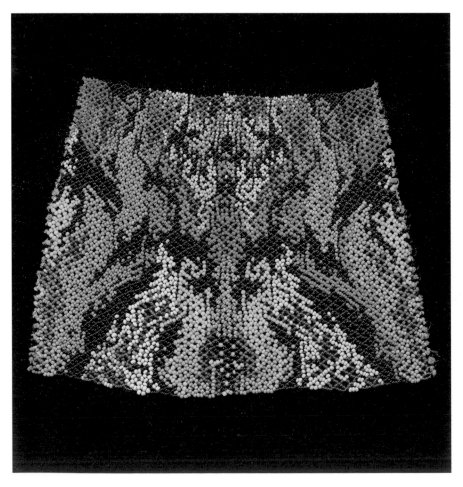
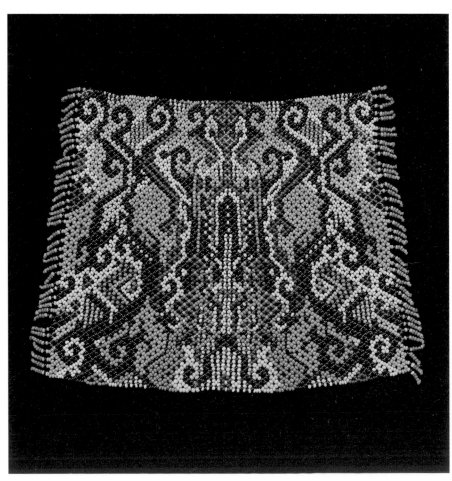

Page 220 top left:

Indonesia
Kalimantan (Kayan tribe,
Mahakam river region)
H 10 cm, W (top) 11 cm,
(bottom) 14.5 cm
glass beads strung on fibre
name: *lawong tap*
woman's cap ornament (2
per cap)
late 19th, early 20th century
geometrical motifs with
stylised panther's head; ±50
beads per square cm

Page 220 top right:

Indonesia
Kalimantan (Kayan tribe,
Mahakam river region)
H 10.5 cm, W (top) 11.5 cm,
(bottom) 15 cm
glass beads strung on fibre
name: *lawong tap*
woman's cap ornament (2
per cap)
late 19th, early 20th century
geometrical motifs with
stylised dragon's, or dog's
head; ±50 beads per square
cm

Page 220 bottom left:

Indonesia
Kalimantan (Kayan tribe,
Mahakam river region)
H 12.7 cm, W (top) 12.5 cm,
(bottom) 17.5 cm
glass beads strung on fibre
name: *lawong tap*
woman's cap adornment (2
per cap)
late 19th, early 20th century
abstract motifs; ±45 beads
per square cm

Page 220 bottom right:

Indonesia
Kalimantan (Kayan tribe,
Mahakam river region)
H 11 cm, W (top) 12.5 cm,
(bottom) 15 cm
glass beads strung on fibre
name: *lawong tap*
woman's cap ornament (2
per cap)
late 19th, early 20th century
geometrical motifs with
stylised panther's head
each square cm contains
±50 beads, so this cap orna-
ment contains some
6500–7000 beads!

Right:

Indonesia
Kalimantan (Kayan tribe,
Mahakam river region)
H ±10 cm D ±18 cm
plaited cane, covered by
cotton and glass beads
strung on fibre
name: *lawong unjuk*
man's hat
early 20th century
hat worn during festivals;
2 cut away triangles con-
taining tied up strings of
beads

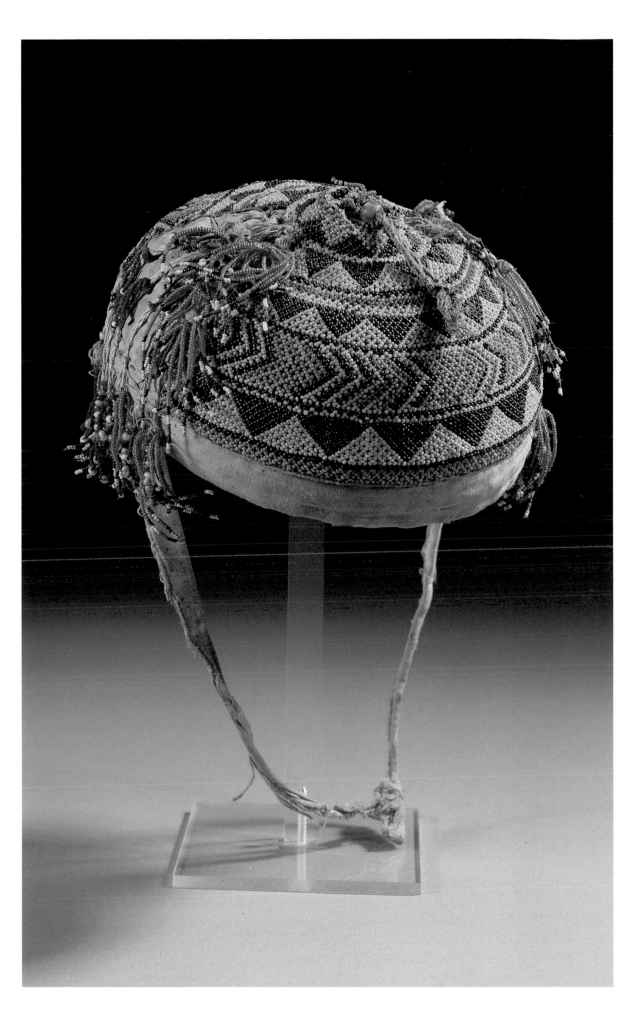

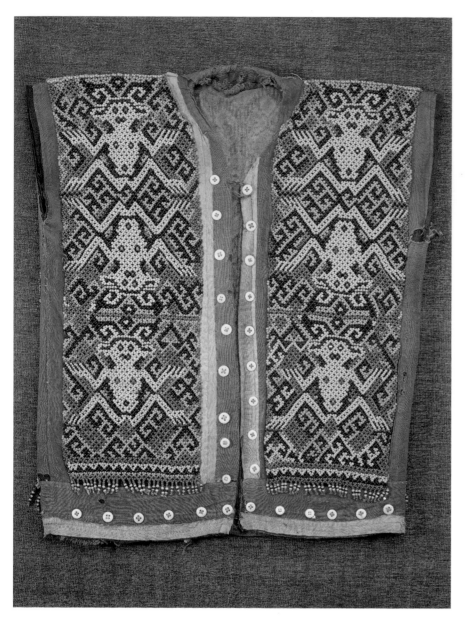

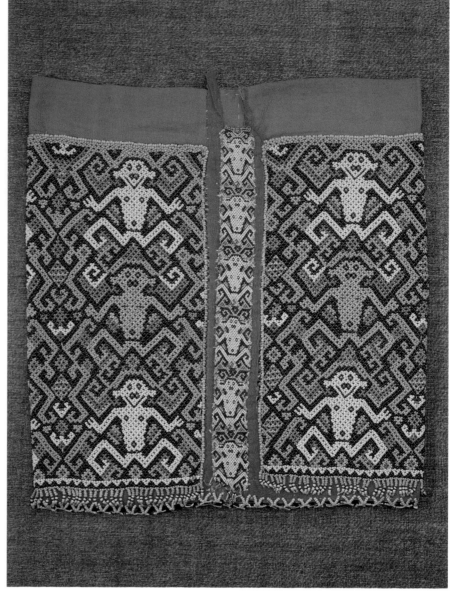

Indonesia
Kalimantan (Maloh tribe,
Upper Kapuas region)
H 50 cm, W 2x42 cm,
1810 grammes
cotton, glass beads strung
on fibre
name: *sape manik*
ceremonial woman's coat
early 20th century
geometrical motifs and
human figures (*kaletau*); for
the lining of the coat an old
ikat cloth was used; at the
back 2 rows of human fig-
ures; the front edge
trimmed with china but-
tons

Indonesia
Kalimantan (Maloh tribe,
Upper Kapuas region)
H 51 cm, W 2x48 cm,
2100 grammes, band in the
middle 42 cm, W 4.5 cm
cotton, glass beads strung
on fibre
name: *kain manik*
ceremonial woman's skirt
early 20th century
geometrical motifs, human
figures; human figures
(*kaletau*) in the middle with
blue, which is special; very
small beads on the band in
the middle (45 beads per
square cm = ±8000 beads;
remainder: 15 beads per
square cm= ±54.000 beads)

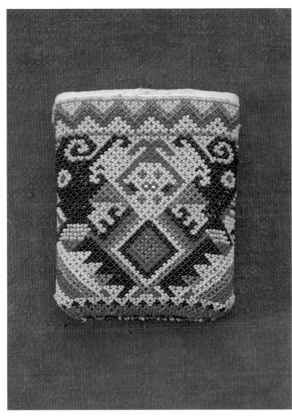

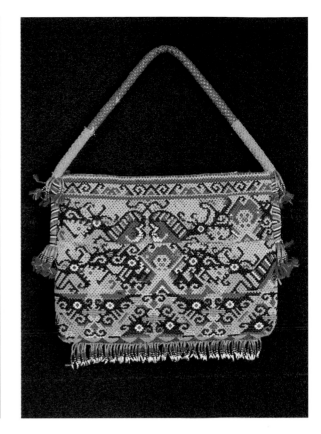

Indonesia, Malaysia

Left:
Kalimantan / Sarawak
(Kayan tribe)
L 59.5 cm, W 2.8 cm
glass beads strung on fibre
ribbon adorning the sheath
of a *mandau* (headhunter's
sword)
late 19th, early 20th century
geometrical motifs

Right:
Kalimantan/Sarawak
(Kayan tribe)
L 37 cm, W 4.5 cm
glass beads strung on fibre,
pieces of cotton at the end
bracelet
late 19th, early 20th century
2 human figures (*kaletau*)
between geometrical bead-
work

Indonesia

Kalimantan (East Borneo)
glass beads on fibre
woman's headband
early 20th century
geometrical motifs: possible
Muslim influence

Indonesia

Kalimantan (Kayan tribe,
Upper Kapuas region)
H 10 cm, W 8 cm
cotton and glass beads
strung on fibre
tobacco pouch (cigarette
case)
±55 years old
presented to a Dutch colo-
nial civil servant between
1945–1948

Malaysia

Sarawak (Kenyah tribe)
H (bag) 19,5 cm H (with
handle) 31 cm, W 26 cm
plaited cane, cotton, glass
beads strung on fibre
bag
middle 20th century
decoration: geometrical fig-
ures, *aso* (dragon) figures,
human figures

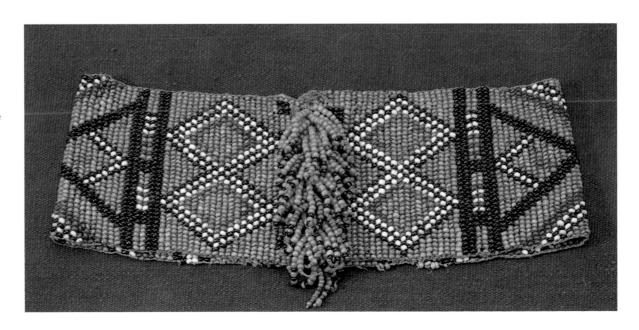

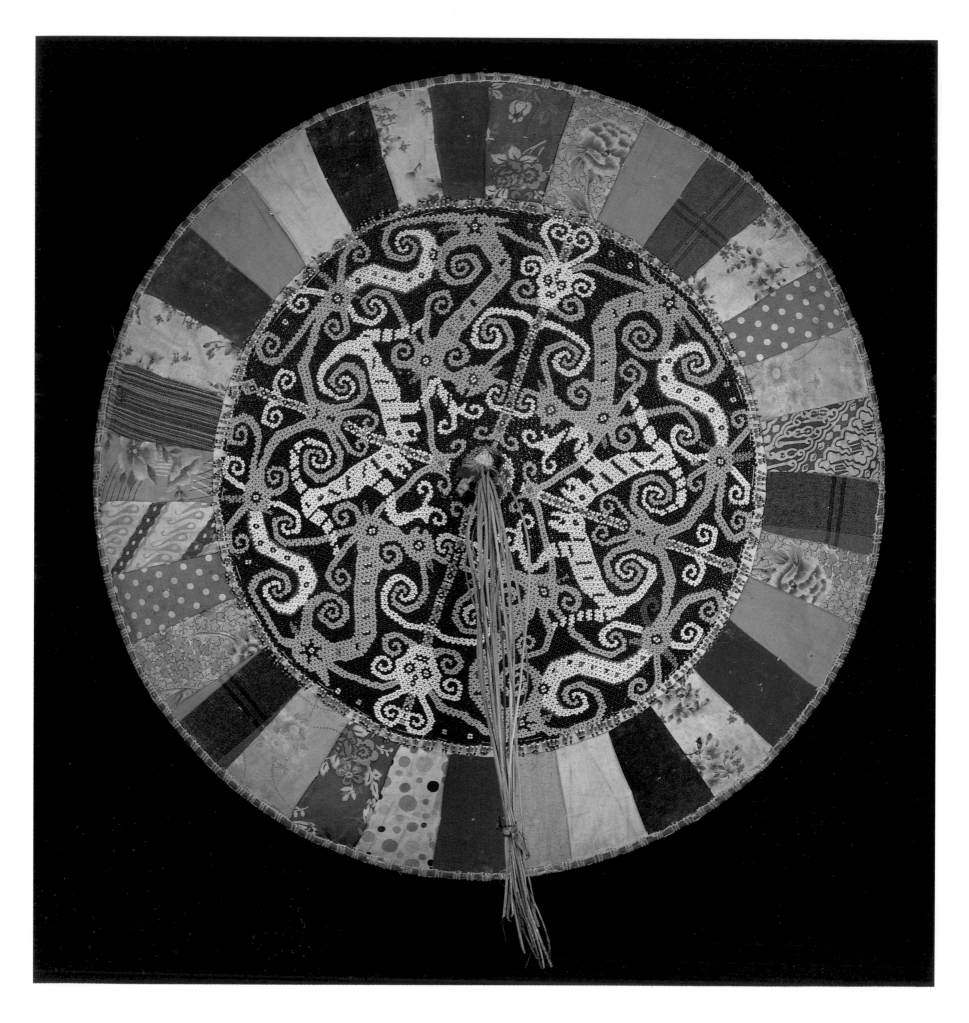

224

Left:

Malaysia
Sarawak (Kenyah Dayak
tribe)
D 53.5 cm
name: *aban sa'ong*
sun hat of plaited strips of
palm leaf (edges covered
with cotton); adorned with
beads strung on fibre; deco-
rations of *aso* (dragons),
anthropomorphic figures
1st half 20th century

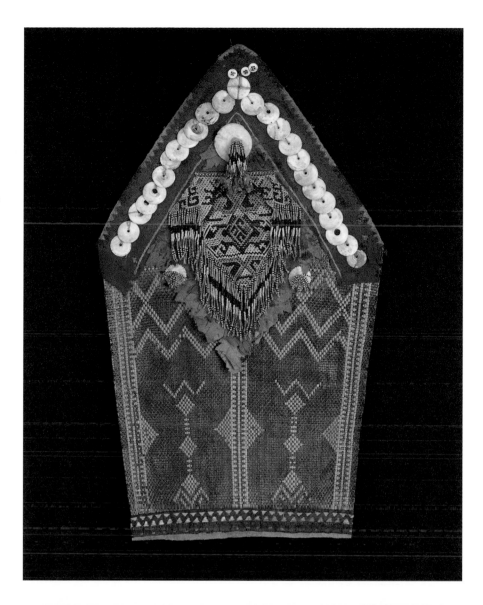

Malaysia
Sarawak ((most probably)
Dayak tribe)
L 49 cm, W 29 cm,
plaited cane, shell, china
buttons, glass beads on
fibre
name: *tikai buret*
man's seating mat
early 20th century
was tied at the back and
worn around the waist

Page 226:

Malaysia
Sarawak (Kenyak and
Kayan Dayak tribes)
L (teeth) 6 cm,
L (chain) 27 cm
panther teeth and glass
beads
ear ornaments
late 19th century
worn by men through the
upper ear; chain along the
back of the head
(see page 228)

Page 227:

Malaysia
Sarawak (Bidayhu tribe)
D (outside) 34 cm
plaited cane, panther teeth,
copper wire, silver, glass
beads, cowrie shells
man's necklace
early 20th century
2 teeth have a worked silver
cover

Indonesia
Kalimantan (Maloh tribe,
Upper Kapuas region)
H 55 cm, W 88 cm,
2100 grammes
cotton, glass beads strung
on fibre
name: *kain manik*
ceremonial woman's skirt
early 20th century
3 lengths of beadwork;
2 geometrical motifs; mid-
dle part human figures

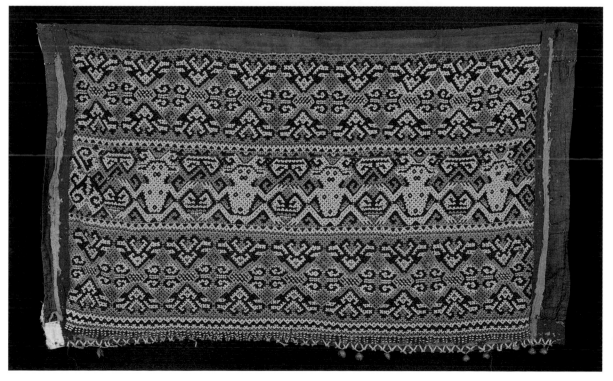

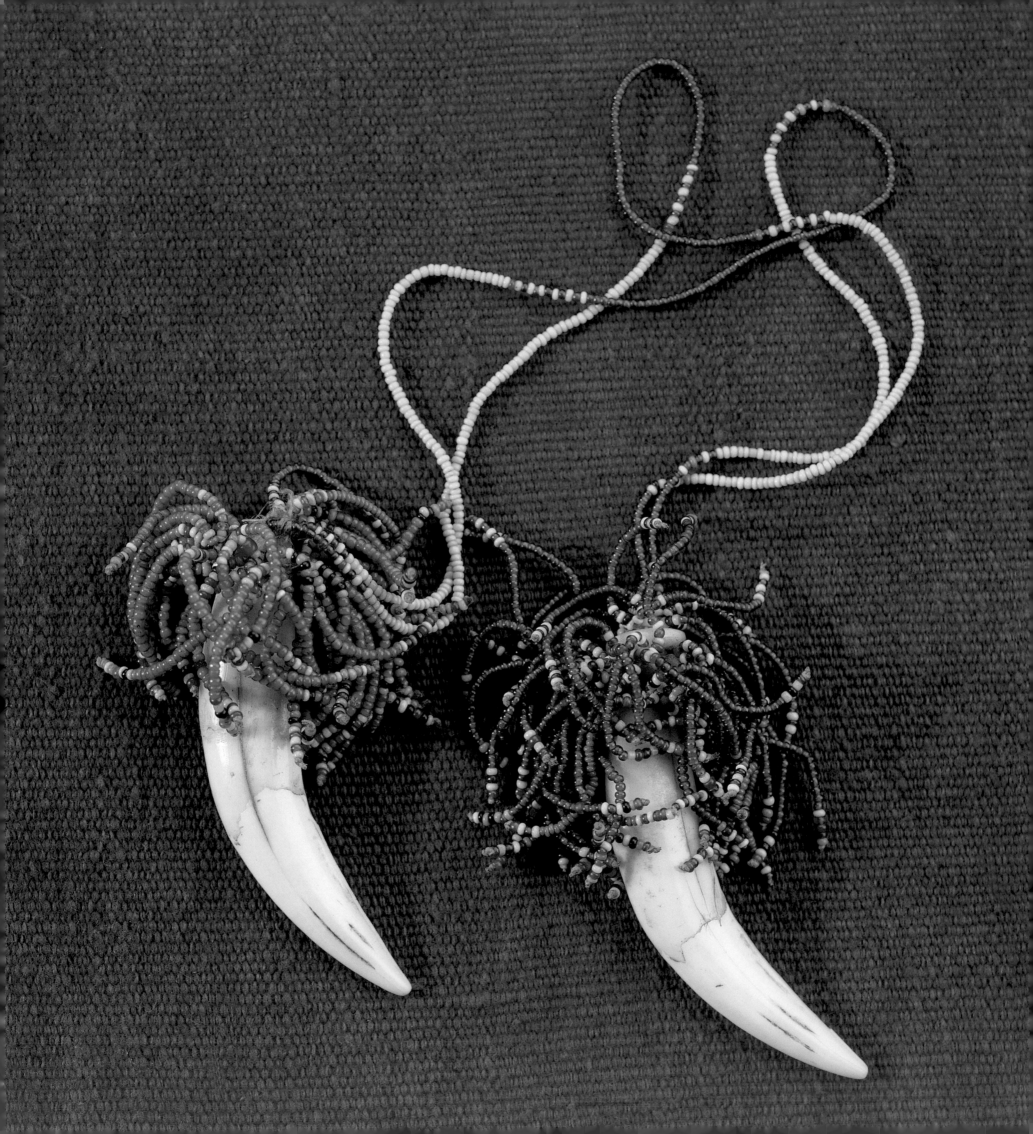

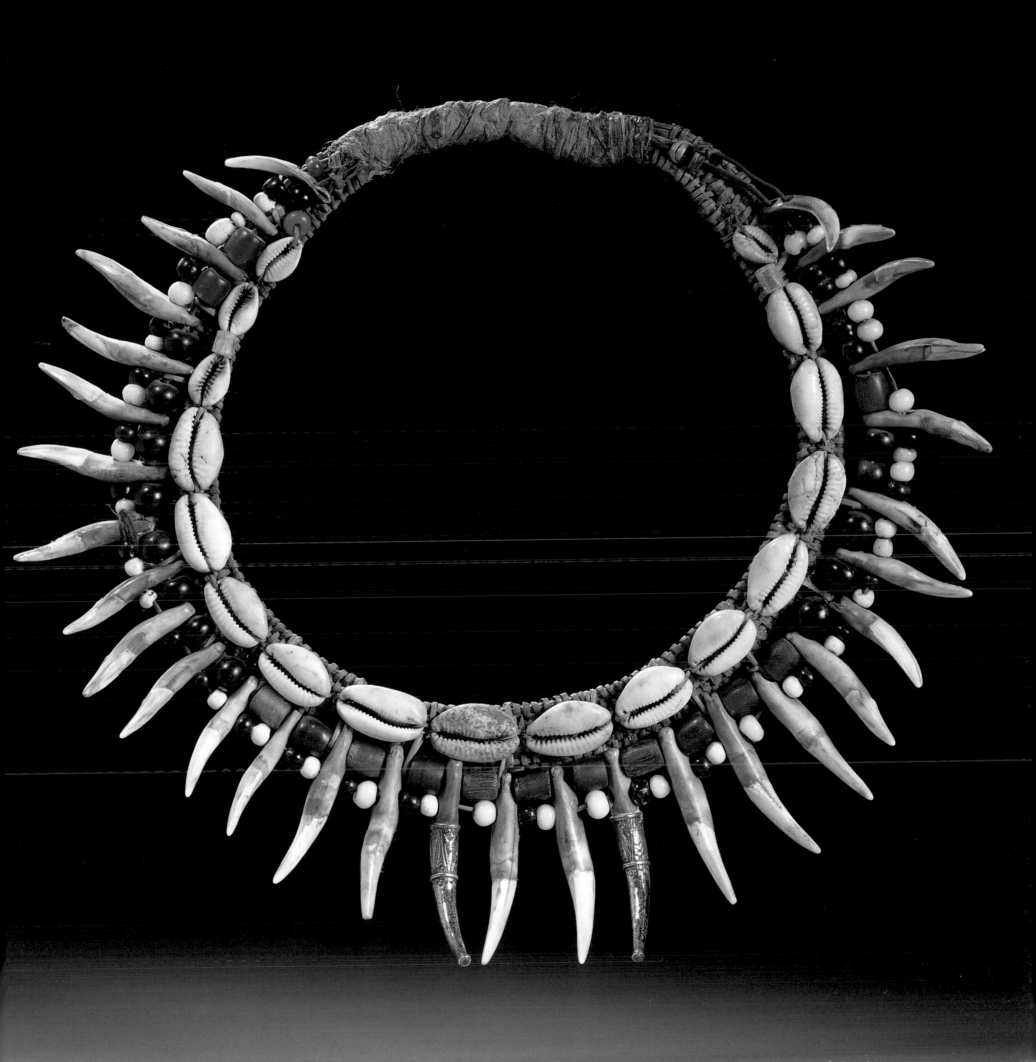

Indonesia, Malaysia
Kalimantan/Sarawak
(Kayan/Kenyah tribe)
H 5 cm, W 4.2 cm,
65.8 grammes
bronze
earring
1st half 20th century
aso, dragon motif, also
found in beadwork

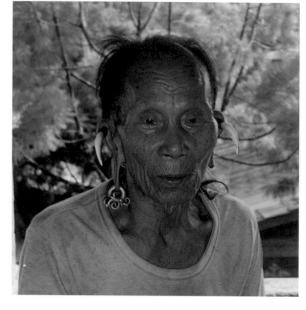

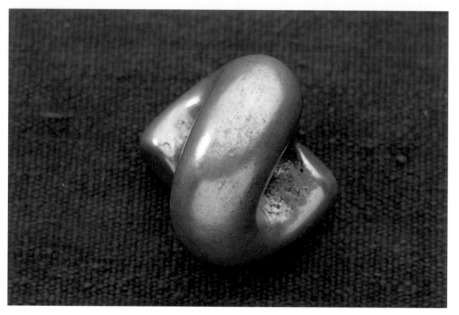

Malaysia
Sarawak (Kenyah, Kayan,
Kelabit tribes)
H 4 cm, W 4 cm,
232 grammes
brass
man's earring
1st half 20th century

Kayan man with panther
teeth through the upper
part of the ears , and heavy
bronze *aso* earrings,
Sarawak, 1988.

Kayan woman with heavy
brass earrings, Kapit,
Sarawak, 1988.

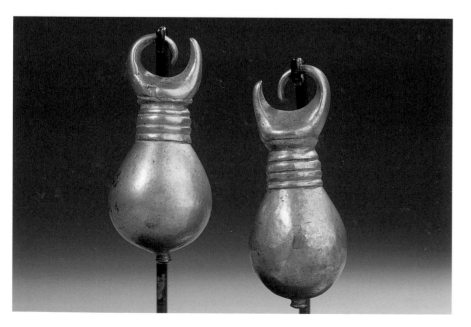

Malaysia, Indonesia
Sarawak, Kalimantan
Kayan/Kenyah tribe
(also other Dayak groups)
H 7.8 cm,
544 grammes together
brass
early 20th century

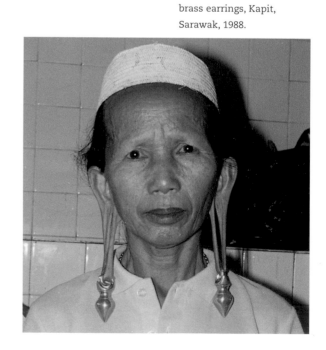

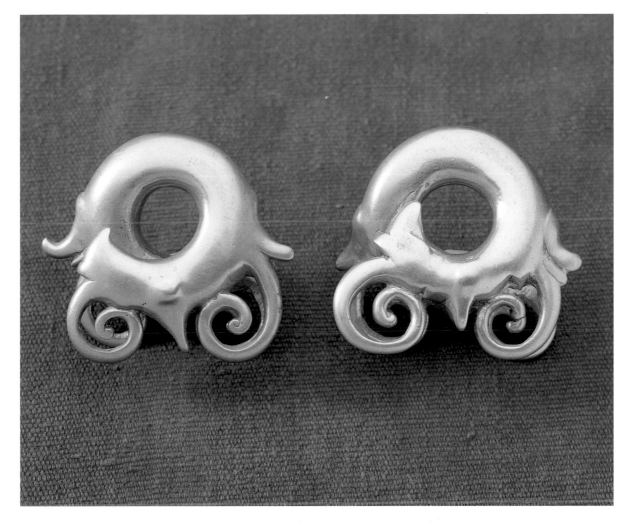

Malaysia
Sarawak
(Kayan tribe; Punan Buson)
H 5.5 cm, W 6 cm,
373 grammes together
bronze
earrings
1st half 20th century
aso motif, also found in
beadwork

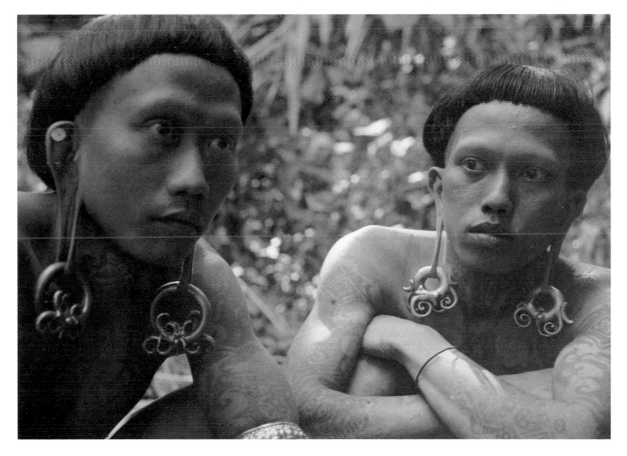

Two Punan Buson men in
the area of the Kajang river.
Both are wearing heavy
bronze earrings *aso* figures,
1930s.

229

Indonesia, Malaysia
Sumatra (8), Malaysia (1 –
middle right)
Upland Padang
(Minangkabau)
L 9.9 – 29.2 cm, W 7 cm –
13.1 cm, 127 – 303 grammes
name: *pandiëng*
clasps
1st half 20th century
different materials:
silver and niello*: 2 bottom
right, 1 bottom left, 1 top
left
red copper with silver inlay:
1 middle left
brass and gala** with gold
inlay: 1 top middle
brass and gala: 2 bottom
middle, 1 top right
*niello = metal/sulphuric
acid compound of lead, sil-
ver, copper and borax
**gala = type of black resin

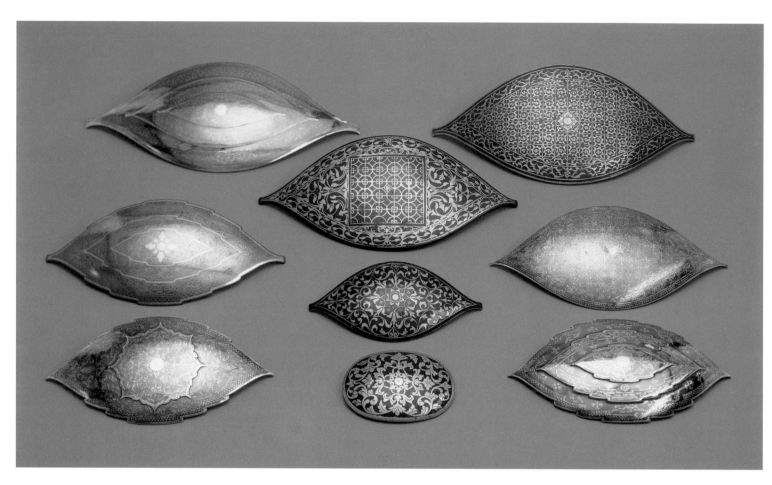

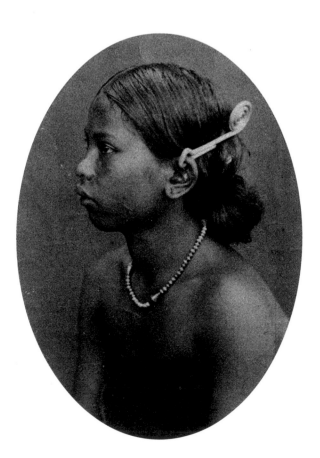

Indonesia
Sumatra (Karo Batak tribe)
H 17.5 cm, W 17.5 cm,
1915 grammes together
silver alloy
name: *padung-padung*
ear jewels
early 20th century
opens at the top; worn
inserted into the upper ear
and attached to the head
cloth; one earring pointing
forward, one backward
(see page 2)

Left:
Batak woman wearing
padung earring, Sumatra, c.
1890.

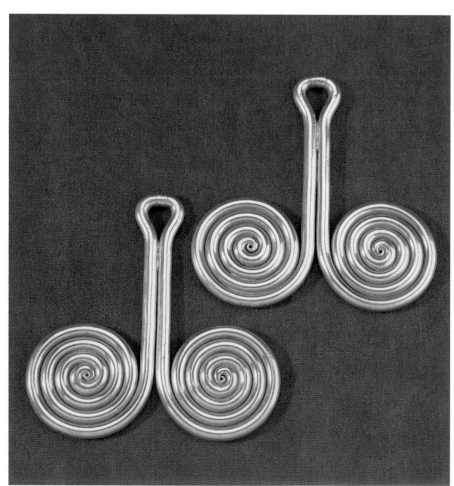

Indonesia
South Nias
H 10 cm, D ±10 cm,
747 grammes
shell (*tridacna gigas*)
name: *töla gasa*
bracelet
late 19th, early 20th century
made from the heart of a
gigantic *tridacna gigas* shell;
worn by men on the right
arm

Indonesia
Alor
L 83 cm, W 8 cm, H (includ-
ing bead string) 43 cm,
glass beads, bone, pieces of
mother-of-pearl
man's girdle
1st half 20th century

Page 232:

Indonesia
Tanimbar
D 20 cm
fibre, shell, copper wire,
cane
name: *wangpar*
man's necklace
early 20th century
name shells: *ovula-ovum*, or
the common egg cowrie

Page 233:

Old man from Tanimbar
with golden ear pendants
and *wangpar* necklace,
c. 1923.

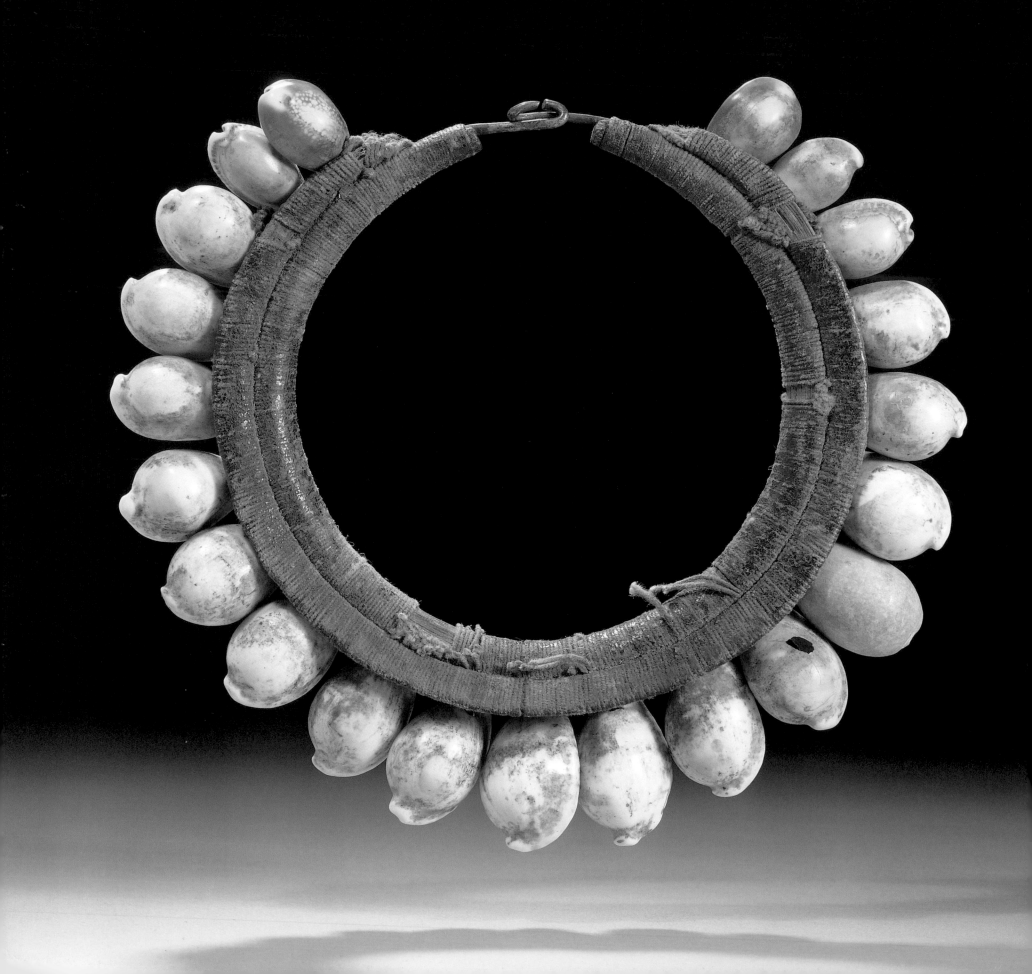

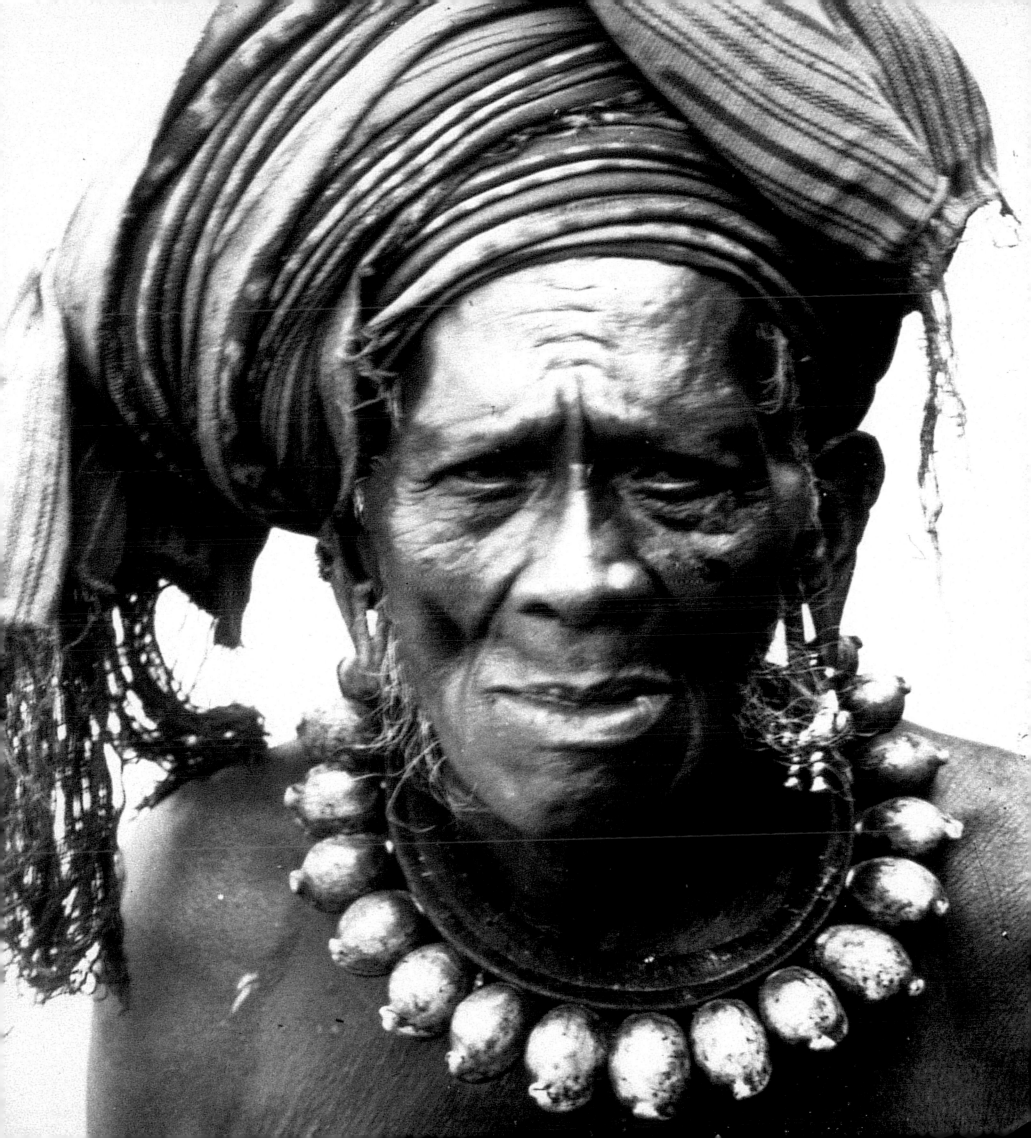

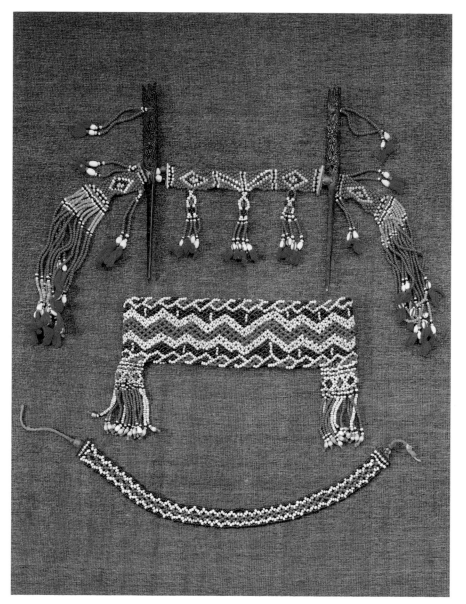

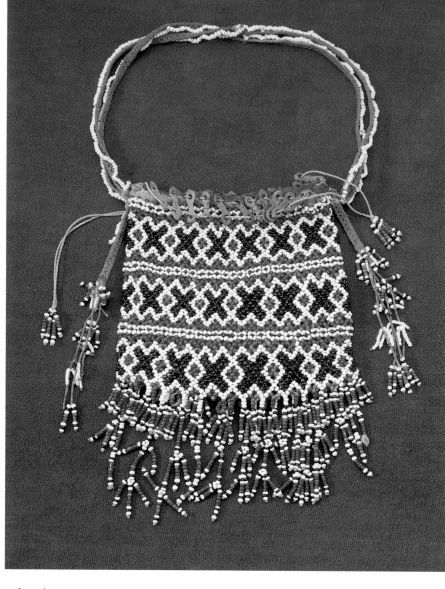

Indonesia
Alor
matching 3-piece set:
headband + 2 buffalo horn
pegs L 67 cm, H 22 cm
headband L 25 cm, H 15 cm
necklace L 40 cm, W 2 cm
cotton, buffalo horn, glass
beads, bone
middle 20th century

Indonesia
Timor
(Atoni, or Dawan tribe)
H 20 cm (beadwork),
total H 38 cm, W 16 cm
cotton + beadwork, glass
beads, pewter
name: *alu inu*
betel-nut bag
1st half 20th century

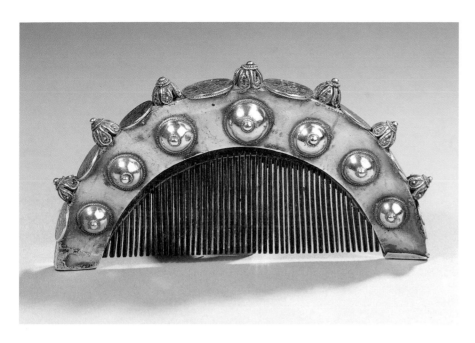

Indonesia
Timor (Atoni tribe)
H 7.5 cm, W 14 cm,
92 grammes
buffalo horn and silver
decorative comb
middle 20th century
8 Dutch coins (1941-1945)
used for decoration (6 x
1/10 guilders, 2 x 1/4
guilders)

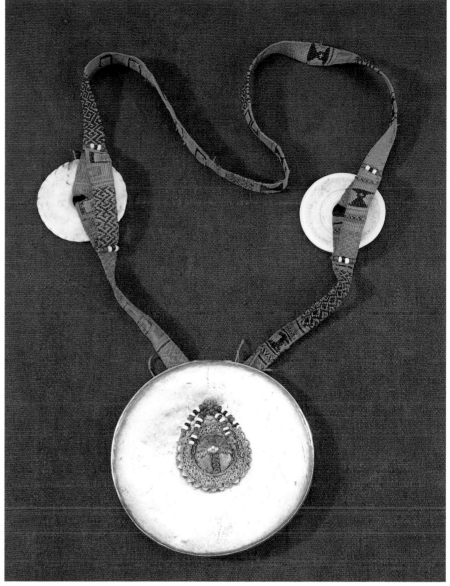

Indonesia
West/Central Timor
D (breastplate) 13 cm,
H ±49 cm, 189 grammes
cloth, silver, shell, glass
beads
name: *tefán*
breastplate attached to
necklace
1st half 20th century
2 shell discs attached to
cloth

Indonesia
West/Central Timor
(Atoni tribe)
Left:
H 8 cm, W 6.5 cm, 95
grammes
silver
name: *buku niti*
bracelet used during dance
ceremonies
1st half 20th century
bracelet with jingling bell

Top:
H 6.5 cm, W 7.5 cm,
77 grammes
silver
name: *buku niti*
bracelet used during dance
ceremonies
1st half 20th century
2 cockerels on either side of
a jingling bell

Bottom:
H 6 cm, W 8 cm, 122
grammes
silver
name: *nitti maskuna*
bracelet
1st half 20th century

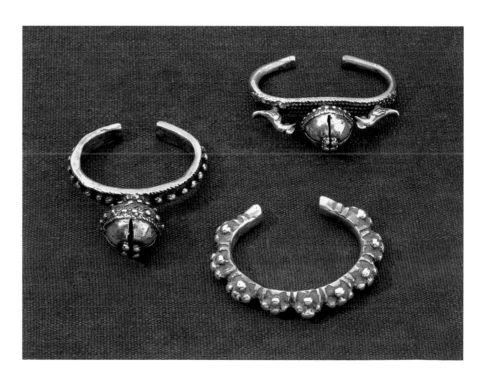

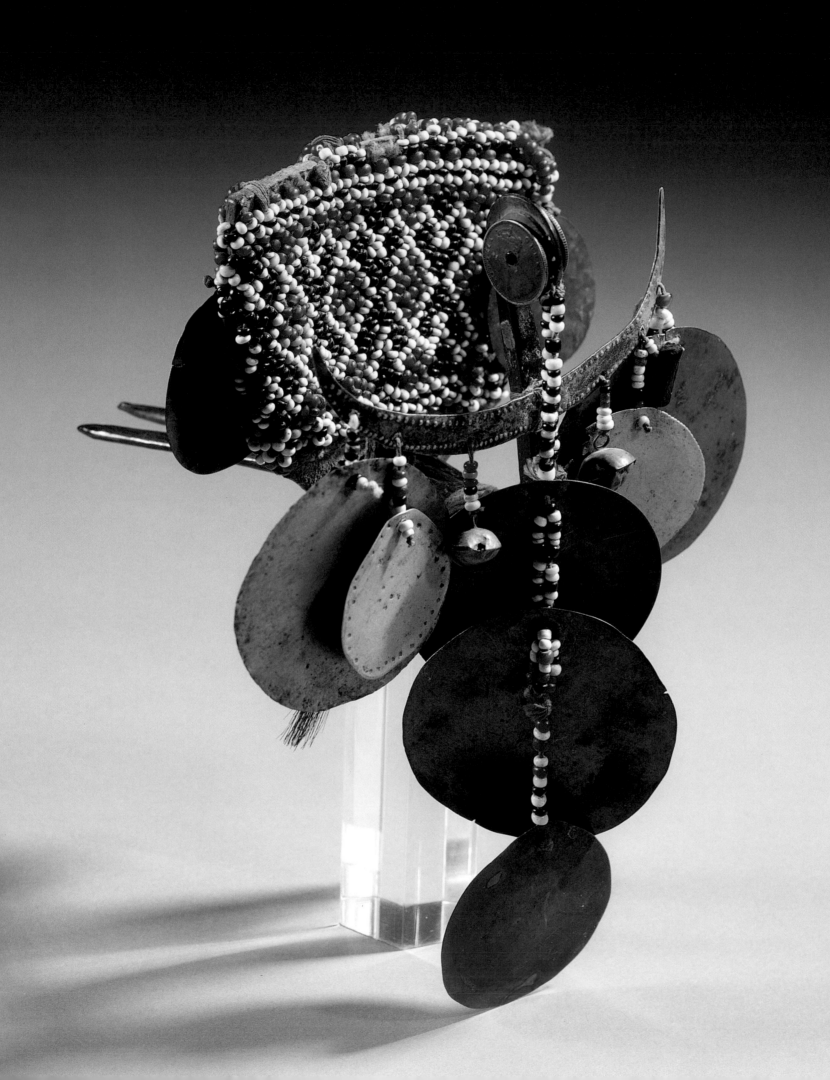

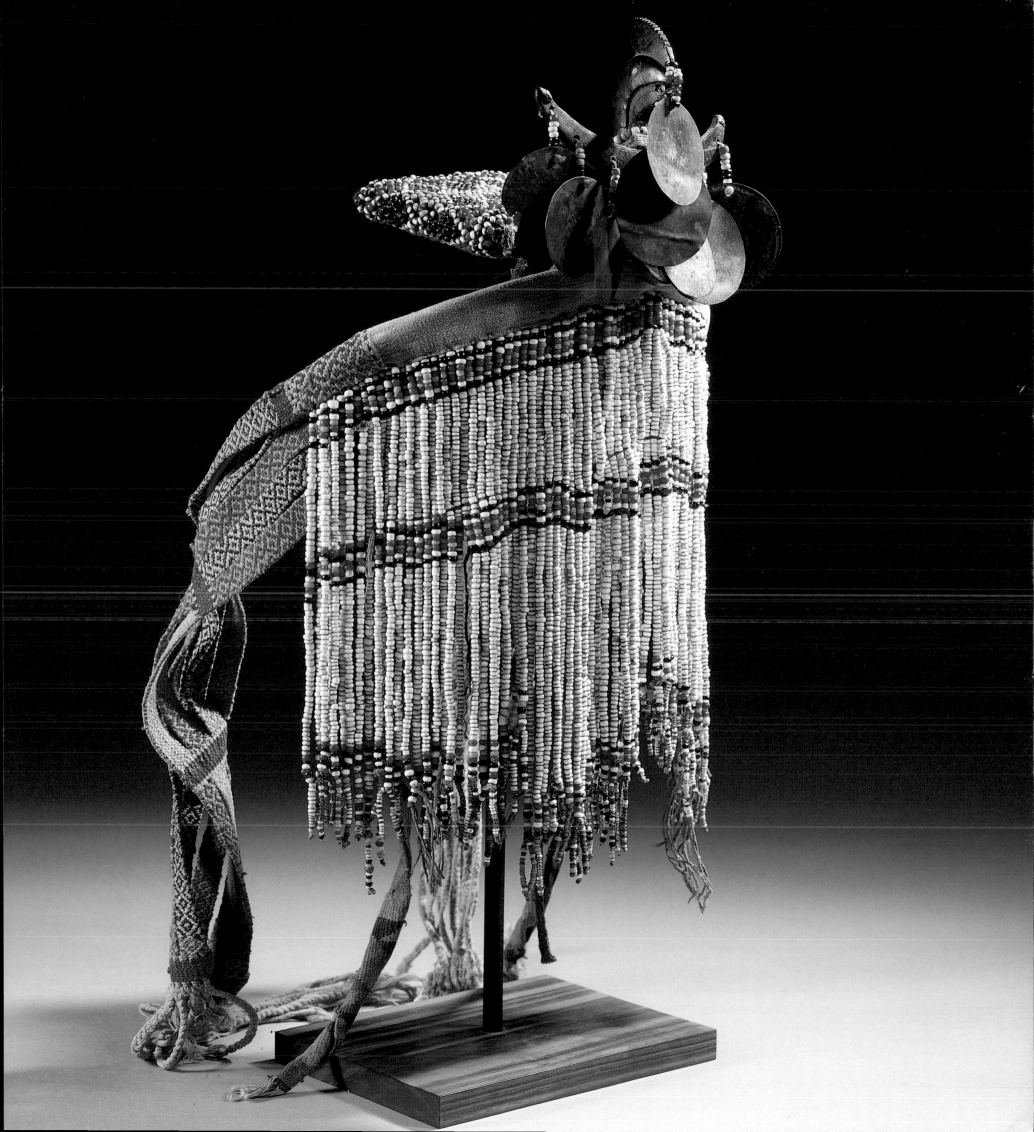

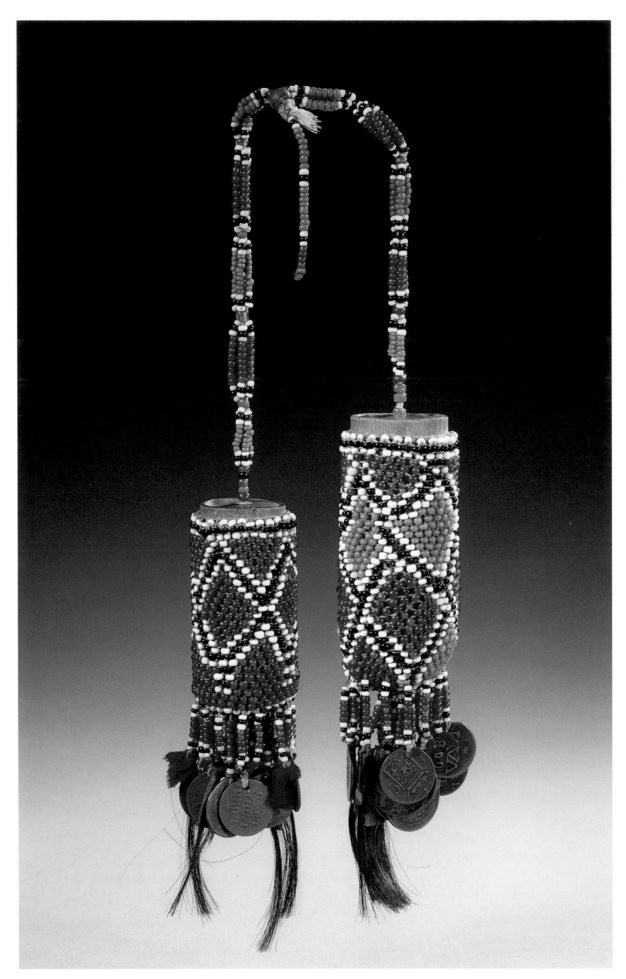

Page 236:

Indonesia
West Timor (Atoni tribe)
L 13 cm, H (comb) 8.5 cm,
H (with discs) 17 cm
silver, buffalo horn, leather,
glass beads, 2 coins
warrior's comb
early 20th century
coins are from Queen
Victoria's reign, before 1874

Page 237:

Indonesia
West Timor (Atoni tribe)
L (comb) 19 cm, headband
±20 cm, H (overall) 32 cm
buffalo horn, leather, silver,
cloth, glass beads
ceremonial warrior's comb
1st half 20th century
comb + headband + bead
apron, hanging in front of
the eyes; the upper part of
the comb in the form of a
cock

Left:

Indonesia
Timor
(Atoni, or Dawan tribe)
H (with chain) ±30 cm
bamboo, glass beads, coins,
horsehair
2 lime containers
early 20th century
glass beads around bamboo
containers
VOC coins from 1734, Dutch
East Indies coins until 1856

Right:

Indonesia
Timor
Top left:
L (without beads) 10 cm
bone, wood, glass beads
lime container
early 20th century
with zoomorphic figures

Top right:
L (without beads) 11 cm
bone, wood, glass beads,
pewter
lime container
early 20th century
opening at one side with a
wooden stopper, covered
with pewter showing
stylised animals (a.o. scor-
pions); bone lime contain-
ers are very rare; the major-
ity are made of bamboo
and glass beads

Bottom:
L (without beads) 9.5 cm
bone, wood, glass beads
lime container
early 20th century
with stylised zoomorphic
figures

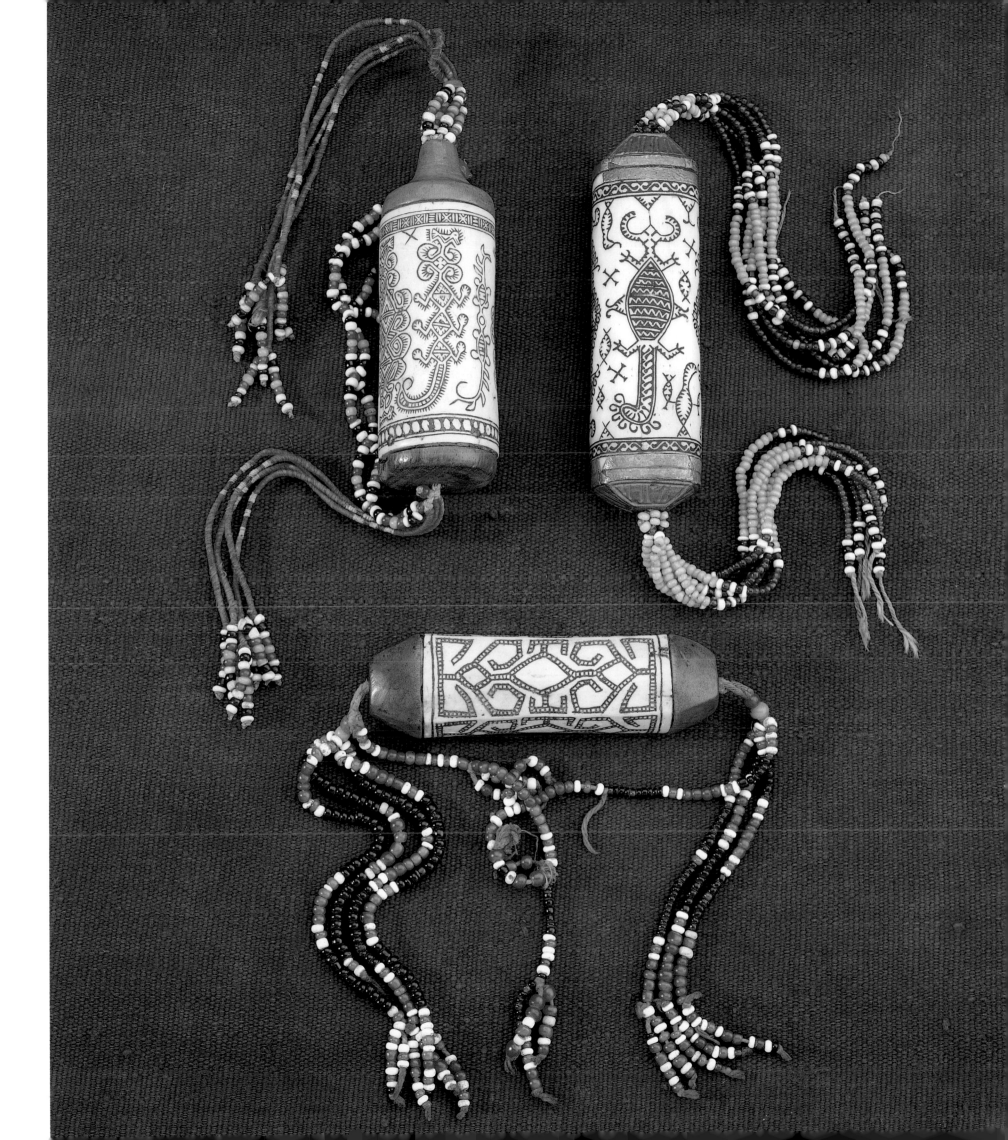

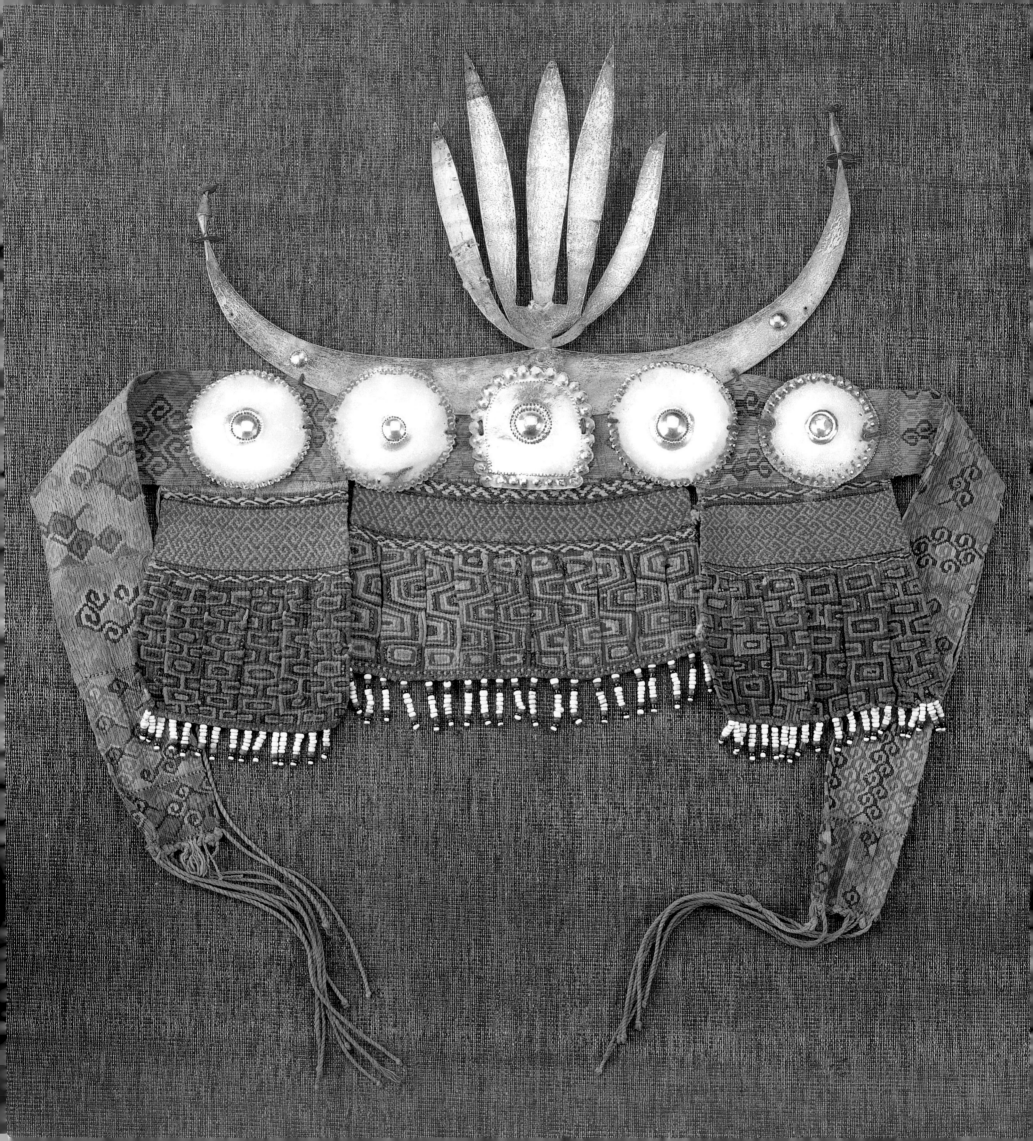

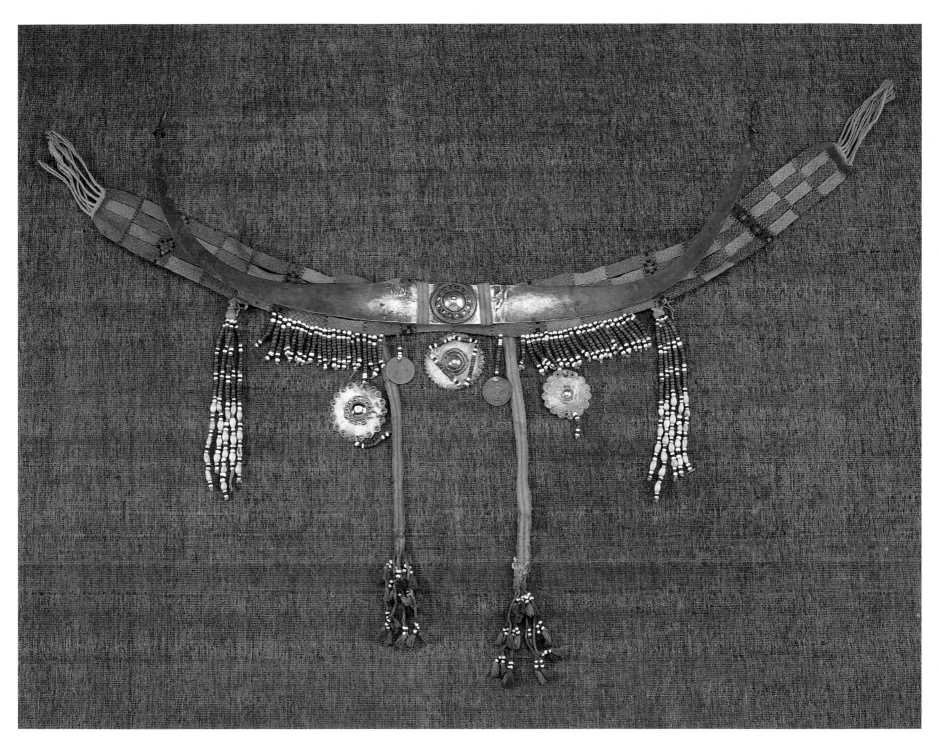

Indonesia
West Timor (Atoni tribe)
L 82 cm, H 34 cm
cloth, glass beads, silver
man's headdress
name: *pilu bokaf*
1st half 20th century

Indonesia
West Timor (Atoni tribe)
L (cloth) 82 cm,
L (metal) 50 cm
cloth, silver alloy, glass
beads, coins (Dutch East
Indies, 1920)
name: *noni funan*
man's headdress
1st half 20th century
silver alloy in the form of
buffalo horns

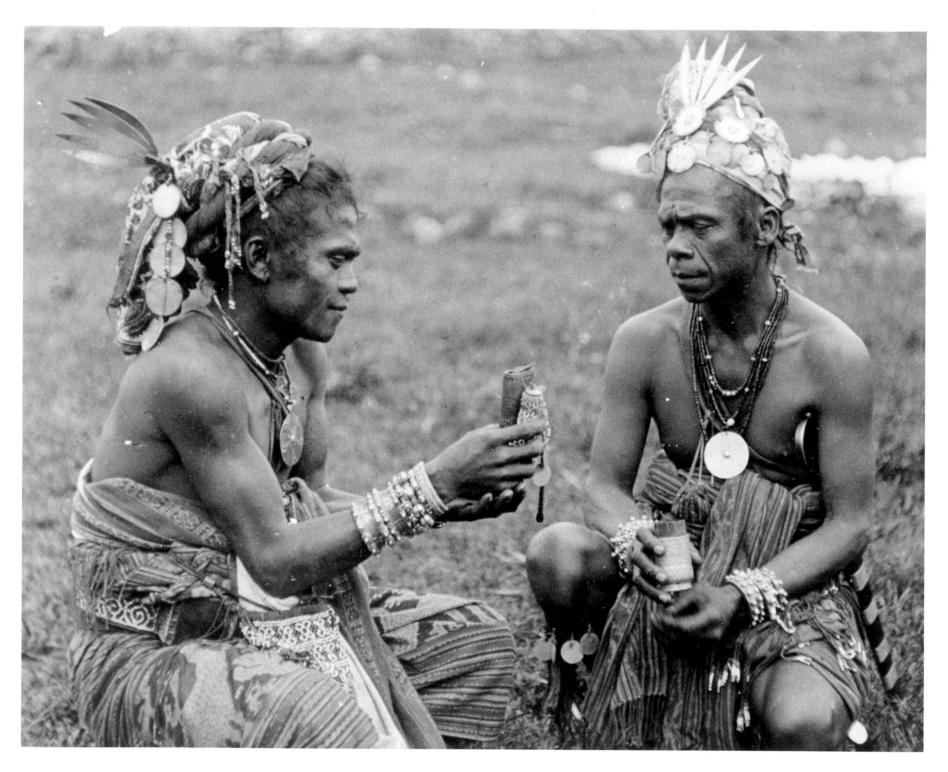

Two Timorese men wearing
silver bracelets, silver
breast plates, headdress
decorated with silver, and
small beadwork bags,
c. 1920.

Indonesia
Timor
H 29 cm, W 13 cm
sperm whale tooth,
buffalo horn, shell
powder horn
19th century
upper part is carved buffalo
horn; stopper with carved
face; powder horn as a
whole in the form of a
stylised human figure

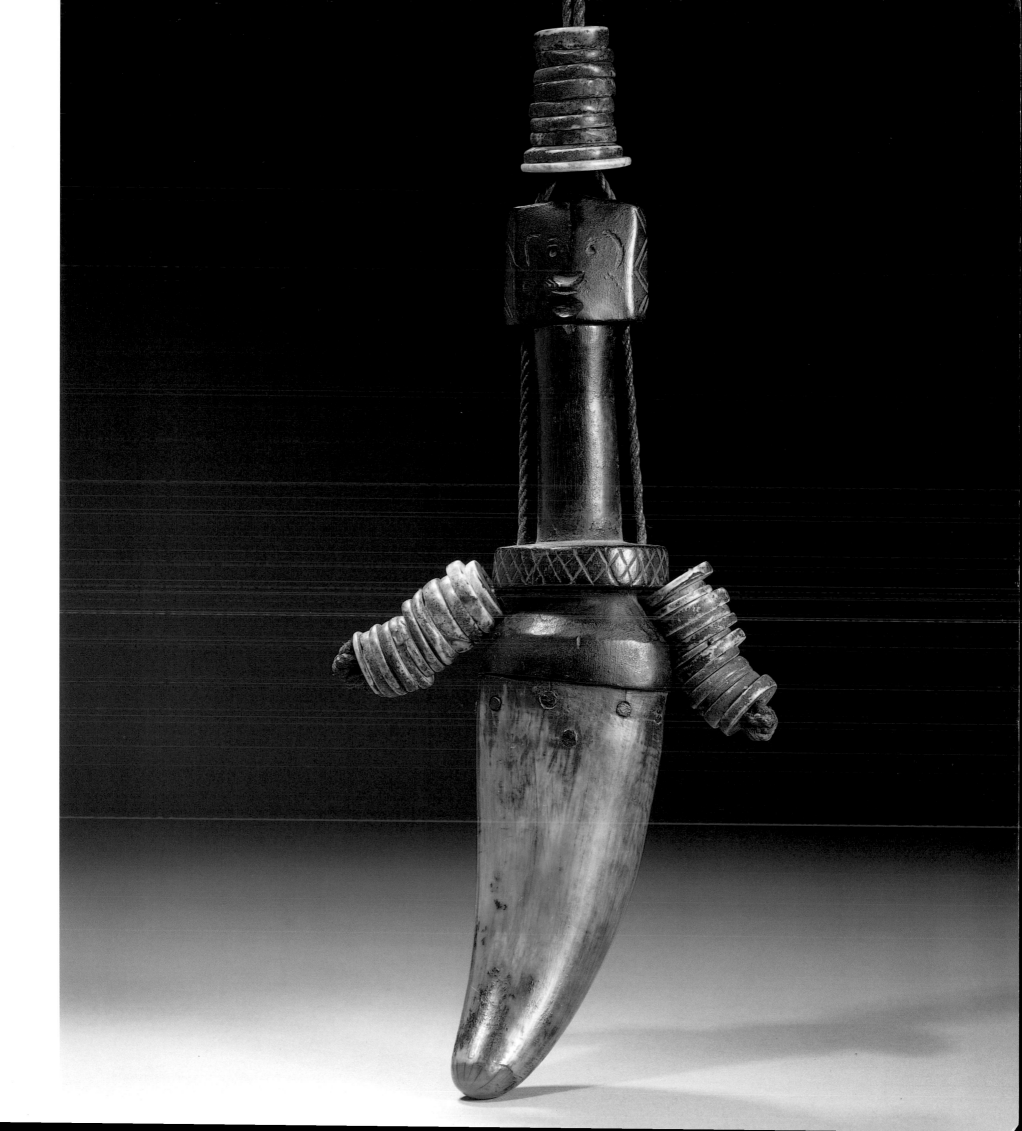

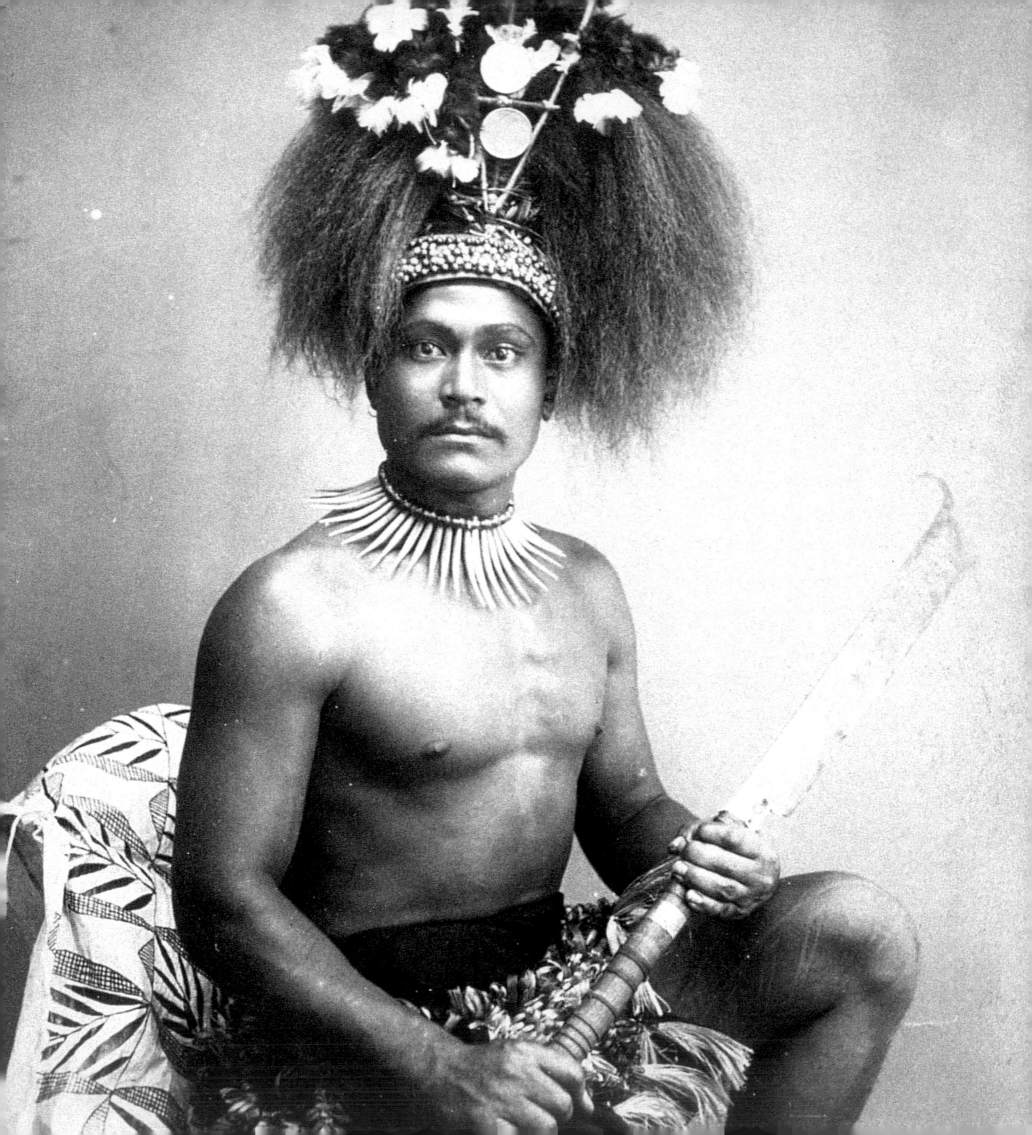

Pacific Islands

Young Samoan warrior
from a noble family, wear-
ing a very valuable necklace
consisting of teeth of a
sperm whale (*wasekaseka*),
c. 1890.

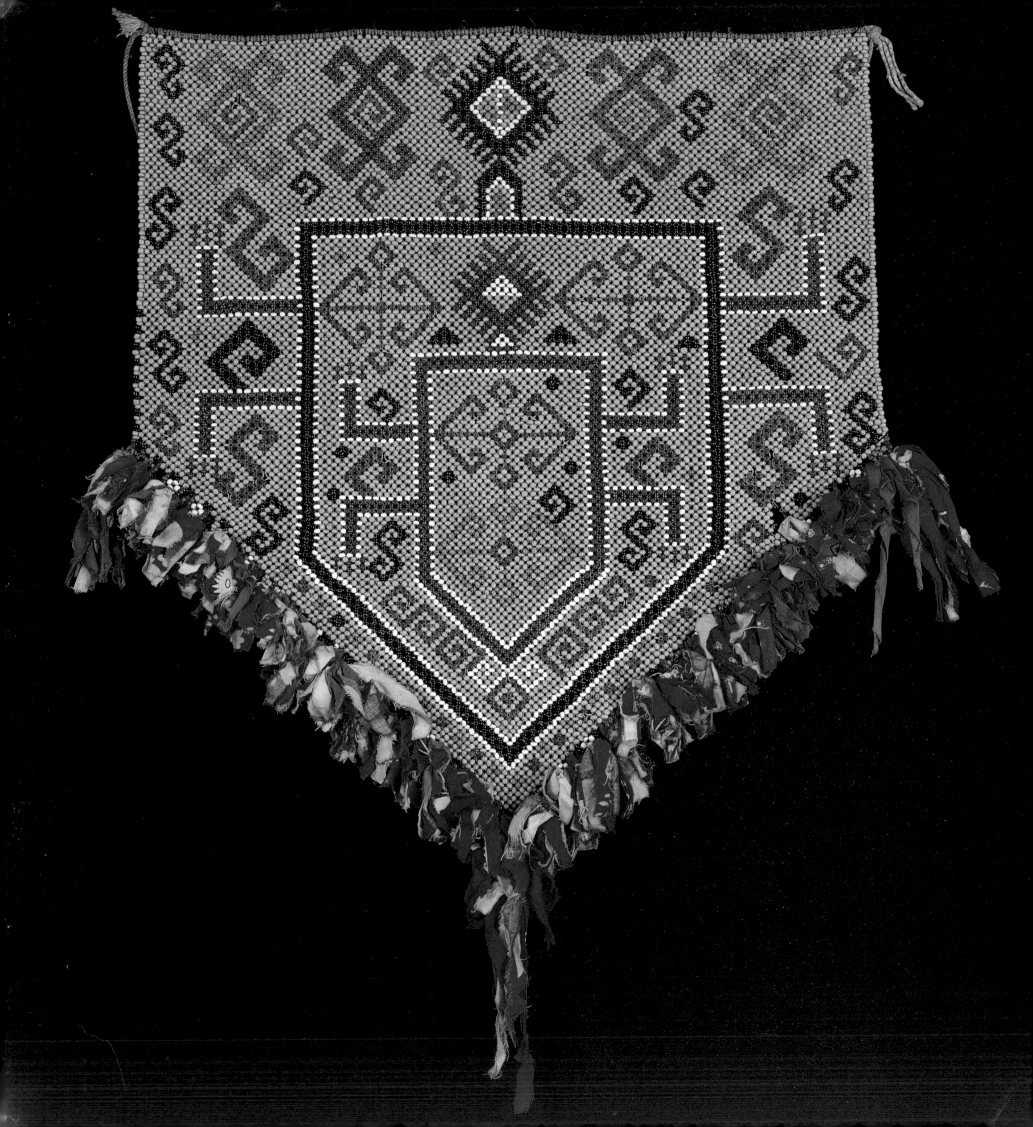

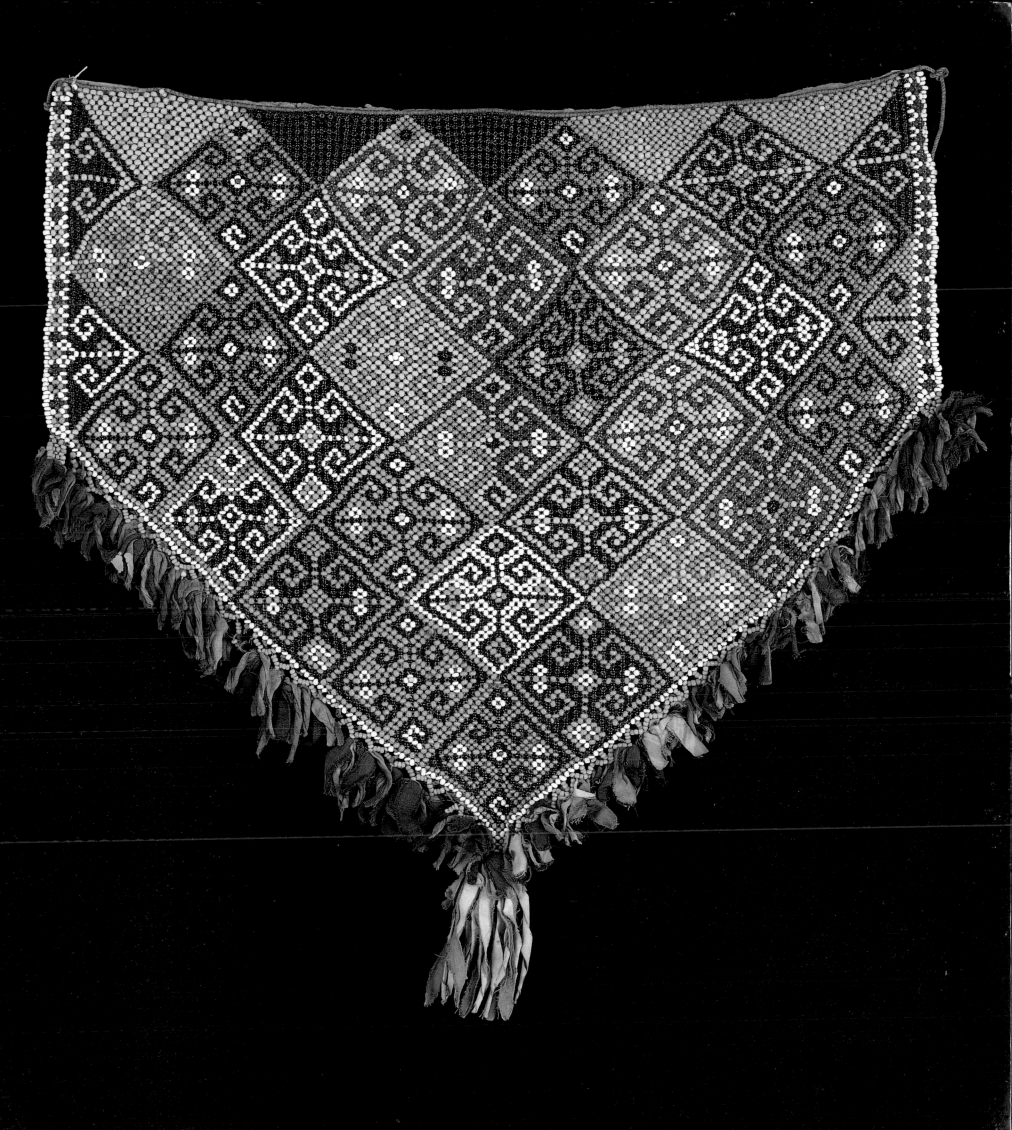

Page 246:

Irian Jaya
Doreri District, Kepala
Burung ('Bird's Head') and
Cenderawasih Bay region,
formerly Geelvink Bay areas
H (beads & cotton) ±58 cm,
H (beads) 43 cm, W 43 cm
fibres, glass beads, cotton
woman's dance apron
1st half 20th century
in the middle part two
stylised turtles can be seen
(perhaps 2 human figures –
mother and child)

Page 247:

Irian Jaya
Doreri District, Kepala
Burung ('Bird's Head') and
Cenderawasih Bay region,
formerly Geelvink Bay areas
H (beads and cotton) 61 cm,
H (beads) 51 cm, W 59 cm
fibres, glass beads, cotton
woman's dance apron
1st half 20th century
decoration: geometrical
motifs

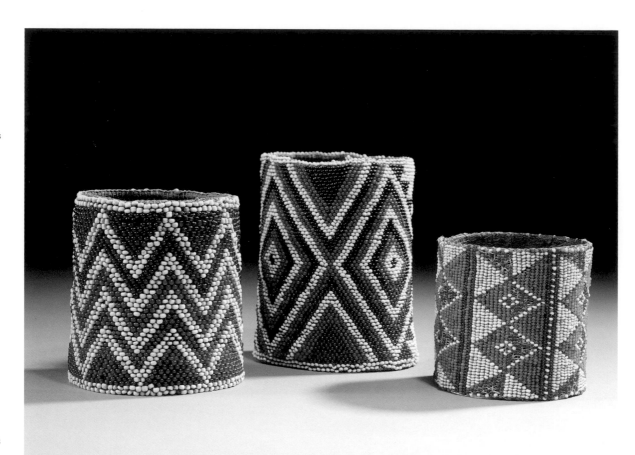

**New Caledonia, Admirality
Islands**
Right:
Admirality Islands
H 8 cm, D 8 cm
tree bark, fibre, glass beads
bracelet
early 20th century

Centre:
New Caledonia
H 12 cm, D 9 cm
fibre and glass beads
bracelet
early 20th century

Left:
New Caledonia
H 10.5 cm, D 9 cm
fibre and glass beads
bracelet
early 20th century

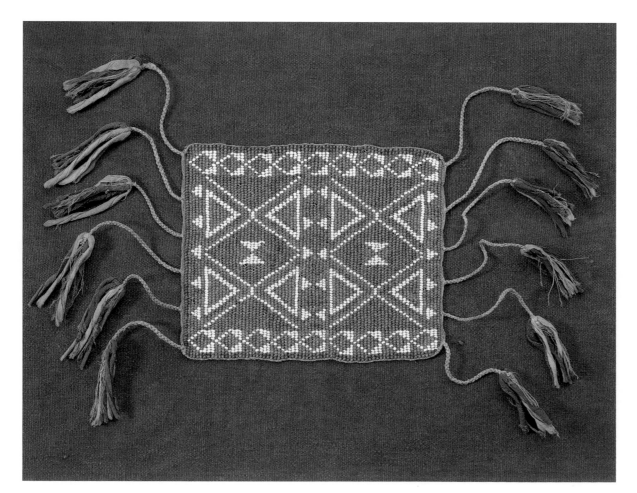

Admirality Islands
L (beadwork) 19.5 cm,
L (with tassels) 49 cm,
W 15.5 cm
fibre, cotton, glass beads
worn as bracelet
early 20th century

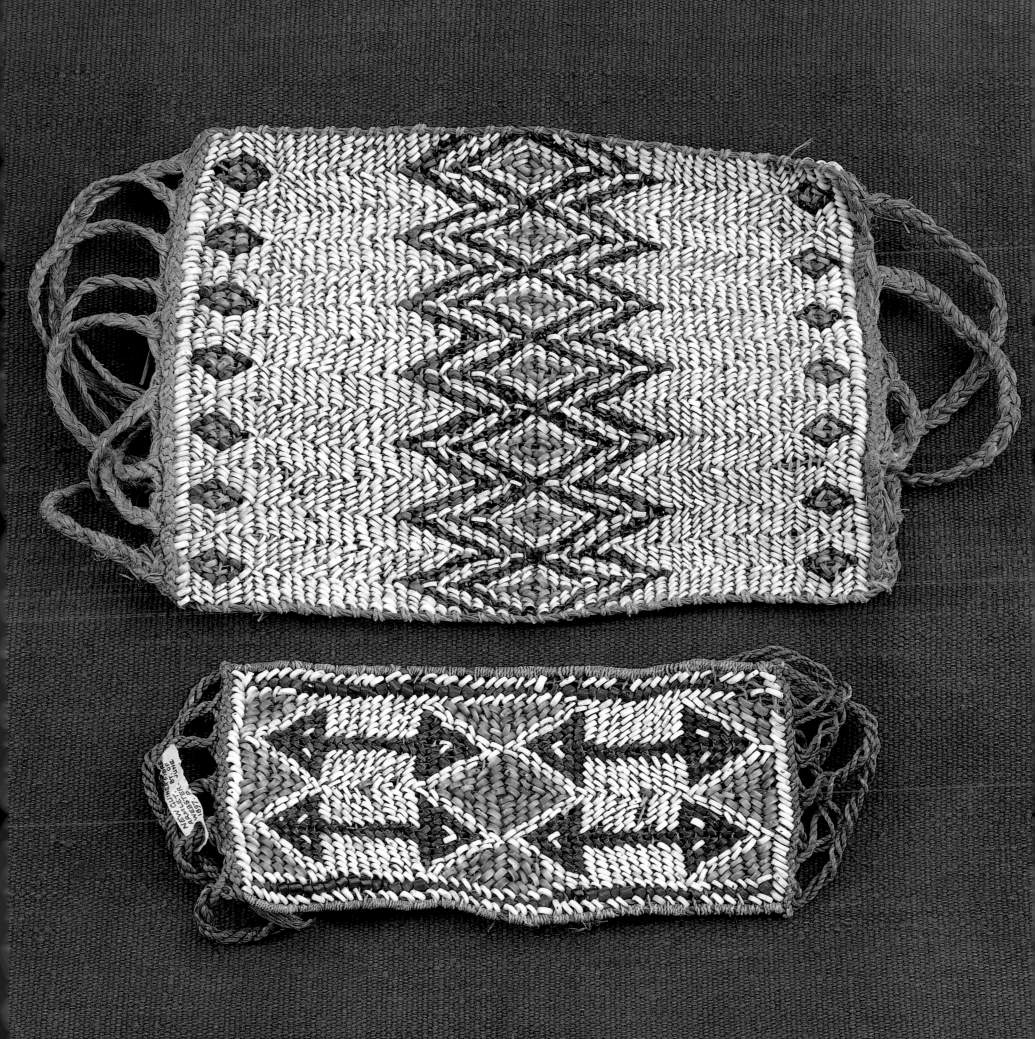

Page 249:

Solomon Islands
Malaita
Top:
L 18 cm, W 13 cm
discs of spondylus shell
(red and white), coconut
fibre, discs of black coral
name: *aba gwaro*
bracelet
19th century
fitted around the upper or
lower arm by means of
fibres

Bottom:
L 14 cm, W 6.5 cm
discs of spondylus shell
(red and white), coconut
fibre, discs of black coral
name: *aba gwaro*
bracelet
19th century
(attached card: 'Webster
June 1897')

Left:

Marquesas Islands
sperm whale tooth and
coconut fibre
name: *tambua*
necklace worn by warriors
19th century
only men of high standing
could afford such a neck-
lace

Left:

Marquesas Islands
L 6.8 cm, W (biggest) 4 cm
sperm whale ivory
name: *hakakai*
man's earplug
19th century
human figure carved in the
protruding part of the tooth

Page 252:

Marquesas Islands
D 23 cm
coconut fibre, dolphin teeth
and glass beads
name: *peu ei* or *peue taki ei*
headband
before 1910
(provenance: Kriech 1910,
Linden Museum Stuttgart,
Mrs Nelly van den Abbeele)

Page 253:

Fiji
D 29 cm
coconut fibre and sperm
whale tooth segments
name: *wasekaseka*
necklace
19th century
similar necklaces are also
found on Samoa and Tonga
and are considered very
valuable; only worn by men
from the ruling families
(see page 244)

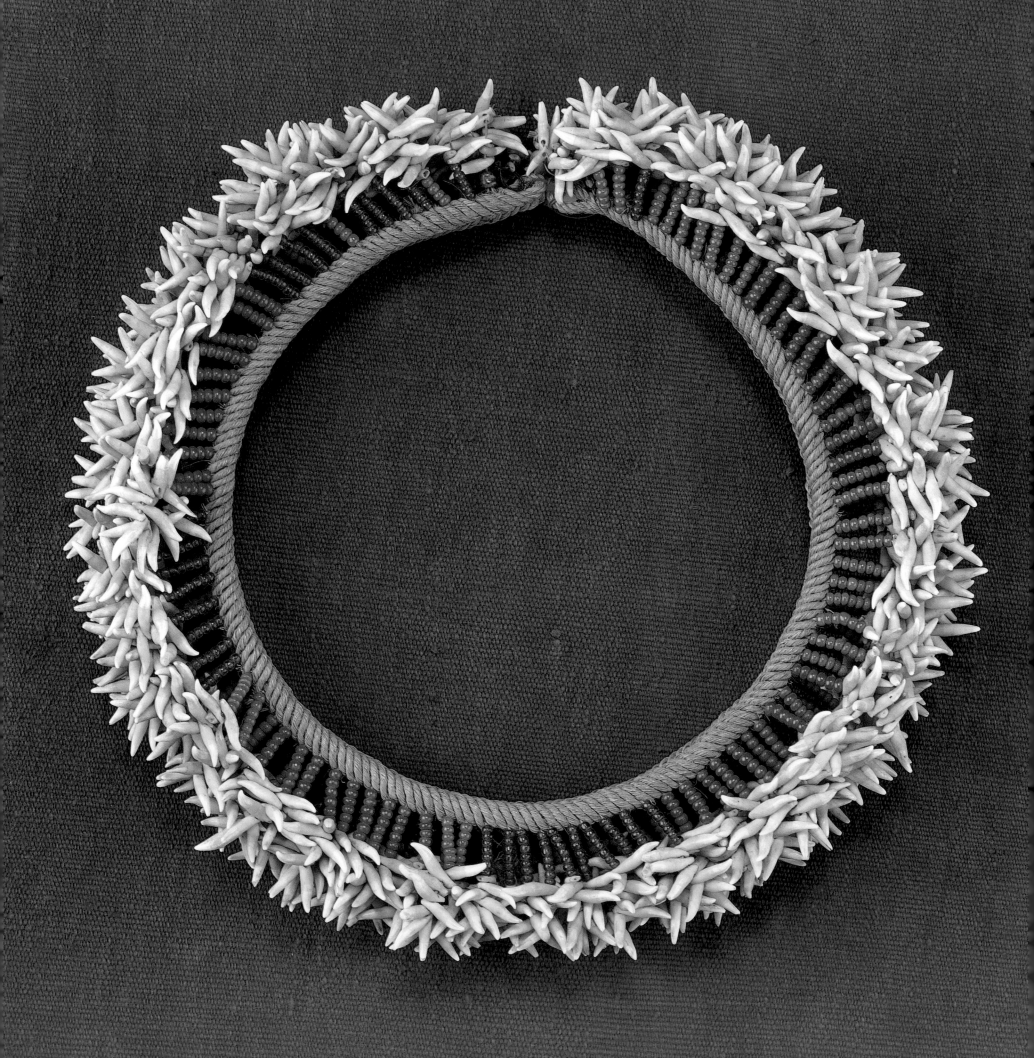

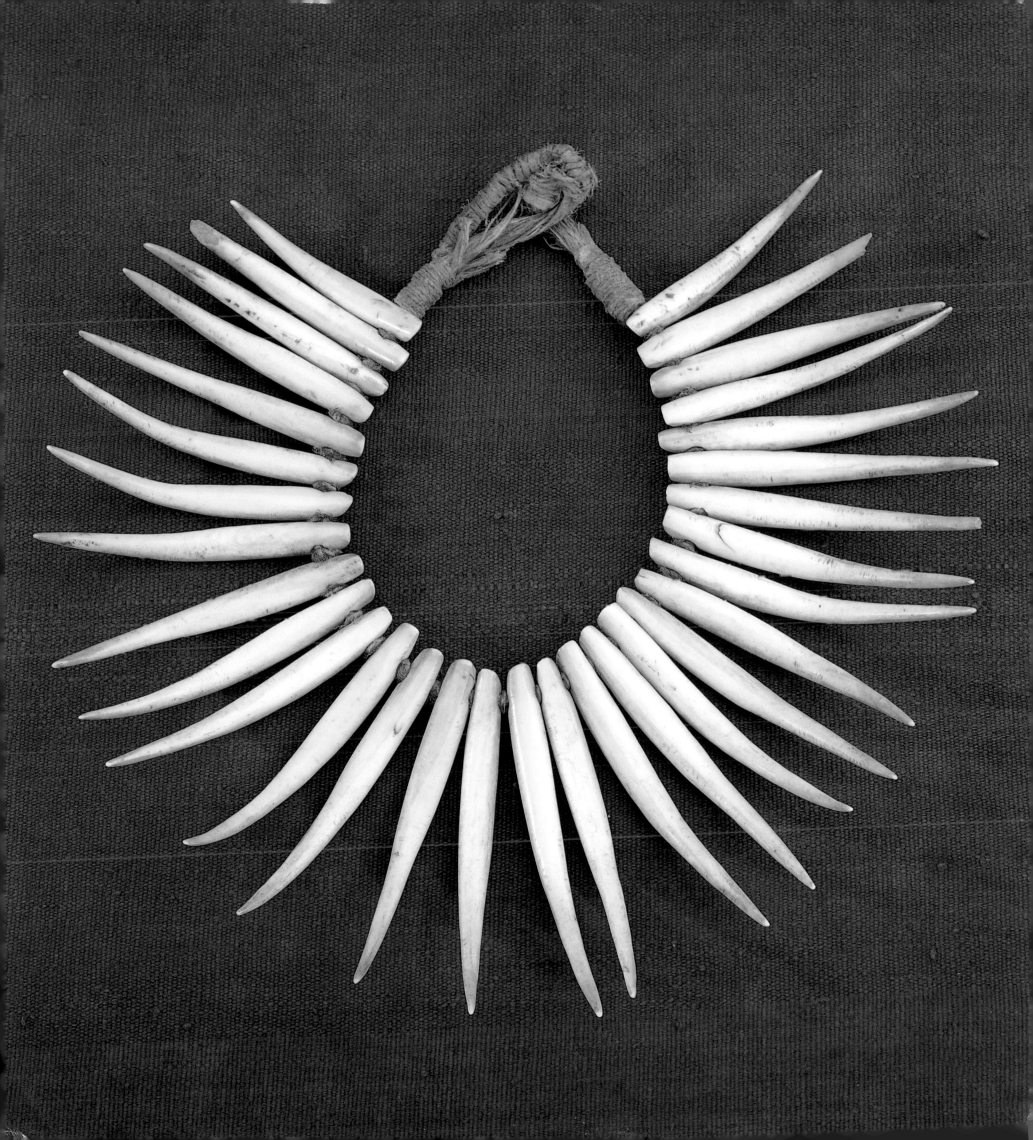

Illustration credits

Dam, Eric van: 219

Donders, Lilianne:
48 (top left, top right), 49

Hoek, Corien W.: 15

Huis in 't Veld-Kneefel,
Hilly: 124

KIT, Amsterdam:
1, 10, 18, 48 (bottom), 122
(top, centre, bottom), 184,
186, 188 left, 190, 191, 242

Lim Poh Chiang: 217, 229

Maréchaux, P. et M.:
49 (postcard)

Moser, H.: 78 (drawing from
his book: *Durch Central-
Asien*, Leipzig, 1885)

Munneke, Roelof: 4

Pankoj Shah: 3

Pran Nath Mago, Delhi:
jacket

Registrar General, Census of
India, New Delhi: 118

Star, René van der:
8, 52 (top left, top right), 125
(left, middle, right), 181, 188
right, 189 left, 214, 228 right
top and bottom

Untracht, Oppi:
120, 121 (all three), 123

Museum of Ethnology,
Rotterdam: 2, 12, 16, 172,
182, 230, 233, 244

Index

Index

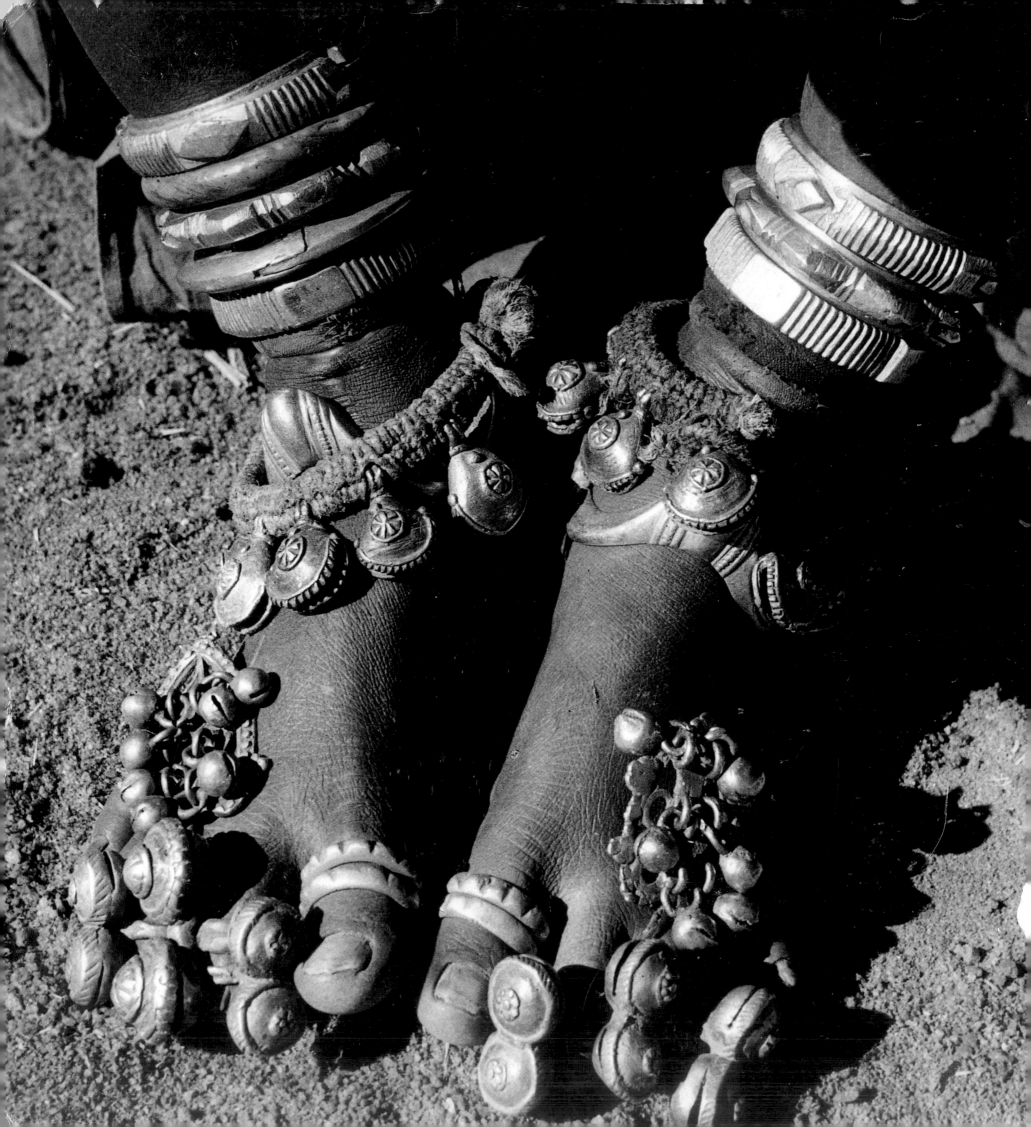